DAVID HOCKNEY by David Hockney

Edited by **Nikos Stangos**

MY EARLY YEARS

BY DAVID HOCKNEY

Introductory Essay by **HENRY GELDZAHLER**

Harry N. Abrams, Inc., Publishers, New York

Front cover: David Hockney in a photograph by Peter Schlesinger, 1975
Back cover: One of the cassettes inscribed by Hockney used in preparing the text for this book

Rae Dalven's translation of Constantine Cavafy's poem "Waiting for the Barbarians," from *The Complete Poems of Cavafy*, is quoted by kind permission of the author's literary estate and Hogarth Press.

Library of Congress Cataloging in Publication Data
Hockney, David
 David Hockney
 1. Hockney, David.
N6797.H57 A42 759.2[B] 76-11721
ISBN 0-8109-1058-6
ISBN 0-8109-2409-9 (pbk.)

First paperback edition published in 1988
by Harry N. Abrams, Incorporated, New York.
All rights reserved. No part of the contents of this book may be reproduced without the written permission of the publisher

A Times Mirror Company

Printed and bound in Spain by Artes Graficas, Toledo S.A.
D.L. TO–663–1988

CONTENTS

Editorial Note The text of this book is an edited version of about twenty-five hours of taped conversations between David Hockney and myself, which took place in London in the summer of 1975. The transcript of these conversations came to about five hundred pages, and from this the present text narrative is faithfully reconstructed. The result is as accurate as possible a transcription of an oral account into a written story. For this reason, grammatical or syntactical correctness has sometimes assumed secondary importance, except when, for the sake of clarity, changes had to be made. Moreover, as we wanted the book to follow a chronological order, passages frequently had to be shifted backwards or forwards and occasional repetition had to be allowed for the sake of the narrative. Further factual information and documentation relating to his work was added, taken from unpublished sources or provided by Hockney himself during many hours of consultation with him. The book is organized in sections of text and illustrations, and each section is a distinct stage in the development of Hockney's work within its biographical context.

It is conceivable that, in some respects, David Hockney's account of certain personal incidents in his life might have been quite different on a different occasion; memory is selective and, according to circumstances, colours events differently. If, at the time when these conversations took place, Hockney had had in the forefront of his mind artistic or personal preoccupations other than those he happened to have during the period of our collaboration, the emphases might have been somewhat different. However, it must be stressed that the information contained in this book, and the documentation on Hockney's work to date which it provides, make it a standard reference work. Moreover, the book reproduces almost all of Hockney's paintings and graphic works, as well as a large number of his drawings.

This publication would have been virtually impossible without the enormous help with illustrations and information provided by John Kasmin, Paul Cornwall-Jones and Ruth Kelsey. Helpful editorial suggestions and support in all stages of the textual editing were given by the artist's brother, Paul Hockney, and by Peter Schlesinger, George Lawson, who also translated into Italian the titles of the works reproduced, R. B. Kitaj and Sandra Fisher. David Hockney and I are most grateful for their interest and assistance.

Marginal numbers in roman refer to black-and-white plates, those in italics to colour plates.

Nikos Stangos

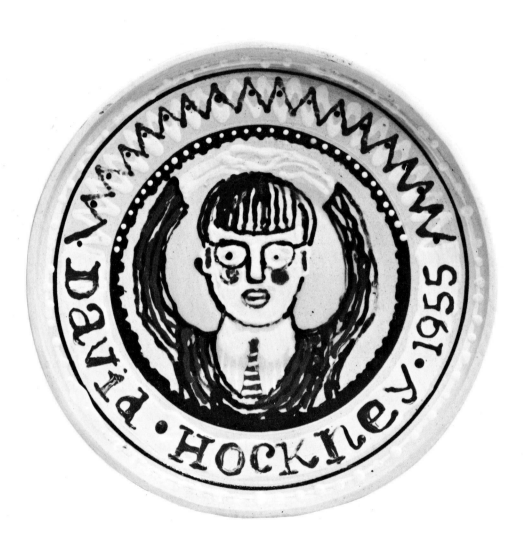

Introduction by Henry Geldzahler

David Hockney's art has been lively from the first because he has conducted his education in public with a charming and endearing innocence. The pictures are often distinctly autobiographical, confirming Hockney's place in the grand tradition of English eccentricity. He has at each stage given us touchingly curious indications of how he felt, what he knew and whom he admired. The humour both disguises feeling and insists that it is too strong to reveal without being disguised.

Hockney has never been interested in the commissioned portrait. As he has become increasingly fascinated by exactly how things look and in finding ways to paint what he sees with greater veracity, he has turned quite naturally to drawing and painting his close friends again and again. They are his guitar, absinthe bottle and journal, the objects of his affection.

Ivy Compton-Burnett in her novels minutely examines family relationships. She describes the wit, courage and anguish of people who live under the same roof whether through choice or through force of circumstance. The surface crackles with brittle, inconsequential conversation, but at the same time it heaves and swells with volcanic rumblings, the real, almost unmanageable feelings of need and rejection that characterize the intimacy she depicts. The work of David Hockney projects similar complexities.

Although in recent years the work has become more illusionistic, Hockney himself now has fewer illusions. The world and its people are still lovable and good; but the romantic haze has blown away. Hockney today sees the world more as it is, clearly and memorably. Earlier he saw what it might be. The tougher, less romantic attitude signifies maturity. The levity of the early work remains undaunted – as in the past, Hockney is uncanny in his ability to choose just the right moment for celebration – but there is an underlying acuteness of vision that is the product of a newly athleticized capacity for deliberation. As a result, the more recent paintings give the viewer as much as Hockney's work has always given, but they are greater in their demands.

David Hockney has been painting seriously, as a student and in the world, since 1960. Distinct caesuras can be pinpointed and a development can be described most easily in his striving towards clarity, which he has achieved largely through a deliberate limiting of means. Over the years this has amounted to a relinquishing of skills and devices which may always be called on again to solve a particular problem or create a special effect. Thus, each time he paints,

by making a limited number of choices from an ever-increasing repertoire of means, Hockney produces art of great physical interest and variety. He might be described as an inspired, literate and sophisticated primitive in that he borrows and experiments with techniques and styles whenever it suits him. He is not afraid of straying down a curious bypath if his interest so leads him. It is for this reason that the picturesque story-telling in Hockney's work is never undermined by exhausted technique, so often a limitation in the work of artists, both figurative and abstract, who are illustrators and little more.

Technical prowess has heightened the power and concentration of his paintings. At the same time he is able to delight in the discovery and use of techniques in a way that has rarely been seen since the generation of Picasso, Klee, Miró and Hofmann.

Since 1964, and consistently since 1966, David Hockney has proclaimed a higher ambition in his work: to compete with the history of art rather than with members of his own generation. As a younger man he borrowed or mimicked contemporary taste. Now there are no more empty spaces, no fudging; the intervals must be dealt with as convincingly as is the subject matter.

Increasingly in his work he is concerned with specificity, finding the exact essence and how to clothe it. Samuel Johnson would have approved: 'I had rather see the portrait of a dog I know than all the allegories you can show me.' This was not always so with David Hockney. A painting like Flight into Italy – Swiss Landscape, 1962, suggests that he was interested at the time in juxtaposing many kinds of information on a flat surface: a mountain range in rainbow-like stripes quoted from contemporary abstraction; the clearly-lettered sign 'Paris' contrasted with the speedy blurring of 'thats Switzerland that was' (a reference to a Shell advertisement then current) and the streaked figures in the van. The sky is unpainted, while the mountains are brightly coloured. At the bottom, a passage of thick paint is mixed with sand. 6

Much, even most of Hockney's pre-1965 work can be characterized positively as charged with energy, or negatively as overloaded with information and inconsistent stylistic devices. Therein, given either characterization, lies its immaturity and its charm. It is fruitless to accuse the early work of not being later. What surprises is how much the early work bears scrutiny, how well it stands up in its inconsistencies. A presence, a sureness, a wit keep these paintings from going too far towards private and obscure reference, keep the excesses of stylistic diversity in hand, just in hand in some cases.

Some of the excitement we still feel in this early work can be traced to the variety of influences Hockney was open to. In Sam Who Walked Alone by Night, 1961, which was suggested by a story about a boy who occasionally wore dresses, we find references to Dubuffet in the flattening of the head and upper body and in their simplification; in the same painting the articulation of the head, its necklessness, reminds us of the then much praised English sculptors Reg Butler, Kenneth Armitage and Lynn Chadwick. (As with so much overpraised art, English sculpture of the 1950s is now somewhat maligned – the truth lies somewhere in between.) The canvas is shaped, in two parts, the body wider than the head. It is one of several paintings of these years in which Hockney played with the rectangle, altering its shape for reasons of economy, humour and expressiveness. 26

Francis Bacon too is present here. He was very much on Hockney's mind as a figurative artist who in an age dominated by abstraction continued to invent fresh and powerful personages with vigorous brushwork and varied paint quality. Bacon was in London, his habits and life-style topics of conversation and, most importantly, his paintings were often on view at the Hanover Gallery and at the Tate. As David Hockney was early committed to maintaining the human figure as the fittest subject for a painter, his admiration of England's best figurative artist was

natural. He took what he wanted from Bacon when he needed it in certain passages of certain paintings: the body of the figure in The Cha-Cha that was Danced in the Early Hours of 24th March, 1961, or the way the paint is laid down in his interpretation of Ford Maddox Brown's famous Victorian standby, The Last of England, which became The Last of England?, 1961. In the Hockney version the man and woman of Brown's painting have become two boys. The composition is close enough to the Pre-Raphaelite picture to be easily associated with it. The great difference lies in the contrast between the millimetric literalness of Brown's painting and the slipped, fudged expressiveness of David Hockney's. Francis Bacon has stepped between. Bacon was important, so was Larry Rivers, so was Dubuffet, so were the abstract expressionists. As with all brilliant students everything was new, potentially delicious, and had to be tasted.

Willem de Kooning, a Dutchman who came to America in his mid-twenties in 1926, brought a lively intelligence to the New York School in his portraits during the early 1940s and, famously and definitely, in The Women, his great series of paintings begun in 1949–50 that advanced cubist techniques of representing the human figure. By the time Hockney entered the Royal College of Art in London in 1960, de Kooning's brand of abstraction was what fascinated most of his more adventurous fellow students.

But abstraction aped from art magazine illustrations and half-digested influences of New York painting did not hold Hockney long. He had had a very traditional training at the Bradford School of Art from 1953 to 1957. Then, during a two-year break, working in hospitals in Bradford and Hastings to discharge his military service obligation as a conscientious objector, the empty routine had driven him deep into reading. Traces of abstract expressionism appeared in his work in the early sixties, but Hockney's attention was more devoted to finding a way to meld his literary loves with his need to depict figures and their relationships. It was at this point that he began to become himself, to discover his subject and to grope towards his technique.

At the Royal College he soon discovered another, older student with similar interests, the American R. B. Kitaj, who was studying at the College under the United States Government's G.I. Bill of Rights which paid tuition for the higher education of former servicemen. Like Hockney, Ron Kitaj was interested in painting the figure and in literature. They soon discovered another mutual passion, political idealism. It was Ron Kitaj, a bit older and more experienced, who first suggested to Hockney that he paint what most interested him, literature, politics and people and their relationships.

What Hockney needed at the time was a way in which to introduce his subjects into art, a device that had been legitimized but not used up. It was several months before he dared to swim so forcibly against the stream as to use recognizable human elements. Instead he introduced lettering and words into his abstract compositions. A witty indication of Hockney's dilemma is a small painting of 1960 called Little Head in which the figure is the usual circular form topping a vertical rectangle with rounded corners. There is a reference here to the sculpture of William Turnbull, sculpture which is to turn up again on the lawns of Hockney's California-collector paintings half a decade later. The clearest indication that we are confronted with a figure, beyond the juxtaposition of these head-like and body-like forms, is in the quite literal semi-colon that sets the features in the face. Hockney was playing with the necessity to make his message literal by using typography figuratively, a literary playfulness he shares with another Yorkshireman, Laurence Sterne, whose Tristram Shandy with its black and missing pages so amused him when he came across them a decade later.

In Witch Riding on a Cloud, 1960, a bit earlier, several devices are introduced or rather overlaid on what was at first an abstraction: a large letter E, a graffiti-inspired outline figure that recalls both cave painting and Egypt, and the lower case word witches. To Hockney the

painting seemed lacking in content without these additions. Blues, mauves, reds and greys billowing about the canvas simply did not suffice.

Words in paintings have a long history. One can go almost as far back as one wants; hieroglyphics in Egyptian wall paintings, names on Greek vases, holy and botanical words in medieval manuscript illuminations, scriptural quotations in countless Renaissance paintings, and in our century, more prominently, the lettering used to such great effect in cubism to identify objects and to locate the picture plane. All this Hockney knew, some specifically, some vaguely. The most recent example of an imaginative use of lettering in figurative painting was in the work of the American Larry Rivers.

The Third Love Painting, 1960, would be a rather standard abstract-expressionist painting 2
were it not for the form looming towards figuration at the bottom right of the canvas and were it not for the placing and the content of the writing, a combination of quotations from Walt Whitman and from graffiti on the walls of the men's room in the Earls Court Underground station, a contrast between the dignified and sublimated love of the male with its lowest and most urgent counterpart. The Whitman lines quoted most extensively in this painting are the lovely closing ones from 'When I Heard at the Close of the Day'. The poem begins:

> When I heard at the close of the day how my name had been received with plaudits in the capitol, still it was not a happy night for me that followed.

The poet then finds his joy and ease not in national praise but in private companionship. The lines printed on the lower left of the canvas are the last of the poem:

> For the one I love most lay sleeping by me under the same cover in the cool night,
> In the stillness in the autumn moonbeams his face was inclined toward me,
> And his arm lay lightly round my breast – and that night I was happy.

This on a canvas with 'ring me anytime at home' and 'come on david admit it' and ruder matter as well.

At the same time Hockney was doing his first etching, Myself and My Heroes, Walt 30
Whitman, Mahatma Gandhi and a self-portrait. Whitman's attraction was as a vernacular poet of wide sympathies and lovely music; Gandhi's was as a pacifist and anti-imperialist. Hockney also admired Gandhi's vegetarianism; his mother had brought him up not to eat meat and his father not to smoke. (He now does both.) The self-portrait in this etching, a rather rare subject in Hockney's work, is the familiar figure of those years, the stone-like head sitting on a cut-off rectangle with rounded shoulders, this time wearing a little cap. His self-portrait in words is as modest, in the face of his heroes, as is his little cap: 'I am 23 years old and wear glasses.' He used a related image of himself in his first popular and critical success, the sequence of sixteen etchings, A Rake's Progress, 1961–3. These are the only self-portraits in his mature work until the 60–75
recent etching, The Student: Homage to Picasso, myself and another hero, as it were, and 393
more recently his image in the mirror at the centre of his My Parents and Myself, 1975. 414

Portraiture has been a concern of Hockney's from the beginning. The most complex of the early paintings and perhaps also the most successful is Play within a Play, 1963, a playful portrait 93
of Hockney's first dealer, John Kasmin, that takes several of its devices from a recently acquired and vastly admired painting by Domenichino in London's National Gallery. Kasmin's features are distorted because his face and hands are pressed against a piece of clear plastic, a 'modern' touch that wittily emphasized the primacy of the picture plane.

Portraits of two people occur more frequently than single figures; more than two are never dealt with except in A Grand Procession of Dignitaries in the Semi-Egyptian Style, 1961. This 4

may well represent a revulsion on Hockney's part against his Bradford Art School training which insisted that an 'interesting' composition must deal with at least three figures. It is in the drawings that the simple portrait of the single figure predominates. Despite the careful rendering of Hockney's drawings of the past five years, drawing for him is still to a large extent a form of note-taking. It represents time spent vis à vis someone he doesn't know but finds attractive, is getting to know, or knows so well that the likeness is no challenge. It is in these latter drawings, when he is observing close friends yet again after years of studying them, that the work is most masterful, relaxed and ambitious. Limning the likeness can be a strain. When the likeness is available through familiarity he can concentrate on the mise en page, focusing our attention on a shirt or a chair, and eliminating what he feels to be non-essential: a wall, the floor, everything in the room that isn't the sitter or a minimal compositional element.

There is a moment, which can be pinpointed, when Hockney's drawings became consistently more concise and informative, more concerned with giving precise information. In September 1963, the London Sunday Times sent him to Egypt to do a series of drawings which in the end they did not use. They are among his best drawings up to that time. Shell Garage – 79 Egypt is the most elaborate of the series; Yoghurt Salesman Walking Home, Luxor, the most charming, with its easy contrast of the flowing Arab robe and the determined set of the carefully rendered head, the boy's yoghurt box balanced firmly in place. Before this time most of the drawings were preparatory to specific paintings, or quick notes to himself. In this Egyptian sequence each drawing was an end in itself, the artist as a sharply observant tourist collecting information for the benefit of the Home Counties – the Englishman abroad. Like Edward Lear or Graham Greene, he displays an affectionate yet wryly ironic view of the exotic.

David Hockney does two kinds of drawings, line drawings in black ink, usually with a rapidograph pen, and coloured pencil drawings. In the line drawings he has always observed supremely well; lately he has set himself more difficult problems in them, placing the sitter in more complicated poses, giving more information and detail in the faces, hands and clothing. He also does superb drawings using coloured pencils in which he masses and blocks colour; the line is there, of course, to bound a form, to set a perimeter, but the outlook is basically painterly. Indeed one might say, somewhat simplistically, that while the line drawings relate primarily to the prints, the coloured drawings reveal his painter's mind. The coloured drawings are most often done as ends in themselves, friends, landscapes, compositional ideas. They amount to a substantial body of work.

The movement in Hockney's art towards greater precision and closer observation can now be seen as an ineluctable process. We have already seen how he threw up a smoke-screen of expressionist devices in the earliest work, 1960–3. In 1964 and 1965 he composed many fanciful still lifes, interiors and landscapes in which the use of chiaroscuro and local colour began to give the work a modelled look. The forms might be painted simply and flatly with emphatic shadows (as in English Garden, 1965) or they might be conscientiously rounded, from dark 129 above to light below, as in the waves of Atlantic Crossing, 1965, and in the fully rounded 131 biomorphic clouds that could have been lifted whole from Jean Arp by transposing two sculptures into paint and exaggerating their highlights. There are many more paintings of the period that share this mood and employ these devices; the mood can be characterized as theatrical and the devices, illustrative. The earliest painting worked fully in this manner is Iowa, 108 1964, painted there when Hockney was teaching at the University. A clutter in the clouds indicates that he has not yet mastered the style; but the painting has the charm of its deliberate simplification, as do all these paintings, the charm of paring down to essentials before leaping into terra incognita. Looking back one can now see this new manner adumbrated as a peep at

stage scenery through the curtains of Closing Scene, *1963. Many of these paintings were* 94
'staged', deliberate problems; Blue Interior and Two Still Lifes, *1965, is a typical abstract* 134
invention of this moment. A fully rendered couch and a wide chair surround two sides of a
legless table with three cylinders set on its surface; three vertical forms of unexplained purpose
echo the cylinders in a space beyond the grouping; the furniture sits on a simple-minded rug,
and the whole painting is surrounded by continuous finger-flames of pink and blue that form a
frame within the rectangle of the painting – the whole an invention – a scene that never was on
sea or land.

 In the early months of 1966, before he left in June for Los Angeles where he was to stay a year,
Hockney was busy with projects unrelated to painting. He designed a witty production of Alfred
Jarry's Ubu Roi *for the Royal Court Theatre, the drawings for which survive. In one of these,* 170–6
'Ubu Collecting Taxes from Peasants', he invents architecture for the stage that harks back to his
first California paintings, Wilshire Boulevard, Los Angeles, *1964, and* Building, Pershing Square, 116, 113
Los Angeles, *1964, and points forward to the* French Shop, *1971. In another he represents the* 257
'Polish Army' as two soldiers, one with a cockaded paper pyramid for a hat, the other with a 176
cockaded paper rock, bound together with a paper bandage tied behind the second soldier.
During these same months he illustrated the book of Nehemiah for a modern illustrated Bible 154
commissioned by the Oxford University Press, with eight line drawings, which hint at Assyria
and which picture elliptically the rebuilding of Jerusalem. The third project of early 1966 was the
illustration of some of Hockney's favourite poems by the earlier twentieth-century Greek 157–69
Alexandrian C. P. Cavafy, introduced to the English-speaking public by E. M. Forster. Hockney's
interest was long-standing. Two of his first etchings, both of 1961, Kaisarion with all his Beauty 34
and Mirror, Mirror, on the Wall, *were inspired by Cavafy poems. Nine of the thirteen Cavafy* 35
etchings in the book, Illustrations for Fourteen Poems from C. P. Cavafy, *picture two boys.*
They are seen in bed, in a living-room, in front of a shop. The figures are drawn with great
simplicity and tenderness, never explicitly erotic but with the shy awkwardness of casual
contact. Sometimes they illustrate specific poems, as in 'He Enquired After the Quality'; more 167
often they picture a relationship, most touchingly in 'According to the Prescriptions of Ancient 159
Magicians'. The sources of these illustrations were drawings and photographs of Beirut, visited
in January 1966, photos from physique magazines, and drawings of friends.

 Through all these years, 1960–6, one senses that Hockney was competing with recent art and
with his own generation, that he felt his pictures must somehow look 'modern', experimental
and fanciful. The paintings of these years don't strain towards these effects; they were arrived at
intuitively by an artist of limited ambition who thought allegorically and with verve; an artist
who took his cues from what he had observed and embroidered fancifully on his sources,
magazine illustrations, the life of the studio, and often earlier art, an Egyptian head, a Muybridge
photograph. Whatever fed his imagination became a fit and sufficient trigger. During these
years he travelled extensively in Europe, Egypt and America, always with the devouring hunger
and curiosity which mark his intellect and shape his taste. He visited museums, saw new kinds
of architecture bathed in a flatter and less shadowed light, and realized increasingly the wonder
and appeal of a world beyond Bradford, beyond London, beyond England, and finally beyond
Europe. He also began slowly to realize, with increasing rigour of thought, that it was not
only the art of the 1960s that fascinated him, but the art of the past, the best art of the Western
tradition. At this point he stopped striving for originality; if one painted in the 1960s one was
necessarily an artist of one's moment – one did not have to put that part in, so to speak.

 Hockney's work since the middle sixties has been increasingly concerned with frontality,
facing the subject and viewing it closely and stereoscopically, with the stillness of Byzantine art,

and the surrealist sense of time out of time; simultaneously the pictures are an accretion of time, layer on layer, from conception to completion, often the result of months of thought and effort; painting and repainting, correcting perspective and adjusting colour. One of the accomplishments of these paintings is the impacted time we apprehend. The image is available at first sight and retains a timeless quality. But the picture continues to unfold as it becomes apparent that the craftsmanship is one of the vehicles through which the story is told.

In the past several years much attention has been concentrated on a group of American realist painters who depend on photography to a large extent for their finely detailed and accurately rendered representations of storefronts, cars, gas stations, modern entrance lobbies, etc. Richard Estes is the best known and most accomplished of these super-realists. Exhibitions and catalogues have been devoted to them in Germany and Italy and, by now, probably in Japan as well. There are many differences between the style they have adopted and what David Hockney is after; the most apparent is their lack of an ironic sense. The super-realists often confront us with a tense stillness, a frozen moment suggestive of the horror of paranoia or a waking dream. Once they have a photograph or transparency to work from their attitude seems to be that to describe is all. Hockney still judges and loves like an old humanist. One also realizes, looking at their work, after some familiarity with Hockney's, that with the exception of Estes they have left accreted time out of their world. The time in most super-realist painting is the time of the still photograph that is its source, rather than the considerable time that it took to paint it. And yet it is the latter time, many hours of exhausting mental concentration, that forces itself upon the viewer – to the detriment of what one enjoys of the split-second imagery. Just as Hockney was not a pop artist in the early sixties, though he shared some of their presuppositions, he is not a super-realist in the seventies.

There are as many kinds of 'realism' as there are realist artists, or as there are individual styles within abstraction. If there weren't this natural variety, there might be a correct way to represent reality in paintings, an academic realism to meet every occasion. This cannot be. There is no such thing as a universally realistic painting; all attempts at recreating reality on canvas depend on decisions of inclusion and exclusion. It is these decisions that separate artists and the 'realistic' painting of different eras.

Hockney's later manner was developed away from London and New York, during his several trips across America. He first visited America in 1961; on that trip he saw only New York. It was on subsequent visits, when he was invited to teach in the Mid-West and in California, that an affection for the deadpan coolness of America clutched his heart. It was an America he was predisposed to like through his familiarity with American physique magazines, mostly produced in Los Angeles and San Francisco. Nikolaus Pevsner, in his Englishness of English Art, speaks of the detachment, reticence and taciturnity of English portraiture, and goes on to say, 'The English portrait conceals more than it reveals, and what it reveals it reveals with studied understatement.' He then quotes Jane Austen who in Emma says of 'the English style' that it is achieved 'by burying under a calmness that seems all but indifference, the real attachment'. These are descriptions that capture the arm's-distance involvement of Hockney's love-affair with America, particularly California, its swimming pools, swimmers and architecture, its art collectors, sprinkled lawns and blank allure.

In 1964 Hockney taught at the University of Iowa, in 1965 at the University of Colorado, in 1966 at the University of California in Los Angeles and the University of California at Irvine (in Orange County, south of Los Angeles) and finally, in 1967, at the University of California at Berkeley. Then, as he says, 'I retired.' He retired from teaching, but not from visiting America, most particularly California, a continuing if lessening fascination. While at the University of Colorado

he did a number of paintings, one of which, Man Taking Shower, 1965, *points forward and back*
in his work, forward in the treatment of the nude man outlined against the tiles of the shower
stall, with falling water, whose depiction forms a new and persistent interest; back, in the
multiple focus of the composition, the bed and chairs rendered small in the distance, while in
the foreground a rather abstracted plant with four dark green leaves lies flat to establish the
picture plane. The man's body is painted more carefully, built up more convincingly, than in the
earlier, expressionist Domestic Scene, Los Angeles, 1963, *painted before he went to California* 95
with the aid of imagination, a physique magazine and mother wit. The composition of Man
Taking Shower, 1965, *is flatter, more frontal, than an earlier representation of a similar scene,*
Man Taking Shower in Beverly Hills, 1964, *in which the figure is still somewhat generalized,* 97
and the compositional device of the carpet cutting the bottom of the painting diagonally is still
more involved with picture-making than with picturing. On the other hand Man Taking
Shower, 1965, *retains expressionist elements and is itself* retardataire *in Hockney's develop-*
ment when compared to the painting of the following year, Peter Getting Out of Nick's Pool, 145
1966, *in which he hits his California manner in full stride.*

The California manner is at its height, clearest, cleanest and least complex in the two years
1966–7. *It is characterized by a coolness of vision and execution, a flattened, virtually shadowless*
transcription of architecture, pools, lawns, boys and collectors. It is a catalogue of the Los
Angeles art world in which Hockney spent his California years that will stand for the period
much as Evelyn Waugh's Loved One *stands for the earlier Los Angeles of Forest Lawn and other*
excesses. There are sensual intellectual Englishmen for whom Southern California has been a
more sympathetic Riviera, a warm and modern escape from the vagaries of English class and
weather: Aldous Huxley, Christopher Isherwood, and David Hockney. The paintings of these
years were his best to date and there is one good one after another: Beverly Hills Housewife, 187
Portrait of Nick Wilder, Savings and Loan Building, A Lawn Sprinkler, A Neat Lawn *and,* 147, 198, 19█
perhaps the best of all, A Bigger Splash. *All are detached and crystalline, all breathe a clarity of* 196, 189
light, perception and realized intention that mark Hockney's new and greater ambition to paint
the world of today dead-on, as he saw it, with no concessions to modernism except those that
were the built-in presuppositions shared by most of the painters at work in the 1960s.

The intellectual preoccupations of these paintings are simple to state; how to apply
academic training in perspective, foreshortening, rendering and composition to a new subject
matter in such a way as to capture it on a surface that continues to look absolutely flat. There is
nothing random about the choice of subjects or about his angle of vision. Hockney chooses to
stand at the centre of the picture, to plant himself firmly and to look through both eyes,
stereoscopically, rather than through the cyclopean viewpoint of the camera and its
photograph. The camera can help to fix the subject in his mind, to cue for colour and for formal
relationships; it cannot substitute for feeling or for thought. Its decisions are too mechanical. An
earlier English painter, Walter Sickert, wrote in The English Review *in January 1912: 'The*
camera, like alcohol . . . may be an occasional servant to a draughtsman, which only he may use
who can do without it. And further, the healthier the man is as a draughtsman, the more
inclined will he be to do without it altogether.' Hockney usually uses his camera in the way
Sickert describes as a form of note-taking, most often when he is travelling. Some fifty leather-
bound books of photographs in his library testify to an abiding interest. They cover the past ten
years with increasing persistence and detail. Occasionally a photograph leads to a painting, for
example Three Chairs with a Section of a Picasso Mural, 1970, *and* Beach Umbrella, 1971; *but* 318, 258
almost invariably the painting was already taking shape in his mind before and as he took the
photograph. And, as comparisons between the specific photographs and their subsequent

related painting indicate, an artist has intervened. But this, the standard apology for painting based largely on photographs, is hardly necessary when one considers that just as photography may be used in the service of painting, the reverse is also possible. For example, Charles Sheeler, the American precisionist whom David Hockney greatly admires, might well be described in his middle years as a photographer who turned to oil and canvas in order to overcome the limitations of print-making by which all photography is bound, and in particular the severe limitations of colour photographic printing in the current state of the art. Although Hockney is only occasionally a painter in the service of his photography, like Sheeler's his interests are aesthetically coherent. His best photographs and the several paintings he has based on them are as precisely and crisply personal as are his prints, drawings and paintings observed directly from life.

Hockney's photo albums reveal his romanticism and sentimentality about people and places. His friends are photographed again and again, in new settings, in new clothes, with new partners. If art and life can be separated for a moment to allow for the making of a point, they refer more to Hockney's life than to his art. As he says, he takes holiday snaps all the year round.

There is a technical fascination that runs through these California paintings of 1966–7 : how to render water and reflections on glass. While these are not absolutely new concerns in his art (water falls and splashes rather unconvincingly in Man Taking Shower in Beverly Hills, 1964, 97 *and still water is somewhat crudely depicted in* Picture of a Hollywood Swimming Pool, 1964, 119 *and in* Two Boys in a Pool, Hollywood, 1965) *they typify the work of these two years as much as* 123 *do the constant blue sky and the simple rectilinear architecture. In* Peter Getting Out of Nick's 145 Pool, *the play of light on the water, suggested by curving, interweaving lines, is abstract but understandable, the bright orthogonals indicating light falling harshly on the glass. In* Portrait of 147 Nick Wilder *the window glass is transparent, revealing curtains behind, and the water is less continuously interwoven. We see rather the shapes of jigsaw and camouflage.*

One thing is abundantly clear from even a cursory look at these paintings. When there is a figure in them, no matter what the relation of its size may be to the total canvas, it is the figure that controls the content of the painting. Peter Getting Out of Nick's Pool *is conceived in a series of horizontal bands: the roof, the wall with sliding glass doors, and the pool itself – only Peter emerges as a vertical element and thus very much the subject of the painting. In* Portrait of Nick Wilder, *the Los Angeles art dealer is shown in the same pool with the same building behind him but this time the horizontals are suppressed. We find him demurely emerging, cut off and stylized like a Roman bust at the far end of a flatly curving pool, coolly green and blue, reminiscent of a Mediterranean grotto. In both pictures the setting may dominate visually, but the fact that Hockney has chosen to depict a figure in a setting, and he only depicts his friends, spices these paintings with a second personality.*

In A Bigger Splash, 1967, *the figure has submerged and, as Charles Harrison wrote in* Studio 189 International, *January 1968, 'will never surface in this world'. Looking at this painting we are somehow not concerned with the absence of the figure, obviously present an instant ago. The subject of the painting is the explosive wetness of the splash in contrast to the warm and fragrant stillness of the setting, no longer depicted with the expressionism of the earlier paintings, but frozen in place between the thrust of the diving-board and the inevitable Southern California building in the background. The water is painted from a photograph Hockney found in a technical book on swimming pools, the building from a drawing he had recently made. The result has the charm of a nineteenth-century French academic painting in which the figure (the water in* A Bigger Splash) *is painted in the studio and integrated into a landscape that has been observed on the artist's travels, perhaps in North Africa. It is this*

staginess that accounts for the painting's success. It is obviously contrived. Yet it works perfectly, a moment of stilled excitement in an over-manicured world.

Hockney's most ambitious California paintings are two that combine so many problems it is difficult to think of them otherwise than as deliberately complex, the hurdle set high by the artist to prove what he can do, first to himself, then to his audience. In the heyday of the Salon, in Paris in the latter half of the nineteenth century, paintings like Beverly Hills Housewife, 1966–7, and 187 American Collectors (Fred and Marcia Weisman), 1968, might have been considered 191 , 'machines', impressively large paintings grandly conceived to show the artist's strength. In both, leading Los Angeles collectors are shown in the setting of their glass-walled, flash and angle houses; what one notices and remembers are the unending light-struck sheets of glass and the relentlessly rectangular architecture. These impressions are somewhat softened and yet perversely reinforced by the contrasting of animal skins, vegetation and recognizable art by recognized artists. The Beverly Hills Housewife has a zebra-covered Corbusier lounge chair and a moosehead on the wall; these represent the presence and interests of her absent husband; the little palm tree at stage front right sets the scene and hits off nicely the William Turnbull sculpture. Diagonals of light on the glass wall are treated as they were in an earlier California painting of the same year, Peter Getting Out of Nick's Pool. The painting is all of a piece, cool and distant and amused. The housewife's head is recognizably her own and yet its individuality is deliberately downplayed; like her house and her objects she exists in a windless clarity emphasized by her frozen stance, wooden dress and three-quarters profile, Egyptian and expressionless. The painting is so stabilized that it is only with the work of the next few years in mind that we look back on it as a moment of stasis, that could have led to emptiness if repeated.

David Hockney seems to have sensed the dangers of depending in his portraits on an endless blankness of attitude. In American Collectors, 1968, Christopher Isherwood and Don 192 Bachardy, 1968, and Henry Geldzahler and Christopher Scott, 1969, a greater ambition is 228 realized and a new series of qualities appear in the portraits: a heightening sense of individual character, an increased concern with modelling and rendering the features, and a more subtle feeling for the interreactions that mark domestic life. The stance of the woman in American Collectors echoes the Henry Moore sculpture on a pedestal at the centre of the painting, her mouth echoes the distorted mouth of the North-west Coast totem at the right. The feeling of aridity in the picture is heightened by the segregation of the grass and tree to the extreme left and right of the painting. She looks at us, he stands stiffly sideways seeing something outside our field of vision. Although this double portrait was not commissioned, the Weismans owned the painting for several years, but it was soon stored away, on loan to the Pasadena Museum of Art, and is now in Germany. The Weismans were not flattered by it.

The only commissioned painting David Hockney has done is of Sir David Webster, then 308 retiring as General Administrator at Covent Garden. Hockney loves opera. He takes every opportunity of seeing familiar and unfamiliar ones in London and while travelling. He often plays opera on the phonograph in his studio, and in his car he plays opera tapes on any long or short journey. During the opening scene of a Tosca at Covent Garden he once turned to a friend and said of Cavaradossi, the neo-classic painter-hero, who in the first act steps down from his mural to sing an aria, 'He's just like me, he paints for a while, then he listens to opera.' Fortunately, Hockney came to know and like Sir David and the portrait is sympathetic in tone if a bit cool in colour; lavenders, blues and greens for the floor, wall and table, red the tulips and reddish the face, face and tulips rendered with equal care. Sir David sits on a Marcel Breuer chair borrowed from Hockney's studio, placed several feet from the glass table that dominates the living-room; the flowers are Hockney's favourites.

Soon after painting Portrait of Sir David Webster *in 1971 Hockney included the whole glass table in the elaborate and somewhat ominous* Still Life on a Glass Table. *The right side of the* Still Life *is the left half of Sit David Webster's portrait. When we see them together Sir David looks lucky to have gotten into his portrait.* Still Life on a Glass Table *has the emotional energy of a portrait. All the objects on it are things the artist lives with, vases, lamp and ashtray, charged with familiarity and associations; yet there is a poignancy in their separateness. They do not so much interweave as declare their identities. A bit of thunder in the shadow under the table belies the decorum of the objects.* Still Life on a Glass Table *is as autobiographical as the late paintings are permitted to get.*

256

The greater richness of the paintings since 1968 reflects the care and time that have gone into them. Hockney's work was never casually worked out or negligently arrived at. But in recent years he has moved away from the flattened, modernist space and composition of the California pool and splash paintings of the mid-sixties to a deeper, more traditional manner of rendering space, furniture and people; he has set himself more ambitious problems. He is still a modern artist; he is working today; but many of the modernisms have dropped from his art. In the portrait of Christopher Isherwood and Don Bachardy, 1968, *begun in California and finished in London, clearly defined zones are set, one behind the other, emphasizing depth. The change at this point in Hockney's conception of painting is made apparent by comparing this double portrait with* Peter Getting Out of Nick's Pool, 1966, *in which the various compositional bands read one above rather than behind the other. In* Christopher Isherwood and Don Bachardy *the table, heavy with books and weighted with fruit and their attendant accentuated shadows, is radically foreshortened to lead the eye between and beyond the figures which themselves sit comfortably ensconced and established in their own zone, the middle one, seen both from top to bottom and from front to back. Don Bachardy looks at us, while Christopher Isherwood, respecting the new spatial development in Hockney's work, keeps his eyes and his glance in their proper zone. The solid three-dimensionality of their wicker armchairs reinforces the spatial complexity of the painting. The figures sit deeply and comfortably in their chairs, with shadowed shirts and trousers, and are themselves shadowed on the cubes in which they sit. The greatest detail in the painting is, naturally enough, in the faces. The books, the fruit, Christopher's trousers are still rendered somewhat tubistically. The perspective is exaggerated slightly to make a point. The wall behind them lies flat, but we are allowed an escape from the rigorous composition into the window seat at the right, a shallow escape but a subtle one for it helps move the eye to the right, as Christopher's glance at Don moves it to the left.*

192

145

It is in the portrait of Henry Geldzahler and Christopher Scott, 1969, *that Hockney concentrates for the first time with great care on the accuracy of one-point perspective. He came to New York in late 1968 to make drawings and take photographs for the painting. He didn't paint exactly what he saw. The view out of the window in the painting is the view from another room in the apartment. The couch at the time was in sad condition (it hadn't been recovered since it was made in the mid-thirties). Hockney replaced its spots and tears with an imagined pale mauve satin; he also improved and regularized the parquet floor in the service of perspective. The lamp was there; the table with its diagonal reflections and the vase with tulips were London afterthoughts. They establish a foreground as the view out the window establishes the distance. Thus the couch and its person sit firmly in the weighted and positioned centre of the composition. Kynaston McShine has called the painting an Annunciation. The figure of Henry Geldzahler is painted with greater verisimilitude than that of Christopher Scott; Hockney knows him better. He sees Chris as coming and going, at attention in a quasi-military raincoat, wooden and enigmatic. The parquet floor and the glass table lead*

228

inexorably to the vanishing point above the central figure's head. The triangularity is further emphasized by the overall diamond shape of Henry Geldzahler, which is dropped from the vanishing point in such a way as to flatten the picture and return the viewer to the surface. For all its clarity of composition and detail this painting remains somewhat inscrutable. A story is being told but once again, true to English tradition, it is beneath the surface. Hockney's painting has developed greater resonance. The poetry is less explicit and we are therefore slower to grasp it. This accounts for the greater staying power of these paintings. We see them, remember them, and see more on subsequent viewings.

Hockney's attitude towards abstract art has always been one of the reluctant admirer. He sees it as a bit empty and argues that most abstractionists repeat themselves unthinkingly. He believes that poetry and the recognizable are inextricably linked; and yet abstraction exerts a continuing fascination for him. It stands as one pole in his thinking, an attitude of mind alien to his own with which he refreshes himself periodically. As we have seen, the paintings of his first year at the Royal College of Art, 1960–1, were increasingly successful attempts at climbing out of the molasses of art school abstract expressionism. He soon found his way to the keen observation of the world, the lovingly amused attitude that sits so naturally with him. It took some years for all traces of the early expressionism to fall from his work. As early as 1961 he was using shaped canvases for reasons of expression and wit. A few of these are Tea Painting in an Illusionistic Style, Figure in a Flat Style *and* Hotel, *all 1961; and* The Second Marriage, *1963. By 1965–6 he was painting clean and fresh pictures that had little to do with abstraction but everything to do with the modernist principles enunciated by abstract artists and theorists; a painting is two-dimensional and its flatness must be respected or honesty and virtue are lost. It is only in the years since 1968 that Hockney has moved forward in his own thinking and back into tradition by introducing accurate perspective,* trompe-l'œil *and illusionistic space into much of his work. At the same time he has been playing with increasing fluency and contrast with the manipulation of paint and its varied textures within single paintings, for example* Beach Umbrella, *1971.*

Hockney's continuing interest in aspects of abstraction can be seen in isolation in certain paintings: Two Stains on a Room on a Canvas, *1967, in which both American stain painting (Morris Louis, Helen Frankenthaler, Friedl Dzubas) and reductionist sculpture are cited, mocked and incorporated; and* Rubber Ring Floating in a Swimming Pool, *1971, in which the arrangement on the canvas reads two ways, as the depiction of the scene proclaimed in the title, and as a compositional comment on the work of such contemporary abstract painters as Kenneth Noland, Jules Olitski and Edward Avedesian.*

In two other paintings, Cubistic Sculpture with Shadow, *1971, and* Mount Fuji, *1972, the borrowed or quoted stain is used in the service of heightened illusion. The shadow in the painting of the Gonzalez sculpture is strong in contrast and thin in application, hitting off the distinction between the carefully invented arbitrariness of the sculpture and the more casual, accidental arbitrariness of the shadow. In* Mount Fuji, *an amalgam of a postcard of Mount Fuji and a photograph in a Japanese manual on flower arrangement, the flowers and the bamboo vase are painted with a hard and snappy verisimilitude. They seem graspable, in relief, even from several feet away. This tactile quality is reinforced by the blue stained canvas that reads so convincingly as a mountain in the distance in the context of this painting. Seen alone, without the flowers or the title, in progress in the studio, there was nothing to differentiate the blue stain from the work of any of a dozen contemporaries; it lay flat on the canvas with only the shallow space lent by the subtle veils of density that characterize acrylic paint used as a stain on unprimed canvas. The completed painting, one of Hockney's best, always hits one forcefully as*

5

40, 7

258

203

259

320, 333

a single unified image, the flowers and mountain comprehended in a glance. No amount of intellectualization, no separation of its components into hard and soft, near and far, 'real' and misty, destroys the unity for long. The painting wilfully snaps back into its own focus.

There is a strain in Hockney's work which runs counter to and complements his love of the Mediterranean and Southern California. He refers to it as his fondness for 'Gothic gloom'. Hockney's personality and his art are wide and varied enough to comprehend the two propensities and even to fuse them. We see the 'Gothic gloom' at its purest in certain of the etchings illustrating Grimm's Fairy Tales, *a project that absorbed him during 1969. He produced* 260–88 *a superb sequence of thirty-nine etchings illustrating six tales he chose from among three hundred in the canon. While one can hardly characterize the bulk of these illustrations as either Gothic or gloomy – there are many references to sunny climes and happy days – a Wagnerian mood of dark tones and thumpings below the surface can be descried in 'The haunted castle'* 278 *and in the ominous 'Cold water about to hit the Prince'. Wagnerian also, in this most sustained* 281 *of Hockney's print projects, is the magisterial sense of pace and shifting moods – the juxtaposition of a carefully rendered tower with a rose, the transformation of straw into gold. This northern, romantic vein is tapped also in* L'Arbois, Sainte-Maxime, 1968–9, Parking privé, 213, 212 1968, *and in* Still Life with TV, *the first painting of 1969. In the first two landscapes, there is a* 230 *dense and clotted arboreal massing at the centre of the paintings that stops the eye from penetrating in a most uncharacteristic way. The sun-struck buildings are there, behind the trees, but we can't quite get to them. (Another painting,* Schloss, 1968, *derives almost explicitly* 210 *from the atmosphere and research for the Grimm illustrations.)* Still Life with TV *is a straightforward rendering of objects on a table, chosen by the artist and arranged by him; an unopened dictionary, a blank TV screen, a sharpened pencil, a blank sheet of paper and a sealed sausage, all resting on a wooden table. The table is brown, the wall behind the objects yellow (a rare colour in Hockney's work). The blank TV is made relatively lively and eerily interesting through the subtly modulated ochre-grey of the screen. Shadows are emphasized, perspective is accurate and the result is a feeling of slight uneasiness, not quite the uneasiness of Magritte (so often reducible to a visual joke) but rather the haunting loneliness of Edward Hopper, or the romantic evocativeness of Caspar David Friedrich, an artist Hockney was coming to prize highly.*

Looking for Friedrichs became something between a hobby and an obsession on his increasingly frequent short trips to Germany. What appeals in Friedrich is compositional clarity, a sensitivity to the extremes of atmospheric conditions and times of day – moonlight, dawn, glaciers, fogs and, most arresting, shafts of light beaming down from the sky – and the sense that a story is being unfolded within the confines of a rectangle. Hockney most admires artists who have confronted their subject matter, wrested it from the complexities of 'reality'. They do not dislocate reality as do the surrealists; they claim a subject and a way of seeing it. To Hopper with his small-town streets and single figures in rented rooms, to Caspar David Friedrich's bare trees in the snow and setting suns, we can add two seemingly unrelated enthusiasms, Georges de la Tour and Charles Sheeler. All these artists insist successfully on limited types of subject matter (in de la Tour, religious stillness by candlelight; in Sheeler, awe at the power and purity of machinery); and they know how to effect a perfect marriage between a peculiar subject matter and an obsessive need to view it in an invented 'realistic' style, perfectly suiting the subject to the manner of its portrayal. In each case, what they rendered was unthinkable before they saw for us. The way they saw is the way we now see.

In recent years Hockney has borrowed from his early expressionism, he has quoted from his California sunniness, and he has introduced a new tension, a veiled uneasiness the more subtly

felt because it lies beneath what seems so straightforward both in handling and in subject. Perhaps the first time we feel this new aura is in The Room, Manchester Street, *1967, a portrait* 205 *of Hockney's friend and contemporary, the painter Patrick Procktor. The double portrait has allowed Hockney a close, almost voyeuristic scrutiny of relationships, a subject that fascinates him more than any other. How do couples work? How do two people assert and adjust themselves? How can one be alone and not alone at the same time? These are questions he returns to again and again, always with greater understanding, but always with some last question unanswered. As early as* The First Marriage, *1962, and many paintings of 1963,* The 49, 7 Second Marriage, The Hypnotist, Domestic Scene, Los Angeles *and* Seated Woman Drinking 86, 95, Tea, Being Served by Standing Companion, *the subject is double. In the next five years there* 88 *is an occasional use of two figures (*Two Boys in a Pool, Hollywood, *1965, and* Rocky Mountains 123, 128 *and* Tired Indians, *1965). And then in 1968 there is a full return to the double portrait. Since then, Hockney's interest has amounted to a continuing investigation of a difficult human problem, novelistic in intensity, unique in the painting of our time.*

A painting still unfinished at this writing is Hockney's portrait of his parents, which includes 414 *a self-portrait looking back at us from the centre of the picture. After letting the idea for this painting percolate for several years Hockney finally resolved his dilemma by having his mother sit facing us while his father sits sideways looking both at the mother and into the distance. The artist, looking surprisingly boyish, stands between them, his face reflected in a mirror. He is both a painter viewing his subject and a son looking at his parents. This painting is David Hockney's most blunt and inelegant double portrait. It is painted with a Yorkshire accent appropriate to its subject – honest, unflattering but, finally, accepting and loving.**

For the past several years, from 1973 to 1975, Hockney has spent most of his time in Paris, painting and drawing in a large room facing a quiet courtyard not far from the Boulevard St Germain. He moved to Paris in part because his life in London had become too public. Between press coverage of his every move and his own generous social impulses there was insufficient privacy for work. The delicate balance between social life and isolation was held for a time in Paris, but an immensely popular retrospective exhibition at the Musée des Arts Décoratifs, and the many commercial showings of Jack Hazan's semi-documentary, semi-fictional film, A Bigger Splash, *brought Hockney's art and his charismatic personality to the attention of a wider public.*

Ideally, Hockney would like to draw and paint all day after a short walk in the morning to buy the papers and fresh milk for his tea. In the evening he enjoys having drinks and dinner with a few friends, usually beginning and ending in the studio to review the day's work. In order to regain a measure of privacy when this schedule comes undone, Hockney now moves back and forth between Los Angeles, London and Paris. He plans soon to add New York to his repertory of alternative homes.

In the Paris years Hockney produced a series of drawings that became the subject of an exhibition at the Galerie Claude Bernard. Between 1960 and 1972 painting and print-making alternated as his main interests, while drawing served as the underpinning common to both activities. In Paris, for the first time drawing became an end in itself. The drawings of Celia Birtwell in coloured pencil are among the best of the Paris period. In depicting the moods of a lovely young woman, they demonstrate a growing sensitivity on Hockney's part to feminity itself. In these drawings we see the influence of a century of French art – Ingres, Degas, Toulouse-Lautrec, Heleu, Pascin, Matisse and Balthus. At a time when School of Paris painters have joined American abstractionists in abandoning women as a subject, a provincial painter from the north of England was able to surprise and delight Parisians by continuing a tradition that seemed to be passing away with Picasso.

*Hockney finally abandoned this painting, after altering it, in February 1976 and re-painted it on a fresh canvas between February and July 1977 without his self-portrait. This painting was exhibited for the first time at the Hayward Annual, part II, Hayward Gallery, in July–September 1977.

In the early 1970s Hockney's technical facility grew to such a degree that it frightened him into pulling back. The Tate Gallery's Mr and Mrs Clark and Percy and the double portrait George *252, 392* Lawson and Wayne Sleep, *abandoned in 1973 and resumed in late 1975, achieved such heights of naturalism and finish that a sentimental and anecdotal quality in the subject matter threatened to undermine the paintings' formal strengths. While Hockney sought to grapple with the problem of these double portraits, drawing allowed him to continue working from day to day without fear of slipping into a helpless academicism. His drawing style still gave him licence to be as precise as he needed to be in representing the face, or dress, or hands, by allowing him the freedom to leave large areas of the paper blank or covered with the merest indications.*

Baldly stated, it is David Hockney's ambition to be more than an eccentric and popular figure in the history of English art. Hockney's popularity is due in part to his skill as a portraitist and illustrator, in defining character, in telling stories, in capturing and monumentalizing fleeting moments, and in transforming the familiar into the exotic. He has faithfully husbanded these talents by avoiding technical refinement uninspired by exploration and experiment. The fact that there are amazingly few swimming pool paintings testifies to his unwillingness to repeat his successes. But in celebrating his imagery, Hockney's audience has at times disappointed him in failing to judge his work according to the formal standards he sets for himself.

Among the few paintings of the Paris period is the masterpiece, Contre-jour in the French *410* Style – Against the Day dans le style français, *1974, which, despite its dazzling subject matter, never lets us forget that we are looking at superb painting.* Contre-jour *shows a view through a window at the Louvre, more than half of which is hidden by a miraculously glowing window shade. For all his explicitness, Hockney doesn't hesitate to employ such abstract mannerisms as the pointillist rendering of the marbled window embrasure, a rectangle within the picture that yet frames it, and the almost square, Albers-like format of the yellow-green window shade, the most arresting element in the painting. The embrasure is flatly rendered, as is the shade, and the floor is drawn with less regard to perspective than to the four sides of the painting. (The parquet at the Louvre behaves in more orthodox fashion.) All this flatness is given the lie by the illusionistic reflections in the floor's polish and by the vista seen through the bottom third of the window. Feathery trees and a light-struck building stand on the opposite side of the courtyard. A gravel path shooting out in perspective makes our apprehension of distance acute. But then the circle at the end of the path finds its echo in the iron grille-work outside the window, which again brings us up short at one of the picture's planes.*

Considering Hockney's doctrinaire objection both to abstraction and to the paraphernalia of organized religion, one is surprised by the symbolism of the cross formed by the side rails and mounting of the window, symbolism perhaps influenced by the example of the much admired Caspar David Friedrich. On one level it is the cross, at first barely perceived, that seems to illuminate the glowing rectangle that is the window shade.

Conflicting and contrasting elements reveal themselves in a close analysis of Contre-jour in the French Style; *the painting is a masterpiece because both before and after its complexities are noted its imagery and its life as an object unite to produce a new and memorable vision. Solutions such as this indicate that David Hockney's ambition is not beyond his reach.*

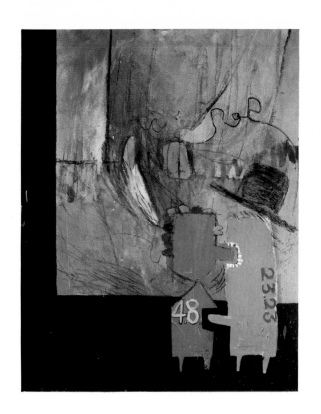

1 *Adhesiveness* 1960
2 *The Third Love Painting* 1960

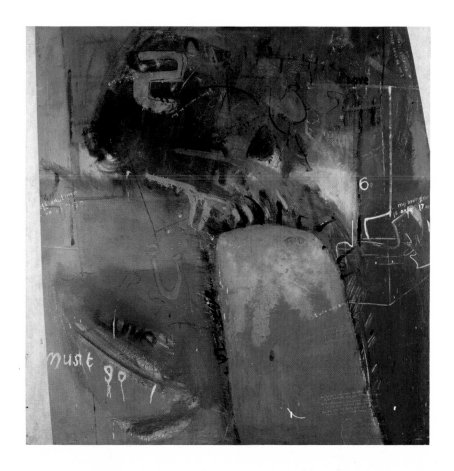

3 *The Cha-Cha that was Danced in the Early Hours of 24th March* 1961

4 *A Grand Procession of Dignitaries in the Semi-Egyptian Style* 1961

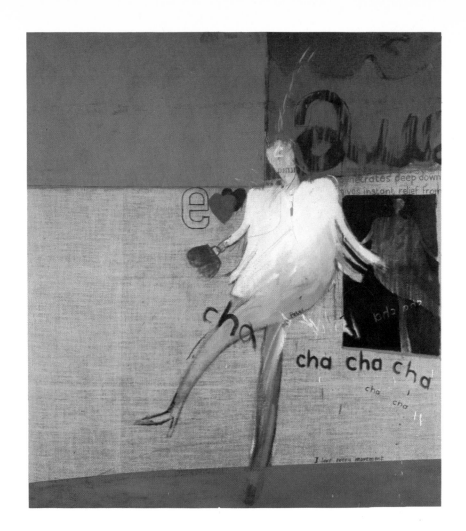

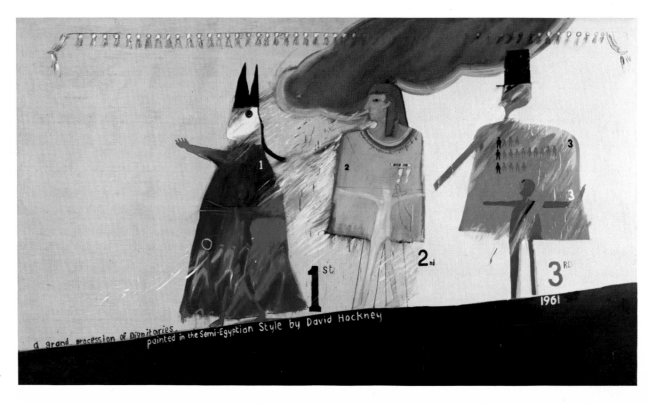

I first began writing this Life of mine in my own hand . . . but it took up too much of my time and seemed utterly pointless. So when I came across a son of Michele Goro, of Pieve a Groppine, a young boy of about fourteen who was in a poor state of health, I set him to the task. And while I worked I dictated my Life to him, with the result that as I quite enjoyed doing this I worked much more keenly and produced a good deal more. So I left the burden of writing to him and I hope to carry on with the story as far as my memory allows.

No matter what sort he is, everyone who has to his credit what are or really seem great achievements, if he cares for truth and goodness, ought to write the story of his own life in his own hand; but no one should venture on such a splendid undertaking before he is over forty.

The Life of Benvenuto, the Son of Giovanni Cellini,
Written by himself in Florence, 1558

DAVID HOCKNEY by David Hockney

It is very good advice to believe only what an artist does, rather than what he says about his work. Any respectable art historian would never go only by an artist's words; he would look for evidence of them in his work. I think it was Sickert who said somewhere Never believe what an artist says, only what he does; then he proceeded to write a book. After an artist has done the work, it's reasonably easy to theorize about it, but to theorize about it beforehand could be disastrous. I don't think one should do it even if one has the inclination. People interested in painting might be fascinated by an artist's statements about his work, but I don't think one can rely on that alone to learn about an artist's work, which is all trial and error.

Birth, family and early apprenticeship

I was born in Bradford in 1937. I have three brothers and a sister. I was the fourth child; I have one younger brother. Two of them live in Australia, my eldest brother still lives in Bradford, and my sister is a district nurse in Bedfordshire. Until I was eleven, I went to the local council school in Bradford, where my brothers and sister went. Then I went to Bradford Grammar School on a scholarship; my eldest brother had also had a scholarship there, but he left the year I commenced, in 1948. My other brothers went to a different school. I always say I hated it. I wasn't really happy there; I was probably too bored.

At the age of eleven I'd decided, in my mind, that I wanted to be an artist, but the meaning of the word 'artist' to me then was very vague – the man who made Christmas cards was an artist, the man who painted posters was an artist, the man who just did lettering for posters was an artist. Anyone was an artist who in his job had to pick up a brush and paint something.

It's difficult to say *why* I decided I wanted to be an artist. Obviously, I had some facility, more than other people, but sometimes facility comes because one is more interested in looking at things, examining them, and making a representation of them, more interested in the visual world, than other people are. When I was eleven, the only art you saw in a town like Bradford was the art of painting posters and signs. This was how one made one's living as an artist, I thought. The idea of an artist just spending his time painting pictures, for himself, didn't really occur to me. Of course I knew there were paintings you saw in books and in galleries, but I thought they were done in the evenings, when the artists had finished painting the signs or the Christmas cards or whatever they made their living from.

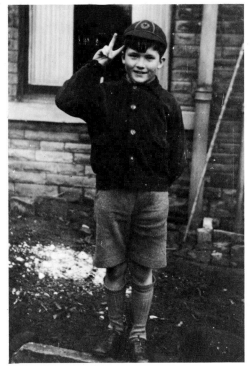

David Hockney aged about three, with his mother *Hockney at about ten, in his Cub cap*

My father had a slight interest in art. He didn't know much about pictures, but he had attended evening classes at the art school in Bradford in the twenties and thirties, which meant he'd been interested enough to try his hand at drawing and painting. When I was eleven, my father was painting old bicycles; just after the war you couldn't buy new bicycles – they were all exported – so my father used to buy old ones and paint them up to look like new. I used to watch him do it. The fascination of the brush dipping in the paint, putting it on, I love that, even now, I loved it then. There's something about it – I think anyone who makes pictures loves it, it is a marvellous thing to dip a brush into paint and make marks on anything, even on a bicycle, the feel of a thick brush full of paint coating something. Even now, I could spend the whole day painting a door just one flat colour.

My father obviously enjoyed doing that kind of thing. I remember in about 1950 he decided to modernize the house. He began by putting a whole sheet of hardboard flush over each of the panelled doors, and then he painted sunsets on the doors – sunsets that looked as if they were wood-veneer pictures. He painted all the doors like this, and I thought they were wonderful. He also used to paint posters a little bit. He was quite good at lettering. In those days, there were people who could do very quick hand-lettering; there was a demand for it. Posters advertising films were painted by hand. I would go up and look to see how they were done. You could still see the brush marks. People also did little signs for restaurants and cafés. To me this was the work of a real artist.

Bradford Grammar School

At Bradford Grammar School we had just an hour and a half of art classes a week in the first year; after that you went in for either classics or science or modern languages and you did *not* study art. I thought that was terrible. You could only study art if you were in the bottom

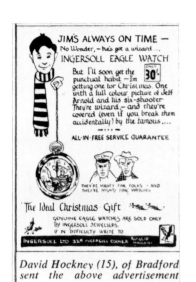

JIM'S ALWAYS ON TIME —
No Wonder, – he's got a wizard ...
INGERSOLL EAGLE WATCH

But I'll soon get the punctual habit – I'm getting one for Christmas. One with a full colour picture of Jeff Arnold and his six-shooter. They're wizard, – and they're covered (even if you break them accidentally) by the famous....

ALL-IN FREE SERVICE GUARANTEE

The Ideal Christmas Gift

GENUINE EAGLE WATCHES ARE SOLD ONLY BY INGERSOLL JEWELLERS.
IF IN DIFFICULTY WRITE TO

INGERSOLL LTD 225 INGERSOLL CORNER RUISLIP MIDDLESEX

David Hockney (15), of Bradford sent the above advertisement

Hockney's entry for a newspaper competition, in which he won second prize

form and did a general course. So I said Well, I'll be in the general form, if you don't mind. It was quite easy to arrange, because if you did less work you were automatically put in that section. I remember the mathematics teacher used to have some little cacti on the window sill; I always thought I never needed to listen in those classes, and I used to just sit at the back and secretly draw the cacti. Then they told me off for not doing much work, and the headmaster said Why are you so lazy? You got a scholarship. When I pointed out that I wanted to do art, they told me There's plenty of time for that *later*. Not the answer you give to somebody who's keen on any subject, I think. They probably wouldn't do it now.

I think it's a very bad thing people aren't made to study art. Whole generations of people in England went to schools where they had no visual education, and you can see the results all around us. Visual education is treated as if it's quite unimportant, but it's of vast importance because the things we see around us affect us all our lives. After the first year at the Grammar School you didn't do any more art until you got into the sixth form, when you did art appreciation, and I think that's a little bit late. Even if one isn't going to be an artist – of course, most people aren't going to be artists – art training sharpens the visual sense, and if people's visual sense is sharp you get beautiful things around you, whereas if it's not they don't care about their surroundings. It makes a vast difference to a city, to a country.

Every term there was a school magazine and I did drawings for it, mostly on scraper-board, because the block-makers weren't very sophisticated so you had to have lots of bold contrast in the pictures. They often published my drawings. I also entered a competition for a newspaper – I've forgotten the exact details, but I think you had to draw an advertisement for a watch. The first prize was won by Gerald Scarfe, and the second prize was won by me. Gerald Scarfe told me about it; I think his mother was looking it up and said to him Do you know who got the second prize – it was David Hockney.

I spent a lot of time doing little posters – to me, that was the use you put art to; if you were getting quite good at it, that's what you did. People who wanted things doing would come up to me at school. I remember doing lots of posters for the debating society, because that was more interesting – you could think up little pictures, depending on the theme of the debate. That was the first time I had the opportunity to carry out my fantasy about being an artist. And it was nice; people would say I like your poster for so-and-so, and they were up on the noticeboards. Everyone in the school passed the noticeboards and saw the posters, so there was a little exhibiting-place I could use all the time. Doing the posters at home did save me from trouble; I hardly ever did any schoolwork at home, as I was supposed to do, and my mother would say to me What about your homework? Are you doing it? and I'd say Yes, when really I'd be doing a poster. I'd say This is for the school.

Part of Hockney's last primary school report, July 1946

CONDUCT Good 280 274 TEACHER'S INITIALS J. Baker.

PROGRESS. Irene R. Baker.

David has done Excellent work this year. He is very much more tidy than he was. He did a very stupid thing in the problem examination and he had to suffer for it. However I hope it has taught him to rely on his own good sense as it might have lost him his position. I could do with more like him.

J. R. Baker.

THE GRAMMAR SCHOOL,
BRADFORD.

11th March 1950.

K. Hockney Esq.,
18 Hutton Terrace,
Eccleshill,
Bradford.

Dear Mr. Hockney,

 David's Form Master and those who
teach him have been considering his future,
and they think it worth while my writing
to you to suggest that as his ability and
keenness appear to be on the artistic
side he might suitably transfer, before
long, to a School of Art, and there prepare
himself for a career in some branch of
drawing or painting.

 I should like to know what you think
of this suggestion, and if you approve of
it, at what age you think he should turn
over to a more specialised form of
education.

 Yours sincerely,

 R.B. Graham.

 Headmaster.

Letter to Hockney's father from his headmaster, 11 March 1950

Hockney's cartoons in the Bradford Grammar School magazine, 1953

The art master used to be encouraging, and so did a man who taught English. Once we were supposed to write an essay on some subject, and I hadn't done it because I'd spent all my time making a collage self-portrait for the art class. So when he said Where is your essay? Can I read it out? I had the collage with me for the art class and – I was, I suppose, a cheeky schoolboy – I said I haven't done the essay, but I've done this. And he looked at the collage, and he said Oh, it's marvellous. I was so taken aback because I expected him to say You terrible person.

At the school there was an art society which met in the evenings, and I used to go to that. The school magazine always had a report about the various societies, and I remember in my very first term the report on the art society said 'Hockney D. provided light relief'. I was about eleven, and I didn't know what 'light relief' was; it sounded like sculpture to me – I thought maybe that was what I'd been doing there.

I wanted to go to the junior art school, attached to Bradford School of Art, when I was fourteen, but the scholarship people wouldn't let me leave the Grammar School and the headmaster said It's silly, and you need this education. I hated them for making me stay. I left immediately I was sixteen, after I'd done the GCE – I failed French, I think, I'm still no good at it. My parents were a bit reluctant to let me start art school then, because when my brothers left school they had gone out to work. Their worries were only financial, that's all; they wanted to be fair to the other children as well, because my eldest brother had wanted to be

REF: CH/NSP/JWW CITY OF BRADFORD
 EDUCATION OFFICE
 TOWN HALL

All Communications to be addressed to—

A. SPALDING, B.A.
Director of Education

 Telephone 26833 5th April, 1950.

 Dear Sir,

 Your application for permission
 to withdraw your son, David, from
 Bradford Grammar School in order that he
 might attend the Regional College of Art
 has been submitted to the Committee.

 After careful consideration the
 Committee believed that your son's best
 interests would be served by completion
 of his course of general education before
 specialising in Art. They, therefore,
 were not prepared to grant your request.

 Your son should continue to
 attend the Bradford Grammar School in
 accordance with the terms of the under-
 taking you gave as a condition of his
 admission.

 Yours faithfully,

 A. Spalding
 Director of Education.

 Mr. K. Hockney,
 18 Hutton Terrace,
 Eccleshill,
 BRADFORD.

Letter to Hockney's father from the Director of Education in Bradford, 5 April 1950

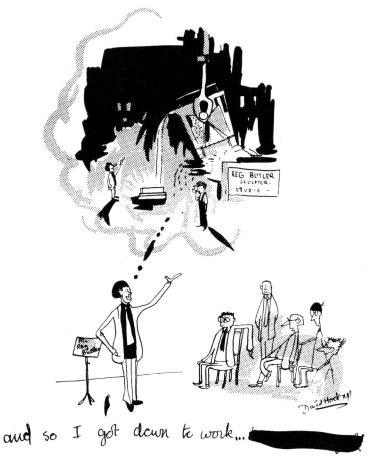

Hockney's cartoons in the Bradford Grammar School magazine, 1953

Bradford School of Art

an artist too but he had to leave school and start work, and he became an articled accountant instead. I was obviously more devious and keener on art than he was. I said Oh, it's essential to go to art school; to be an artist you have to be trained. But my mother said Well, why don't you go and try to get a job in a commercial art studio in Leeds? She sent some little drawings up to London, to the National Council for Design, or something, and she got a letter back saying No, they were no good at all. And so I said – I was quite pleased – Well, it means, you see, you have to go to art school to learn. But I did try to get a job. I made up a little portfolio; I did some lettering and other things I thought commercial artists would do. I took it round some studios in Leeds and finally one of them said Well, we could give you a job, but you would be better off going to art school. And I said Oh, I know, I know. Then they told me they might give me a job, but I said No, maybe I'll go to art school, I'll take your advice. I went back home and told my mother They said I must go to art school even if it's just for a year. She seemed convinced, so I started at the School of Art in Bradford. I had a grant of about forty pounds a year; my brother, when he left school, earned perhaps two pounds a week as an articled clerk, and I was getting a pound a week as a student.

When I started at the art school, they said Well, you should do commercial art. At first I was ready to do anything they suggested, I was so pleased to get in there, but after I'd been there three or four weeks I realized that really I'd be better off saying I wanted to do painting because all you did then was drawing and painting, especially from life. Most of the students

Bradford Grammar School.

REPORT for Term ending December 21st, 1950.

Name....... Hockney D

Form...... T Y No. of boys.. 25 Average Age.. 13 9

SUBJECT	Term Order	Exam. Order	
Divinity	11	–	Has ability, but does not concentrate and disturbs others in the class L.J.A.
English	11	19	He still does not really believe that an artist needs occasionally to use words. K.W.
History	3	5	Quite good – but he could be really good if he kept his mind on his work. C.F.
~~Greek or~~ Geography	9	10	He tries most of the time but is too casual. J.A.V.D.
French	25	22	He shows an occasional gleam of understanding. J.B.W.
Latin or German			
Physics or			
Biology or Chemistry	3	8	Very good work. J.H.D.
Mathematics	18	17=	He will not put his heart into his work M.B.
Art	1	2	Good work, fair progress. D.M.
Handicraft	15	–	Very fair efforts. G.Ra.

Attendance—Times absent...... 0 Times late...... 1

I am sure that he has the ability to reach a much higher standard in all his work. He would do well to conquer the tendency to let his attention wander from the job in hand.

C.F. James FORM MASTER

N.B. Mathematics & English reports. Is he really silly? He can't afford even to pretend to be.

R.B. Graham. HEADMASTER

Hockney's report from Bradford Grammar School in December 1950, when he was thirteen

(Far right) Hockney's last report from Bradford Grammar School, July 1953

Hockney standing by the front door painted by his father

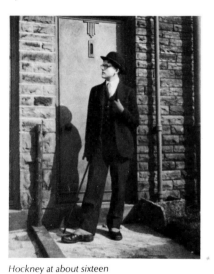

Hockney at about sixteen

Hockney with, from left to right, his brother, his mother, his sister and his father

Bradford Grammar School.

REPORT for Term ending July 24th, 1953.

Name _Hockney D._

Form _Remove X_ No. of boys in Form _26_ Average Age _16.4_

SUBJECT	Term Order	EXAM. ORDER	
Divinity	5	–	Quite good work. _LSH_
English	13		He has continued to make progress. _E.W._
History	4/16		His work has been of a remarkably high standard and he deserves success. _MJ.P._
~~Greek or~~ Geography	6		He has shown great interest and ability this term. _AWH_
Latin			
French	19/19		Negligible progress. _H.A.T._
Physics or German			
~~Biology or~~ Chemistry ~~Gen. Science~~	23.		He has experienced much difficulty in this subject _JBB_
Mathematics	M.2. 14/25		His efforts have been spasmodic, and his work has suffered in consequence. _H.C.B._
Art	1/18	–	Very good. _R.F.B._
Handicraft			

Attendance—Times absent Times late

He has undoubted ability in art especially in cartoon and sign-writing work. Although fundamentally a serious-minded boy, he has allowed his form-mates from his third Form days, to make him an almost legendary figure of fun. It is only in his last year that he has shown his serious side - but we have enjoyed his company. _E.O.Davies_ FORM MASTER

Best wishes to him in his new start. He will be glad to be rid of the 'figure of fun' & to establish himself as a sincere & serious person by steady work & merit. _H.B.Graham._ HEADMASTER.

Next Term begins on Tuesday, Sept. 15th, at 9 a.m., and ends on Tuesday, Dec. 22nd, at noon.

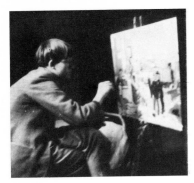

Hockney working in his bedroom at home

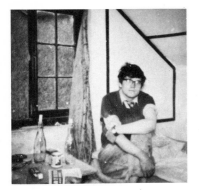

Hockney in the bedroom of the cottage he rented at St Leonards-on-Sea

Hockney and fellow students at the School of Art in Bradford

on this course said they wanted to be teachers – it was regarded as the teacher training course. I told them I wanted to change to the painting course. Ah, you want to be a teacher. No, no, I said, an artist – it seemed to me to be giving in already if you said 'teacher'. I thought you should teach only after you had practised the art for a while on your own; otherwise you wouldn't know what to teach. They tried again to put me off; they said Do you have a private income? I said What's that? I don't know what a private income is. They said You'll never make a living as a painter. Most people never will but, again, it seems a rotten thing to say to somebody of sixteen, if he's keen. *I* would never say that to somebody of sixteen. Anyway, I wasn't put off, and I changed to the course for the National Diploma in Design. You studied a main subject and a subsidiary subject for two years; my main subject was painting, and my subsidiary was lithography. Then the last two years you could specialize in one subject, which for me was painting. It meant that for four years all you did was draw and paint, mostly from life; for two days a week you did life painting, two days a week what they called figure composition, which had to be realistic, from life, and one day a week drawing. During the first two years one day a week was devoted either to perspective or anatomy. The training was completely academic. In the last year a lady gave a few lectures on art history and for your final examination you had to write an essay on an artist or a school of painting. I wrote on Kokoschka and Soutine. Strange.

I was interested in everything at first. I was an innocent little boy of sixteen and I believed everything they told me, everything. If they said You have to study perspective, I'd study perspective; if they told me to study anatomy, I'd study anatomy. It was thrilling, after being at the Grammar School, to be at a school where I knew I would enjoy everything they asked me to do. I loved it all and I used to spend twelve hours a day in the art school. For four years I spent twelve hours there every day. There were classes from nine-thirty to twelve-thirty, from two to four-thirty and from five to seven; then there were night-classes from seven to nine, for older people coming in from the outside. If you were a full-time student you could stay for those as well; they always had a model, so I just stayed and drew all the time right through to nine o'clock.

What you look at is important when you are that young. Most of the art I saw was at the art school. In those days there were very few art books and the library was very small; I can remember the arrival of the first big art books with colour pictures, the Skira books from Switzerland. I pored over them – they were books on nineteenth-century French painting, the impressionists. I didn't make my first trip to London until I was nineteen, which meant the only *real* paintings I'd ever seen were in Bradford, Leeds, Manchester and York. The Leeds Art Gallery had quite good pictures. In those days they had the great big Rembrandt equestrian picture which is now in the National Gallery, and they had one or two French pictures, and Flemish ones. The only contemporary art we saw was English. When I was first at the art school we saw work by people like Keith Vaughan, John Minton, the early St Ives abstractionists, Terry Frost, who became the Gregory Fellow at Leeds University as a painter; by 1957 we knew Roger Hilton's work. In my last year, when we'd already done a lot of drawing, I realized how academic the art school was and I began to think, the whole problem is, I don't know anything about modern art. They liked Sickert; Sickert was the great god and the whole style of painting in that art school – and in every other art school in England – was a cross between Sickert and the Euston Road School. That was the problem later, when people thought the art schools were in a mess; in a sense they were, because everyone was painting the same thing. On the other hand, if you're a twenty-year-old, what does it matter? They're all doing the same thing now; they just put boards on the floor instead. But it doesn't matter.

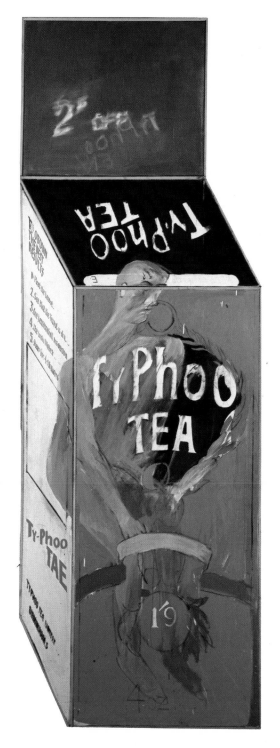

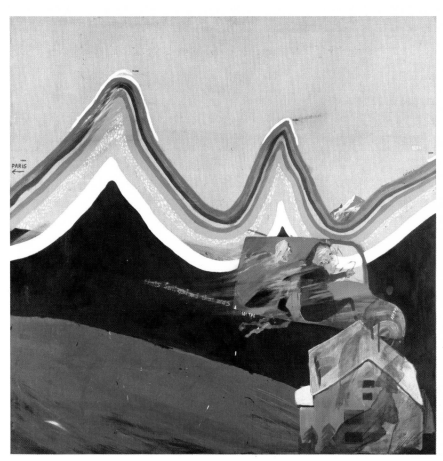

5 *Tea Painting in an Illusionistic Style* 1961

6 *Flight into Italy – Swiss Landscape* 1962

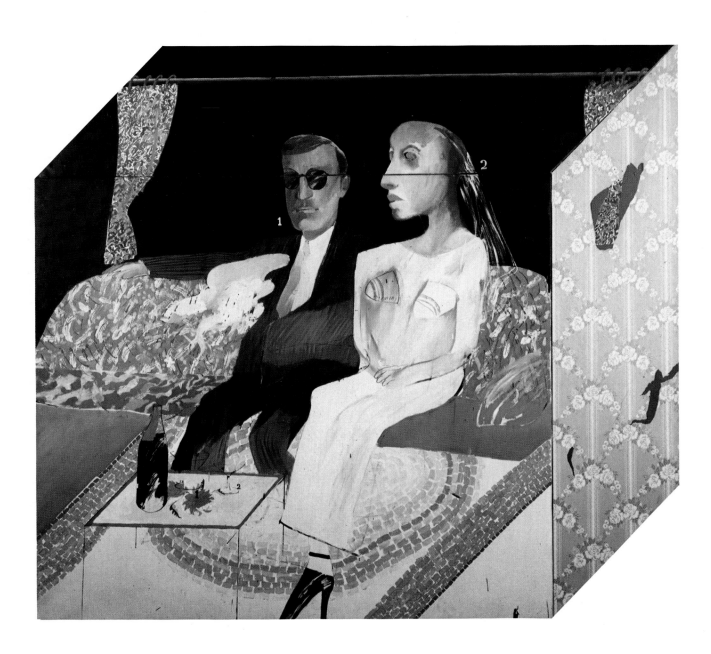

7 *The Second Marriage* 1963

Hockney at eighteen, photographed by Douglas Bolton. Reproduced by courtesy of Kenneth Grose.

Some of Hockney's early paintings, including Self-Portrait *(1954; 9) and* Portrait of My Father *(1955; 8).*

By the time I was leaving, I'd started having doubts as to what was valuable: had I really done anything valuable? Had the time been wasted? Well, of course, it's really a bit silly asking a twenty-year-old whether he has wasted his time or not. Anyway, these doubts were raised in me because I'd become more aware of contemporary art. I had become quite interested in Stanley Spencer, possibly because of the literary content; I knew he was regarded as a rather eccentric artist out of the main class of art both by the academics, who favoured Sickert and Degas, and by the abstractionists who dismissed him. But by 1957 I'd certainly become aware of a lot of contemporary art, partly through the artists in Leeds, through the Gregory Fellows. Alan Davie was the Gregory Fellow then and he had a large exhibition, I remember, in Wakefield, when I was still a student; I was very impressed with the works. That was the first abstraction; it confused me at first, but I could cope with it – I wasn't thrown into complete disarray.

The first painting sold *Portrait of My Father* is almost the first oil painting I ever did. It was painted at home on 8
Saturday afternoons when my father had finished work. In the last two summers I was at Bradford I used to paint out of doors. I did a number of little pictures of semi-detached houses, Bradford suburbs. I put all the paints on a little cart made from a pram, wheeled it out and painted on the spot. And they loved my pictures at the art school; they thought they were quite clever. But *Portrait of My Father* was *sold*. I sent that and another picture of the street where I lived in Bradford to an exhibition in Leeds, in 1954 I think, the Yorkshire Artists Exhibition, which was held every two years in the Leeds Art Gallery for local Yorkshire artists. It was a big event. All the staff of the art school sent pictures and most of the paintings were made up of the graduate fellows there, who were regarded as highly professional. Most of the other pictures were by teachers of local art schools. When I sent these two pictures, I didn't even bother putting a price on them; I thought, no one will buy them anyway.

I remember going to the opening on a Saturday afternoon. They had free sandwiches and tea and I thought it was a great event, an enormous event. A man at the opening saw *Portrait of My Father*, found out that a young boy had done it, and offered me ten pounds for it; I was amazed! It was a great deal of money and as my father had bought the canvas I thought, it's really *his* painting, it's his canvas – I'd just done the marks on it. So I phoned him up and said There's a man who'd like to buy this picture, can I sell it? And he said Ooh, yes. He thought it was because it was of *him*, you see, and he said You can do another. So I said Yes, all right. I had to buy drinks for everybody at the art school the next Monday. That probably cost a pound. The idea of spending a whole pound in a pub seemed absurd, but with the rest of the ten pounds I got some more canvases and painted some more pictures and then I exhibited them, in local exhibitions in Bradford and Leeds, mostly. The paintings are mostly oil paintings. Doing an oil painting was considered advanced, and a painting three feet by four feet was considered then to be a major canvas you were going to be slaving away at for a long time.

When I painted *Portrait of My Father*, my father, who'd bought the canvas, set up the easel and then set the chair up for himself, and he set mirrors round so he could watch the progress of the painting and give a commentary. And he would say Ooh, that's too muddy, is that for my cheek? No, no, it's not that colour. I had this commentary all the time, and I'd say Oh, no, you're wrong, this is how you have to do it, this is how they paint at the art school, and I carried on. You aimed at likeness, but what you were really concerned about were tonal values – tone – making sure you'd got the right tone. This meant you ignored colour. Colour was not a subject of painting in the art school.

After leaving the art school in 1957 I had to do national service, and I objected to doing it. I thought of myself as a pacifist then, and I went and worked for one year at the hospital in Bradford. Then I moved. I rented a cottage at St Leonard's-on-Sea in Sussex, and worked at a hospital in Hastings. For two years I did very little work.

Hockney's registration card as a conscientious objector

I read Proust for eighteen months, which is probably another reason I didn't do any work. I *made* myself read it because at first it was much too difficult. I'd never been abroad, but I'd been told it was one of the great works of art of the twentieth century. I'd read from an early age, but mostly English. So long as it was about England, I had some sense of what it was about. Dickens I'd read and you had some sense of what it was, but Proust was different. I remember asparagus was mentioned in it; I had no idea what asparagus was. I've since read it again, and I realize I couldn't have got much from reading it the first time.

Royal College of Art, 1957

In 1957 I had applied to the Royal College of Art and the Slade with life drawings, life paintings and figure compositions, paintings I'd done at the art school and at home during holidays. Anybody who'd studied painting in art school in those days would then apply either to the Royal College or the Slade or the Royal Academy, which were post-graduate schools; what one learned at art school wasn't sufficient. I was really glad to get back to art school and I was determined to work hard again. I'd been accepted in the Royal College painting department, where the head was Carel Weight. Ron Kitaj was in the same year, and Allen Jones, Derek Boshier, Peter Phillips.

Soon after I started at the Royal College, the kind of paintings I did changed: in those two years of doing hospital work, although I hadn't done any painting, naturally I'd been thinking about it. In my last year at Bradford School of Art I made three or four trips to London and looked at things in the Tate Gallery, the National Gallery. I was young, and all young people are more interested in the art of their immediate time – old Michelangelo, you know, you don't quite see it and understand it.

It was only then, in a way, I'd begun to discover Picasso. In the fifties in England, there was still, especially if you lived in the provinces, a mile of philistinism about Picasso. It's disappeared now. For instance, Alfred Munnings, the horse painter, was always referring to Picasso as an awful, terrible artist, and things like that. I remember reading once that Picasso had said Who is this Sir Munnings? At the time I realized people were just being philistine and the art was obviously much better than anything they were doing. Yet it was quite difficult sorting it out, and so when I started at the Royal College of Art I honestly did not know what to do. I realized it was no good going on painting as I had been; I felt I wanted to do something else. I didn't even have any strong preferences about the modern art I had seen. I was very open. I'd become quite a lover of Picasso though. It'd begun to have quite an effect. I think the very first Picassos I'd liked were from the late thirties: *Weeping Woman*, I remember, was a picture I began to really admire. It was these thirties Picasso paintings and *Guernica* that, I began to realize, I had to take notice of myself. They were great significant pictures and if you were studying painting you had to take notice of them.

So I began at the Royal College and I thought, well, I haven't done any drawing for two years, or very little, I'll make a drawing, a long drawing, to find out what to do in the meantime. And I made two drawings of a skeleton. Each one took about three or four weeks to do: two very academic, very accurate drawings of a whole skeleton, half-life-size. One was done in pencil and the other was drawn with turpentine washes.

Traditionalists v. abstract expressionists

Immediately after I started at the Royal College, I realized that there were two groups of students there: a traditional group who simply carried on as they had done in art school, doing still life, life painting and figure compositions; and then what I thought of as the more adventurous lively students, the brightest ones, who were more involved in the art of their time. They were doing big abstract expressionist paintings on hardboard.

The first student I got to know there was Ron Kitaj. We got on immediately. Also, his

painting straightaway fascinated me. I could tell he knew more about painting than anybody else. He's about four years older than I am, which when you're twenty-two is a lot of difference, in experience anyway. He was a much more serious student than anybody else there. He has a marvellous dry humour that really appeals, but in those days he was much grimmer than he is now, and he was a rather formidable person. He used to put up a kind of front against people as though he couldn't tolerate fools. I got on with him because we had a few things in common. Literature we would talk about; he was interested in Orwell, and I remember talking to him about *The Road to Wigan Pier* which I knew very well as a book from a long time ago. It was written in the year I was born, and my father was always mentioning it; he'd say It was written in the year you were born, and this is what it was like. Ron was a great influence on me, far more than any other factor; not just stylistically – he was a great influence stylistically on a lot of people, and certainly on me – but in his seriousness too. Painting was something that you were studying seriously. A lot of people thought art students were serious in that way, but they weren't; they just gassed around, and I always thought that was silly. The painters teaching at the College then were Carel Weight, Ruskin Spear, Ceri Richards, Roger de Grey, Colin Hayes, Sandra Blow – they got her in because she did big abstracts with sand in them, the sort of thing students were doing; she was brought in to control them! They taught me for many years; some of them had been there twenty, twenty-five years. They left you fairly free, as long as you did drawing, because in those days that was still compulsory – which was fine with me. I'd always liked drawing a figure. Some people hate it, they don't want to do it; I'd always liked it, partly because I've always been able to do it; but I worked at it. Everybody else was doing big abstract expressionist pictures. And I thought, well, that's what you've got to do.

In 1956 there'd been a big exhibition at the Tate of American abstract expressionist painting, and then Bryan Robertson had done shows at the Whitechapel of Pollock and in 1961 Rothko. And this was the latest thing. This was painting that had been done just two or three years before in America. Young students had realized that American painting was more interesting than French painting. The idea of French painting disappeared really, and American abstract expressionism was the great influence. So I tried my hand at it, I did a few pictures, about twenty on three feet by four feet pieces of hardboard that were based on a kind of mixture of Alan Davie cum Jackson Pollock cum Roger Hilton. And I did them for a while, and then I couldn't. It was too barren for me.

The dilemma about the figure

Meanwhile, I was drawing all the time. The one student I kept talking to a lot was Ron Kitaj. Ron was slowly doing these strange pictures, and I talked to him about them and about my work. And I said Well, I don't know, it seems pointless doing it. I'd talk to him about my interests; I was a keen vegetarian then, and interested in politics a bit, and he'd say to me Why don't you paint those subjects? And I thought, it's quite right; that's what I'm complaining about, I'm not doing anything that's from me. So that was the way I broke it. I began to paint those subjects. But I still hadn't the nerve to paint figure pictures; the idea of figure pictures was considered really anti-modern, so my solution was to begin using words. I started writing on the pictures. And when you put a word on a painting, it has a similar effect in a way to a figure; it's a little bit of human thing that you immediately read; it's not just paint. The idea came because I didn't have the courage to paint a real figure, so I thought, I have to make it clear, so I'll write 'Gandhi' on this picture about Gandhi. I can remember people coming round and saying That's ridiculous, writing on pictures, you know, it's mad what you're doing. And I thought, well, it's better; I feel better; you feel as if something's coming out. And then Ron said Yes, that's much more interesting.

The staff said that the students in that year were the worst they'd had for many, many years. They didn't like us; they thought we were a little bolshy, or something, and so they threw out Allen Jones at the end of the first year – they said he was no good at all. I don't think it was because of people doing abstract expressionist pictures. No, it was strange. A lot of students were told their situation would be reviewed in six months; although it didn't happen to me. I think it was simply because of my drawings, which they always liked. Being the way they were, they thought, he can draw; if he can draw then there's something there.

The year I began was the first year they started what they called general studies. Previous to that I think there were a few art history lectures and at the end of the third year you wrote a thesis on any subject you chose; it could be about anything – just a long illustrated essay. I think they introduced the general studies department because Robin Darwin, who was the principal then, wanted to make it into a university. Now I think you get a degree instead of a diploma. Of course it makes no difference at all. At the time I smiled about it. I thought, they're fussing about nothing. I began to have arguments with the staff in the first year, and my arguments were that painting itself is a rich intellectual climate, which doesn't need other subjects to enrich it; that the study of it is the study of a very wide subject. Of course, I always read books, but I never read the books they told me to. History is scattered with painters to whom literature probably didn't mean that much. But my real quarrel with the College was that there were too many lectures and it was taking you away from painting. It's reached a bizarre extreme now in art colleges, where you do everything except art. It's absurd, and it's also producing boring art, I think. Anyway, I thought it was unfair I should have to go to these lectures because I had all this painting to do. In the first term of my first year I did all the work they set, then I just stopped going. I thought, painting comes first, I'm a serious student here.

The Young Contemporaries, 1961

My work develops quite quickly from 1960 on. In, I think, January 1961 there was the Young Contemporaries Exhibition and we showed the paintings of the previous year. That's when I began to sell pictures. I think I showed first in 1960 or 1961, two abstract expressionist pictures. I had begun the tea paintings in 1960 and they were shown in the Young Contemporaries and I sold them, so that was a help. I showed *Jump, Adhesiveness, The First* 16, 1, 17 *Tea Painting* and a few others.

At that Young Contemporaries there was quite a stir created by Royal College of Art students like Peter Phillips, Allen Jones, Derek Boshier who was doing those paintings of toothpaste tubes and things, Ron and one or two others. Patrick Caulfield had already begun at the College. For a student, the exhibition was a big event. It was probably the first time that there'd been a student movement in painting that was uninfluenced by older artists in this country, which made it unusual. The previous generation of students, the abstract expressionists, in a sense had been influenced by older artists who had seen American painting. But this generation was not.

Students ran the Young Contemporaries, but Lawrence Alloway was really the man who was into it and organizing it; he was a great supporter of it. Someone who was an influence on a lot of students was Larry Rivers; he had come to England and a lot of people were very interested in his work, which was a kind of seminal pop art.

The Richard Hamilton prize

Another interesting thing that happened was that Richard Hamilton visited the College. The students used to organize what they called sketch clubs: they'd put up one or two paintings and they'd get somebody from outside, an artist, to come in and talk about the work. And I remember Richard Hamilton was invited. Nobody knew much about him, although he was actually teaching in the College, in the school of interior design. Nobody

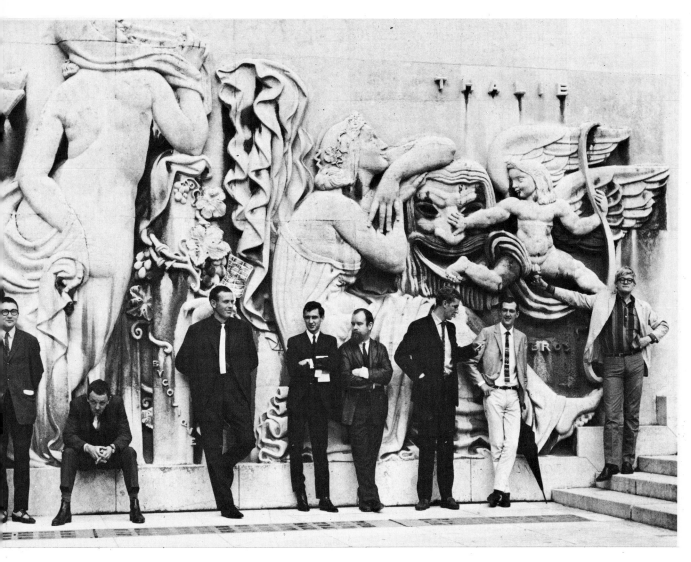

Outside the Musée d'Art Moderne in Paris, at the Third Paris Biennale of Young Artists in 1963. Left to right: Joe Tilson, Gerald Laing, Francis Morland, Peter Phillips, Peter Blake, Derek Boshier, Allen Jones, David Hockney.

knew his *work* much. We knew it later, but not then. He came and talked about the pictures, and they gave out little prizes of two or three pounds. He gave a prize to Ron and a prize to me, and from that moment on the staff of the College never said a word to me about my work being awful. Before that they said it was junk; All this stuff, writing here, that's all junk. Richard had come along to the College and seen what people were really doing, and recognized it instantly as something interesting. The staff didn't even recognize it as a kind of movement where the ideas were similar; they didn't even see it. Richard was quite a boost for students; we felt, oh, it is right what I'm doing, it *is* an interesting thing and I should do it. Then the press began their interest. And also, suddenly, at last there were paintings you could talk about again, instead of just abstract pictures. There was subject matter, and the idea of painting things from ordinary life, and that was when everything was called 'pop art'.

Then the Royal College of Art became incredibly lively, and people used to come and look in at it. Visitors came, and I can remember meeting Joe Tilson and Peter Blake – not as

teachers; they'd just come to look because they'd heard of marvellous things going on. The same thing would happen now if you suddenly heard there were four students there who were doing something; people would go, I would go and look. The whole place came alive, and this had an influence on other students. I remember for instance that the graphic school became really interested in the painting school and every lunchtime they'd all be going in there looking at what people were doing.

I painted quite a number of pictures in 1960; I probably painted twenty, twenty-five pictures. They don't all exist now, partly because they were painted over. If you thought a picture had been a failure, economic reasons made you use the canvas or the hardboard again. So many of the pictures would be just painted over.

Coming to terms with the figure

The change in my work was more gradual than it may appear now. If all these other pictures still existed, you would see how gradual it was. In 1960, for a young art student trying to think of modern art, of the visual art of his time, obviously wanting to be involved in it, the opposition to the figure as a subject was very strong. I opposed it too; I thought, this is not the way to go. Yet obviously I was dying to do it, to come to some terms with the figure. Hence the use of words to make the feeling you get from the picture more specific.

The problem for me was the figure; not wanting to paint the figure in. I've said this many times before, the thing Cézanne says, about the figure being just a cone, a cylinder and a sphere: well, it isn't. His remark meant something at the time, but we know a figure is really more than that, and more will be read into it. To say it is just that means you would reject a great deal of Renaissance painting; this is what it's about; it *is* that. You cannot escape sentimental – in the best sense of the term – feelings and associations from the figure, from the picture, it's inescapable. Because Cézanne's remark is famous – it was thought of as a key attitude in modern art – you've got to face it and answer it. My answer is, of course, that the remark is not true. I understand why it was made, but it is not a truth. I can say that quite bluntly now. In 1960 I would have been much more cautious, partly because I was younger and didn't know.

The writing on the picture

The Third Love Painting for instance: I think the reason it was titled like that was that in those days this was a very common method of titling abstractions – I remember from the Young Contemporaries catalogues, people would say 'Red and Green No. 3', 'No. 2', so in a way it's a slight play on that. I decided to do it much more literally and actually write it in; and I wasn't going to put just 'Love Painting 3', it seemed too cold. A love painting is much more specific; it has many meanings, there are lots of ways you can read the title. But the painting itself is just an abstraction. It's very close to abstract expressionism, in a way; there are one or two shapes that rather dominate it and can be interpreted in, I suppose, an ordinary way. But you are forced to look at the painting quite closely because it is covered with lots of graffiti, which makes you go up to it. You want to read it. I assume people are always inquisitive and nosy, and if you see a little poem written in the corner of a painting it will force you to go up and look at it. And so then the painting becomes something a little different; it's not just, as Whistler would say, an arrangement in browns, pinks and blacks. At the same time, when you see the painting you can see it's not totally preoccupied with content because the paint itself is interesting, it's got rather quick heavy impasto painting areas and just as technique it's quite important. But it also contains pointers which have to do with content, like 'must go' and the Whitman lines; 'My brother is only seventeen' I think was just taken from the walls of a toilet in Earls Court tube station. When you first look casually at the graffiti on a wall, you don't see all the smaller messages; you see the large ones first and only if you lean over and look more closely do you get the smaller, more neurotic ones.

2

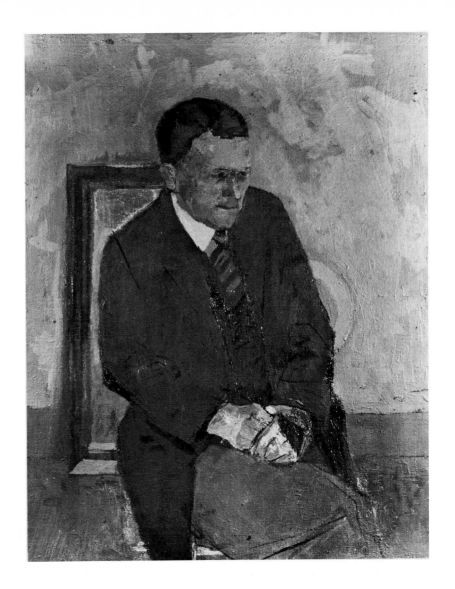

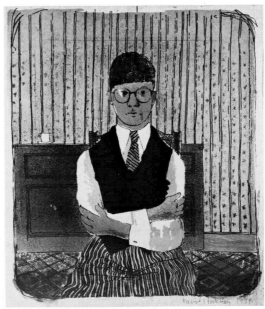

8 *Portrait of My Father* 1955
9 *Self-portrait* 1954

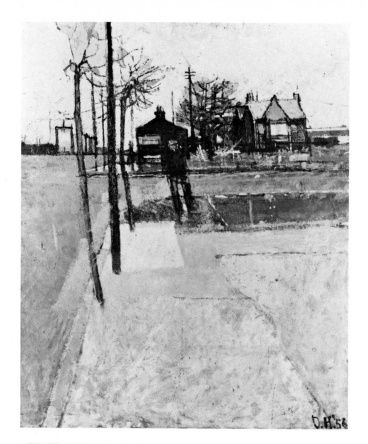

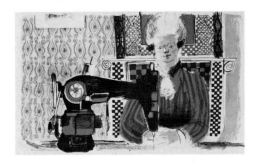

10 *Fish and Chip Shop* 1954

11 *Woman with Sewing Machine* 1954

12 *Standing Figure* 1956

13 *Nude* 1957

14 *Drawing of Dog* 1957

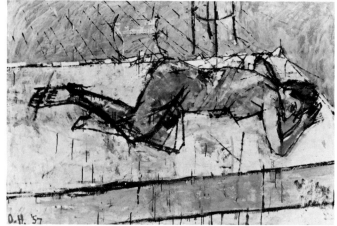

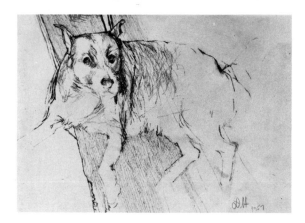

15 *The First Love Painting* 1960
16 *Jump* 1960

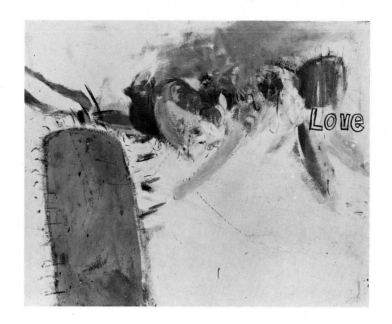

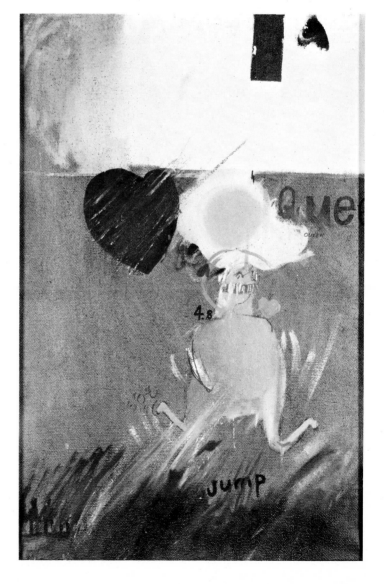

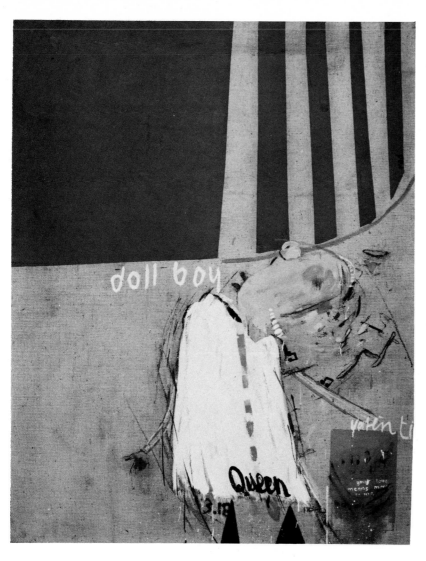

18 *Doll Boy* 1960–1
19 *Little Head* 1960
20 *Your Weight and Fortune* 1961

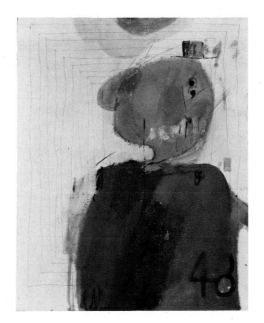

69 I will love you at **8** pm next Wednesday

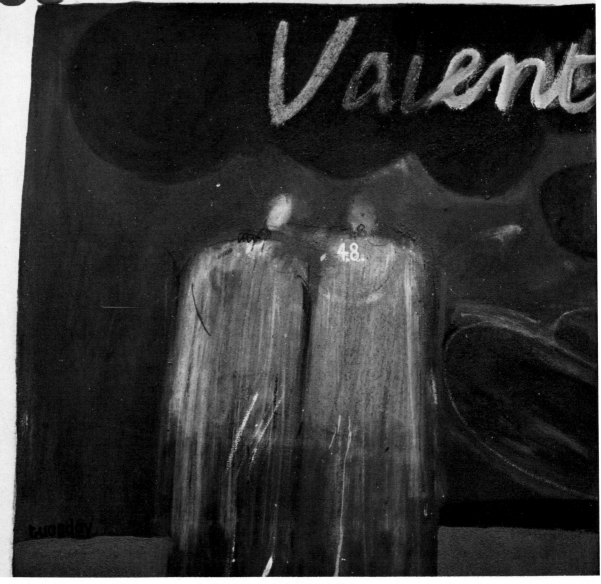

24 *Boy with a Portable Mirror* 1961

25 *Peter C.* 1961

26 *Sam Who Walked Alone by Night* 1961

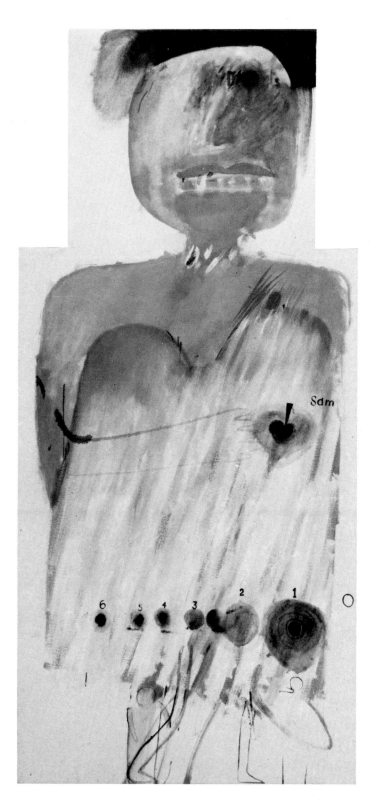

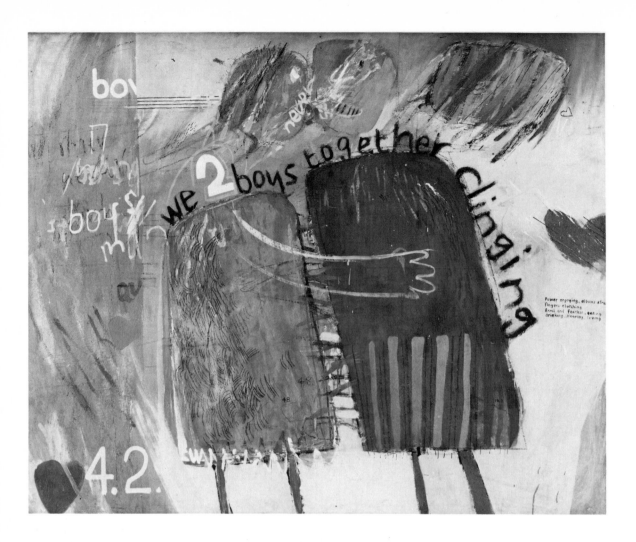

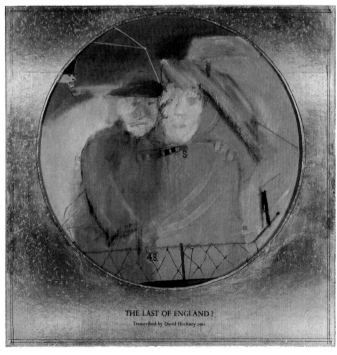

THE LAST OF ENGLAND?
Transcribed by David Hockney 1961

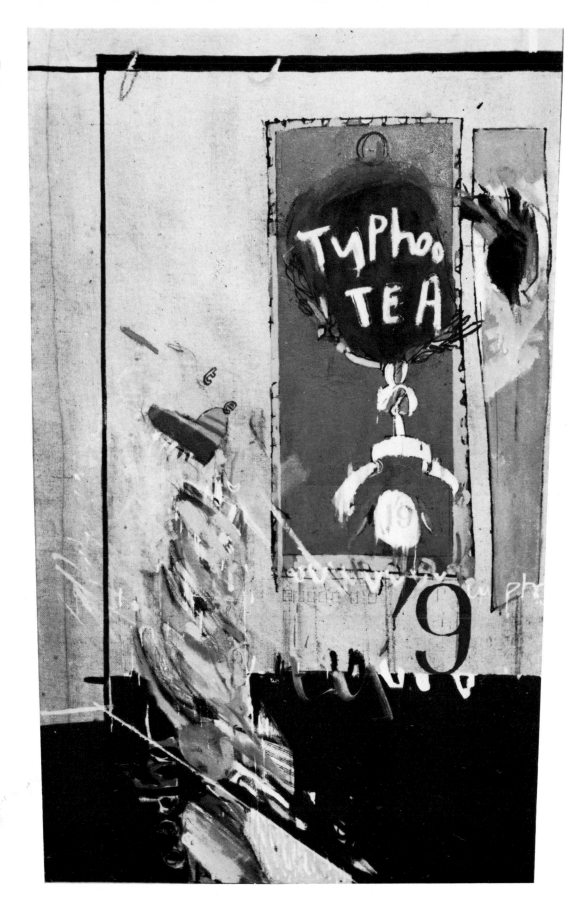

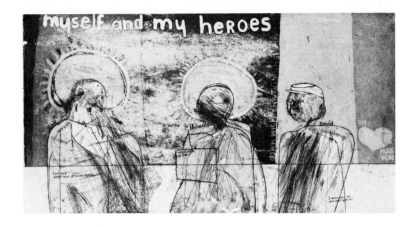

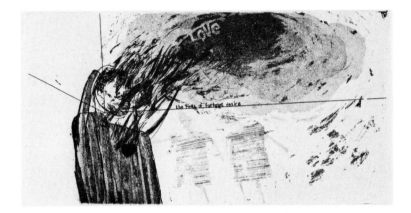

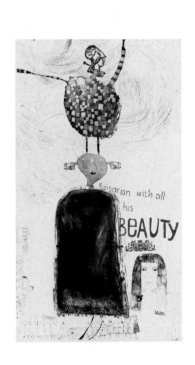

40 *Figure in a Flat Style* 1961

41 *A Man Stood in Front of his House with*
Rain Descending 1962

42 *Life Painting for Myself* 1962

43 *Rimbaud – Vowel Poem* 1962

44 *Help* 1962

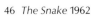

45 *The Cruel Elephant* 1962
46 *The Snake* 1962

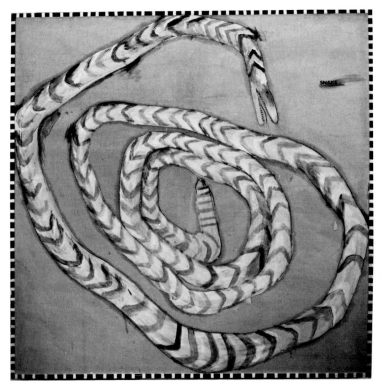

One reason for using writing on paintings is that it makes you go and look at the picture in another way. It's a technique I used especially in 1962 in *Picture Emphasizing Stillness*, where 47 from a distance it looks like a leopard leaping on two men who were just having a quiet talk, having taken a walk from a little semi-detached house; it looks strange, as if the leopard's about to leap on them and eat them, or fight them. And as you walk a little closer to the picture, because you notice a line of type, you read the type first; in a sense this robs the picture of its magic, because you interpret the picture in terms of the written message, which says: They are perfectly safe, this is a still. You realize the leopard will never reach the men. My intention was to force you to go and look closely at the canvas itself, and then in that sense it's naughty because it's robbed you of what you were thinking before, and you've to look at it another way. That was the intention. If you put a real message on a painting it is meant to be read, and it will be read. I began the painting without actually knowing its complete subject. Then I realized that what was odd and attractive about it was that, although it looks as though it's full of action, it's a still; a painting cannot have any action. It was the incongruity of it that attracted me to it as a subject.

Content and form

I wrote a little piece the other day for a catalogue of a show in Los Angeles, just a very short thing about painting (I'm rather against painters making big polemical statements in catalogues. I've never done it myself. There are a few vague ones, that's all. From experience I know they become things that are very heavily quoted). I said I felt I was quite a traditional artist and painter in the sense that to me paintings should have content. I said my paintings have content, always a subject and a little bit of form. And I was traditional in the sense that I felt you should have a balance between these two to make a really good painting. If you didn't (I didn't add it but inferred it), the painting would become boring, in the sense that English Victorian painting is – it can be very charming and it wasn't as bad as people think, but the weakness of it is that its real emphasis is on content as opposed to form. The weakness of a lot of paintings today, of the last ten years, is just the reverse: that their emphasis has been totally on form and not on content. It seems to me that really great pictures – and I'm interested in making *pictures* – must achieve a balance. Take Rembrandt, or anybody we admire: his achievement is the balance between content and form; it's not just form.

What I'm talking about of course is a permanent problem in painting, which probably will never be solved in theory. For instance, look at Piero della Francesca's wonderful pictures that are marvellous and exciting to look at, that delight you. I would think anybody who likes painting at all would like a Piero della Francesca; I couldn't imagine anybody thinking they were awful in any way. Each picture, as far as I know, has a very definite subject; I think every one is a Christian story, isn't it? Yet our delight in the pictures is in the way they're constructed; that's what makes them stand out, not the story. But the problem is that we don't know, we can never tell, how much the subject, in an old fashioned way, inspired these things. It's common knowledge that artists, certain artists, need a subject, that a subject can be inspiring. It's true in literature and it's true in painting. Some artists need subjects more than others, but you can play down the subject too much; there is an importance in it. In the 1960s the subject had been completely played down; abstraction had begun to dominate everything, and people firmly believed that this was the way painting had to go. There was no other way out, people thought. Even I felt that, and I still felt it even when I began to reject it in action; in theory I still couldn't reject it at all. I felt, well, I'm sure they're right, and I think I felt that even as late as 1966. It was in 1965 I painted probably some of the most abstract pictures I'd done, influenced, I think, by American abstraction, what they called American

cool abstraction. But of course what made it very different was that I was using abstraction as my subject, commenting on it – I felt the *need* to use it as a subject. I must admit I think the reason my paintings did have quite an appeal in 1960 and 1961 was that, first of all, people could write something about them. If you're writing about a Franz Kline painting, for instance, on the whole you're writing about formal values and gestures; whereas, if you write about *The Fourth Love Painting*, there are other things you can talk about. You can always [21] talk about formal values in a figurative picture, but there are other things. And that makes it easier for people to write about pictures. I'm sure one reason a lot of people started writing about my painting was that they found it easy to do.

On the other hand, you have painters like Barnett Newman; if you compare Newman as a painter to, say, Degas, I think you can see that Newman is concerned more with ideas – obsessively so, because he's not as good an artist as Degas. He is more concerned with theory as well, though Degas was too – any good artist is, actually; you can't ignore it. But it's Degas's eye and attitudes that matter, the responses he got, the responses he in part *felt*. In Barnett Newman's work it isn't like that at all. I'm not praising one over another, we all know who is the better artist, I'm sure Barnett Newman wouldn't say he was as good as Degas. He loved Degas, actually, as I do. Once Newman came to one of the first shows I had in New York, and he said to me You know, I used to paint like this myself. And I said to him Do you mean I'm going to finish up painting blue stripes? and he laughed. He was a sweet man.

Walt Whitman's code Unlike most of the other students, I did all my painting in the Royal College of Art. I lived in a very small room in Earls Court and I had no room to paint. At the College I had a cubicle where I painted. People had started coming into the College then to look around, as I said before. Every day there'd be somebody coming in and I knew this, so, in a way, I was painting for an audience all the time. The pictures were seen as I was painting them. They were meant to be seen. Any artist of course paints pictures to be seen; the vanity of artists is very rarely connected with money. Most artists would much rather have their work seen and read, as it were, than sold in the end. I know everybody's got to live, but they'd rather their work be understood and liked than sold. So this continuous stream of people was like having an exhibition. I'm not saying that was why I painted, but it was a thing that I became aware of, and wanted to use a little bit. Also I'd become conscious, not of the shock value of homosexuality – you can't shock students, you couldn't then and I don't think you could now; they're not shockable in that way – but that I was being cheeky and bold, and that's what one should do, I thought, be slightly cheeky, although I'm a bit shy.

Adhesiveness takes its title from Walt Whitman – he used the word to describe friendship [1] and I thought it was a marvellous word in that sense. There are so many things in it as a word, and the image of adhesiveness in friendship is wonderful. I used to say I thought it was the first really serious painting I'd done; it is my first painting that begins to have precision. It was done at about the same time as *The Third Love Painting*. The first two Love Paintings have very [2] little lettering on them. In *Doll Boy* a figure begins to emerge, for the first time. There are two [18] mechanical-looking figures in *Adhesiveness*, in a kind of 69 position, so they're the same at the top and the bottom. I put a bowler-hat on one so you'd notice they were figures. It was my first attempt at a double portrait. I also used Whitman's rather childish little thing about playing with each letter of the alphabet: A as one, B two, C three and so on; so the painting has these code numbers on it. I liked the idea of putting numbers and lettering on it in just the same way the cubists put numbers on their work. The numbers really say 'DH' and 'WW'. I remember in the summer of 1960 I read everything by Walt Whitman. I'd known his poetry

before but I'd never realized he was that good. There are quite a few of my paintings based on his work.

Cavafy in the semi-Egyptian style

Later it was the Alexandrian Greek poet Constantine Cavafy who became a great influence. I'd read Lawrence Durrell's novels *The Alexandria Quartet*; in the back of *Justine* there's Cavafy's 'The City', which impressed me. I read more of his poems and I was so struck by their directness and simplicity; and then I found the John Mavrogordato translation in the library in Bradford, in that summer of 1960, and I stole it. I've still got it, I'm sure. I don't feel bad now because it's been redone, but you couldn't buy it then, it was completely out of print. Mind you, in the library in Bradford you had to ask for that book, it was never on the shelves. If you had the intelligence to look it up in the catalogue and ask for it, then it would be all right. But if you were just a casual person who took it down off the shelves and read one of the poems, well it might be too wicked and you might go home and jerk off with poetry. That's what they thought. Anyway, when I found the book I read it from cover to cover, many times, and I thought it was incredible, marvellous.

I was interested in Egypt then for several reasons, in the style, and in Egyptian painting, which in a sense is not one of the really interesting methods of painting, by any means. Egypt is fascinating, but its painting is too rigid to be really intriguing. The only thing that interested me about it was that the rules were so rigid that there's no individualism in the paintings; whoever painted them, it didn't matter; they had to obey the rules and so it all looks the same. And that interested me, the anonymous aspect of the artist, but not the art. Certainly, though, Cavafy kindled another thing about Egypt, and my painting called *A Grand 4 Procession of Dignitaries in the Semi-Egyptian Style* was inspired indirectly by the Cavafy poem, 'Waiting for the Barbarians'.

Doll Boy was a reference to the pop singer Cliff Richard, who was very attractive, very sexy. I'm not a great pop music fan, I wasn't then and I'm not now. But I'm a lover of music and a lover of songs and I like singing. Cliff Richard was a very popular singer and I used to cut out photographs of him from newspapers and magazines and stick them up around my little cubicle in the Royal College of Art, partly because other people used to stick up girl pin-ups, and I thought, I'm not going to do that, can't do that, and here's something just as sexy, and I stuck them up. He had a song in which the words were, 'She's a real live walking talking living doll', and he sang it rather sexily. The title of this painting is based on that line. He's referring to some girl, so I changed it to a boy.

The tea paintings

In *The Fourth Love Painting*, which I painted in 1961, the line of type, 'I will love you at 8 pm 21 next Wednesday', is a slight variation on section XLVIII of 'Dichtung und Wahrheit (An Unwritten Poem)', from *Homage to Clio* by W. H. Auden: '"I will love You forever," swears the poet. I find this easy to swear to. *I will love You at 4.15 p.m. next Tuesday*; is that still as easy?' I set the type up myself and printed it on the canvas before stretching it. It does look slightly odd to have a line of type printed on the canvas. 'Valentine', which is written over the figures in the painting, was a teenage girls' magazine always full of photographs of pop singers. In 1960, a little after painting *Adhesiveness*, I'd painted *The First Tea Painting*; in 1961 I painted 1, 17 two more on the same subject. I used to go into the Royal College of Art very early in the morning. I would work in the mornings, go to the cinema in the afternoons – not much work was done then, anyway – and go back to work when the place was empty at six-thirty. So I was usually in there about seven, seven-thirty or eight in the mornings, before Lyons had opened in South Kensington, and I used to make my own tea in there, because they wouldn't serve a cup of tea till eleven o'clock. I had a little teapot, and a cup, and I bought a bottle of milk, and packets of tea – it was always Typhoo tea, my mother's favourite.

The tea packets piled up with the cans and tubes of paint and they were lying around all the time and I just thought, in a way it's like still-life paintings for me; I'd like to paint something, take something different as a subject. There were postcards, Cliff Richard, cheap reproductions and newspaper photographs pinned up on the wall. I thought, there must be other things lying around, something I could use. There was a packet of Typhoo tea, a very ordinary popular brand of tea, so I used it as a motif. This is as close to pop art as I ever came. But I didn't use it because I was interested in the design of the packet or anything; it was just that it was a very common design, a very common packet, lying around, and I thought it could be used in some way. And again, it's not used in an ordinary still-life way at all. *The First Tea Painting*, partly, again, because I couldn't bring myself to paint figuratively and wasn't thinking like that then, is like an abstract expressionist painting with a strong reference to one strong visual – a very familiar sign. The later pictures, of course, are slightly different. *The Second Tea Painting* has got a little figure at the side, influenced by Bacon and other things. In a way, each is a different subject, although they all have the same motif. These paintings were my first attempt, after the abstract pictures, to put recognizable images into paintings. In *Tea Painting in an Illusionistic Style*, the third tea painting, the subject has become quite different from the first one. The idea that paintings should be rectangular or square was so fixed in every student's mind that even Italian paintings of the Crucifixion, constructed in the shape of the cross, still appeared in my memory as rectangular. Perhaps this was because I only knew them from reproductions and I had been used to scrutinizing the styles and methods of painting the figures. I can remember a precise moment when I realized that the shape of the picture gave it a great deal more power. To make a painting of a packet of tea more illusionistic, I hit on the idea of 'drawing' it with the shape of the canvas. The stretcher is made up from sections and I made the stretchers myself. It was quite difficult stretching them all up – the back is almost as complicated as the front; it took me five days. I don't think anybody had done shapes before. It meant that the blank canvas was itself already illusionistic and I could ignore the concept of illusionistic space and paint merrily in a flat style – people were always talking about flatness in painting in those days. In *The Second Marriage* these elements are even stronger.

It's interesting, I spelt the word 'tea' wrong on the left-hand section of the *Tea Painting in an Illusionistic Style*; I am a bad speller, but to spell a three-letter word wrong!! But it's drawn in perspective and it was quite difficult to do. I took so long planning it that in my concern for flatness or abstraction I spelt it wrong.

Early graphic work

I started doing graphic work in 1961 because I'd run out of money and I couldn't buy any paint, and in the graphic department they gave you the materials free. So I started etching, and the first I did was *Myself and My Heroes*. My 'heroes' were Walt Whitman and Gandhi. There was a little quote from each of them, but for myself I couldn't find anything – I hadn't made any quotes – so it just said, 'I am twenty-three years old and wear glasses,' the only interesting thing I could think to say about myself. And then I did *Kaisarion with all his Beauty*, which is from Cavafy's poem about Kaisarion's beauty, and *Three Kings and a Queen*. *Mirror, Mirror, on the Wall* is from *Snow White*, and the other lines at the bottom, 'proud to have received upon . . .' are from 'The Mirror in the Hall', another Cavafy poem which I loved, because the idea of making a mirror have feelings is a wonderful poetic idea that strongly appeals to me. *The Fires of Furious Desire* is from William Blake – I think Blake's title is 'The Flames of Furious Desire' – and it's a little self-portrait. When I turned a bit against using literary sources for painting for a while, I never gave them up in the prints much. It seemed to me much easier to respond to them in a graphic way; it probably still is.

29

5

7

30

34

33, 35

31

I won a prize of a hundred pounds for *Three Kings and a Queen*, from Robert Erskine who ran a print gallery. It was amazing! I just got the cheque through the post. I didn't even know the exhibition was on. I'd just arranged, before that, to go to America in the summer, which was something very special to me. First of all, to be able to go away in the summer without taking a job was something. Somebody'd offered me this ticket for ten pounds, and I was to pay another thirty pounds later; I hadn't got the thirty pounds, but I had the ten, and I thought, well, take it. And then I got this hundred pounds! I took with me a hundred and ten pounds to New York for three months. That was in summer 1961. Going was more of an accident, being offered the ticket. Before that I thought it cost a thousand pounds to cross the Atlantic, way beyond me.

Also I must admit I'd begun to be interested in America from a sexual point of view; I'd seen American *Physique Pictorial* magazines which I found when I first came to London. And they were full of what I thought were very beautiful bodies, American, and I thought, very nice, that's the real thing. The art I didn't care about. And I went to New York and met a boy in a drugstore in Times Square and stayed with him for three months. When I arrived in New York I only knew one person, Mark Berger, who had been at the Royal College of Art. He was in hospital with hepatitis all the time I was there.

Before I left England, Robert Erskine had said to me Take some etchings and go and see William Lieberman at The Museum of Modern Art; I'm sure he'll buy some off you. I thought, The Museum of Modern Art! I can't do that. Anyway I took a bundle with me to New York, but I didn't go to see him. I did *meet* him, however, later on, and he said Why haven't you come to see me? Robert Erskine wrote me a letter about you. I didn't think it would work like that. He *did* buy them; he took a copy of each of *Kaisarion* and *Mirror, Mirror, on the Wall* for the Museum, and he sold all the other copies I'd taken. I got about two hundred dollars, which was a lot of money for me, and I bought a suit, an American suit, and bleached my hair.

The only artist I met was Claes Oldenburg, at the Green Gallery; he was putting up an exhibition: the first papier mâché shirts and ties. The life of the city was very stimulating, the gay bars – there weren't many in those days; it was a marvellously lively society. I was utterly thrilled by it, all the time I was excited by it. The fact that you could watch television at three in the morning, and go out and the bars would still be open, I thought it was marvellous. And I did quite a lot of drawings then.

Just before I'd gone to America, I had bought a very large stretcher from a friend, eleven feet by seven feet; the student couldn't really afford it, and he couldn't afford to buy the canvas for it, so I bought this stretcher. I kept thinking about it when I was in America, and I thought, when I get back, I'll have thousands of subjects in my head. I also did an etching in America, in the Pratt Workshop, *My Bonnie Lies Over the Ocean*; William Lieberman had sent 38 me there.

When I came back I decided to do *A Rake's Progress* because this was a way of telling a 60–75 story about New York and my experiences and everything. The big stretcher became *A 4 Grand Procession of Dignitaries in the Semi-Egyptian Style*, which I began in September 1961. In New York all the recent paintings I had seen appeared enormous, all of them abstract. Trying to think of a subject for my enormous stretcher at first seemed quite a problem. Before (and since) the subject had come first and decisions about scale second.

I can't quite remember the point when the subject was decided, indeed the title was thought of only after the picture was begun, but at that time I was quite absorbed in the poetry of Cavafy. In New York I had found a new American translation by Rae Dalven of the complete poems and reread them all. His great poem 'Waiting for the Barbarians' had always

impressed me. It seemed to me also that a large canvas demanded a 'large subject', a kind of modern history painting. I thought, you can't paint a little packet of tea on this great big picture. And so I began the painting with no clear idea of what it would look like, but with Cavafy's ironic lines vaguely in my head:

> *Why have our two consuls gone out, both of them, and the Praetors,*
> *Today with their red togas on, with their embroidered togas?*
> *Why are they wearing bracelets, and all those amethysts too,*
> *And all those rings on their fingers with splendid flashing emeralds?*
> *Why should they be carrying today their precious walking sticks,*
> *With silver knobs and golden tops so wonderfully carved?*
> *Because the Barbarians will arrive today.*
> *Things of this sort dazzle the Barbarians.*

The first figure is meant to be ecclesiastical-looking. The second figure is a soldierlike person; he's got medals on him. The third person is full of little workers inside his body – I think they're stencilled on; he's an industrialist, or something. I just invented the figures as I went along. And there are smaller figures inside them to make them look as though they're bigger than they are; they are really just small people. This is the only three-figure composition I have ever done. I called the style 'semi-Egyptian' because there is a true Egyptian style with rules. All styles in a sense have some rules, and if you break them it's a semi-style, I thought; the Egyptian style of painting of course is flat and, since I was breaking the rule of flatness, it was the semi-Egyptian style. The curtain at the top is the first time I used the curtain motif; I wanted it to look theatrical, because I felt the whole event was theatrical – the idea of the people putting on a show for the barbarians. The background 'colour' of the painting is the raw canvas; this was a decision influenced, perhaps, by Francis Bacon, Ron Kitaj and American painting – the idea of not covering all the canvas with paint. This painting and the big works of 1961 – which I started in 1960 – are the works where I became aware as an artist. Previous work was simply a student doing things – though I'm still a student finding out things.

The Young Contemporaries, 1962

At the Young Contemporaries of 1962 I showed the work I'd done in 1961. In those days, I think, you could send six pictures to the exhibition but the most they would ever take was four. I was getting quite confident and I thought, I know, I'll demonstrate my versatility in this exhibition. So the four pictures I sent had the same general title, *A Demonstration of Versatility*, and then a subtitle; each painting was supposedly in a different style. I had become interested in style then. I realized you could play with style in a painting to make a 'collage' without using different materials; you could paint something one way in this corner and another way in another corner, and the picture didn't need unity of style to have unity. The idea had been suggested to me by the work and ideas of Ron Kitaj, who's kept me fascinated by style ever since. I thought, this is an interesting thing you can play with, style as a subject. One of the paintings was *A Grand Procession of Dignitaries in the Semi-Egyptian Style*. Then there was *Tea Painting in an Illusionistic Style, Flight into Italy – Swiss Landscape*, which in the exhibition was called *Painting in a Scenic Style*, and *Figure in a Flat Style*, in which the canvas was in a way shaped like a figure, so that you didn't have to have illusionism in the painting because the illusion was outside in the canvas shape; the style of the real painting could be completely flat. It is simply a very abstracted figure made up of the obvious figurative connections of a small rectangle on top of a larger one, which when resting on an easel looks like a figure; the base of the easel becomes the legs. (The wooden legs were added

6
40

to look like an easel base; they are attached to the painting and lie flat on the wall.) My excitement at the time was in the way the picture was expanded outside the canvas stretchers by the easel itself. By titling the pictures this way in the catalogues there was more space between the lines, so it stood out. I knew all those tricks; if you hadn't anything to do with the exhibition, you were hung in the back room or tucked away somewhere, and I thought, that's what they'll do with my pictures, if they take them. Always in the exhibition the paintings in the places of honour were by the president. I don't blame them – why shouldn't they? They're doing the work. But as I knew this, I knew the way to counteract it was to think of long titles so you get double lines under your name in the entry. Looking back, I have to admit that there were many reasons for doing things. One of the reasons I painted *A Grand Procession of Dignitaries* was that when I came back from America – I arrived back about a week before the College started in September 1961 – people were already grabbing places where they were going to paint the whole year. I'd got that big stretcher and I thought, I can grab a bigger area to paint on it, so I'll do it first; it's a good reason for painting this big picture, it means I get more space. Selfish, I know. These weren't the dominant reasons for doing things, but they came into it.

The emerging figures *Sam Who Walked Alone by Night* was also painted just after I came back from New York in 26 1961. I remember buying in New York a magazine called *One*. It was a kind of literary homosexual magazine, very specifically homosexual; it wasn't really literary. But it was one of the first very obvious gay things. It didn't have any pictures, or very few, and they weren't very sexy; and in it there were little stories. One was about Sam, a little transvestite who every night put on his little pink dress and took a little walk; he only did it at night. I thought it was an amusing story. Stylistically, the painting's influence is strongly Dubuffet. Dubuffet was, in these 1961 pictures, the strong visual influence. I think it was partly because he was the only French artist who was doing anything that was interesting at the time. I still think, looking back, although I'm not as great a fan as I was, that he did some marvellous pictures in the fifties and sixties, certainly some of the best pictures done in France then. He was much better than those abstractionists like Soulages and Manessier, much, much more interesting. It was his style of doing images, the kind of childish drawing he used, that attracted me. You see, I was in a dilemma which was probably similar to Francis Bacon's; he always said he did want to draw – he never draws now – because it would make his pictures very different if he could draw well. You can see the point. His images have a crudity and vigour which help the impact of the pictures. If they relied on a more refined drawing their effect would be quite different. At the time I could draw figures quite well in an academic way. But that's not what I wanted in the paintings. And so I had to turn to something that was quite away from it, and I think that was the appeal of Dubuffet. Here was an opposite way, a crude way. I also liked his work's similarity to children's art, which is like Egyptian art in that it's all the same. So I felt that using that kind of thing was using an anonymous style; and it occurred all the time in those pictures.

The Cha-Cha that was Danced in the Early Hours of 24th March was a real event – a very 3 beautiful boy who was a student at the Royal College of Art danced the cha-cha especially for me because although I didn't know him very well he knew I thought he was stunningly beautiful. At one of those college dances, he danced, very effectively, the cha-cha. It had such an impact on me, I thought, maybe here's another thing I can make a picture of. It's heavily influenced by Bacon, I think, even the way it's painted on hessian, which is a very cheap form of canvas – Bacon painted on the back of good canvas, which looks like hessian. The painting has very bright colours: the two blocks of colour at the top, one with the almost

kind of dark shocking pink zoomed out. The real colour has been lost over the years. This was about the last painting I did on such bad canvas. Really vivid colour loses its zing after a while. The words written in, 'I love every movement', is another line from a popular song of the time called 'Poetry in Motion'. I loved the words about somebody dancing, actually 'poetry in motion'; so corny. And one of the great lines he sings, in a slightly higher voice, is 'I love every movement'. And there is also the lettering, 'gives instant relief from'; it was the words 'penetrates deep down' that attracted me, they're from some kind of rubbing ointment: 'Penetrates deep down and gives instant relief'. They're words that were so common then, they had no other meaning; they never took any other meaning. Now they may.

We Two Boys Together Clinging is from Walt Whitman: 27

> *We two boys together clinging,*
> *One the other never leaving . . .*
> *Arm'd and fearless, eating, drinking, sleeping, loving.*

'The rub of love' The emphasis of the painting is on 'clinging'; not only are the arms clinging but small tentacles help keep the bodies close together as well. At the time of the painting I had a newspaper clipping on the wall with the headline 'TWO BOYS CLING TO CLIFF ALL NIGHT'. There were also a few pictures of Cliff Richard pinned up nearby, although the headline was actually referring to a Bank Holiday mountaineering accident. What one must remember about some of these pictures is that they were partly propaganda of something I felt hadn't been propagandized, especially among students, as a subject: homosexuality. I felt it should be done. Nobody else would use it as a subject, but because it was a part of me it was a subject that I could treat humorously. I loved the line, 'We two boys together clinging'; it's a marvellous, beautiful, poetic line.

I became aware of a lot about myself at that time, for instance about my own sexuality. When I'd been in Bradford, I'd always been very shy about admitting it; in London I wasn't. In my first year at the College the students used to go to the Hoop and Toy pub in South Kensington. One day I met a boy in a cinema and I'd gone to another pub with him just for a drink, and he was kind of groping me. And there was another student from the College watching us. I didn't know. Next day this guy said to me, rather pompously, I saw you in that pub with that boy and what you were doing. At first I was a bit embarrassed and then my reaction was, Of course I was, what about it? It made me rather militant, and I thought, what's the point of hiding it? And there was a time when they used to have dances in the bar of the College and some of the students got fed up, there were too many boys dancing together, and when they heard about it in the suburbs all the old queens started coming.

Lots of sex is fantasy. The only time I was promiscuous was when I first went to live in Los Angeles. I've never been promiscuous since. But I used to go to the bars in Los Angeles and pick up somebody. Half the time they didn't turn you on, or you didn't turn them on, or something like that. And the way people in Los Angeles went on about numbers! If you actually have some good sex with somebody, you can always go back for a bit more, that's the truth. I know a lot of people in Los Angeles who simply live for sex in that they want somebody new all the time, which means that it's a full-time job actually finding them; you can't do any other work, even in Los Angeles where it's easy. I can go a long time without sex. A person came to see me in Paris from *The Advocate*, a gay newspaper, to do an interview. And I had to say The trouble is, it doesn't dominate my life, sex, at all. For some people it does, but at times I'm very indifferent to it; and when people like this man come along and go on as though sex was a pioneering thing, I say, Well, it's really very far from that.

47 *Picture Emphasizing Stillness* 1962

48 *Leaping Leopard,* study for *Picture Emphasizing Stillness*
1962

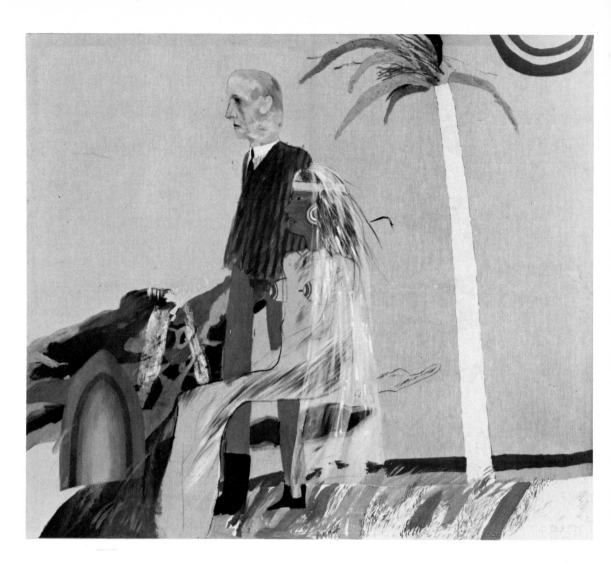

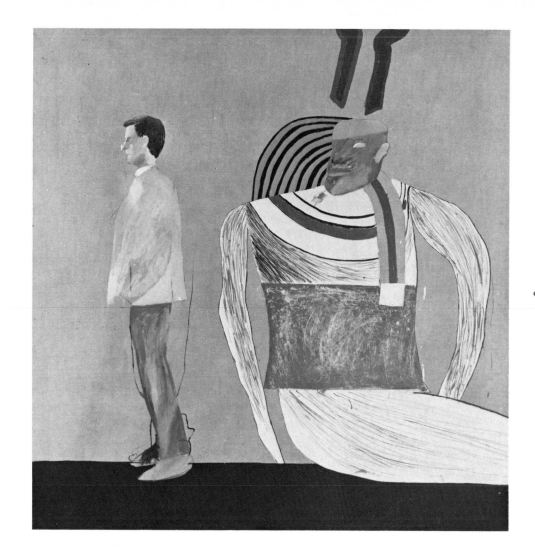

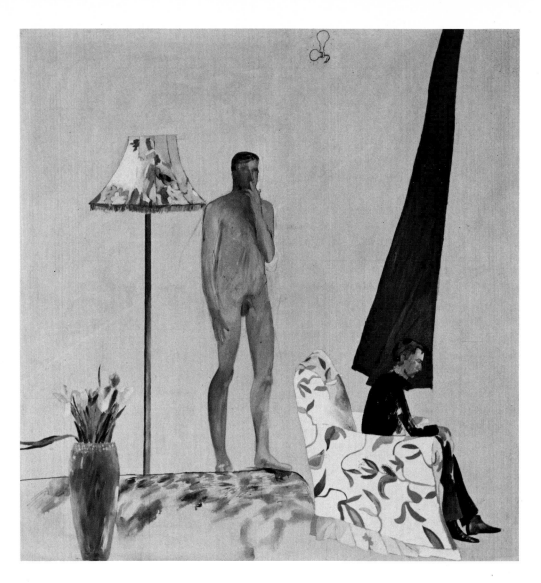

55 *Domestic Scene, Notting Hill* 1963

56 Figure for *Domestic Scene, Notting Hill* 1963

57 *Mo*, study for *Domestic Scene, Notting Hill* 1963

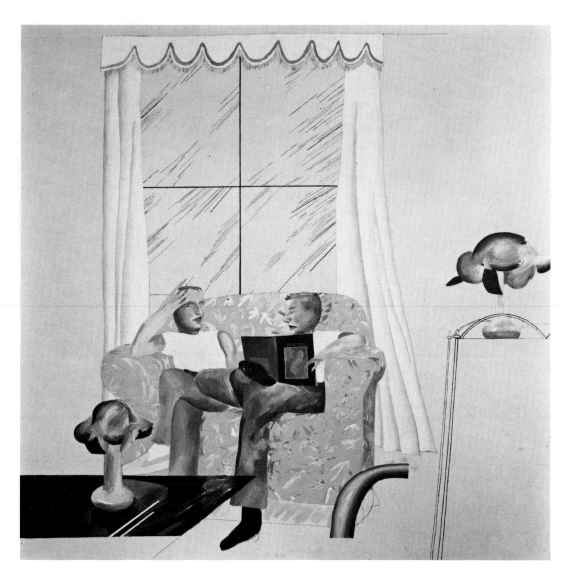

58 *Domestic Scene,
 Broadchalke, Wilts.* 1963

59 *Cubistic Woman* 1963

60

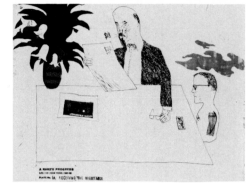

61

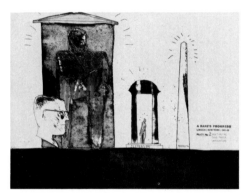

62

63

64

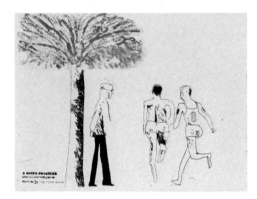

65

66

67

68

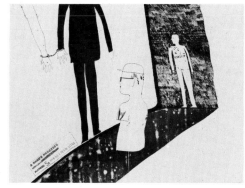

69

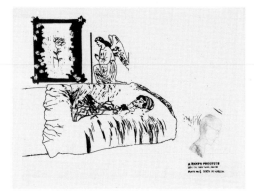

70

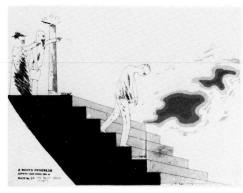

71

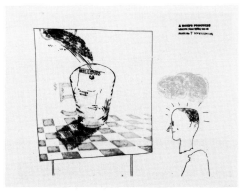

72

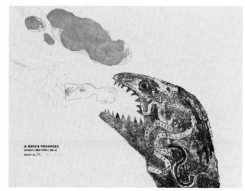

73

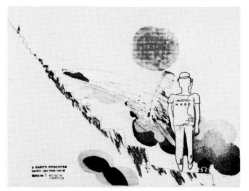

74

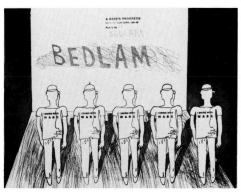

75

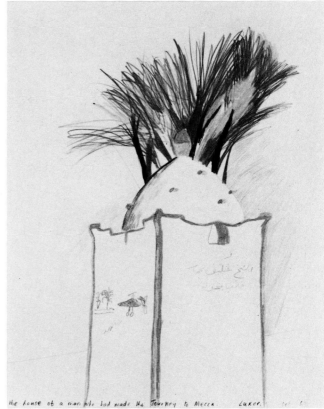

The house of a man who had made the Journey to Mecca. Luxor.

76 *Egypt '69* 1963

77 *The House of a Man who had Made the Journey to Mecca, Luxor* 1963

78 *Four Heads (Egyptian)* 1963

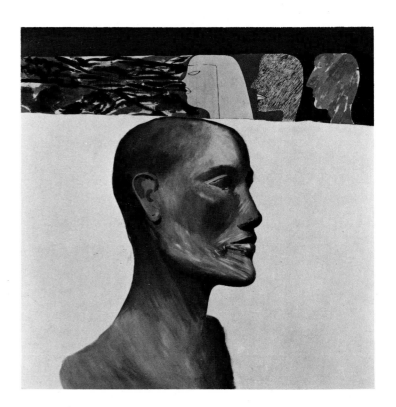

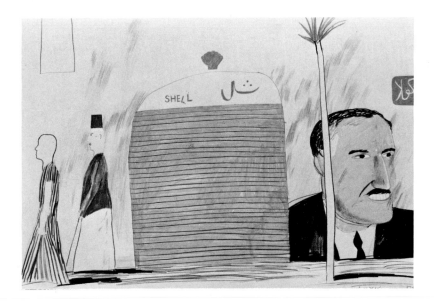

79 *Shell Garage – Egypt* 1963

80 *Great Pyramid at Giza with Broken Head from Thebes* 1963

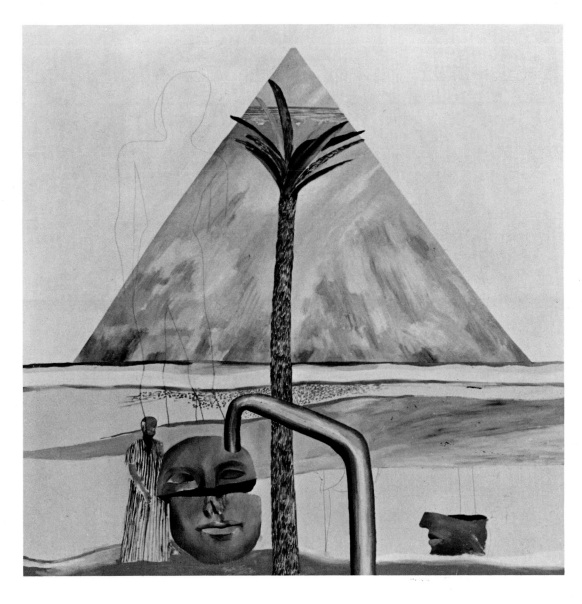

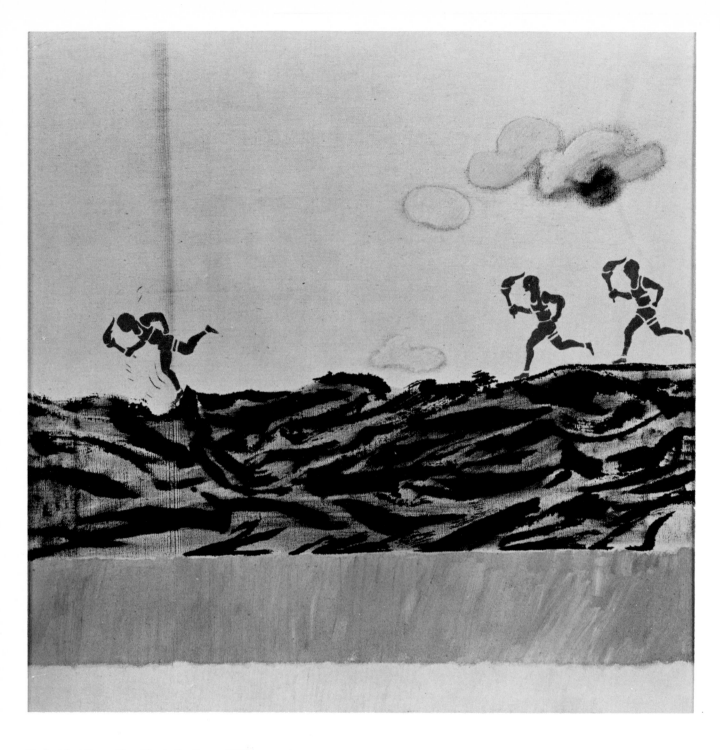

81 *Accident Caused by a Flaw in the Canvas* 1963

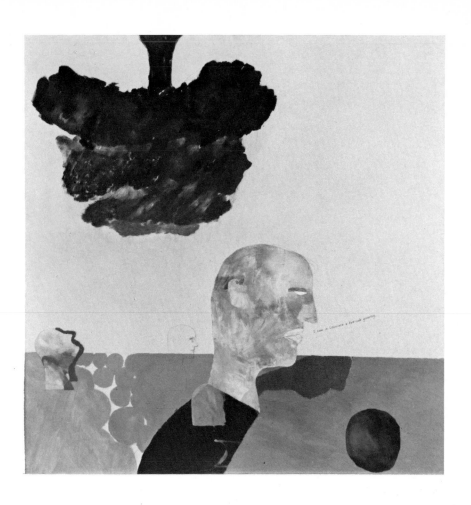

82 *I Saw in Louisiana a Live-Oak Growing*
1963

83 *Two Friends (in a Cul-de-sac)* 1963

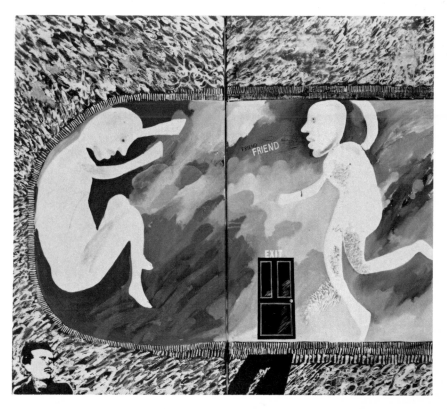

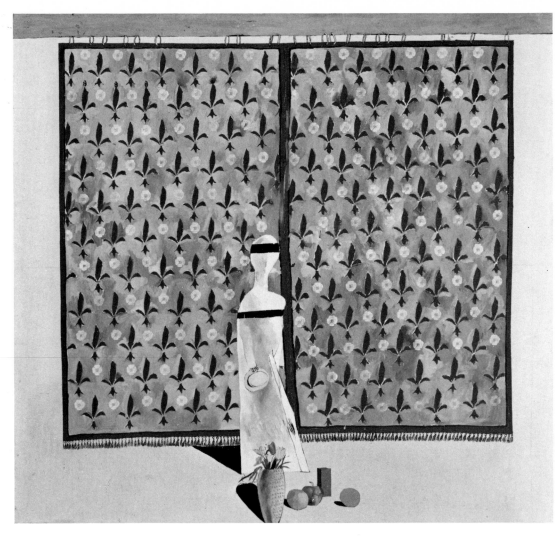

84 *Still Life with Figure and Curtain* 1963
85 *Coloured Curtain Study* 1963

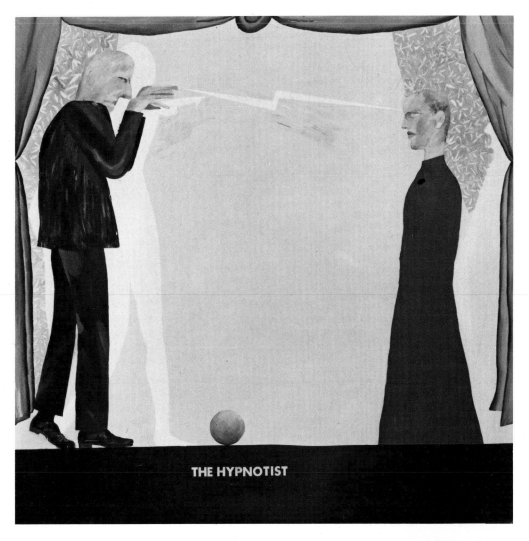

86 *The Hypnotist* 1963
87 *The Hypnotist* 1963

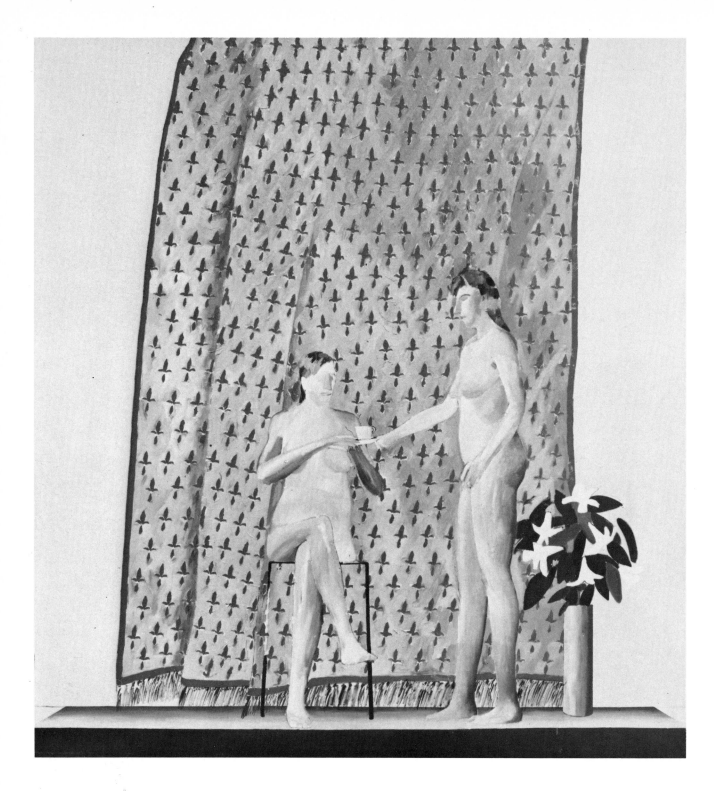

88 *Seated Woman Drinking Tea, Being Served by Standing Companion* 1963

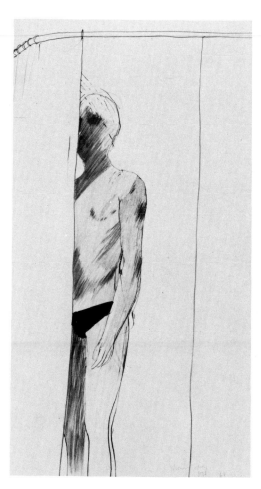

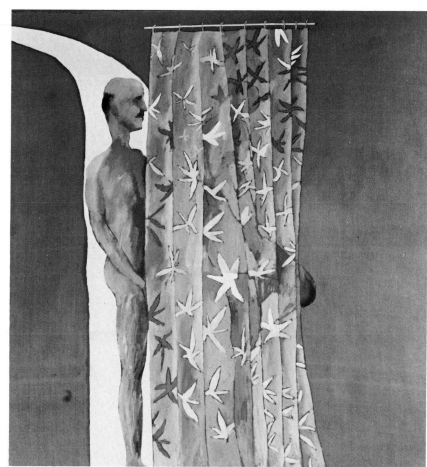

89 *Shower Study* 1963

90 *Two Men in a Shower* 1963

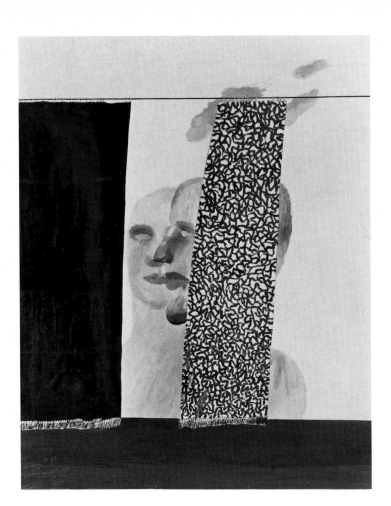

91 *Two Friends and Two Curtains* 1963
92 *Portrait of Kasmin* 1964

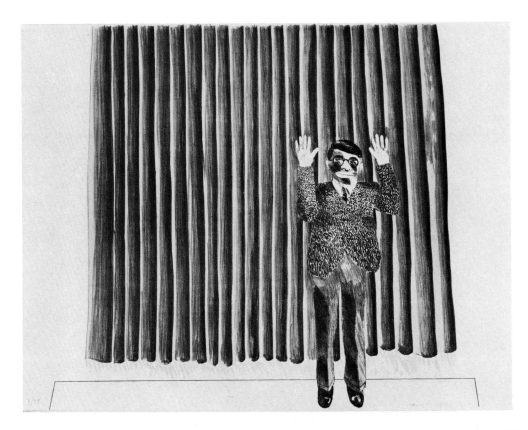

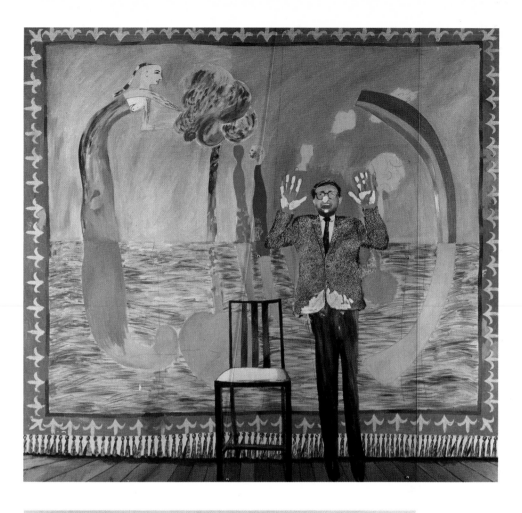

93 *Play within a Play* 1963
94 *Closing Scene* 1963

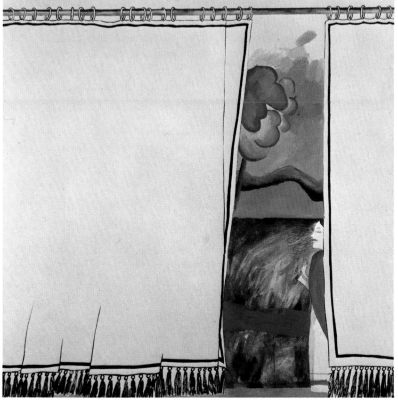

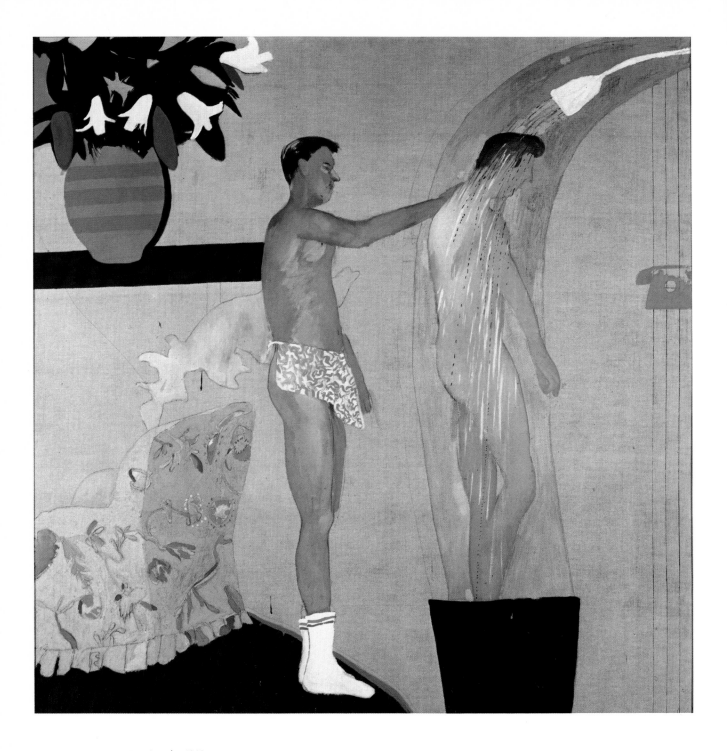

95 *Domestic Scene, Los Angeles* 1963

The Italian journey In December 1961 I went to Italy for the first time, with a friend. Michael Kullman, who ran the general studies department at the Royal College of Art, said he was driving to Berne in Switzerland and he would give us a lift there in his little Mini van and we'd share the petrol. I was looking forward to it; it was going to be my first trip to Switzerland. I was especially looking forward to the Alps and I thought, I'm going to see the Alps, and here's a real subject to make a picture of: mountain landscape in the Alps. I love Gothic gloom almost as much as Mediterranean or Californian sun, and I thought the misty Alps in winter would be a great thrill. But unfortunately I didn't see them. We were in this little van, and we drove all the way from Paris to Berne, and I never saw anything at all of the landscape. I was in the back, because this was my friend's first trip to Europe, and I thought to be polite I should give him the front seat; so I sat in the back, and I missed the mountains. But afterwards when I came back I thought, it's such a shame when I could have painted a mountain picture; and then I thought, well, I can, I can just make it up. And so I painted *Flight into Italy – Swiss Landscape*. 6
It's just taken from a geography book, what the mountains are like, and there's just a little peak of a real one, taken from a postcard, at the back of the flat representation. What looks like a geological band representing the mountain was influenced by the 1962 paintings of Harold and Bernard Cohen.

The trip to Italy was an artistic tour. That was the first time I'd been and I thought Florence at Christmas would be hot; I thought, Italy, it's always sunny there. But it really snowed, very heavily, and the narrow streets of Florence with snow on them were like a Dickensian London Christmas card.

Going to a place like the Uffizi is a delight. But I resisted any influences from the art there, because I thought, it's not modern. Later on I didn't resist them, but in 1961 I did. In 1961 the modern world interested me far more, and America specifically. Things stored up in my head that I never used, partly out of fear and insecurity and thinking you can't do this now, you can't make any use of it. Even today I might think you couldn't make any use of something and I'd be wrong about it; someone would come along and do it, do something from it. But, at the same time, I was never frightened of the art of the past. I remember Peter Phillips bragging, when I said I was going to the National Gallery, that he'd never been in, and wouldn't go in, which I thought was stupid. I said Well you're missing a lot; you've no need to paint like that, but you're missing all these lovely pictures. The reason for not looking at art from other periods is based on a fear of something, it seems to me. I can understand it – I've gone through it myself; anybody who's gone through the thing of becoming an artist knows about it. You couldn't go to Florence and not go to the Uffizi; that is unspeakable and unthinkable. Yet some other people wouldn't go, and of course the Futurists said Blow them up. An interesting theory, but if it were put into practice it would have appalling consequences. I think I've had a permanent affair with the art of the past and it goes hot and cold; the art of the past can be treated too pompously. And for me at that time most people who dealt with it did so in a pedantic, boring way, as though it wasn't living. The truth is, the art of the past is living; the art of the past that has died is not around. But at that time I couldn't see it like that, even though it begins to have an influence soon after, I think. I couldn't help it even if my theory said Ignore it; in practice I couldn't.

Seeing in the Uffizi that big Duccio, the Crucifixion, did confirm my belief in the power you can give to a canvas by shaping it to suit its subject. But at that time I was much more conscious of the current ideas about painting. For instance, flatness: flatness *was* something that people really talked about then, and I was interested in it. Everyone was going on about Jasper Johns's pictures: here was the flatness thing, and it appeared in later abstractions too.

The Snake is my comment on it, a version of it, in that the only illusion is that inside the frame 46
the snake is lying on a canvas; the canvas itself isn't painted. The handmade frame is meant
to suggest a mechanical version of the snake. The starting point of this picture was an
attempt to animate a target, which was a popular theme among students at the time – it
probably derived from Kenneth Noland and Johns. I wanted to give my target painting a
completely different subject, but all the time there was this idea of flatness. I thought it was
something I should be involved in.

The first life paintings At the Royal College of Art, in those days, there was a stipulation that each year you had to
do about twelve life paintings, which would take quite a lot of time if you were doing them in
an academic way. Then they thought that was being a bit rigid, and I think they altered it to
three, saying it only meant that in your diploma show you had to have at least three paintings
done from life. I had a few quarrels with them over it because I said the models weren't
attractive enough; and they said it shouldn't make any difference, i.e. it's only a sphere, a
cylinder and a cone. And I said Well, I think it does make a difference, you can't get away
from it; and it's true, it does. Any great painter of the nude has always painted nudes that he
liked; Renoir paints rather pretty plumpy girls, because he obviously thought they were really
wonderful. He was sexually attracted to them and thought they were beautiful, so he painted
them; and if some thin little girl came along he'd probably have thought, lousy model. Quite
right. Michelangelo paints muscular marvellous young men; he thinks they're wonderful. In
short, you get inspired. So I got a copy of one of those American physique magazines and
copied the cover; and just to show them that even if the painting isn't anatomically correct I
could do an anatomically correct thing, I stuck on one of my early drawings of the skeleton
and I called it in a cheeky moment *Life Painting for a Diploma*. It's mocking their idea of being
objective about a nude in front of you when really your feelings must be affected. I thought
they were ignoring feeling, and they shouldn't. It was a way of telling them something.

They really did have old fat women as models, big tits hanging down; they sit on a chair
and their ass goes falling over it. To me the idea of this flesh attracting you – you couldn't get
further away from attractive flesh than this flesh. So I said Can't you get some better models?
They said Well, we try to get variety in models, you know; but the idea of painting an
attractive one they thought was rather wicked. And I said Well, I can't work like that. Could I
get a model, could I bring one, and would you pay him? They said All right, we'll pay him the
set rate; and so I got Mo McDermott to come in. I'd just met Mo then, and he hadn't anything
to do, so I said Will you come and pose at the College? Nobody else at the College wanted to
paint him; they didn't like painting male models, so I had him to myself. He just sat in my little
corner. I'd already done one or two little drawings of him, but the first painting I did of him
was *Life Painting for Myself*. He's painted in three poses; there's a standing figure, and a sitting 42
figure, and his clothes are just beginning to be painted on the right, a little striped T-shirt and
blue jeans. I wrote on the painting: 'life painting for myself', and right at the bottom it says
'Don't give up yet'. I didn't write that on – someone else did, when the painting was left on an
easel in the College. I don't know to this day who did it, but I left it on, and I fixed the painting,
so it's part of it now. But it's not my writing and I didn't actually do it.

At the time I was a keen vegetarian; I used to give out leaflets for the London Vegetarian
Society. My mother has been a vegetarian all her life. I'd done a drawing in New York of a pig
escaping from a hot-dog machine, and one of an elephant treading on grass, flattening it,
which I used when I painted *The Cruel Elephant*. Instead of drawing the grass in, I put the 45
words 'crawling insects', which the elephant is forced to tread on, flattening them. I put a
man on the top of the elephant, so it's as though the man's weighing the elephant down and

the elephant didn't after all intend to kill the crawling insects – it's that extra weight of the man that is the cruelty.

The marriage paintings After leaving the Royal College of Art in summer 1962, I went to Italy again, with an American boy called Jeff Goodman. And then we took a train to Munich and from Munich to Berlin, which I was a bit attracted to by Christopher Isherwood's Berlin stories. You never quite believe places change; when I went to Alexandria I thought it would be like Cavafy. The first thing I painted when I came back from Germany was *Berlin: A Souvenir*, which in a way was going back a little because it has abstract expressionist references again. Berlin also inspired the little pictures called *The Berliner and the Bavarian*, and the leopard in *Picture* 47 *Emphasizing Stillness* is done from a little drawing of a leaping leopard I saw in a Berlin 48 museum. Another museum gave me the subject of *The First Marriage* – its other title, *A* 49 *Marriage of Styles*, perhaps gives more clues it. I never seem to be able to go around a museum at the same pace as anybody else, and when I went to the Pergamon Museum with Jeff we got separated. Suddenly I caught sight of him standing next to an Egyptian sculpted figure, unconcerned about it because he was studying something on the wall. Both figures were looking the same way, and it amused me that in my first glimpse of them they looked united. In the painting, the husband stands politely, and the sculpture is made to look like his wife who is a bit tired and therefore sitting down. They're both looking at the same thing, but we can't see it. As the scene in the museum became focused for me, it seemed all the more amusing because the connection between the two figures was so tenuous. A day or two later I made a drawing of the scene, and then back in London I concocted it more elaborately. I loved the idea of playing with the word 'marriage'. The setting is vague but the Gothic window in the bottom left-hand corner was, I remember, added for its ecclesiastical connections with marriage.

 Man in a Museum has the same theme as the *Marriage* pictures. *The Second Marriage* is a 52, 7 more complex version of *The First Marriage*; in the studio I thought about the idea and elaborated on it. The man in *The Second Marriage* looks more like a bridegroom, more domestic. The picture has a more complicated and specific setting, involving illusionistic and perspective effects, and the curtain motif occurs in a domestic interior. The form of the curtain first made me interested in it as a subject, and then it dawned on me that it could be even more interesting because it was *flat* – the magic word again. A curtain, after all, is exactly like a painting; you can take a painting off a stretcher, hang it up like a curtain; so a painted curtain could be very real. All the philosophical things about flatness, if you go into it, are about reality, and if you cut out illusion then painting becomes completely 'real'. The idea of the curtains is the same thing.

 The head of the woman in *The Second Marriage* was painted from a photograph of an Egyptian head in Berlin. I was attracted to the picture by the superb quality of the photograph almost as much as by the beauty of the head. *The Second Marriage* prompted *The Hypnotist*, 86 which is even more theatrical: a hypnotist is a more theatrical person than a married man. The curtain occurs in that painting too. All the paintings I'd been doing at that time had two figures in them, close together or directly linked, and I felt like painting another picture with the figures very separated. I'd realized by then that a reasonable way to unite figures that were painted on the edges of a large canvas was to put them in a theatrical or stage-like setting. I hit upon the idea of a hypnotist at work. One of the sources for the idea was a scene in a movie called *The Raven*, where Vincent Price and Peter Lorre are magicians seated in a large room. The camera doesn't move much so they appear on each side of the screen, and each tries to impress the other with his magic. Vincent Price pulls off his belt, it becomes a

snake and he hurls it at Peter Lorre. As it wraps itself round his neck, Peter Lorre pulls it off and it becomes a silk scarf. After a few more tricks Vincent Price in his anger uses his hands like a hypnotist and green electric bolts fly between his finger tips and Peter Lorre's. The flash seems almost drawn in strong contrast with the gloomy photographic realism of the figures.

My version has a rather evil-looking hypnotist and an innocent helpless-looking boy (he has no visible arms). This is one of the few early paintings from which I also made an etching. I drew the etching plate with the figures in the same positions as in the painting, but of course when it was printed it was reversed. Seeing both pictures together made me realize that even pictures are read from left to right. 87

87

The curtain in the painting in the picture

Immediately after *The Hypnotist* I painted *Still Life with Figure and Curtain*, which was done in a very formal way. Soon after I began it, I went in the National Gallery one day and had a very rare experience of seeing. I thought I knew the National Gallery and all the pictures very well, but in 1963 they'd bought a group of paintings by the seventeenth-century artist Domenichino. I wandered in and found them in a room and they thrilled me, because they were things I could use. I suddenly saw what they were about. The moment these pictures revealed themselves, I realized my ideas were far from being new. It wasn't their subject matter from Greek mythology that interested me, but the fact that they really seemed like *trompe-l'œil* painting. They were paintings made to look like tapestries made from paintings, already a double level of reality. All of them had borders round and tassels hanging at the bottom and perhaps an inch of floor showing, making the illusionistic depth of the picture one inch. In one of them, *Apollo Killing Cyclops*, the tapestry was folded back a little, like the illusionistic device on a Kodak film box, and in front of this was a dwarf. I don't really know who he is or what it was meant to be about but the doubling back from the spectator interested me. *Play within a Play* is my version of *Apollo Killing Cyclops*. Instead of calling it 'Picture within a Picture within a Picture', I thought I'd use the common literary version of it: *Play within a Play*. It uses Domenichino's idea of a very shallow space with a picture on a tapestry that has illusion and you don't know whether the illusion is real or not, because it has this border round it. You're playing so many games, and they are visual. The tapestry is invented, using elements of images from previous work. The figure is a portrait of John Kasmin. Kas had always wanted me to paint him but I'd never got round to it as I couldn't really decide how to do it. Now it seemed appropriate to trap him in this small space between art and life (the sheet of glass is real and where his hands or clothes touch they are painted on the surface of the glass). I had originally intended to cover the whole picture with glass but the weight of the glass would have made it almost impossible to move (I couldn't afford expensive art movers), so the shape is really a compromise. Anyway, the original glass broke and was replaced by a perspex sheet. In 1970 I had the painting transcribed into a real tapestry by Archie Brennan in Edinburgh, so the double play becomes a triple play. A tapestry made from a painting, made from a painting of a tapestry, made from a painting. I must admit, looking back on it now, I think of it as one of the more complex and successful pictures of that period. Later on, when David Oxtoby, a fellow artist and old friend from Bradford, called to see me, he looked at the tapestry which I'd hung on my wall and asked me why it had been made. I told him It's from my painting done from another painting of a tapestry done from a painting. He said Oh Dave could you lend me it? I'll make a painting of it. A lovely spiral! 93

84

93

Then I did the other two curtain pictures: in *Seated Woman Drinking Tea, Being Served by Standing Companion*, the figures are painted from Muybridge. I'd bought Muybridge's *The Human Figure in Motion* a year or so before, to help me draw the figure. I knew Francis Bacon 88

88

used it, but I was using the book as well for literally drawing figures. I loved the title of that photograph; his titles are marvellous and direct. It makes no mention of the woman being nude, which is slightly odd, and I liked that; it's dry. If you said 'Seated Lady Nude Being Served by a Standing Nude Companion', it's not as good.

The artist and his dealer

Around that time I took a job teaching etching at Maidstone School of Art. I chose etching rather than painting because I thought I could etch myself there, and I thought I could live on one day a week's teaching money. Meanwhile, I'd started selling pictures.

By the time I left the Royal College of Art I'd become a kind of rich student. I got a grant of three hundred pounds a year and perhaps I got another three or four hundred a year from pictures. It was enough, and I didn't have to work during the holidays. I'd met Kasmin in about January 1961, when he was working for Marlborough Fine Art. He was interested in my pictures; he said Bring some more into the Marlborough, and I did, and they *hated* them. Harry Fischer thought they were awful, and told Kas These are dreadful; what are you doing with all this junk? But James Kirkman, who worked there then, bought them for about ten pounds each, still has them I think. Kas, in the late summer of 1961 when I'd gone to America, had given me a little bit of money to go, about forty pounds, and he said When you come back, if you want some, I'll give you a bit more. In America I got a letter from him saying I've left the Marlborough Gallery; when you come back don't go there, come and see me. And so I did. And he said I'm going to open a gallery soon and I'd like to deal in these pictures. I'll buy some pictures from you. He was the only person that said that then, so I said Very nice; yes, all right. And he kept buying pictures. They were incredibly cheap then. Even paintings were only fifteen pounds. He sold them for fifteen pounds and took about three himself. Then in my last year at the Royal College of Art, from September 1961 to July 1962, Kas bought all the pictures I painted, so I'd quite a bit of money. I thought I was rich; and I was, really. I could buy canvas, real paint, and I began to travel a bit. Instead of hitchhiking I could go on the train. That was the Christmas I went to Italy. It was the first Christmas I hadn't worked at the post office delivering Christmas mail. When I left the College Kas said, I will give you a six hundred pound a year contract, which was twice what the grant had been. And I thought, even if I don't get anything else, I've got six hundred pounds, twice what I've been living on – that's fine; I don't need much more and I can paint every day too. And then I thought, well, one day a week teaching is all right, and so I took this job in Maidstone. But I gave it up six or eight months after. I've never taught in England since.

Kasmin's contract in practice turned out to be more than six hundred pounds a year because I painted more pictures, and he'd buy them and sell them. So I was getting money in. I began to earn about fifteen hundred pounds a year, which was very good if you had just left college. It was as good as any teaching would bring in. And I was making it from my work, which was even better.

A Rake's Progress

I was still doing *A Rake's Progress*, which I'd started in 1961; I didn't finish it till 1963, 60–75 because it was a long job. I didn't have an assistant then. I started on it when I came back from New York, after *A Grand Procession of Dignitaries* was finished. My original intention was to do eight etchings, to take Hogarth's titles and somehow play with them and set it in New York in modern times. What I liked was telling a story just visually. Hogarth's original story has no words, it's a graphic tale. You have to interpret it all. So I thought, this is what I will do, and when I started Robin Darwin, the head of the College, said It's a good idea, could we make a book of it for the Lion and Unicorn Press? And I said Yes, I don't mind. And then he said Eight is not sufficient, you'll have to do more; rather ruining my conception. He said Can you do twenty-four? And I thought, well, all right, I'll try; and I began. Just technically, to do

twenty-four etchings on your own with nobody helping you on the technical side is a considerable amount of work. Just the process of putting wax on to zinc plates, putting aquatints on to them, even when you're not drawing, all this takes a long time. I quickly discovered that twenty-four was going to be a very big job, both technically and in spreading the story out; there'd have to be a lot of padding, and I don't like padding. So I said to them I don't like the idea of doing twenty-four because the story has to be padded out too much. I don't want to do it that way. I agreed finally to do sixteen. I actually made more than that because there are a few versions of some of them. By the time I left the Royal College of Art I think I'd done about half and I didn't want to abandon it, and then they said You can come in and finish it off whenever you want, so I did; I kept going in and carrying on with it until, I remember, in 1963 I felt I wanted to go to New York again and finish it off. So I got some money from Kasmin to go. I showed him what I had done; Kasmin didn't have much money in those days either, so I said I'm finishing this, and if you could give me some money for the fare, I'll give you one of the sets. And I went on the Queen Elizabeth and flew back. I stayed in New York about three weeks and did two more etchings there, in the Pratt Workshop, and looked around again. I found the things to finish off the etchings and I came back and did finish them finally in 1963 some time. That's also when I first met Paul Cornwall-Jones.

Up to then I was printing all the proofs myself, at the College. And when I met Paul it was just about finished and I'd got them all up on the wall. As it progressed I kept sticking them up. Finally, I had the sixteen rough proofs on the wall, and then Paul offered to publish it, buy it for Alecto, and he offered me five thousand pounds which was a staggering amount of money. An edition of fifty – It meant they were paying me a hundred pounds each for a set of sixteen prints, and they were going to print them. They sold the sets for two hundred and fifty pounds each, and I didn't dare tell people the price because it was so outrageous. I was ashamed of it; I thought, etchings should cost two or three pounds each; two hundred and fifty pounds – madness! But with the money – which wasn't paid to me immediately, it was spread over two or three years – I realized I could go and live in California for a year without taking money with me; they'd send it out to me, even if I didn't sell any paintings. So that's how I went.

Domestic scenes

I had moved into a large flat in Powis Terrace in 1962. Up until then I'd lived in small rooms and even when I left the College I had to paint in some other place, but then I moved into this flat. It was very cheap, five pounds a week. It was the first time I'd been able to paint and live in a place at the same time, and it was marvellous getting up in the morning and straightaway going to paint. I slept in the room I painted in. There was a little bed in the corner and a chest of drawers at the foot of the bed, and on the chest of drawers, because that's the first thing I saw when I woke up on a morning, I painted 'Get up and work immediately' in quite careful roman lettering, so that when I woke up not only did I read the message, but I also remembered I'd been foolish enough to waste a day doing it all in roman lettering. It made me get up quicker.

When I moved there I was finishing *The First Marriage* and at the beginning of 1963 I began *The Second Marriage*. At that time I used to work on a number of pictures, five or six, simultaneously. Then I began *Domestic Scene, Notting Hill* because I thought, why not paint from life again? The figure had once more begun to dominate the pictures. I felt I needed to fit doing something from life into this pattern.

When you walk into a room you don't notice everything at once and, depending on your taste, there is a descending order in which you observe things. I assume alcoholics notice the booze first, or claustrophobics the height of the ceiling, and so on. Consequently, I

55

deliberately ignored the walls and I didn't paint the floor or anything I considered wasn't important. What I considered important were two figures, the chair, a bed, a lamp, a vase of flowers, curtains and some light bulbs; anything else was irrelevant. Everything in the picture was painted from life. The figures were not intended as portraits but they were two friends: Mo McDermott standing on the bed, and Ossie Clark sitting on the chair. I called it *Domestic Scene, Notting Hill*, because I thought, that's what it is, really. After that, I painted *Domestic* 95 *Scene, Los Angeles* from a photograph in *Physique Pictorial* where there's a boy with a little apron tied round his waist scrubbing the back of another boy in a rather dingy American room; I thought, that's what a domestic scene must be like there. It was painted before I ever visited Los Angeles. Although by then I had made two visits to the United States, I hadn't yet gone further west than Washington, D.C. California in my mind was a sunny land of movie studios and beautiful semi-naked people. My picture of it was admittedly strongly coloured by physique magazines published there; *Physique Pictorial* often had street scenes of wooden houses and palm trees with motorcyclists acting out fantasies for 8mm movies. The interior scenes in the magazine were obviously (like old movies) shot in made-up sets out of doors. Bathrooms had palm-tree shadows across the carpets, or the walls suddenly ended and a swimming pool was visible. The chair in *Domestic Scene, Los Angeles* is the same as in the Notting Hill scene and the telephone is painted from life, the vase of flowers from an illustration in a women's magazine. It was only when I went to live in Los Angeles six months later that I realized my picture was quite close to life.

Around the same time I painted *Two Friends (in a Cul-de-sac)*, where the influence of 83 Dubuffet is still felt. I had found that anything could become a subject of a painting: a poem, something you see, an idea you suddenly have, something you feel – anything was material you could use. That in itself made me feel free. There's vivid evidence at this time of feeling free, stylistically. That's when it first occurs.

Domestic Scene, Broadchalke, Wilts was done from little drawings. The models were Peter 58 Phillips and Joe Tilson, but there's no attempt at likeness. Again, you can see how much style interested me: the flowers are cubistic, yet the figures are not. It was putting one thing with another, mixing them up. The glass is treated in a way I treated glass later. I think that's the first time I painted glass.

Showers In *Two Men in a Shower*, the figure on the left is painted from a magazine; the figure in the 90 shower is done from life. I had a shower curtain like that, and I had Mo stand in it and take a shower so I could see through and paint it. And then the curtain paintings: *Still Life with Figure* 84 *and Curtain*, as I mentioned before, is quite abstract; in *Closing Scene*, the very title suggests 94 something else: the idea of the curtain being pulled across to cover up the picture; playing with words and ideas again. *I Saw in Louisiana a Live-Oak Growing* is from the Whitman poem 82 about the tree that's 'uttering joyous leaves of dark green' all its life without a friend or lover near. I thought, what marvellous lines about a man looking at a tree. The tree is painted upside down to make it look more alone; it was just as simple as that, really.

Accident Caused by a Flaw in the Canvas is a tiny painting; it's not much visually but it's an 81 idea. I'd stretched up a little canvas and when I'd finished stretching it, it had a little flaw or two in the weaving. I was a bit annoyed to discover after doing all this work that there were flaws in the cloth, and thought, what a nuisance, it's no good. I was very conscious about quality. I was selling pictures and you can't sell inferior quality material. I thought, this is terrible, it's a waste. Then I thought, no, as long as I incorporate it into the title, it's not. I took a little stencil of a man running, stencilled him up, and when he comes to the flaw, he's tripping up. I called it an accident; the man is falling over because of the flaw.

I finished *A Rake's Progress* about May 1963 and then we had it printed; it took a few months. An old man printed it, and when I offered him a full set he said he didn't want them, because he didn't like them. Every time I went to see him, to see how they were going on, he would show me a little etching of a churchyard or something, and he would say Can't you do anything like this? And I would say Well, one day, I'll be able to do something like that.

Egypt, 1963 When *A Rake's Progress* was finished I went to Egypt, in September 1963, for the *Sunday Times*. They phoned me up one day and said Would you like to go to Bradford to draw it? They'd only just started the colour magazine and so they were wanting things to put into it, and David Sylvester and Mark Boxer who were doing it had the idea of sending an artist to places. When they asked me if I'd go to Bradford, I said Oh it's too much like J. B. Priestley; not me. I wanted more exotic things – I'd only left Bradford a few years before, and the idea of going back didn't appeal. I said I'll go to Honolulu; I'll draw the view from the top of the Honolulu Hilton for you, if you send me there, and to my surprise they said We'll call you back on it. And they must have discussed it, because they called me back and said Will you go to Egypt? They knew I was interested in Egyptian art. I said Yeah, that would be fine. So I went to Egypt for three, four weeks, and I made a lot of drawings there, about forty drawings, I think. I drew everything. I went to Cairo, then Alexandria, and up to Luxor, where I spent about ten days; it was the most interesting. When I came back I made the paintings of the *Great Pyramid at Giza with Broken Head from Thebes* and *Four Heads (Egyptian)*. 80, 78

At the end of 1963 I had two exhibitions. The first was at Kasmin's, where I showed all the paintings I'd done since I left the Royal College of Art, about eight or ten, and some drawings. They sold all the paintings, I think. The most expensive was *Play within a Play* which was £350. Mark Glazebrook bought it and three or four years later he sold it to Paul Cornwall-Jones for £2,000; I thought Paul had gone mad. At the same time as Kasmin's exhibition, the Alecto Gallery showed all my etchings, *A Rake's Progress* and all the others.

The first trip to California Immediately after the London shows I left London and went to California for the first time, with my money from *A Rake's Progress* and from Kasmin. On the way, I stopped in New York and made two etchings, *Jungle Boy* and *Edward Lear*. I was paid a thousand dollars for each 98, 100 of them.

When I got to Los Angeles I didn't know a soul. People in New York said You're mad for going there if you don't know anybody and you can't drive. They said At least go to San Francisco if you want to go West. And I said No, no, it's Los Angeles I want to go to. So it was arranged; I was going to have an exhibition in New York, at Charles Alan's Gallery, and I said I'd paint the pictures in California. Charles said It's crazy, you know you won't even be able to leave the airport if you can't drive; it's madness. So he phoned up this guy who was a sculptor there, who showed in his gallery, called Oliver Andrews. He very kindly came to meet me at the airport and he drove me to a motel in Santa Monica and just dropped me. He gave me his phone number. I got into the motel, very thrilled; really, *really* thrilled, more than in New York the first time. I was so excited. I think it was partly a sexual fascination and attraction. I arrived in the evening. Of course I'd no transport but the motel was right by the bottom of Santa Monica Canyon, just where Christopher Isherwood lives. I didn't know him then and although I had his address I didn't know it was near there. I checked into this motel and walked on the beach and I was looking for the town; couldn't see it. And I saw some lights and I thought, that must be it. I walked two miles, and when I got there all it was was a big gas station, so brightly lit I'd thought it was the city. So I walked back and thought, what am I

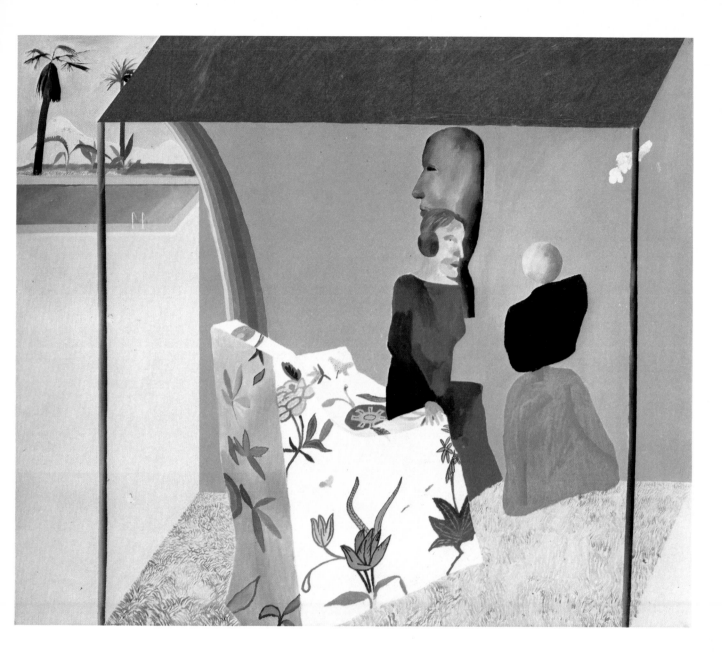

96 *California Art Collector* 1964

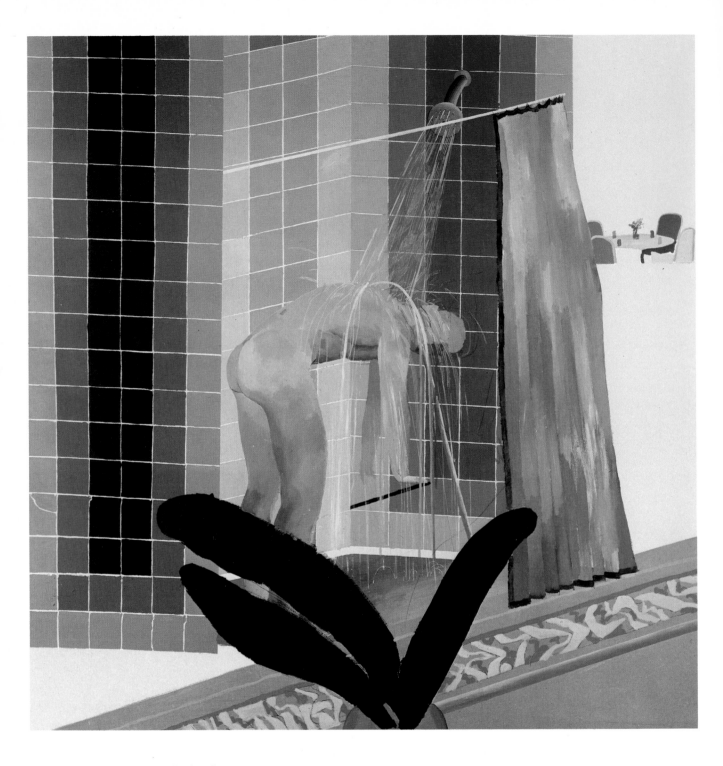

97 *Man Taking Shower in Beverly Hills* 1964

going to do? Next morning I phoned up Oliver and said I want to go into the town; I must buy a bicycle. And he said All right, I'll take you. It appeared the town was just at the back; I'd been looking the wrong way. He took me to buy a bicycle and he told me about an English writer there. I said You mean Christopher Isherwood? And he said Yes. He knew him. So I said I'd love to meet him.

I had read John Rechy's *City of Night*, which I thought was a marvellous picture of a certain kind of life in America. It was one of the first novels covering that kind of sleazy sexy hot night-life in Pershing Square. I looked on the map and saw that Wilshire Boulevard which begins by the sea in Santa Monica goes all the way to Pershing Square; all you have to do is stay on that boulevard. But of course, it's about eighteen miles, which I didn't realize. I started cycling. I got to Pershing Square and it was deserted; about nine in the evening, just got dark, not a soul there. I thought, where is everybody? I had a glass of beer and thought, it's going to take me an hour or more to get back; so I just cycled back and I thought, this just won't do, this bicycle is useless. I shall have to get a car somehow.

The first car, the first studio, the first California paintings

Then Oliver came to visit me next day and said How's the cycling going? And I said Well, I went to Pershing Square. Why did you go to Pershing Square? Nobody in Los Angeles ever goes to downtown Los Angeles, he said. I said I'll have to get a car. And he said I'll take you to the licence place and you can get a provisional licence and then you can drive round, practise a bit; it's easy, driving. I'd never driven before in my life. He showed me a bit of driving. He said All you do is put your foot here to go and your foot there to stop; automatic car, no gears; so I tried it out. We went up to the licence place and they said You fill out this form. And the form had questions on it like What is the top speed limit in California: 45 miles an hour, 65 miles an hour, 100 miles an hour. Well, you can guess, you don't have to be too smart or even to have read the highway code. And all the questions were like this. I just picked the answers using common sense. And they said You made four mistakes; that's allowed. Where's your vehicle? I said How do you mean, where's the vehicle? They said You take the driving test now, the practical bit; you passed the first part. I said Could I come back tomorrow? They said Come back this afternoon; you get three goes for your three dollars. If you fail you can come back. Oliver was amused that I'd inadvertently passed the first part of the test, and he showed me a bit, and then said You might as well have a go. And they gave me the licence.

I was thrilled but frightened. I thought, that's all you do and everybody's zipping about you? I went and bought a Ford Falcon in the afternoon, which cost about a thousand dollars; first car I'd ever had; and I was very scared driving it. I thought, I'll have to practise; and I just drove anywhere. I got on a freeway the second day and I daren't move off any of the lanes and I went all the way to San Bernardino on the freeway, sixty miles inland. I thought, I'll turn round here, if I can find where you get off. Then there's a sign: Las Vegas 200 miles. And I thought, wonderful, I'll practise in the desert, and I drove all the way to Las Vegas, and drove back at night.

The day after, I found a studio. Just drove down to Venice, this place for rent, little sign up. I said I'll take it; room overlooking the sea, not very big. Then I just rented a small apartment, very easy to find in Los Angeles. You just drive down the streets and there are notices saying $1\frac{1}{2}$ rooms to let; a very American way, I thought, half a room. I imagined the half-room being from the ceiling halfway down the walls. Within a week of arriving there in this strange big city, not knowing a soul, I'd passed the driving test, bought a car, driven to Las Vegas and won some money, got myself a studio, started painting, all in a week. And I thought, it's just how I imagined it would be.

I went into an art store and it was full of American equipment. I'd tried acrylic paint in England before and I hadn't liked it at all; texture, colours weren't so very good. But the American ones I liked. It was superior paint. And so I started to use it. It has one or two effects. For one thing you can work on one picture all the time because you never have to wait for it to dry, whereas you might work on two or three oil paintings at a time because it takes so long for the paint to dry.

I began to meet artists. In those days, all the galleries in Los Angeles were on one street in Hollywood. They were run by young people; they showed young artists. I didn't know the artists there at all; I was quite surprised. On a Monday evening the galleries were all open, and people parked their cars and walked up this street and looked in. It was very pleasant, and it was also a way for artists to meet each other socially each week. In a city like Los Angeles it's difficult to meet people accidentally. In Paris it's easy, but not in Los Angeles. At the top of the street there is that place called Barney's Beanerie; Ed Kienholz made a replica of it later. I went there to look around, and I talked, met, was introduced to people. There were a lot of young artists there about my age and there was a kind of small California pop art school, but I'd never heard of it. The only Californian artists I'd ever heard of before I went there were Richard Diebenkorn and David Park; they were from Northern California and painted in a slightly Bomberg way. Diebenkorn is a marvellous painter and a wonderful draughtsman; marvellous drawings always. He's always underplayed in America.

California themes The very first picture I painted there was *Plastic Tree Plus City Hall* and the second was 103
California Art Collector, and then *Ordinary Picture* which still has curtains. 96, 101

After I'd been there a couple of months, Kasmin came out on his first visit to California, to see me and some collectors. I went with him to visit the collectors. I'd never seen houses like that. And the way they liked to show them off! They were mostly women – the husbands were out earning the money. They would show you the pictures, the garden, the house. So then I painted a picture, *California Art Collector*, in February 1964: it's a lady sitting in a garden with some art; there was a Turnbull sculpture. There was a lot of sculpture by Bill Turnbull; somebody'd been and sold them there a few years before. The picture is a complete invention. The only specific thing is the swimming pool, painted from an advertisement for swimming pools in the Sunday edition of the *Los Angeles Times*. The houses I had seen all had large comfortable chairs, fluffy carpets, striped paintings and pre-Columbian or primitive sculptures and recent (1964) three-dimensional work. As the climate and the openness of houses (large glass windows, patios, etc.) reminded me of Italy, I borrowed a few notions from Fra Angelico and Piero della Francesca.

I got into work straight away. By this time I had met Christopher Isherwood and we instantly got on. He was the first author I'd met that I really admired. I got to know him and Don Bachardy, whom he lives with, very well; they would invite me out, take me around to dinner; we had marvellous evenings together. Christopher is always interesting to talk to about anything and I loved it, really loved it. I don't know how it was that we hit it off, but we did. It wasn't only that we were English, but we were both from northern England. I remember Christopher later said Oh David, we've so much in common; we love California, we love American boys, and we're from the north of England. Of course Christopher's from the opposite side of the north of England: his family was quite rich, mine is working class.

I went to visit the place where *Physique Pictorial* was published in a very seedy area of downtown Los Angeles. It's run by a wonderful complete madman and he has this tacky swimming pool surrounded by Hollywood Greek plaster statues. It was marvellous! To me it had the air of Cavafy in the tackiness of things. Even Los Angeles reminded me of Cavafy; the

hot climate's near enough to Alexandria, sensual; and this downtown area was sleazy, a bit dusty, very masculine – men always; women are just not part of that kind of life. I love downtown Los Angeles – marvellous gay bars full of mad Mexican queens, all tacky and everything. The *Physique Pictorial* people get men, boys, when they've just come out of the city gaol: Do you want to earn ten dollars? Take your clothes off, jump in the pool, that sort of thing. They're all a bit rough-looking, but the bodies are quite good. The faces are terrible, not pretty boys, really. I must admit I have a weakness for pretty boys; I prefer them to the big, butch, scabby ones. I was quite thrilled by the place, and I told the guy. I bought a lot of still photographs from him, which I still have.

Iowa In the summer I went to teach at the University of Iowa in Iowa City. I didn't know where it was; it was my first experience of the American interior. They offered something like fifteen hundred dollars for six weeks' teaching. So I agreed to go and I drove off there. I drove all through New Mexico, Oklahoma, Kansas. I kept picking up hitchhikers. And I went up to Chicago and back to Iowa, and when I arrived in Iowa City I drove straight through it; I thought it was just a suburb. Iowa City, city, c-i-t-y equals big place; but in America it doesn't. It's an extremely small university town three hundred miles west of Chicago and it's difficult to lead an interesting life there not connected with the university. I worked on four or five pictures there, only one of them having anything to do with the place.

The landscape of Iowa is rather boring. It is very flat with occasional undulating hills and most of the towns have the same kind of wooden buildings. The most exciting aspect of the landscape I saw were thunderstorms – some of them very electrical, but almost all with fast-moving clouds rapidly changing shape and colour. I taught a painting class and they gave me a studio and I painted several pictures, all in six weeks: *Iowa, Arizona, The Actor, Cubist Boy with Colourful Tree* and *Man Taking Shower in Beverly Hills*. I'd begun that, I'd drawn it out in Los Angeles, and I'd taken it off the stretcher and rolled it up and put it in the car. I had already done *Boy About to Take a Shower* in Los Angeles; the figure in it is an invention but based on observation of athletic American young men. It was painted early in 1964 (but finished in Iowa City) and still contains ideas about curtains. I called the style 'cubistic' as it's a conceptual, not perceptual, drawing. 108, 111, 109, 110, 97 105

Americans take showers all the time – I knew that from experience and physique magazines. For an artist the interest of showers is obvious: the whole body is always in view and in movement, usually gracefully, as the bather is caressing his own body. There is also a three-hundred-year tradition of the bather as a subject in painting. Beverly Hills houses seemed full of showers of all shapes and sizes – with clear glass doors, with frosted glass doors, with transparent curtains, with semi-transparent curtains. They all seemed to me to have elements of luxury: pink fluffy carpets to step out on, close to the bedrooms (very un-English that!). The figure and tiles in *Man Taking Shower in Beverly Hills* are painted from a photograph taken by the Athletic Model Guild, a group of Los Angeles photographers who do studies of the male nude. The idea of painting moving water in a very slow and careful manner was (and still is) very appealing to me. I had great difficulty in painting the figure's feet and, although the plant in the foreground was a definite early part of the composition, I did take a rather easy way out by bending the leaves to cover his feet.

I was also doing life drawings of people, models. I took very few photographs; they were mostly polaroid and I had them in albums. But I wasn't consciously taking photographs in order to use them for painting. In a way, I did what I do now. I use photographs for reference; it's difficult to paint from photographs. If you haven't taken the photograph yourself, you can only do something imaginative with it. If you took it, at least you can remember, you're only

using it to jog your memory, make a note of a shape. To draw from photographs is impossible, I think. They don't have enough information. If you look at any photograph of a face, there's no real information.

Swimming pools The first reference to a swimming pool is in *California Art Collector*. I had made a few drawings of swimming pools in California, and after Iowa I went back to California for a couple of months and made some more drawings there. I went with Ossie Clark, who had started at the Royal College of Art when I left – I knew him already from Notting Hill. He'd come over to America for the first time, and I took him to California. We saw the Beatles' first performance in the Hollywood Bowl, on their first trip to America. I did a lot of drawings there, including ones of the squiggly things on the swimming pools. And then I came back to England near Christmas in 1964 and the first thing I did was *Picture of a Hollywood Swimming* 119 *Pool*, from a drawing. I painted it in England. The method of depicting water was influenced by the later abstract paintings of Dubuffet and Bernard Cohen's spaghetti pictures. I thought, here is a way to do water. The idea of leaving a border of virgin canvas round the image was, in retrospect, a timid one. It makes the picture look more like a painting (you're even less likely to trip up and fall into the pool), which was an essential premise in advanced painting at that time. I have never thought my painting advanced but in 1964 I still consciously wanted to be involved, if only peripherally, with modernism.

In the swimming pool pictures, I had become interested in the more general problem of painting the water, finding a way to do it. It is an interesting formal problem, really, apart from its subject matter; it is a formal problem to represent water, to describe water, because it can be anything – it can be any colour, it's movable, it has no set visual description. I just used my drawings for these paintings and my head invented. Later on, when I returned to more swimming pools – and they're painted in a different way – I took photographs of water. Because the problems I was facing were formal, all the other paintings in a sense became more formal. The still lifes which followed were very formal. Those were the problems which preoccupied me then, much less literary ones than before. There are very few literary references in this period, even in the prints, until the Cavafy etchings. My 'formalist' preoccupations began with real problems: how do you depict something? But the still lifes make references to other formalist art. I believe that the problem of how you depict something *is* a formal problem. It's an interesting one and it's a permanent one; there's no solution to it. There are a thousand and one ways you can go about it. There's no set rule.

At the beginning of 1965 I painted *Two Boys in a Pool, Hollywood* and a picture called 123 *California*. I also did *Different Kinds of Water Pouring into a Swimming Pool, Santa Monica*: 122, 127 different ways of representing water diagrammatically observed. It offered an opportunity for abstraction – almost as much a recurring desire as painting a portrait.

Still lifes And then I began the still lifes: *Picture of a Still Life, Blue Interior and Two Still Lifes,* 133, 134 *Monochrome Landscape with Lettering* and *Portrait Surrounded by Artistic Devices*, based on 130, *137* a drawing of my father. The 'artistic devices' are images and elements of my own and other artists' work and ideas of the time. In *Monochrome Landscape with Lettering*, I made a painting of a monochromatic landscape and then felt it needed a clear title with lettering on the picture. I had left a frame around the image and I felt that the area not covered by paint needed definition; hence the title. I did title the frame 'Monochrome Landscape with Lettering and Frame', and originally intended to put lettering on the wall – 'Wall with Monochrome Landscape with Lettering and Frame' – but I realized I had to stop somewhere, otherwise it could have finished up 'England, London, Bond Street, Kasmin Gallery, Wall with Monochrome Landscape with Lettering and Frame'. Simple comment can be taken too far.

100

All these paintings were, in a way, influenced by American abstractionists, particularly Kenneth Noland, whom I'd got to know through Kasmin who was showing him. I was trying to take note of those paintings. The still lifes were started with the abstraction in mind, and they're all done the same way as Kenneth Noland's, stained acrylic paint on raw cotton duck, and things like that.

Then I went back to America. First I went to teach at the University of Colorado, in Boulder, which is an attractive campus on the edge of the Rocky Mountains. I was given a studio that had no window to look out of, no windows to view the Rocky Mountains. Not being able to see them reminded me of *Flight into Italy – Swiss Landscape*. Here I am surrounded by these beautiful Rocky Mountains; I go in the studio – no window! And all I need is a couple of little windows. So I painted *Rocky Mountains and Tired Indians*. The whole picture is an invention 128
from geological magazines and romantic ideas (the nearest Indians are at least three hundred miles from Boulder). The chair was just put in for compositional purposes, and to explain its being there I called the Indians 'tired'. In the bird there's a bit of illusion; it's a wooden bird. *English Garden* was also painted in Boulder from a photograph of topiary work in England 129
that I found in American *Vogue*. As it was painted at the same time as *Rocky Mountains and Tired Indians*, some students thought it was a picture of Indians squatting on a lawn. I also painted then *A Realistic Still Life*, *A More Realistic Still Life* and *A Less Realistic Still Life*. I'd 135, 138, 136
become interested in the still life or the arrangements of still life. The idea grew from the curtain motif of previous pictures. The reasoning went something like this: curtains are associated with theatricality; visually the theatre is an arrangement on a stage of figures and objects; the traditional still-life painting in art schools (based on Cézanne) is usually an arrangement of apples and vases or wine bottles on a tablecloth, perhaps a curtain in repose. Remembering that Cézanne had said everything can be reduced to a cone, I conceived the idea of inventing some still lifes. The first, *A Realistic Still Life*, is a pile of cylinders, made more realistic by the suggestion of shadow and other elements to create space, or a real space in Cézanne's sense. The second is *A More Realistic Still Life*, which contains more recognizable objects: the traditional apples, simple flowers, a crumpled cloth and a drape behind. The third painting, *A Less Realistic Still Life*, reduced the elements and illusions to much more simple terms, producing what I think of as my most abstract picture. I must admit that the dubious acrobatics of the reasoning were of great appeal at the time.

Meanwhile in New York I'd had my first exhibition. They sold all the pictures; they were still a thousand dollars apiece, or less. Then I went back to California with Patrick Procktor, who had gone to teach in Iowa. We stayed in a little house in West Los Angeles. I didn't do any painting there, but I did a series of prints. I was asked by Ken Tyler to do some lithographs, *A Hollywood Collection*, at Gemini, which was behind a frame-maker's shop, and that's why I 139–44
did the frames as part of the prints.

A sad story At the end of 1965 I had to go back to London for a show at Kasmin's. About a week before I left Hollywood I met in a gay bar a ravishingly beautiful boy. It was lust on my part, sheer lust, and I thought, fantastic! And I took him home that night. It seemed unfair that I should meet him just as I had to leave because of the exhibition; I had to get all the pictures back. So I said Why don't you come to England? He'd never left California before. So he went and got a passport. Robert Lee Earles III was his real name, Bobby Earles, and he was beautiful, a real Hollywood, California boy, blond hair, marvellous. We drove off with Patrick in this big car to New York. Patrick and I kept having rows on the way. He said You've gone mad, David, you're crazy. I said Never mind, we'll make up for it at night, it's all all right. And in New York – Bob, who'd never been there before, didn't like it at all; he thought it was terrible. But I

thought, you're going to love Europe. We came over on the *France*, and Kasmin and a few friends came to meet us at Waterloo Station and we had this big welcome. You don't do it now; people just walk off a plane. But when you come on a boat and it's taken you six days, you feel you've come from Australia. The first night we were back here, Kasmin said Come to a club that's opened in Jermyn Street. And I went with Bobby Earles and just by chance Ringo Starr sat at the table next to him. Bob thought that's what you should expect in London when you came there, that, naturally, he'd meet the Beatles; and I was amazed about all this. He was very dumb; really very dumb. He'd no interest in anything at all; have some sex and that's it; absolutely no interest; all he was interested in, really, was Hollywood bars. After a week I said I think you should go back; I'll give you your ticket to go back. And I put him on a plane and sent him back. There is a drawing, called *Bob, 'France'*, of a marvellous beautiful 151
pink bottom, and that's really all he had in his favour, I suppose. But he's dead now; he died later on. Sad thing. I saw him for a year or two when I went back to California. He was a go-go boy dancing at a bar on Laguna Beach – and a few years later he took an overdose of drugs; tragic. He was a sweet boy and I felt very sad.

Atlantic Crossing was painted when I got back. Crossing the Atlantic by boat can be quite 131
exciting, although the view is very similar to crossing the Pacific Ocean, or the Indian Ocean, or the South China Sea, or the North Sea. Nevertheless, I felt challenged by all that water and the clouds. Crossing the Atlantic by aeroplane, the view appears like a white bubbly sea, just as monotonous but a different colour. Trying to fuse this visual experience with other ideas on Atlantic crossings forms the basis of the picture. At the same time I painted two theatrical pictures: *A Painted Landscape* (or *Red and Blue Landscape*) and *A Theatrical Landscape*. 132

The Cavafy etchings I began the Cavafy prints at the beginning of 1966, but I'd been planning the Cavafy book for 157–69
some time. I wanted to do it also, perhaps, to counteract all that formalism in my recent pictures. I probably decided Now we'll stop painting for a bit and do some prints.

I went to see John Mavrogordato who had done the first English translations. I found out he was living in London, in a little house near Harrods. He was very old then. And his wife said Whatever you want from him you must get it in writing because he's got a very bad memory. That was not quite the truth. He had an appalling memory. He forgot what the beginning of a sentence was by the time he got to the end. He was amazing; you couldn't cope with it. I'd explain what I wanted, then he'd go over to get a book, then he'd forget who I was and what I was doing there. And I'd do it again, and I realized Oh my god, this is hopeless, and he'd mumble on and on about Harold Macmillan because *he* wouldn't re-do his book. I said It wasn't published by Macmillans. He said Oh yes. It was published by the Hogarth Press and he'd got it wrong. I realized I couldn't get anything from him. And that's when Stephen Spender mentioned some new translations.

I went to Beirut in January 1966 just to get atmosphere and drawings for the prints. And I found more in Beirut than in Alexandria because when I went to Alexandria all the Europeans had left. I thought Beirut was more like Alexandria would have been when Cavafy was there: cosmopolitan, different groups of people, French and Arabic. I know there's not much Greek population, but I thought it would be better to go there. I went for two weeks and did drawings of buildings, people. I walked through all the seedy bits of Beirut, picking up things. It was very good.

So then I began work on the etchings. I did about twenty, but only thirteen were used. And that was the first time I worked with Maurice Payne as an assistant who prepared all the plates for me; it was easier to do than *A Rake's Progress*. It took about two or three months

and at the same time I did the sets and costumes for Alfred Jarry's *Ubu Roi*. I worked on both 170–6 at the same time, and that's why there are no paintings from 1966 until the summer, until I went back to California. I meant to do quite a number of other Cavafy poems as well as the ones finally included in the book. I also meant to do 'Waiting for the Barbarians'. They weren't originally going to be, as they turned out, mostly homosexual poems; I think one day I'll do the others. I keep thinking one day I'll do a painting or two from Cavafy poems.

After finishing the Cavafy etchings I went back to California, to teach at UCLA. I wasn't sure how long I was going back for. In the end I stayed just over a year – except for four weeks in London for the opening of *Ubu Roi* at the Royal Court – and I taught for only six weeks. I drove across to California from the East Coast in a little sports car I'd bought in England, and as I got further and further west I became more and more excited, imagining my class would be full of young blond surfers. Unfortunately, most of the people who signed on were housewives. It was supposed to be an advanced class, but I could never tell the difference between the advanced students and the beginners. Then quite by accident a young attractive boy came in. I immediately made him sign on and befriended him. He seemed very talented as well. He told me his name was Peter Schlesinger.

Ubu Roi was the first of the two things I've designed for the stage – the second was Stravinsky's *The Rake's Progress*, in 1975. I was asked by the director of *Ubu Roi*, Ian 408 Cuthbertson, if I'd design it. I knew Alfred Jarry a little bit; I'd even read the play before, but I didn't really remember too much about it. So I agreed to do it when I read it again. You can invent lots of things because Jarry gives lots of instructions: Don't bother about scenery, just put a sign up saying 'Polish Army'; and that really appealed to me. And some of the sets are just like that. The Polish Army was just two people, and we tied a banner round them, and it just said 'Polish Army'. It was fun doing it. Compared to *The Rake's Progress* later, it was much simpler, a simpler concept.

When I was asked to do it, I remember I put up a little resistance, saying I didn't think I could. After all, in paintings before that I had been interested in what you might call theatrical devices, and I thought that in the theatre, the home of theatrical devices, they'd be different, they wouldn't have quite the same meaning as they do in painting, they wouldn't be contradictory – a theatrical device in the theatre is what you'd expect to find. So I agreed to do it without knowing how to do it. I made drawings. I took each scene and made a drawing of it. They worked from those.

The concept was basically very simple: little painted backdrops, much smaller than the stage. They were like big paintings, about twelve feet by eight feet. They dropped down with big ropes on them, like a joke toy theatre, and on one of them there was a big rope falling down the side on to the stage. I said Why have you put that there? And they said It's in the drawing. And in the drawing I'd drawn a line like that and then corrected it to draw the straight edge. My god, they're just so literal, I couldn't believe it. But then I realized that's how scene painters work; they just copy exactly what you do. It was very enjoyable, working on the play. I did the costumes. It was a thing where you could invent all kinds of things. For instance, for the parade ground, when the characters came on, they each carried a big letter, and they put them down on the stage, and it spelt 'Parade Ground'. This was consistent with Alfred Jarry saying Don't bother about scenery.

When *Ubu Roi* was finished I rushed back to California. The first big painting I started then was the portrait called *Beverly Hills Housewife*. I also began *Sunbather*, which has a different 187, 146 kind of water, the idea of the sun shining through water. I used the rainbow colours: violet, yellow, the yellow dancing line on it. I also started drawing then, drawing more and more,

from life. The one thing that had happened in Los Angeles – it had started two years earlier – was that I had begun to paint real things I had seen; all the paintings before that were either ideas or things I'd seen in a book and made something from. In Los Angeles I actually began to paint the city round me, as I'd never – still haven't – done in London, which doesn't mean much to me, I don't think. This led up to much more naturalistic portraits later, so in that sense it was quite a big change. It was a mixture, of course, because some of the paintings weren't done like that, they were simply from imagination. But by 1966 it had begun to dominate. In *Beverly Hills Housewife* I did a specific portrait and a specific house, a real place that looks like that. I worked from drawings and photographs. In *Sunbather* I took a photograph of dancing water and the sunbather is painted from a magazine picture.

Water in swimming pools changes its look more than in any other form. The colour of a river is related to the sky it reflects, and the sea always seems to me to be the same colour and have the same dancing patterns. But the look of swimming-pool water is controllable – even its colour can be man-made – and its dancing rhythms reflect not only the sky but, because of its transparency, the depth of the water as well. So I had to use techniques to represent this (in the later swimming-pool pictures of 1971 I became more aware of the wetness of the surface). If the water surface is almost still and there is strong sun, then dancing lines with the colours of the spectrum appear everywhere. If the pool hasn't been used for a few minutes and there's no breeze, the look is of a simple gradation of colour that follows the incline of the floor of the pool. Added to all this is the infinite variety of patterns of material that the pool can be made from. I once saw a pool in France where the floor had been painted with loose blue brush strokes, which gave a marvellous contrast between artistically rendered water and the natural. As yet I've not been tempted to do anything with that.

After *Sunbather* I did *Portrait of Nick Wilder*, which I began early in 1966. I had Mark *147* Lancaster take pictures of Nick in the pool like that; I got Nick to pose with just his head coming out of the swimming pool and Mark had to go in the pool to take the pictures. I just painted it. I think this was about the first absolutely specific portrait I'd painted for many years, since being a student in Bradford probably. There'd been portraits but they weren't of real people. I'd come to the conclusion I could now do a specific portrait.

Realism turning into naturalism

To me, moving into more naturalism was a freedom. I thought, if I want to, I could paint a portrait; this is what I mean by freedom. Tomorrow if I want, I could get up, I could do a drawing of someone, I could draw my mother from memory, I could even paint a strange little abstract picture. It would all fit in to my concept of painting as an art. A lot of painters can't do that – their concept is completely different. It's too narrow; they make it much too narrow. A lot of them, like Frank Stella, who told me so, can't draw at all. But there are probably older painters, English abstract painters, who were trained to draw. Anybody who'd been in art school before I had must have done a considerable amount of drawing. To me, a lot of painters were trapping themselves; they were picking such a narrow aspect of painting and specializing in it. And it's a trap. Now there's nothing wrong with the trap if you have the courage to just leave it, but that takes a lot of courage, if you look back in the history of painting.

The traps

In Paris in 1974 they had a Juan Gris exhibition; he was a cubist who came after Picasso and Braque, and he did marvellous things. But Picasso by 1923 had abandoned cubism and reverted to his classicism. It's easy to see why he abandoned it now, but at the time, it wouldn't be. And a man who had developed this complex, sophisticated art just felt, it's been exploited, done enough; and looking back now you can see he was right. Juan Gris went on

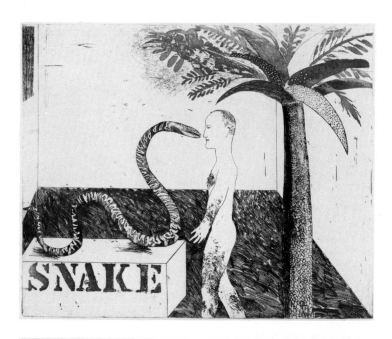

98 *Jungle Boy* 1964
99 *The Acrobat* 1964
100 *Edward Lear* 1964

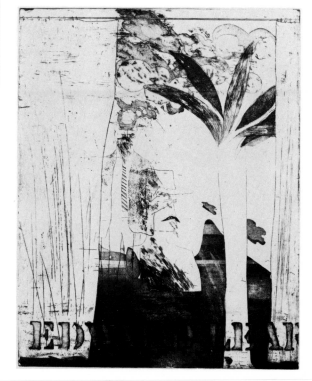

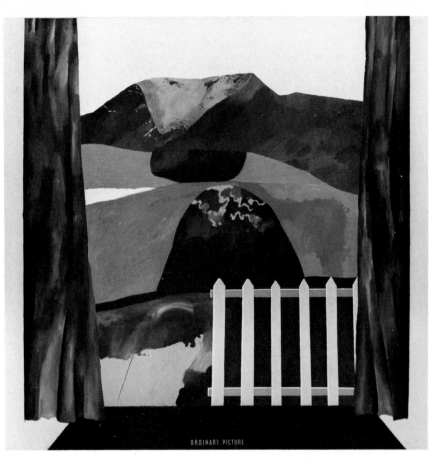

101 *Ordinary Picture* 1964
102 *California Bank* 1964
103 *Plastic Tree Plus City Hall* 1964

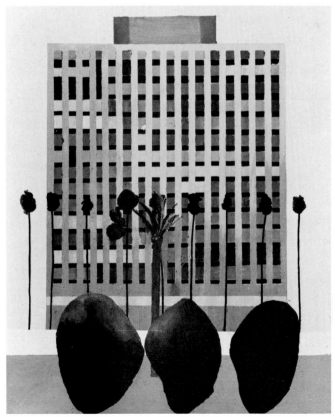

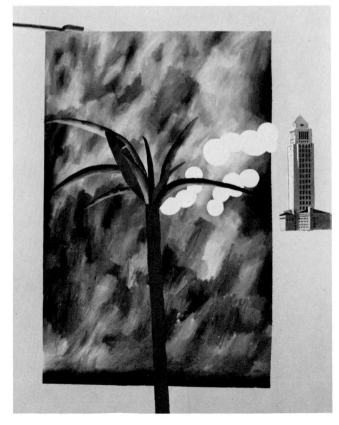

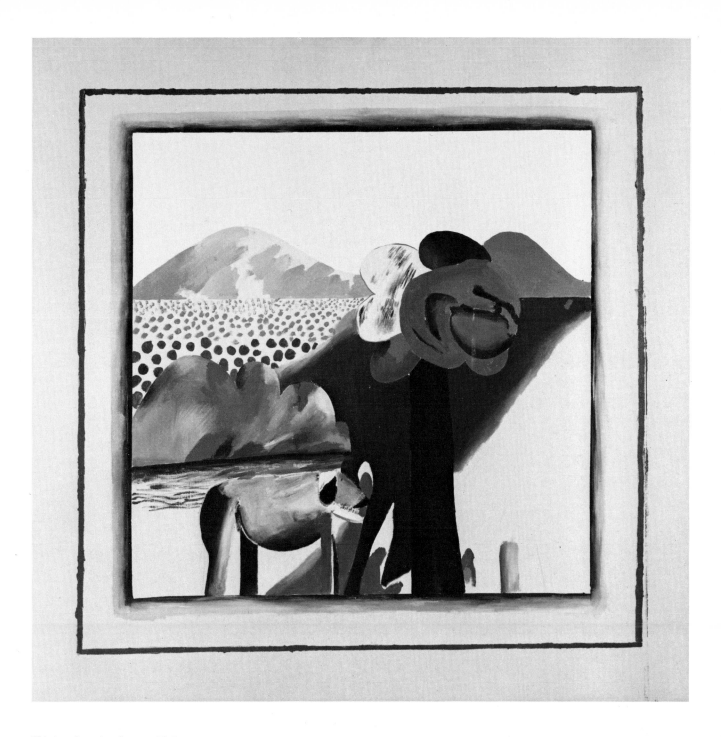

104 *Imaginary Landscape with Dog* 1964

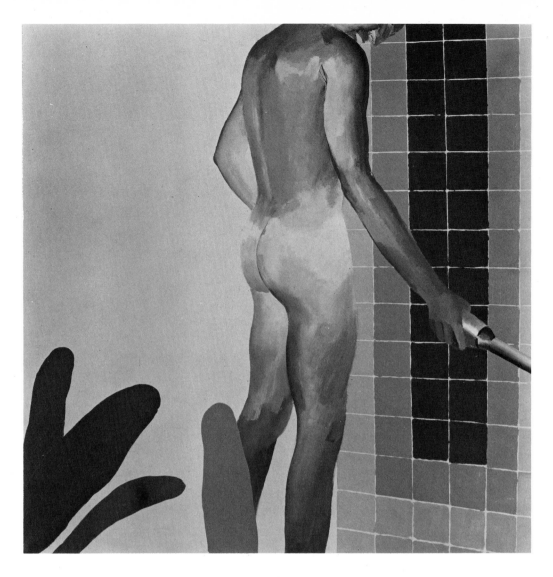

105 *Boy About to Take a Shower*
1964

106 *Beverly Hills Shower* 1964

107 *Man Taking Shower* 1965

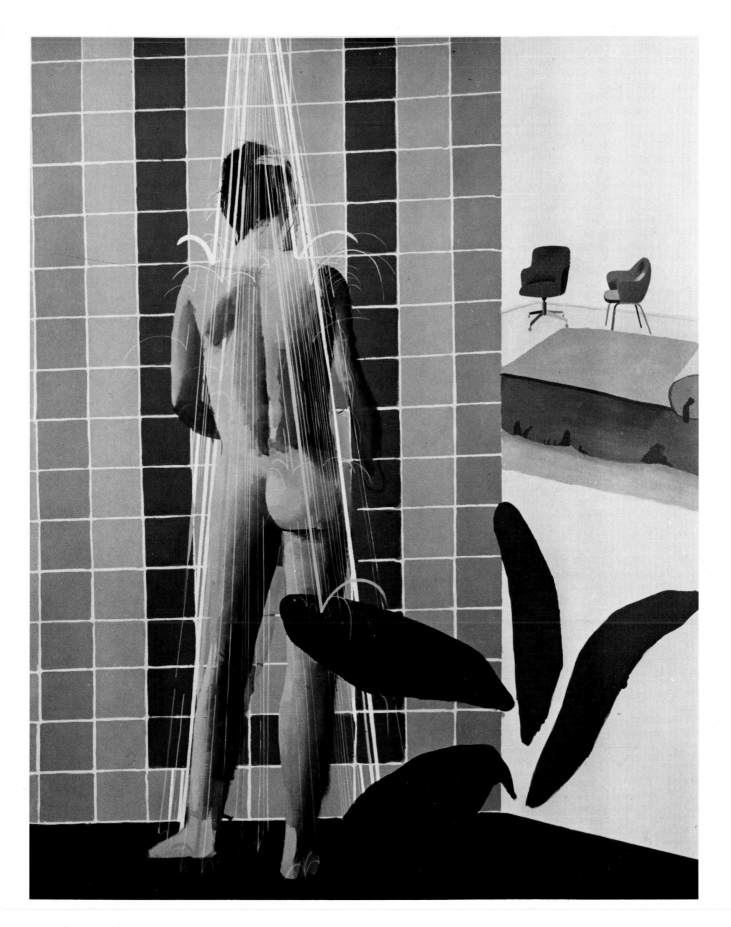

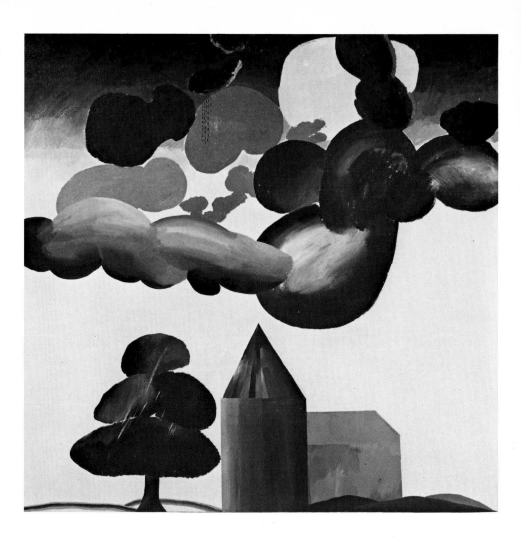

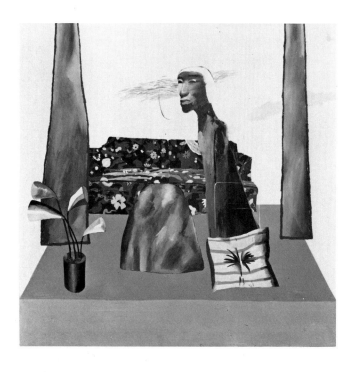

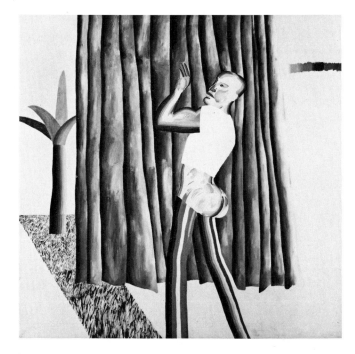

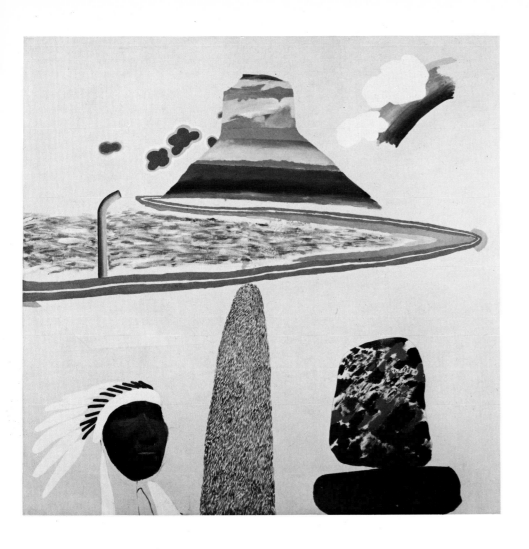

111 *Arizona* 1964
112 *American Cubist Boy* 1964

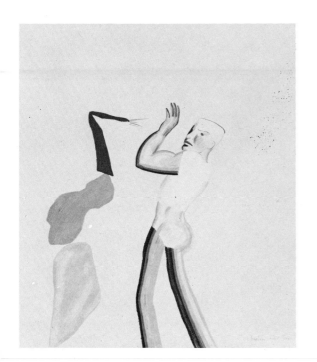

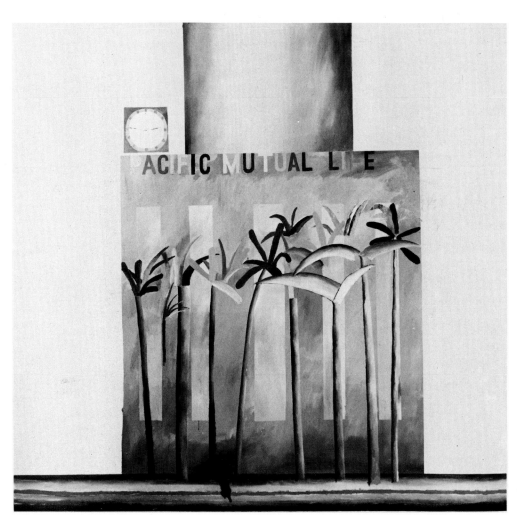

113 *Building, Pershing Square, Los Angeles* 1964

114 *Pacific Mutual Life* 1964

115 *Pershing Square Study I* 1964

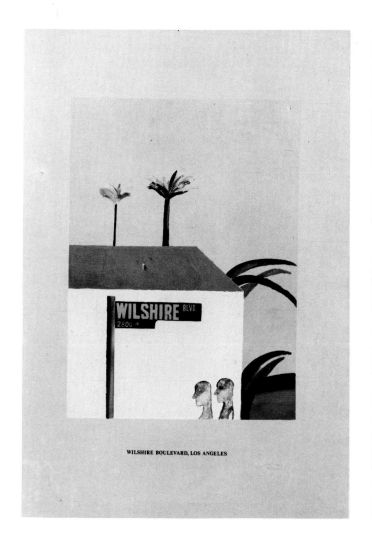

WILSHIRE BOULEVARD, LOS ANGELES

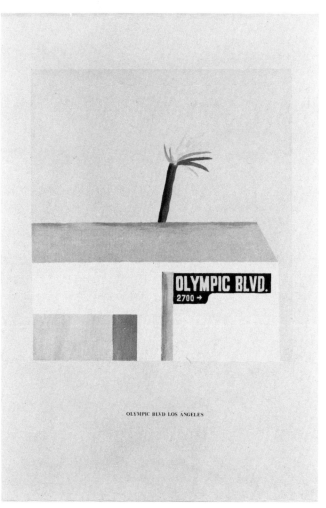

OLYMPIC BLVD LOS ANGELES

116 *Wilshire Boulevard, Los Angeles* 1964
117 *Olympic Boulevard, Los Angeles* 1964
118 *Washington Boulevard* 1964

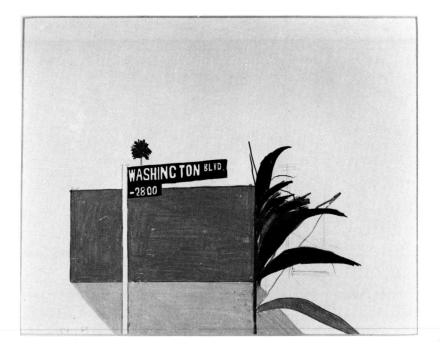

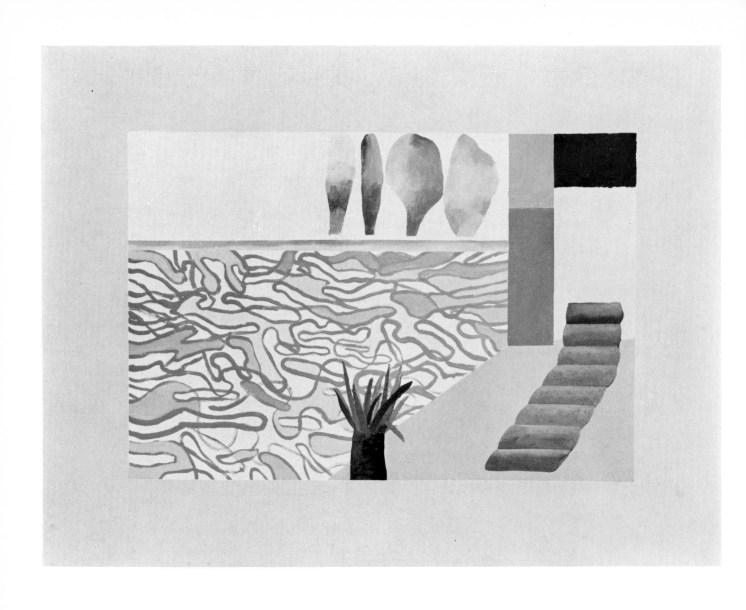

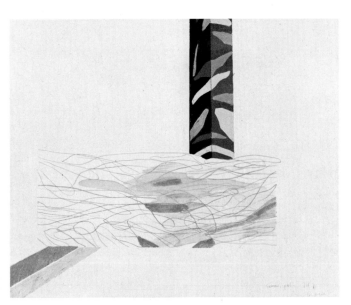

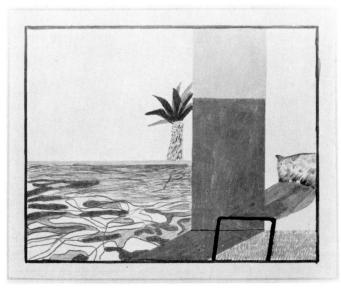

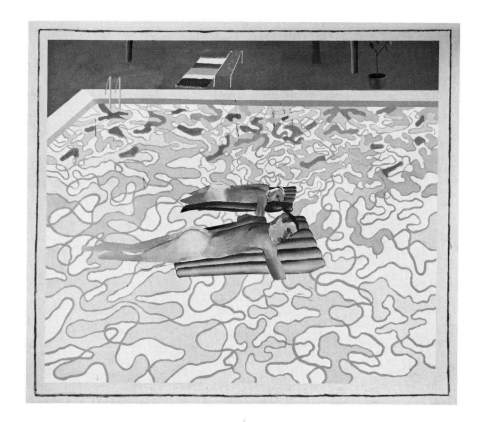

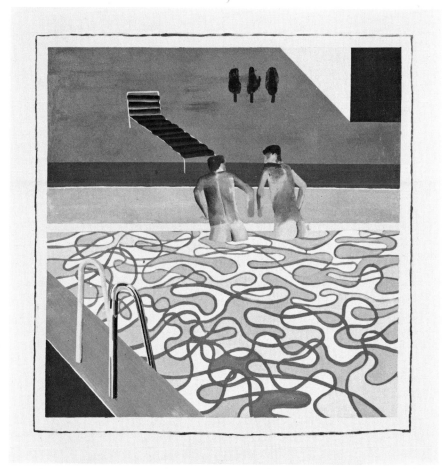

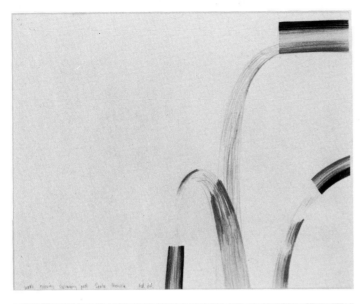

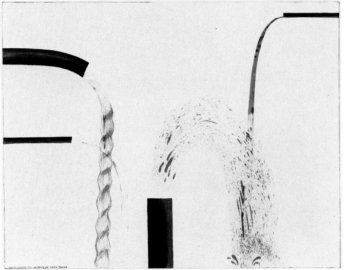

124 *Water Entering Swimming Pool, Santa Monica* 1964

125 *Water Pouring into Swimming Pool, Santa Monica* 1964

126 *Striped Water* 1965

127 *Different Kinds of Water Pouring into a Swimming Pool, Santa Monica* 1965

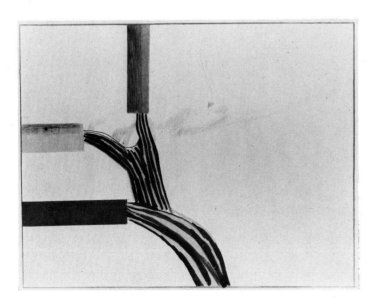

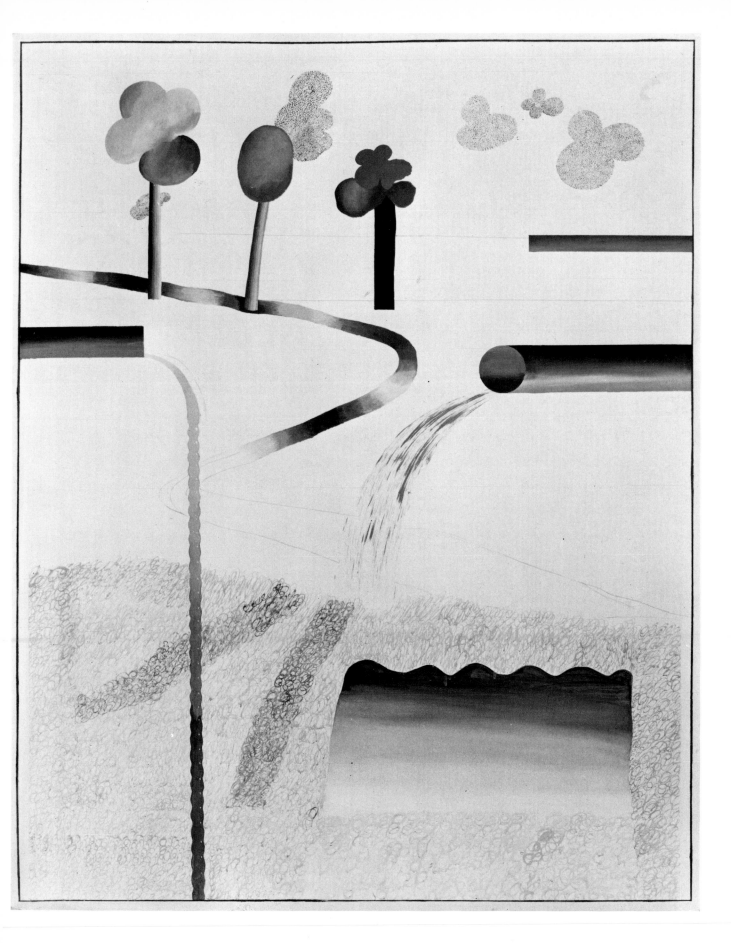

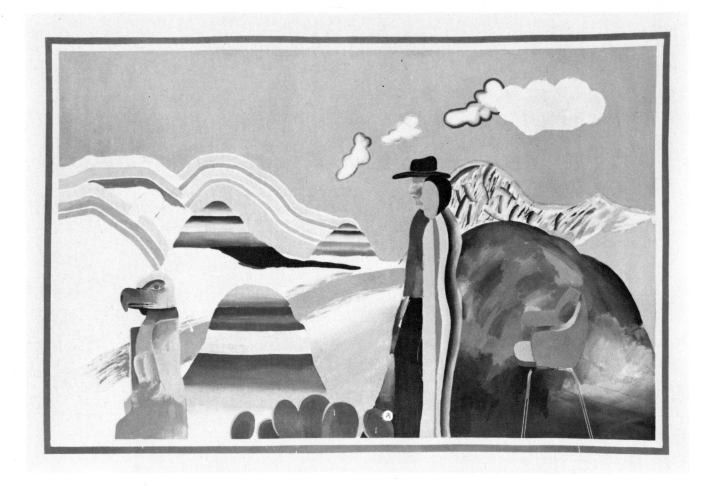

MONOCHROME LANDSCAPE WITH LETTERING

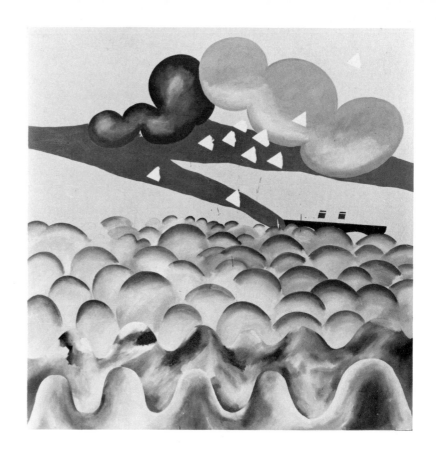

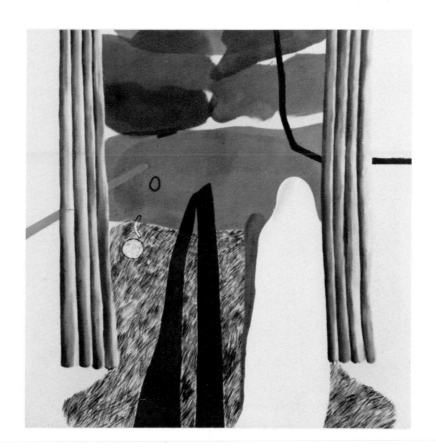

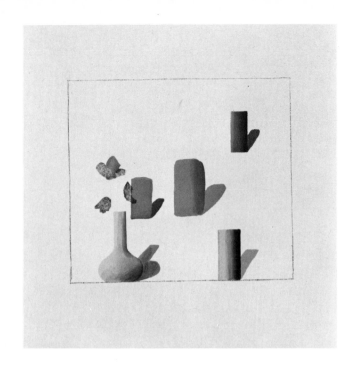

 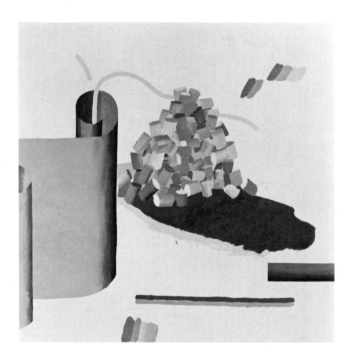

133 *Picture of a Still Life* 1965

134 *Blue Interior and Two Still Lifes* 1965

135 *A Realistic Still Life* 1965

136 *A Less Realistic Still Life* 1965

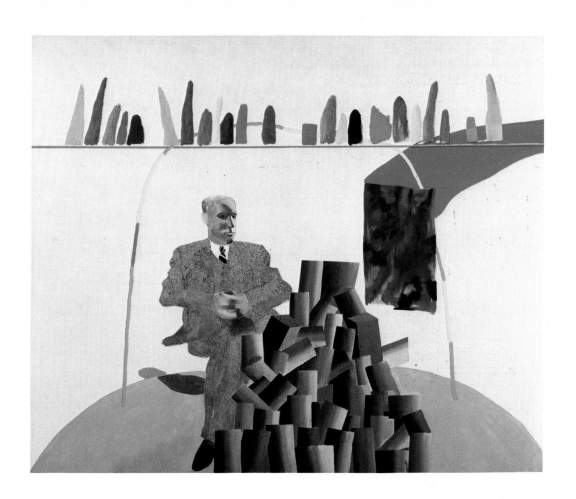

137 *Portrait Surrounded by Artistic Devices* 1965
138 *A More Realistic Still Life* 1965

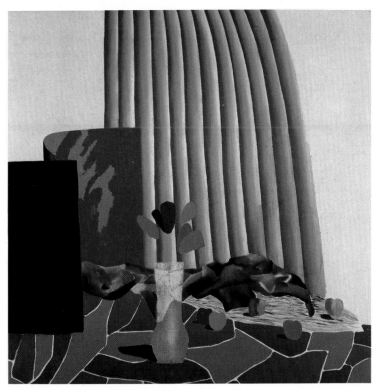

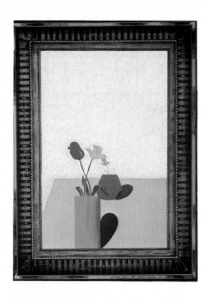

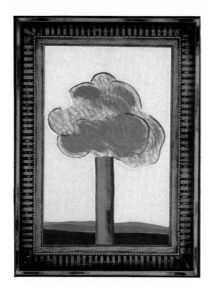

A Hollywood Collection 1965

139 'Picture of a Still Life that has an Elaborate Silver Frame'

140 'Picture of a Landscape in an Elaborate Gold Frame'

141 'Picture of a Portrait in a Silver Frame'

142 'Picture of Melrose Avenue in an Ornate Gold Frame'

143 'Picture of a Simply Framed Traditional Nude Drawing'

144 'Picture of a Pointless Abstraction Framed under Glass'

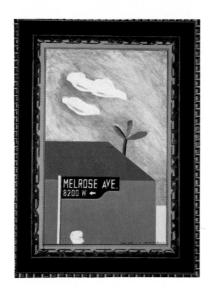

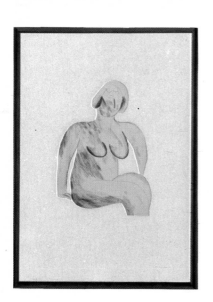

with cubism a bit longer and then he died. As you went through the exhibition and you got towards the end you could see how he too had exploited it all. He was drying up and was in the process of trying to get out. If he'd lived he probably would have managed to. He happened to die. It's a pity; at the end the paintings aren't as good. He just happened to die in that down period when he was sorting it out, and obviously he was not a man of Picasso's stature. Picasso had the courage anyway, and said I'll quit this; and when he quit, what he returned to was so staggering: classicism! When Stravinsky returned to classicism for similar reasons, people always said He's betraying it; because they didn't really understand what the thing was about. Well Picasso can do that, but lesser artists can't. They get trapped. And in the end the only way, probably, to get out is just to make a complete change, stop, and just think again. When you stop doing something, it doesn't mean you are rejecting the previous work; that's the mistake; it's not rejecting it, it's saying I have exploited it enough now and I wish to take a look at another corner. If the break, the change, is motivated by confidence, then it's true; you just go on. If the break is from lack of confidence, it's just a break. I get into traps; any artist will get into traps. You just begin to feel it. Sometimes it's easier than at others to get out of them.

The new academies The very term academic is not about a style; it's really about attitudes, a drying-up, and sterility. I have always had a fear of repetition; it's why I've hardly ever worked in what you could call a series. I have done a few things using the same motif, but it's very rare that there's more than three, and I like to think that was to exhaust an idea. But doing variations on a theme doesn't appeal to me; I think it's too easy. Any visually competent person could take six shapes and do a hundred variations on them, easily; and I think it's all rather pointless. I like variety in pictures. In most of my exhibitions I've tried to have – as in *A Hollywood Collection* – one of a different subject. The idea of doing a whole exhibition of swimming pools, for instance, wouldn't appeal to me at all, even though you could do them very differently. And yet people do say Oh, he's a painter of swimming pools. I've in fact only done a very few pictures of swimming pools, if you look at my work as a whole. And in 1971 when I was doing them again, the whole technique was very different. I can see how an artist might want to really exploit a subject, subtly – that's the way to work – to do lots and lots. But the truth is, when you exhibit them all, it just seems too boring. I think it might be interesting for the artist doing them, but for the viewer looking at them it's a different matter.

It's perfectly natural for an artist to like work that he's uninfluenced by. Nowadays, I sometimes complain about abstract painting, but there's lots of abstract painting I have loved. I've not really been involved with it. At times you can't help reacting to a thing – you don't need to be stimulated to want to take those ideas; the ideas themselves are sufficient to give you some aesthetic stimulation. I'm always interested in what's happened in the arts. If you're an artist and you're aware of art, you can't avoid it, really. There are odd painters who ignore it, but I don't think I could. There are times when I certainly ignore a great deal of it because I'm too interested in something else that's not a part of that art scene. The whole idea of conceptualism in art hasn't interested me much at all; there's been very little influence from it on my work.

But for the kind of person I am, the influence of people around me is unavoidable. Painters often use their family as models, as a subject round them. If you feel about it, and it's possible to express your feelings in a visual way. . . . Like when I met Peter Schlesinger and he became a subject in paintings almost straight away.

In 1967 I went to Berkeley for ten weeks; I was living in Los Angeles. In Berkeley I stayed in a hotel room, because they gave me a studio, and I just taught on Tuesday, Wednesday and

Thursday afternoons. I'd often fly back to Los Angeles; Peter was at UCLA. I'd fly back to Los Angeles on a Friday, come back to Berkeley on the Monday. In Berkeley I painted a picture called *The Room, Tarzana*. The source of the picture originally was a photograph in the *San Francisco Sunday Chronicle*, a colour photograph of a room; just an advertisement for Macy's. The photograph caught my eye because it was so simple and such a direct view, although it's got angles in it. For me it's a slightly rare picture because I'm not a great user of the diagonal – usually I use strong horizontals. In this photograph there were strong diagonal lines all over the place, but it was so simple and beautiful, I thought, it's marvellous, it's like a piece of sculpture, I must use it. And of course I must put a figure on the bed, I don't want it just empty, so I'll paint Peter lying on the bed. The picture is a direct transcription of the photograph. I had Peter come up to Berkeley and I laid him on a table at the same angle. It

The source of light was the first picture in which I'd taken any notice of light, shadows. For instance, in *Portrait of Nick Wilder* there are no real shadows, and there are none at all in *A Bigger Splash*. In *Beverly Hills Housewife* there's a hint of shadows; the light is ignored, it's not a subject. In *The Room, Tarzana*, because of this light dancing around, I realized the light in the room was a subject and for the first time it became an interesting thing for me, light. Consequently I had to arrange Peter so the light was coming from the direction of the window. Before, I wouldn't have bothered to think of things like that; I'd just have laid him on the table and drawn him, and it wouldn't have mattered to me whether the shadows went this way or that. I remember being struck by it as I was painting it; real light; this is the first time I'm taking any notice of shadows and light. After that, it begins to get stronger in the pictures: a *contre-jour* in *The Room, Manchester Street*; in *Christopher Isherwood and Don Bachardy* there's a real source of light coming in from the right-hand side; then in the later portraits I'm very careful about the light, I begin to realize where the sources are. And it all became a more and more traditional way of painting a picture. I think it was this, in a way, that led later on to almost excessive naturalism. And I found moving away from *that* harder than moving away from anything else.

In 1966 I did some drawings for the *Oxford Illustrated Bible*. They'd asked a few artists, emphasizing that you didn't have to be a Christian; they didn't expect you to be pious. So I agreed to do it. Mine was the Book of Nehemiah, about the rebuilding of Jerusalem, and the original drawings are done all on one page like a comic strip. I did them quite quickly. They make no references to anything; they're completely made up out of my head. I used Muybridge to help draw figures if there was some difficult pose. They're just simple and direct. My mother, a keen Christian, has them now.

Three splashes *The Little Splash*, which is a tiny painting, about two feet by one foot, was the first of three paintings (the others are *The Splash* and *A Bigger Splash*) painted in 1966 from a photograph I found in a book about how to build swimming pools I found on a news stand in Hollywood. It was a nice little subject, a splash. The little picture was painted quite quickly, probably in two days. And I thought, it's worth making this bigger, doing it a little differently, and so I did a slightly bigger one, *The Splash*, and I took a bit more care with it. But then I thought the background was perhaps slightly fussy, the buildings were a little too complicated, not quite right. So I decided I'd do a third version, a big one using a very simple building and strong light. And I painted it at the same time that I was painting *The Room, Tarzana*, so the idea of the strong light was in my mind, although there are no shadows in the painting; it's very strong Californian light, bold colour, blue skies. I rolled it on with rollers, and the splash itself is painted with small brushes and little lines; it took me about two weeks to paint the splash. I loved the idea, first of all, of painting like Leonardo, all his studies of water, swirling things. And I loved the idea of painting this thing that lasts for two seconds; it takes me two weeks to

188

147
189, 187

205
192

154

193
194

paint this event that lasts for two seconds. The effect of it as it got bigger was more stunning – everybody knows a splash can't be frozen in time, it doesn't exist, so when you see it like that in a painting it's even more striking than in a photograph, because you know a photograph took a second to take, or less. In fact if it's a splash and there's no blur in it, you know it took a sixtieth of a second, less time than the splash existed for. The painting took much longer to make than the splash existed for, so it has a very different effect on the viewer. When we hung *A Bigger Splash* in the Paris exhibition in 1974, I thought it was good. When we hung it on the wall and they were doing the spotlighting – it's marvellous the way you can affect a picture by the way you throw the light on it – I had them point one of the lights right on the splash itself, so it was even whiter; it was really sparkling. It looked very good there. If you have a picture in a very well-lit room, you see the picture better; the more light, the better it is, unless you go too far and the light completely bleaches the colour.

Acrylic v. oil All this time I was using acrylic paint; texture interested me very little. In the earlier oil pictures it had. It interests me more now because I'm painting with oil again, although the only reason I went back to oil was that I got frustrated with acrylic colours. That was partly because of the naturalism. I wanted things to be more naturalistic and acrylic is not really the best medium. When you use simple and bold colours, acrylic is a fine medium; the colours are very intense and they stay intense, they don't alter much. I probably will do some acrylic painting again; it's not that I've abandoned it. But because I'm using oil paint again now, I'm getting interested in texture. You can put oil paint on and manipulate it on the canvas, but you can't do that much with acrylic paint because it dries too fast. It's very difficult with acrylic paint to grade one colour into another. To do that I used to have to do elaborate things. I can remember one time doing a painting of George Lawson and Wayne Sleep, with 392
Mo helping me: all I was doing was painting a wall with the light coming in on the left, so the wall gets darker and darker. I mixed colours for the wall, put them on a palette and walked along going from light to dark, while Mo kept it damp with lots of water sprays; and all the time your one fear is that it'll dry and you'll have to try and blend the other colour in, while keeping it still wet so you can do the next. And you've got to keep going and doing it at such a speed! To paint a wall like this with oils would take you a long time, but it's quite easy. You can work for days and keep altering it as well; you can scrape the paint off if you don't like it. Once acrylic paint is down, you can't get it off. It's that permanent.

I used borders around an image a lot, from about 1964 to 1967. This wasn't just a framing device. It started off as a formal device. I think the first one where the real painted picture is within the border was *Picture of a Hollywood Swimming Pool* in 1964. By 1967 I'd realized that 119
the reason I was using the border was that the pictures had become more fully pictorial; it was a kind of concession to current art. It seemed to me that if I cut that picture off there, it became more conventional, and I was still a little frightened of that then. I abandoned it later because, thinking about it, it seemed cowardly and I felt I should be a bit more honest and accept the fact that the pictures were moving in another direction. When you decide to make a move in painting it's not as though you wake up one morning and decide to make the move. It's very gradual, and often you don't even know you're making the move till you can look back afterwards, probably at two years' work. I tend to work rather slowly; I don't churn out pictures. I think the very most I've ever done in a year is about eighteen. And that was a long time ago.

A Bigger Splash is a balanced composition; it's worked out that way, very consciously. It's an inventive picture. The architecture is very typical southern Californian architecture; you can probably find a building like it anywhere there. But many of my California pictures are

more carefully constructed in an abstract way. For instance, if you've no figures in the picture, then the construction of it is a little easier. *A Bigger Splash* could be considered figurative in the sense that there was a figure who's just gone under the water. The splash must have been made by something; presumably it was made by a figure. But if you take away the chair, for instance, and the reflection in the glass, it becomes much more abstract. You could even take away the glass, and then it becomes even more so; no colour – absolutely flat. I started by drawing those lines across there, and that colour was put on, then *that* colour was put on, then *that* colour was put on, with a roller; and it's subdivided again. It was just about a striped painting. I didn't photograph it at all as it progressed; occasionally I have done that, but I didn't with this one. At the same time I painted another picture: *A Lawn Sprinkler*. This was also rolled out flat. Before the sprinkler was put in, before the windows were put in, it looked at one point exactly like a symmetrical Robin Denny painting. I was consciously making a slight attempt at that, to give it an ironic touch, the way all those buildings are square.

190

Of course all painting, no matter what you're painting, is abstract in that it's got to be organized. No matter what the illusion created, it is a flat canvas and it has to be organized into shapes. In that respect, it's just the same as organizing shapes that don't mean much, that are just literally shapes on a canvas. In *that* sense all painting is abstract; it must be organized. On the other hand, if in the end you go too far with naturalism in painting, there is no need to even organize; just look, as it were, at what's in front of you and paint what you see till the canvas ends. I did that in 1968, to some extent, with that *Early Morning, Sainte-Maxime*, although that was done a little differently, from a photograph I took. I was so impressed with the photograph that I painted it straight and I didn't feel any need to impose myself on it. If you compare the source material for *The Room, Tarzana* and the painting, you can see that I've imposed very little of myself on the painting; but someone else painting that scene or using that same source material would probably finish up with a different mood.

211

Early on, from 1960 to about 1963, I'd draw with the brush straight on to the canvas. When I painted *Domestic Scene, Notting Hill* (1963), the chair, the lamp, the vase, the figure were drawn out in pencil first, and then I filled them in. Starting by drawing on the canvas and then painting is obviously very different from painting straight on to the canvas without a drawing. Once you've done the drawing, you're constructed and you just fill in the colours; that's all you need do if you're ignoring everything else. For instance, if you're painting some flowers on a table, if you're just wanting to paint the flowers and ignore everything else in the room, you make a drawing of them, an outline drawing, and fill it in. But if you're painting the room as well, then filling in is not as easy because you have to relate it; you have to decide on something for a wall, and where you want the wall to be, etc. You have to make many decisions about it. If you're just isolating the object, as I did for example in *Domestic Scene, Notting Hill*, then it's easier, in this sense. The outline is the outer definition of that painted section. There's no question of putting a bit of colour next to the colour of the flower to show it off, because that begins to be a wall or space; And in the case of that particular painting I had the idea I didn't want that. I only wanted to ignore it. So I would draw things out. I forget how I begin pictures, but in any case I began increasingly to draw first before painting. It might have had to do with using acrylic paint; with acrylic paint you must plan a little bit because you can't scrape it off as you can oil paint. At the end of the day, if you didn't like it, you'd have to start with a completely new canvas. But once you start bits of the painting you decide to keep, and you've painted a section, and you think, it's going quite well, or, this is how I want it, yes, it's beginning to appear, it makes you slightly more cautious in other areas.

55

There's no need to be like that with oil paint. You can remove any section of it; you can remove it quite a while afterwards, two months afterwards, with solvent. Acrylic conditions the process; it's limiting, in a way. That's why two years ago I went back to oil paint, which I hadn't used for ten years. And the first four paintings I started in oils I abandoned completely, partly because I was a little rusty, and it only slowly came back to me. I was taught to paint with oil paint in art school. They taught you quite a few things about it, what you could do with it; but you discover most of it for yourself.

There is another technique with acrylic paint that I began to use in 1967 or 1968. It is a technique that was used a lot by American painters, by Helen Frankenthaler and then, later, by Morris Louis, Kenneth Noland. Acrylic paint is diluted with water. If you put a little detergent into this diluted paint, then paint on to unprimed raw cotton duck, the detergent has the effect of breaking up the oil in the cotton, making it much more absorbent, as though you're painting on blotting-paper. The paint spreads and stains right into the canvas, literally staining the canvas and not resting on its surface. You have some control over it. You learn how much detergent to put in; if you put in too much it just goes everywhere, but if you put in too little it's very slow. I learned this technique through Lenny Bocour, in New York, who manufactured acrylic paint, and I realized it was a possible technique for me to use. I really used it on water paintings, literally to paint water with kind of watercolour effects. And to try it out I painted *Two Stains on a Room on a Canvas*. The painting just started with the stains. 203 One is orange and one is blue, and I just literally put them on the canvas – I knew I was going to ignore them and paint a picture round them. Next, working right up to the edge, I gessoed the rest of the canvas so the paint there would be entirely different from the stains. Then I drew this little scene, like a scene in the corner of an art gallery, with a sculpture on the floor. I painted the curtain and the floor, just as though the stains weren't there, except, of course, where the curtain goes behind the stain. In the title, I said *Two Stains*, not *in* a Room, but *on a Room on a Canvas* – playing with words about painting.

I don't think the picture's that interesting, but it was a technique that I later used extensively. I also liked the idea that the eye could sense the difference between this watery effect of the acrylic paint with detergent in it and the effect of acrylic paint painted on a gesso ground. In a sense, this is using texture; the eye can tell there are two distinct textures on the paintings, two very, very distinct things. I'm not sure that that's completely possible in oil paint; I don't think you can quite get these effects. Because of the detergent in the acrylic, it takes three or four hours to dry, but you can, within the washes, manipulate it. For instance, you can put on a wash of blue, as I did in the swimming pools, of a deep blue, and then you can put on washes of lighter blues; or, more easily, dark on light, it's better. You can manipulate it, because it will stay damp for more than an hour, which is long enough to move the shapes about and arrange the painting. *Two Stains* was done at the end of 1967, when I was back in England. It's an absurd painting, it's even a slightly funny painting; but it was my way of making an experiment. I could have made the experiment on a little canvas hung up on the wall and never made a picture of it at all. Even if you're doing a little technical experiment, it's nice to do it in pictorial form, make a picture of it in some way. It tests your powers of invention: How would you do it? how can you do it? Possibly in the future I will do some paintings where I use all kinds of techniques in the same painting, in acrylic paint and oil paint. You can of course begin a painting with acrylic paint, and then you can put oil paint on top, but you can't do it the other way round – once you begin in oil, you can't put acrylic on top. So far I've never mixed them, but I probably will because of that technique; even if you dilute oil paint a great deal with turps, you still wouldn't get the canvas to act like a

blotting-paper. It runs off the edges. Bringing together different technical elements is like my bringing together different stylistic elements. This whole thing about painting having to have unity I find difficult to understand; unity is a vague word, I think – nobody says what they actually mean by it. Unity of subject matter? Unity of paint and texture? Perhaps all pictures are forced to have a unity, in a sense; I mean, all pictures that we accept as pictures, excluding incompetent pictures.

The idea of middle-of-the-road painting horrifies me. What's known as 'modern art criticism' has used the term 'mainstream' for painting; it horrifies me, I must admit. To me, art, especially modern art, is idiosyncratic. The idea of a mainstream is an irrelevant thing. There's something second-rate about the mainstream; there's something too ordinary about the very concept. It's like the middle. In art the peripheries are more interesting. This has, perhaps, placed me in a rather isolated position, though not in complete isolation, because there are painters around who actually agree with me and are very sympathetic – my dear friend and colleague R.B.K. [R. B. Kitaj] for one, and a few other people, like Richard Hamilton. If ever I hear and read of the word 'mainstream', I know it's got nothing to do with me. At times you don't mind being alone; I'm not interested in the mainstream of anything; but there are times when you do feel lonely artistically, perhaps if you're not as confident, for a week or a month. I am a loner, in a sense, as a person. I don't mind being alone and working alone on many ideas. I have a tendency, I think, to just dislike the crowd; if the crowd goes one way, I think my natural instinct says: Go the other way, David. I wouldn't mind if the whole mass of people turned right when I went left. I can cope with being alone; I'm perfectly all right, in fact in a way I may even prefer it. Whether that has anything to do with my rejection of mainstream art I don't know, but that's my instinct. Maybe I'm helped in this by knowing that people, generally, like my work. It's something I occasionally think about now. In the past, I didn't think about it because, of course, I didn't know how many people liked it. I'm now well aware that, in a sense, although I say I'm alone and I'm not connected with the mainstream, I'm quite a popular artist. But I assume it's because my painting works on a lot of levels, that's all. I don't actually give it a great deal of thought. I give it some. No, I don't care. I don't think because one is popular it's necessarily bad; I'm not an elitist snob like that. It's a myth that if you're liked by only four people it must be good. It might also be very bad: they might be your mother, your brother, your uncle and your aunt. I have noticed that, in a sense, I'm a rather difficult artist for what we might call the serious art world to categorize; they never know quite how to do it. Now that, of course, is not my worry. I've no need to categorize my work or give it a name – no artist has. Nobody actually *has* to give one's work a name but people like to, and sometimes people don't know whether even to take it seriously; again, that doesn't worry me. There's no reason why they should lose too much sleep over it. But just occasionally it's a little frightening because, like all artists, you go hot and cold with confidence; sometimes you have real doubts all the time. I'm always having doubts; they're always there and I assume they always will be. You're always wanting to improve something, or do something better. That's natural. I assume that's permanent.

The only thing I can say is that I have other fears: I have great fears of repeating myself, which is what stops me doing variations on a theme, when I could easily produce a great deal of work from it. I could paint four times as many pictures in a year than I do if I did that. As for the success, you can ignore it. First of all, a lot of people will like a painting for the wrong reason, or not for the reason it was painted; they won't know what it's about. It doesn't matter. People often like something for the wrong reason. You can like a piece of furniture

because it belonged to some interesting person; another person can like it because it's rather well designed. It doesn't matter what the reason is. If you're not too involved with it, you don't actually care even if you know you're liking it for the wrong reason. I think it's relatively easy to ignore success and try to stop yourself being affected by it. With even a small amount of integrity you can do it. I never actually believe half the things that are written about me. They're always saying things like It can't last, it's so lively, it must fall down. I always ignore that as well; I ignore them when they say it's all good. I have my true opinion. That's what I really value. My 'popularity' might have something to do with my being a figurative artist. But, on the other hand, there's a good intellectual case for figurative art. It seems to me the idea of a permanent avant-garde going on and on and on is an absurd idea. Ron Kitaj was telling me about an argument he was having with someone at the Tate Gallery who was saying how they should support advanced art, as though it was a fight. It sounds as though it's 1910, not 1975. We must remember that in 1975 many figurative artists are completely acceptable; the idea of abstract painting is also completely acceptable, it's just that a lot of people think it's not that interesting. I tend to agree with them. But the fight for modern art has been won. There's still philistinism around, but it's not what it was; and the great battles, which I know it's easy to forget about now – and they *were* battles many years ago – have been won and modern art did triumph; the battle *has* been won in the history of art in our time, because it was right. So the idea of a great battle still going on today is absurd and dramatic where there is no drama.

Figurative art and the new synthesis

Although I am a figurative artist, I am very conscious of all that has happened in art during the last seventy-five years. I don't ignore it; I feel I've tried to assimilate it into my kind of art. There is one new aspect of art that not many people seem to recognize: that we are now living in a period when for the first time, wherever you live, if you are diligent enough you can get a good view of a great deal of past art and of the very complex history of art during the last fifty years. It can be seen and read about and experienced without leaving London or New York or Paris, in books. I know pictures in books are not the same as pictures on walls. But it is the first time this has been possible. Forty years ago if you lived in London, to know what was going on in Paris you had to go there. And even when you got there, you probably had to know where to look carefully. I feel this change, for when I was in art school at Bradford, the library was very small; there weren't many books, simply because there weren't many books published. Today any art school would have a quite big library of art, a great many magazines; they'd know what was painted even six months ago, what was done last month. This must be something new, and I think it's possible to use it. It also gives us a different view of the past, a more interesting view of it. I think that you can use in art this fact that you can view the past in a way that was not at all possible fifty years ago. Now, it seems to me that this fact should change a few things, if people become aware of it – as they're bound to do. If we just confine it to painting, it makes the history of painting during the last fifty years interesting; as it slowly developed, it probably accounted for the diversity of that painting. It has been, in a sense, quite a rich period from 1900 to 1950, even to 1960. And although I say that in Bradford, even in 1953, it was difficult to find out what was happening in art, possibly in Paris in 1930 it was much easier; it was a more art-conscious city and a few intellectuals would know what was going on and slowly relate it to the past. I think up to now very few people have used this idea, that you can take from the great diversity there's been and put it all in your work. The way I say it, it sounds like a polemic for eclecticism, but I'm not meaning it in just an eclectic way. Eclecticism can be a *synthesis* in the end, and that's what you hope will happen when you acknowledge it might be eclecticism. I am an eclectic artist. I feel that

there's nothing stopping me now from painting almost anything, even just some stripes if I want, it can all fit in with a view. I feel that some older figurative painters aren't aware of recent art history at all. Their art doesn't show it; there's no reference to the great complexity of the last fifty years. There may seem to be very little in mine too, but it's slowly going through my work and I certainly begin to see that there's great scope for trying now to make the diversity of modernism into a synthesis. It seems to me that it's worth doing, it's worth attempting. It is a complex thing, and that's why the idea of just designing colours and shapes on a canvas, and limiting yourself to that area, seems to me so narrow; it's as though you've got a wonderful room and you just stay in a corner and look at that corner. Whereas, if you really look around the room, you see so much more, and it's so much more interesting.

There definitely is a kind of crisis in the visual arts. I think anybody will acknowledge it now, though we have been slow to do so. I don't think it's a very serious thing; I know it will be overcome. Art is not going to die, even painting isn't going to die; it can't, because if it died it would mean that in the future all our images would be based on a mechanical process. I think that would be so boring, eventually art would start up again, there would be a reaction. So in that sense the idea of the death of painting is all a slight red herring, I think. People in the arts are not really looking at the past sufficiently hard to see that within it there is some coherence and it can be sorted out. All it means is that the people who look hardest will get something from it. People who look hardest in the end will be good artists. There'll always be some good artists come along. In the past there've been high periods and low periods; nothing goes on for ever. The High Renaissance eventually became Mannerism; then there was another period when great art was produced. The graph of the past goes up and down like that. It's unfortunate if you're living in the trough; you think, wonderful it must be when you're up on the top there. For all we know, the trough might last thirty years, which is our active lifetimes.

Art as we know it is difficult to define, anyway. I can remember years and years ago in Bradford, when I was a student, finding a copy of Tolstoy's *What is Art?*, and in my naivety I expected that on page twelve he would say what it was. I read the whole book and still wasn't clear. Now I realize the question cannot be fully answered, certainly not in a rational, intellectual way like that. Somehow, you have a feeling, this is art. Perhaps the difference is just in quality: this is high quality art, this is trivial art. I wouldn't bother to try and define it; accept the fact that definition is probably impossible.

Painting and photography In the case of painting, it's photography, I think, that has caused confusion. And in a sense when people say painting is dying, I think it's the other way round; I think photography is. I think photography has let us down in that it's not what we thought it was. It is something good, but it's not the answer, it's not a totally acceptable method of making pictures, and certainly it must never be allowed to be the only one; it's a view that's too mechanical, too devoid of life. I'm not even sure how emotionally powerful a photograph can be. Take a photograph of a woman and a child crying. I find pictures like that not quite true for me. Obviously suffering occurs. But you're aware that the photographer is standing in front of them; you feel that, instead of taking the photograph, he should be helping. After all, a man can paint a picture later; he could have helped and then painted the picture.

This weakness in photography is becoming clearer to me, so I assume it's becoming clearer to other people. I can't be the only person thinking like this. If you go to an exhibition of photographs, there are certain things about the photographs that dull you in the end. They always have the same texture; somehow, the sense of scale is always the same; there's a monotony in photographic exhibitions that you wouldn't get in an exhibition of paintings.

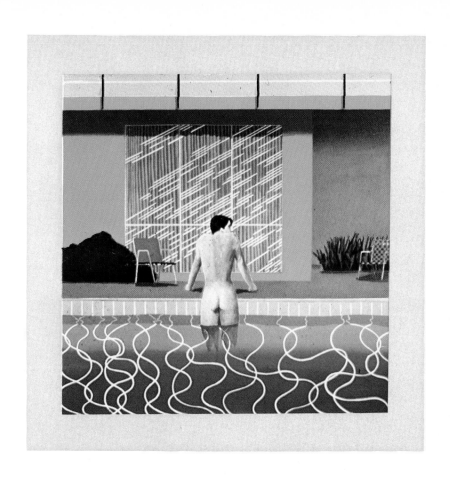

145 *Peter Getting Out of Nick's Pool* 1966
146 *Sunbather* 1966

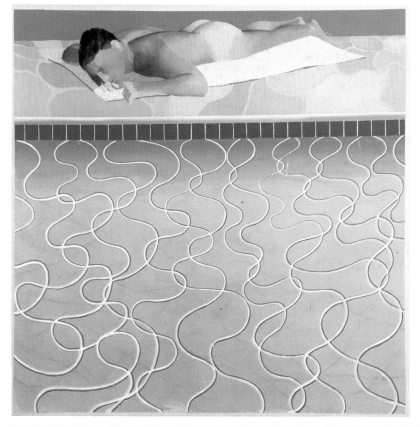

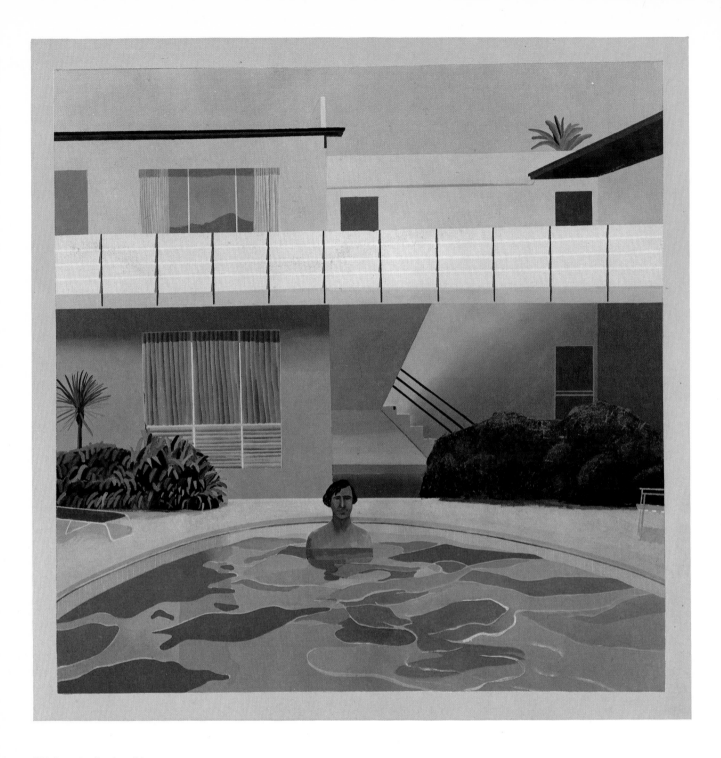

147 *Portrait of Nick Wilder* 1966

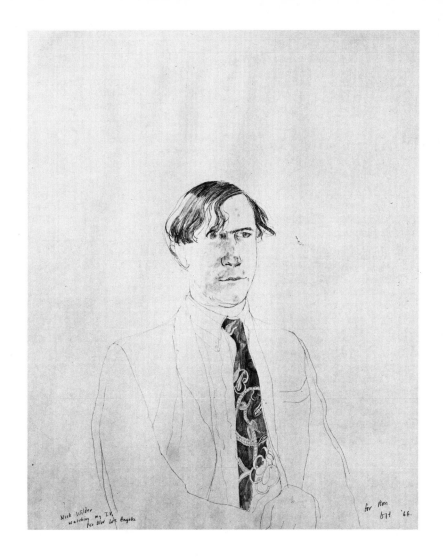

148 *Nick Wilder Watching My TV* 1966

149 *Nick Wilder's Apartment with*
 John McCracken Sculpture 1966

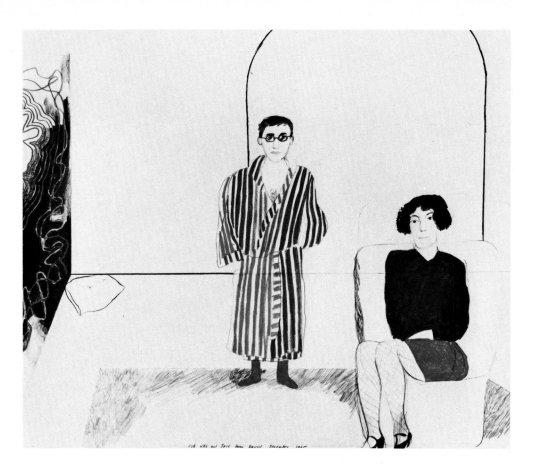

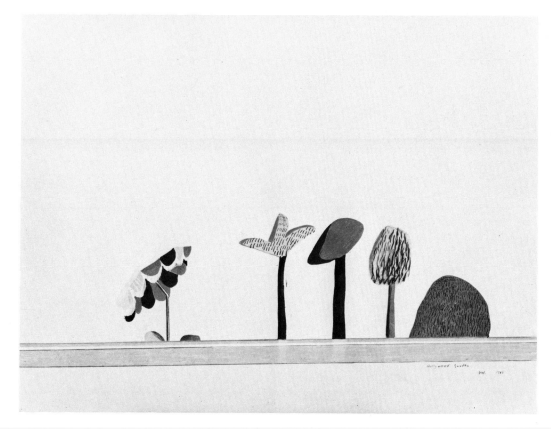

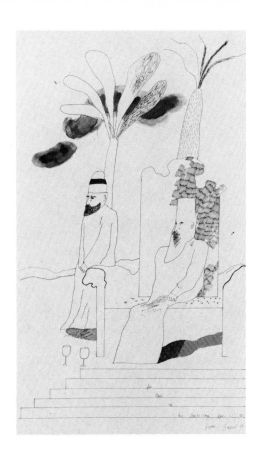

154 *Nehemiah Checking the Walls of Jerusalem* 1966

155 *Beirut* 1966

156 *Mountain Landscape, Lebanon* 1966

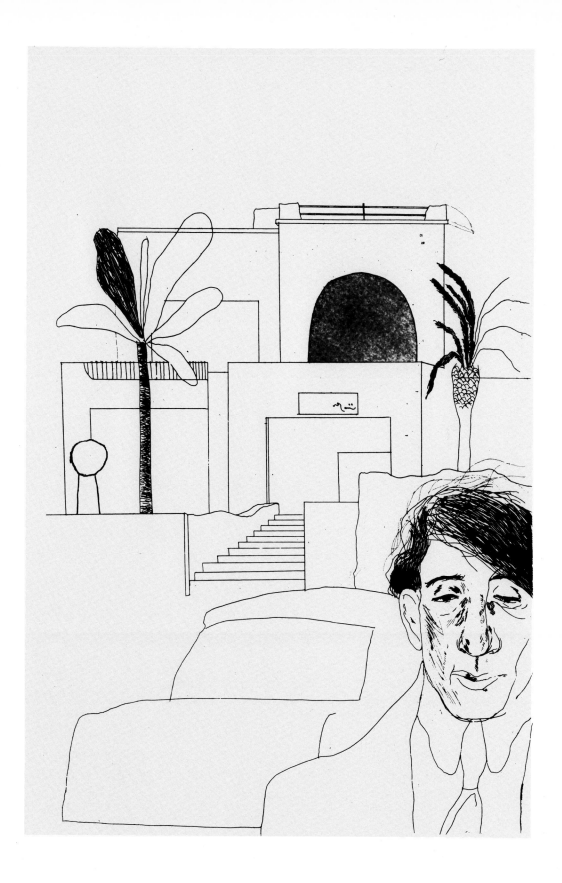

157 'Portrait of Cavafy II'

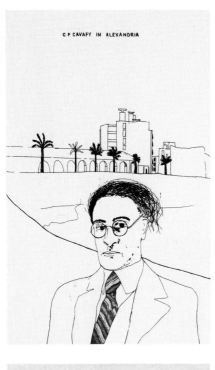

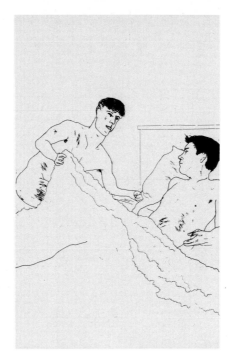

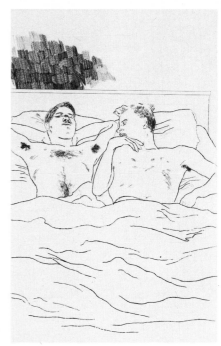

158 'Portrait of Cavafy I'

159 'According to the Prescriptions
 of Ancient Magicians'

160 'In the Dull Village'

161 'In an Old Book'

162 'In Despair'

163 'Two Boys Aged 23 and 24'

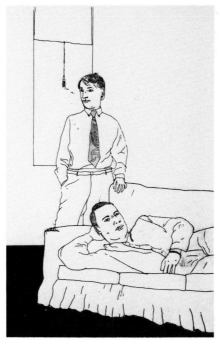
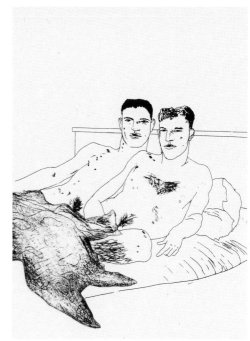
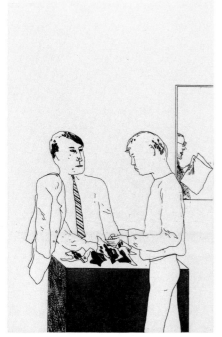
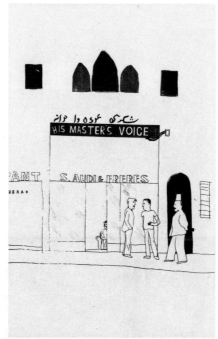

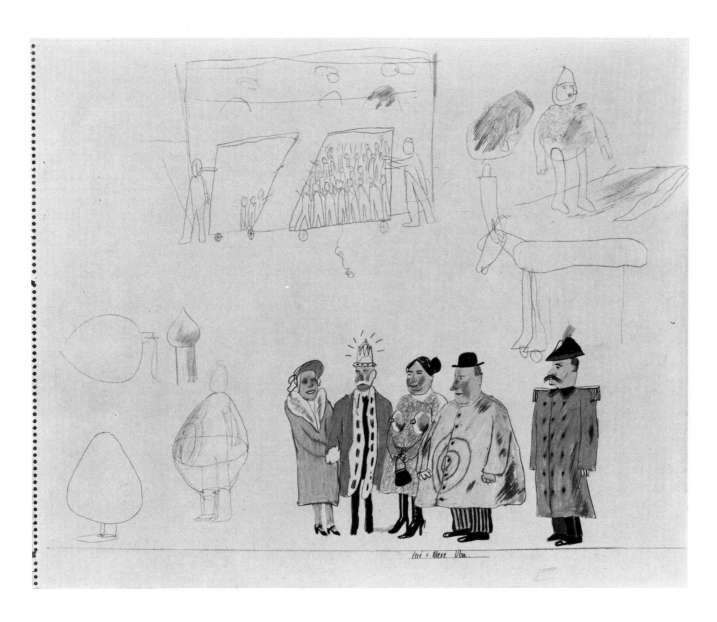

Preliminary drawings for *Ubu Roi* 1966

170 'Père and Mère Ubu'

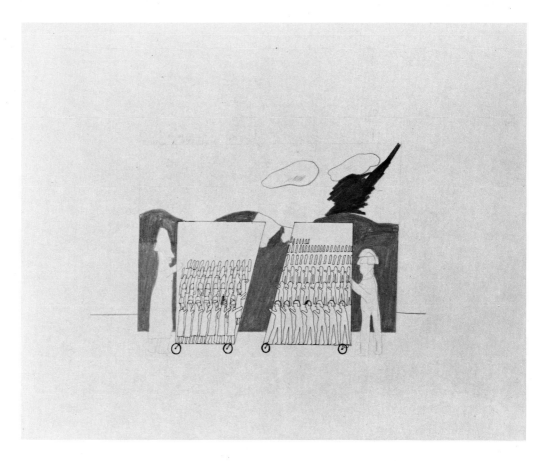

171 'Battle Machine'
172 'Bordue in His Cell'

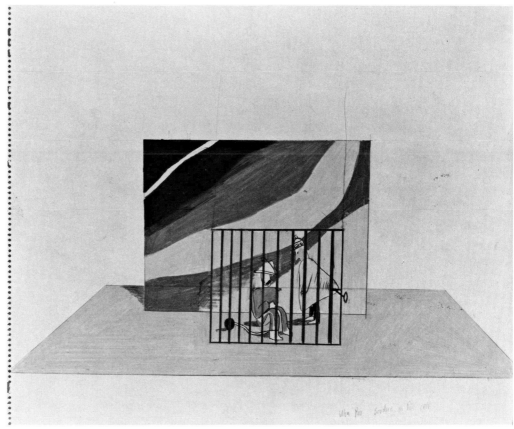

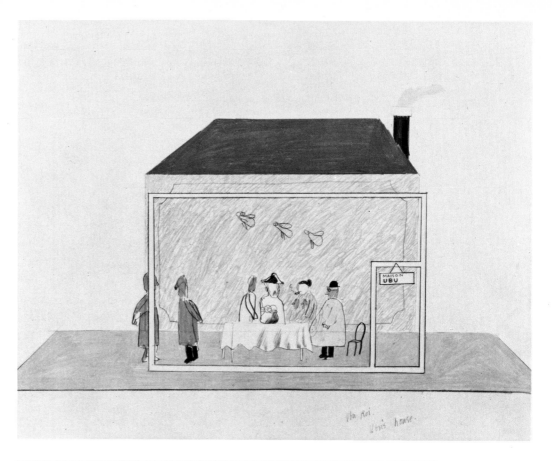

173 'Ubu's House'

174 'Ubu's Banquet with
Conveyor Belt Table'

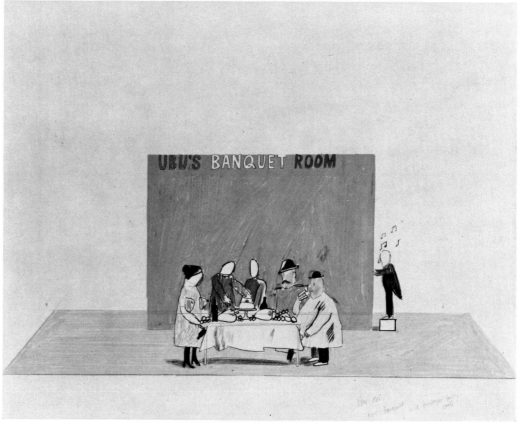

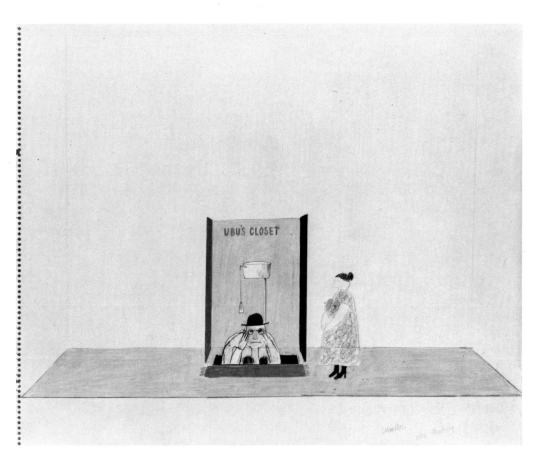

175 'Ubu Thinking'
176 'Polish Army'

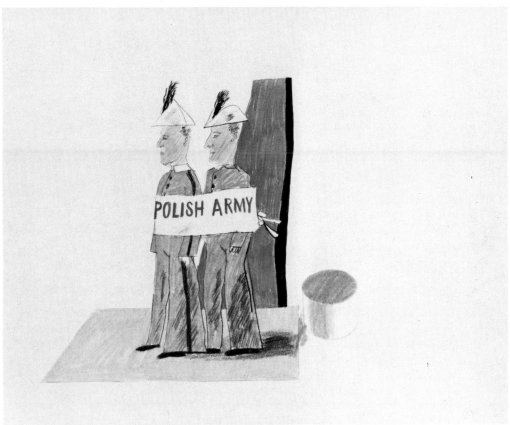

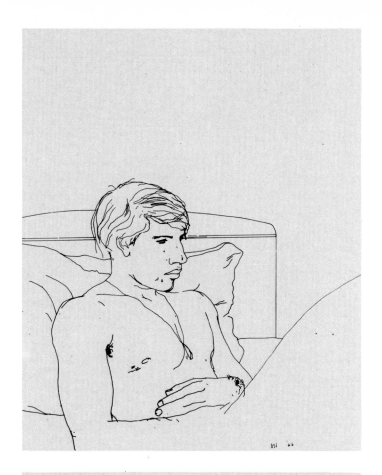

177 *Peter in Santa Cruz* 1966
178 *Peter, La Plaza Hotel, Santa Cruz* 1966

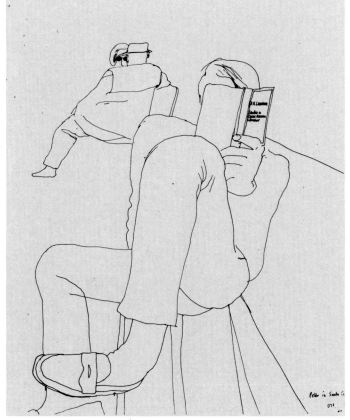

179 *Peter in Bed* 1966
180 *Peter, Swimming Pool, Encino, California* 1966

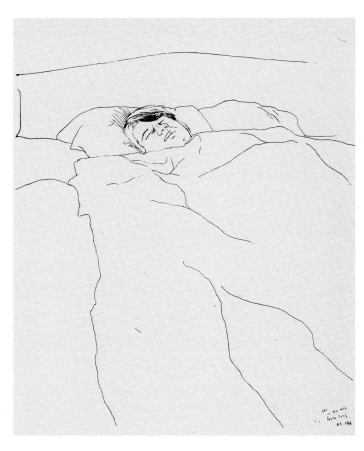

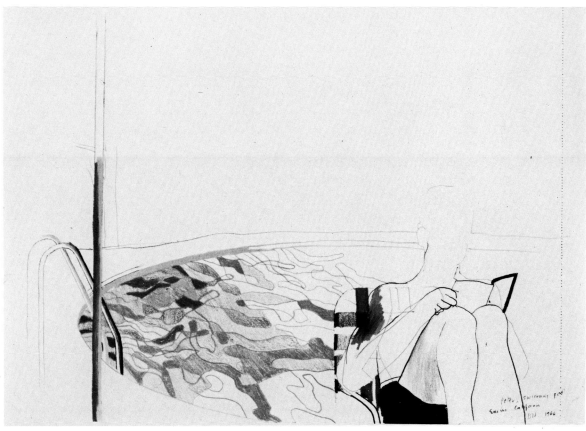

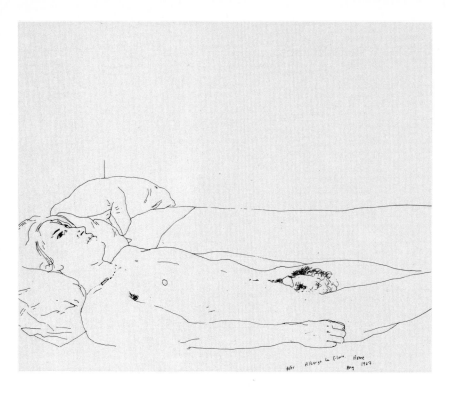

181 *Peter (Albergo da Flora II)* 1967
182 *Peter* 1967

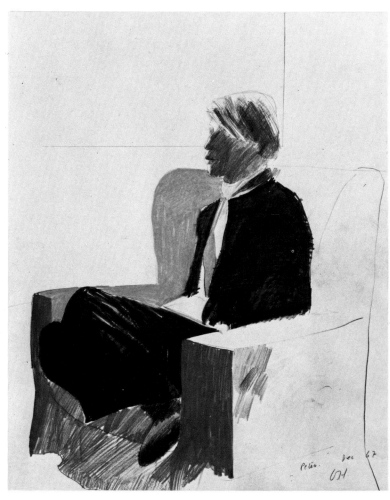

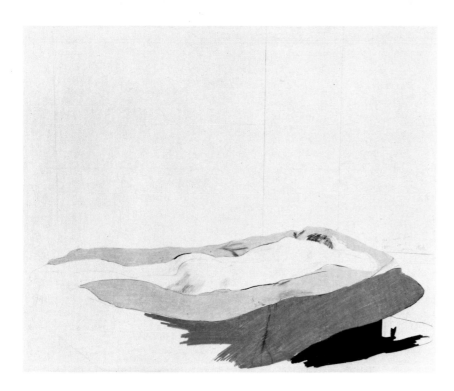

183 *Mo on a Grey Bed* 1966
184 *Mo* 1967

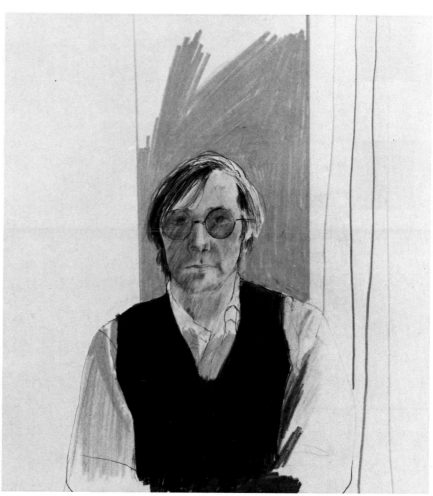

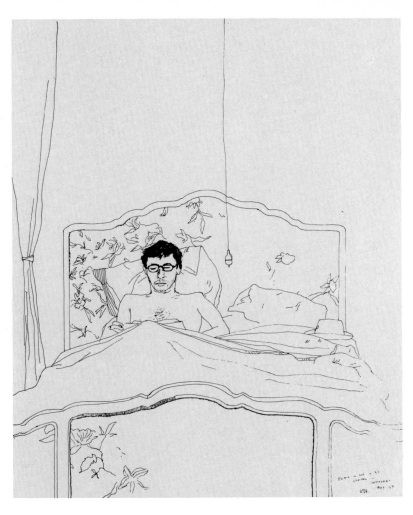

185 *Kasmin in Bed in his Château in Carennac 1967*

186 *Jane in a Straw Hat, Carennac 1967*

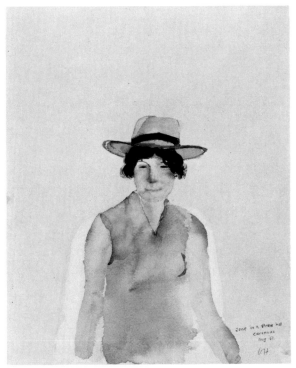

In the National Gallery, there's no monotony; but I think if you had a National Gallery of the greatest photographs taken so far, I think you would just see a certain monotony. I'm putting forward a little case, and it has to be answered, people have to think about it. I think it's not really being discussed enough at the moment. You'd think an art school should be discussing it, but to discuss it you have to sense it first, and maybe it's taking time. I think it will come. Certainly photography is an interesting art, or can be, but I think it's been – not overpraised, but relied on too much, so that in painting and drawing people have used photographs and abandoned actually looking at the world. I think it will all recur when we begin to sort out what photography truly is. After all, photography is a quite recent development. It does coincide in a sense with the modern period in art, and that's probably no accident. Surely the decline in portrait painting and the rise of the portrait photograph isn't coincidental. Yet it seems to me that a really good drawing or painting of a figure is infinitely more interesting than any photograph. Picasso's painting of Gertrude Stein is more interesting than any photograph I've ever seen of her, and for us to think not is foolish. And if that's the case, what does it mean? We tend to think the information a photographer provides is true. Just as you can make a drawing of somebody and then the friends of the person say It's not like him, you can take a photograph and you can eventually say You know, it's not like him, he doesn't look like that. So the information in a photograph is not always true. We've tended to think the camera cannot lie, and I think it probably can lie just as much as a painting.

The camera can lie

Back in England, 1967

I came back to Europe from California in the summer of 1967, with Peter Schlesinger; it was his first visit. I bought a little car, a Morris Minor district nurse's car, convertible; I didn't know they still made them. I found a brand new one, bought it, and we did a tour of Europe: Italy, France, everywhere. Patrick Procktor came with us, and that's when he started doing his watercolours. I said to him Why don't we take little stools and watercolours? I'd tried watercolours once before, in Egypt, and didn't like them, and I actually abandoned them this time as well – I didn't really like them as a medium. I had taken my coloured pencils, so I finished up giving the watercolours to Patrick. We did a nice cultural tour of Italy and then spent a week in Viareggio on the beach; then I came back to London. Peter had to go back to California to school in October, and I stayed on in London until January 1968 to paint *The Room, Manchester Street*, which is a portrait of Patrick Procktor in his studio. In 1967 Patrick's studio looked clean, neat and office-like. The next year it looked like a den in the Casbah – it seemed to change as often as Auntie Mame's. I recorded the changes in photographs, and this painting was made from drawings, life and photographs.

205

Then I painted *A Table* and *Some Neat Cushions*, which is from a little drawing I'd made in California. I showed these paintings at Kasmin's in January 1968. All the exhibitions I'd had at Kasmin's I'd given a title. The first was called 'Pictures with People in' – all the pictures had a figure. The second was called 'Pictures with frames and still-life pictures'. In this one I used the titles of the five paintings in it, and called it 'A splash, a lawn, two rooms, two stains, some neat cushions and a table ... painted'. *A Table* is actually painted from the photograph in the Macy's advertisement I had used for *The Room, Tarzana*. The attraction of it was its simplicity. It seems a rather dull painting to me now, but it was just its colour and simple, rather sculptural shape that I liked at the time. It relates to *Two Stains on a Room on a Canvas*.

204, 201

In the catalogue for the Young Generation Exhibition of, I think, 1964, artists had to make a little statement. Mine was very short. I said I thought my pictures divided into two categories: what I called technical pictures, excessively formal, in which the balance was towards form;

and excessively dramatic pictures, in which the balance was towards content. And in a way this still holds true. I think I still get involved with these categories and at times I feel the need to do pictures that are – I use the word 'technical', in the sense that they're about the techniques of painting, my painting, painting going on around me, as opposed to life. They're statements in a way about painting. But my double portraits are quite different because the moment you put two large figures in a picture you do have dramatic content that you can't ignore.

I stayed in England until January 1968, when the exhibition opened. Peter came back for holidays in December. I finished these pictures, then Peter had to go back and so I decided I would go back to California too, for six months. Peter said he wanted to come and live in Europe, so he applied to the Slade and it was arranged he would start there in September.

And back again to California, 1968

Back in California I painted three pictures, two double portraits and a big view out of a window. They took six months to do. All very big pictures: *Christopher Isherwood and Don* 192 *Bachardy, American Collectors (Fred and Marcia Weisman)* and *California Seascape.* 191, 206

I lived with Peter in Santa Monica. Ron Kitaj was teaching at Berkeley, so I went up to San Francisco a lot to see him, and he'd come down and stay. I introduced him to Christopher Isherwood one night. Ron is a great book collector, and he said he'd love to meet Christopher Isherwood, so I said Come down and I'll cook for you. I said to Christopher There's a friend of mine coming, he's a very interesting artist. Christopher came round and Ron arrived with about five first editions of Christopher's which he wanted him to sign. I remember he had *Lions and Shadows*; in the first edition there's a photograph of Christopher aged twenty-one, and it's amazing how he still looks the same. The face is still amazingly like him.

At Berkeley, where Ron was teaching, all the teachers were a bit different from in England. There are two kinds of art scene in California; there's what you might call the professional one – galleries and the artists who make work for them; and then there are the artists who teach in the universities. They overlap, of course. I guess it's the same in England. People who teach and show their work, people who teach and don't show their work – and also people who teach and don't do any work. I'm a terrible teacher. The only thing I liked teaching was drawing. I did a drawing class at UCLA and at Irvine, and I liked doing that because you can be specific. It was life drawing: we had a model in the room and we got twenty-five people in the class, quite big, and they began to draw, and I would go round each one. Everybody had made some mark on the sheet of paper, so I could talk about it. I knew what the marks were supposed to refer to, that the inspiration had come from a human being sitting in front of us, and I could always talk about it. But teaching painting is something else. You might go in one room and somebody's painting a landscape or a still life, and you go in the next room and somebody's painting two stripes or something like that, and somebody else is doing something else; some things you're a little more sympathetic to, some things you aren't. You're supposed to go and speak to them all, and sometimes I never knew what to say. If I didn't care about the painting, if that kind of painting didn't really interest me, I felt, I can't say it's rotten or bad, a lot of people do it, it might be interesting to some, but to me it's not, so what do I do? What can I say?

Berkeley was the last place I taught at, I've never taught since anywhere, except for three days at the Slade, a drawing class, in 1971. Somebody once asked Ron to look at his pictures; Ron went to look at them and they were all stripes. And Ron said Before I say anything, you do know there's ten thousand other people painting pictures very similar to this, don't you? There's a lot of truth in that. The person probably got the message. Ron can be a bit intolerant but, after all, the artist has to be committed the way the layman does not.

I'm a lover of music, but my commitment to it isn't great or strong enough to make me bother taking sides in musical arguments. I view them all as slightly pedantic; to me, it doesn't matter. Just as I'm sure lots of people would look at arguments in painting as slightly irrelevant. I must admit, I've come to look at some arguments in painting as though I was outside them.

The most domestic scene, California

Peter and I lived together. Peter's the only person I've really lived with; we were lovers. I've lived with other people, but not really as lovers. And of course it makes a difference; life was a little quieter. One period in California, from summer 1966 to 1967, I lived with Nick Wilder in Hollywood and I rented a really run-down little house in a very seedy part of Los Angeles, on Pico Boulevard, Pico and Crenshaw. I meant just to paint there, and I stayed at Nick's most of the time, but when Peter and I thought we'd move in together, there wasn't room at Nick's, so we went to live in this house. Every time you put the gas on, cockroaches sped away from the oven, but I didn't mind. I never had a phone put in, because right outside the door was a phone booth, and I kept quarters and dimes to make calls. In Los Angeles everything's a trunk call – you can't call more than four blocks away. During the day Peter was out at school, and I painted, and in the evenings we'd go out and eat something. I don't think I ever cooked there at all. We used to go to the cinema a lot, then go back and read, just sit in bed and read. Because there was no phone, life was quiet and I think that year I painted more pictures than I'd ever done before. From the summer of 1966 to 1967 I painted *Beverly Hills Housewife, Portrait of Nick Wilder, Sunbather* with the squiggly water, the three Splashes and *The Room, Tarzana*. Some of them I did at Berkeley. In Santa Monica, in a *tiny* little room, a *tiny* studio, I painted *Beverly Hills Housewife* which is twelve feet long, two canvases run together. I could never get more than about five feet away from it. *Christopher Isherwood and Don Bachardy* was painted in a studio not much bigger. It's amazing how I did big pictures in small rooms. The truth is that you don't need great big studios, although it's nice to work in a big room. In Berkeley they gave me a very large proper studio; *A Bigger Splash* and *The Room, Tarzana* were painted there. It was the first time I'd ever had a proper studio with a north light.

During this time, I never went to bars at all. Peter was only nineteen and he couldn't go into a bar, so I gave up. I hardly drank. I used to go and buy a bottle of Californian wine; I remember we always kept wine in the place. The fridge was just full of white wine, no food.

Christopher Isherwood and Don Bachardy

We saw Nick Wilder a lot, and Nick's friends, who were always rather young and beautiful boys. We'd go swimming at Nick's. He still lived where I'd painted him, just in a cheaper part of the block, and he had a pool there and we'd go swimming in that pool. I saw a lot of Christopher Isherwood and Don Bachardy. And we lived next door to a Californian artist called Ron Davis, a geometric artist. He was just getting going then and we became friendly. He showed at Nick's gallery, and I used to play chess with him sometimes. I think the very first game of chess we played he won, and he said That's what comes of playing with geometric artists. The second game I won, and I said That's what comes of playing with figurative artists who know what to do with a queen. Looking back on it, it was certainly the happiest year I spent in California, and it was the worst place we lived in.

After we left London in January 1968, Peter and I drove across America. Peter had gone back to California a few days before me because his school started, and so I flew to New York with Kasmin. A friend of Peter's had bought a Volkswagen in Europe and was going to drive across to California, and I thought it would be fun to drive with him. Peter was a bit annoyed, so I said Why don't you just fly to New York from California and we'll all drive across, if you can take three days off school. He said yes, he would. Kasmin and I were staying at the Stanhope Hotel. Peter arrived after midnight and we left at five in the morning. I have

extensive photographs of that trip; it was like an *Easy Rider* in a Volkswagen. Nice pictures of Colorado when it was snowing.

When we reached California I rented a tiny little penthouse in Santa Monica, old-fashioned, built in 1934, which for California is very old. It was like being on the Queen Mary, with the mist in the morning, in winter – in Santa Monica they get a bit of mist coming in from the sea – and it was very nice. They were very happy times; once we were in the house, I didn't care if I went out to see anybody or not, whereas before that, when I lived in California, I was a roamer, I had to go out. It was because of Peter. Why should I go to a bar and roam around? There was no need for it. Perhaps if he'd been of an age to go into bars we might have done, I don't know, but he didn't want to, he didn't bother.

Before we moved into the penthouse, Peter had been living across the street in this little wooden house with two other students whom I knew as well, they'd been in my class. I got a very small room in this little wooden house to paint in. A wooden house, five people lived in it, and it had a lovely big garden. Doesn't exist any more. It's now an apartment block with probably two hundred people living in the same space. It's the way things change.

Then I though I'd do a double portrait. I'd done the portrait of Patrick Procktor in England, *The Room, Manchester Street,* and the year before I'd done the one of Nick Wilder. And I'd done paintings with two figures before, the Marriage pictures and the Domestic Scenes. But a specific double portrait, no. I decided I'd like to paint Christopher Isherwood and Don Bachardy. So I started doing a lot of drawings of Don and Christopher, not compositions of the picture, just drawings of the faces, to get to know the faces and what they're like. Then I took a lot of photographs of them in a room, trying to find compositions, how to do it, and whenever I said Relax, Christopher always sat with his foot across his knee, and he always looked at Don. Don never looked that way; he was always looking at me. So I thought, that's the pose it should be. And I began the picture.

It's set in their house, a few blocks from my studio, and it's painted quite simply, large areas of colour. The still life on the table I arranged in life. They never had books on the table. I remember somebody asked why there were four books in front of Don and only three books in front of Christopher. Was this because Don wasn't as well-read and needed more? Amazing what people read into pictures. There are four books because I needed four to balance it out. The corn-cob was always on the table. It's part of the little formal still life. I thought it made a nice space. Everything happens in the bottom half of the painting. The top half is very simple, but you couldn't cut it off, it makes the space. If you start on the right and you follow Christopher across to Don, then you come to the books, you move round in a circle looking at the still life and the figures. It was arranged in that kind of way, composition-wise; it's a circle, you're going round. In a circle you can go round any way, as long as there's no writing in it. Normally you read from left to right, like in a book. I think people are still used to looking that way, from left to right, and then if it doesn't work they read it the other way. But if you want it to be read up and down, you have to work on it hard. The natural thing is reading across. That's why you follow Christopher's gaze towards Don, and then you're immediately bounced back by Don's face.

One of my methods of painting, from the Royal College of Art on, was to paint a lot and then just sit in front of the picture, sometimes for an hour, without doing anything at all, quite concentrating on the picture, sometimes enjoying it, if I thought it was done all right. I get a thrill out of my own pictures; obviously, any artist does, if they're painted reasonably. If you didn't, you'd give up, wouldn't you? But I can stand and look at my paintings for a long time, deciding things, deciding what to do. I usually sit in silence then, never play music.

192

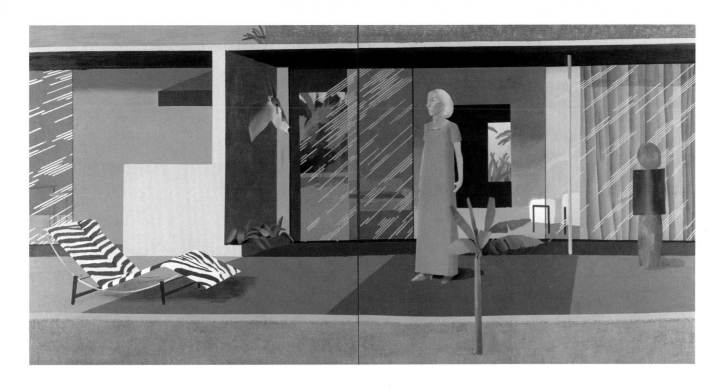

187 *Beverly Hills Housewife* 1966
188 *The Room, Tarzana* 1967

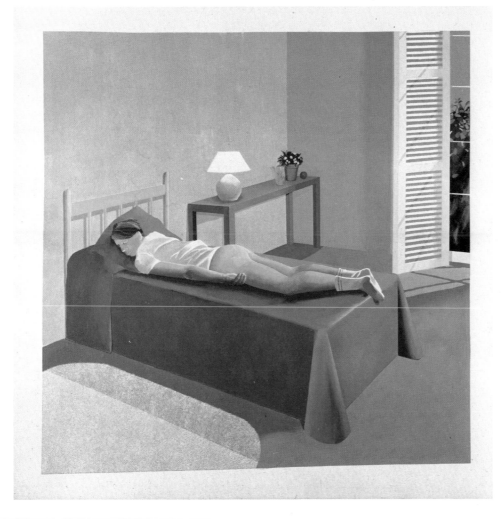

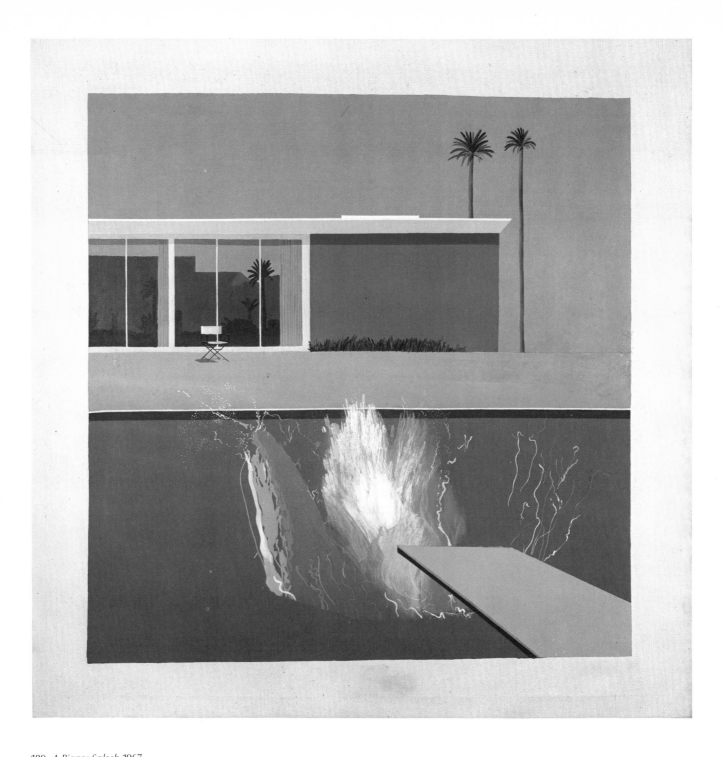

189 *A Bigger Splash* 1967

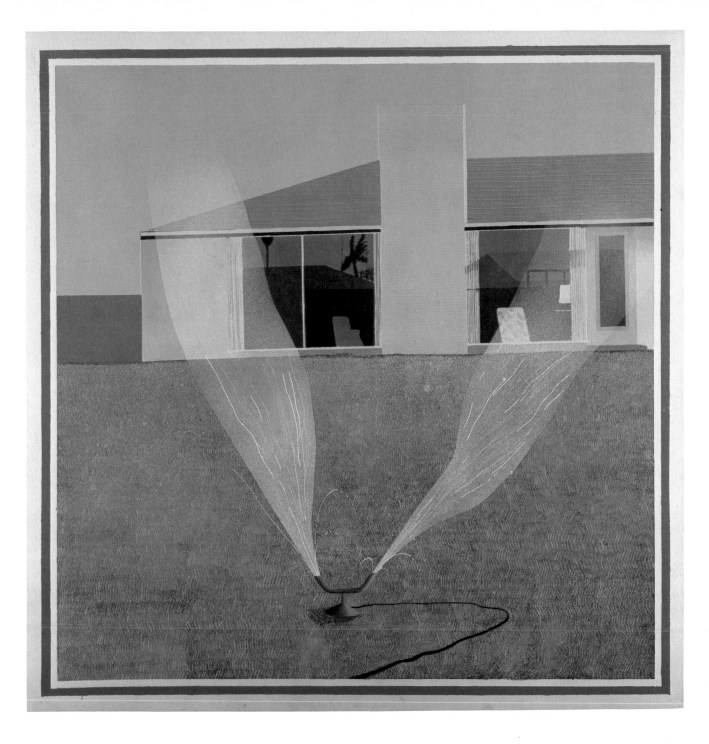

190 *A Lawn Sprinkler* 1967

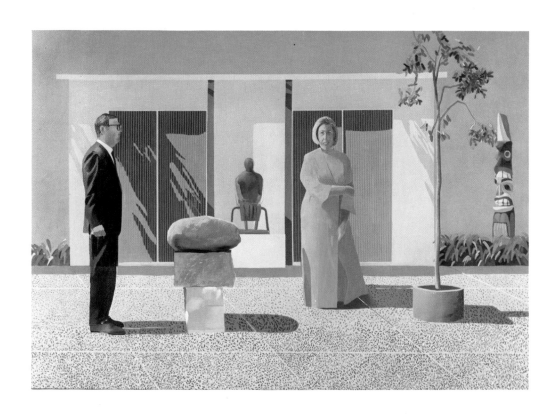

191 *American Collectors (Fred and Marcia Weisman)* 1968

192 *Christopher Isherwood and Don Bachardy* 1968

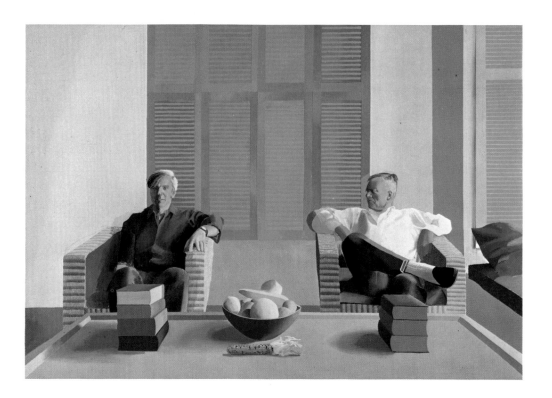

I only play music when I'm painting if I'm doing something mechanical. If I'm drawing people, if they want to listen to music, I'll play it for them, but I can't hear it. I forget what the music is even though I've put it on, and chose it. I never talk when I'm drawing a person, especially if I'm making line drawings. I prefer there to be no noise at all so I can concentrate more. You can't make a line too slowly, you have to go at a certain speed; so the concentration needed is quite strong. It's very tiring as well. If you make two or three line drawings, it's very tiring in the head, because you have to do it all at one go, something you've no need to do with pencil drawing; that doesn't have to be done in one go; you can stop, you can rub out. With line drawings, you don't want to do that. You can't rub out line, mustn't do it. It's exciting doing it, and I think it's harder than anything else; so when they succeed, they're much better drawings, often. The failure rate amongst my line drawings is still high; I'm always tearing them up and putting crosses through them, because you can't touch them up. If you draw the leg all wrong, you just have to throw it away.

That's not the case with drawing on a canvas because you can alter it, move it about, draw with pencil, rub it out. And usually I'm drawing on the canvas from another drawing, so the decisions are made. To copy a line drawing would be quite easy because the decisions have been made. To reduce things to line I think is really one of the hardest things. To draw hair, for instance, how do you do it, to make it work and feel like hair in line? So that it's black? It's hard. If you can colour with pencils, it's easy. But once it's been done it can be copied out in fifteen minutes.

The *Christopher Isherwood and Don Bachardy* painting was painted in the little studio in the wooden house I described before. Christopher came and sat a number of times. After about a month I also started the picture of *American Collectors*. I worked on them both at the same time, and then I started a third one, about a month later, *California Seascape*. Then Don went off to England and stayed there about two months, so I couldn't work on him very much. I worked on Christopher. As Don had gone off he felt a bit alone, and I saw a great deal of him. He used to come round almost every day; he lived just round the corner, five minutes' walk away. I would say Come in the studio whenever you want. If I'm doing something else, I'll stop and work on your figure; you can just sit in a chair. I'd got a chair that was the same height as the one in the painting, and the light was the same coming in the window. He would always talk when I painted, but I didn't mind that. He'd talk about Don being in England. I do remember he said Oh David, don't ever get too possessive about your friends; let them feel free. Later I think he was a bit hurt that Don stayed away a long time. Still, it was good advice, though when it happens to you it's not quite like that; you do feel that it's unavoidable. He'd talk about books, California, anything. He's a sweet, dear person, always interesting.

When I came back to England in the summer, bringing the painting rolled up, Don had left just a week before I arrived back, which was a bit annoying. The painting of Christopher is much better than Don; it's looser. Don could have been like that; it's because it's not painted from life. I think it does make a difference. I like to do the face, the hands, the pose, from life. You might be doing the painting from a drawing, but then when your subject sits down you might notice something else about him and alter that aspect of the figure in the painting.

Fred and Marcia Weisman didn't come to sit for *American Collectors*. I thought in that picture it wasn't as necessary because in a sense their garden with the art in it is part of the portrait of them, whereas in the painting of Christopher and Don there are just those books and some fruit, the only objects in the room. The books are something to do with them but not much. In the Weisman portrait there's a Turnbull sculpture, a Henry Moore sculpture, other

things, all part of them. The portrait wasn't just in the faces, it was in the whole setting. Marcia had asked me if I would paint her husband and I explained that I didn't really do commissioned portraits, but maybe it would be interesting to paint them both. There was a subject there. I realized they were an interesting couple as a subject. So I said I'll come up and draw and take some pictures in the house; then I remembered this garden of sculpture. There's a totem pole in the picture that looks rather like Marcia. It really had a similar look: the face, the mouth and things. I couldn't resist putting that in. So it's a slightly different kind of portrait in that the objects round the figures are part of them. I left the drip on Fred Weisman's hand because it seemed to make his stance more intense, as though he were squeezing so hard that his paint was coming off.

Then I did *California Seascape*. Dick Smith was living in Corona del Mar and when I called once he said Why don't you paint a picture of the window, a small one, for me? He wanted to commission it. And I did a little watercolour, I think, and a pencil drawing, which I think he's got. And then I thought, Oh, it's wonderful; I'll do a big version of it, it's like a marvellous picture within a picture really. 206

England 1968: the swinging London that never was

In August or September 1968 I came back to England with Peter, who started at the Slade in September. We decided to live in Powis Terrace. It was the first time since 1964 I'd moved back there, knowing I was going to stay a long time. If it hadn't been for Peter, I would probably have gone on living in California and travelled back and forth a lot. We set ourselves up in Powis Terrace in a quite domestic way. It was very happy, very nice. I painted away there, and Peter had a little studio round the corner in a house in Notting Hill where he did some very big paintings; they were quite ambitious.

Then we started making little trips to Europe. I had fallen in love with Europe again in 1967, when Peter and I made the motor tour; it had been four or five years since I'd travelled around. I'd been so full of America for five years, but coming back to Europe you realize it's certainly more interesting to drive round than America. America's wonderful as landscape, but every time you pull into a restaurant you know what the menu's going to be. Gets you down a bit. I'd always wanted to do Grimm's *Fairy Tales* and I was beginning to prepare for them, so just to gather material I thought we'd go to Germany and do a trip down the Rhine, first by boat and then by car. I took lots of pictures of castles; it was just architecture I was wanting to get references for. We travelled about: Amsterdam – any place. Peter hadn't been; I kept taking him.

It was nice being back in London. I still had a lot of friends there, Mark Lancaster, Stephen Buckley, Patrick Procktor, Ossie Clark, many. Patrick I still saw quite a lot of; I'd been very close to him, but because I'd been away a long time things changed a little bit, especially when Peter came to live with me. When I'd lived in London before, I'd go out with Patrick practically every night.

Although there was talk of swinging London, I never thought it was swinging, ever, although actually when it was supposed to be happening I was living in California. By 1968 it had worn off. Certainly, though, for me it never swung. I was associated with all that by accident, because, first of all, I'm not a swinger in that sense; and anyway, if swinging London was associated with anything it was with mini-skirts and girls, which I'm not interested in at all. I never even noticed them. My criticism of London was still that it couldn't ever really be a swinging place because it's too closed. I remember they started a club in the King's Road, the Arethusa, and they sent me a pen with my name on it, saying Sign and become a member; it was going to be very 'exclusive'. And I can remember writing back saying that's the very thing that would put me off; that's the trouble with this city, everything has to be exclusive. The

nice thing about America is that the bars are open very late; you don't have to have all that farting around with clubs and membership and salad on a plate, something ridiculous, because anybody can go in and drinks are cheap. You can meet eager kids who've gone to New York to paint or something. Unlike in London, lots of painters don't teach in New York, so I found it harder there than in London to meet people; but you could meet them in bars. All you needed was twenty-five cents to buy a beer. You could stay in there till four in the morning, and there were always lively kids who'd speak to you and want to know things. I loved that. If it had been an exclusive club with membership, they'd never get there, and that's the weakness of London. It's still true today; it's not been altered. Nobody does anything about it; I'm always criticizing it myself, even now. If they altered the licensing laws and the whole thing about places being clubs, it would make a vast difference here. In a way it's still to do with the class system; it's still to do with the fact, for instance, that drinking after eleven o'clock costs more because you have to join a club. The poor workers, they're supposed to go to bed and get up to work. It's very undemocratic. I don't think many countries would tolerate different rules for different people. America certainly wouldn't; it's a much more egalitarian place. There are no meeting places in London except the pubs with their ridiculous hours. Eleven o'clock is a ridiculous hour to close. People don't need that much sleep. I never go in pubs, simply because at the time I would want to go in them they're just about to close. If you go to the theatre or the cinema you want to go to a pub afterwards for a drink, but they're closed. That's why there are no meeting places; they've closed them all up. The place is dead; just tacky night clubs for tired businessmen. That's not life in a city. I still think something could be done about it. I'm always saying I'm just about to write a letter to *The Times*.

Ossie Clark was part of swinging London. He noticed the girls, all those girls who were making the clothes for him and Celia. Ossie was involved in it. I wasn't only uninvolved, I was antagonistic to it, basically. The whole idea was too upper-class English. Perhaps I'm being unfair; in a sense something did happen, there were changes – in fact at one time it looked as though all this class structure was breaking down. It did break down a bit, certainly; it has altered now, but not as much as I thought it would ten years ago. Comparing London in 1975 with London in 1965, it hasn't really changed much. Something changed for a while, but I think it was killed here by English conservatism. It's sad in a way, because there's a lot of energy here, there's a lot of talent. And much of it just leaves. I met some English kids at a bar in Los Angeles recently, and they said to me Why don't you live here any more? And I said I'm living in Paris. They said It's so boring in London – it's so much better here, you can do things. It's sad, really, when you hear people say that. It means the stodgy side of England is still there, spoiling it.

The one good thing about swinging London was that there was a lot of energy released from working-class kids – that hadn't happened before; the Beatles and the Rolling Stones and all that. But it was eventually killed, I think, by English conservatism, trying to make it exclusive again, instead of opening it up. They said It's exciting, we'll keep it like this and close it up – which has just killed it completely. It's a pity. The same thing probably happens to younger exciting artists, they're stifled somehow, although that, I tend to think, is sometimes the fault of the artist; an individual artist has no need to be concerned. I think you can ignore this conservatism in England if you want to. I just smile at it. I'm from an English working-class background, and I always feel a slight antagonism to middle-class things in England – not a bitter antagonism, though, because I think it's laughable. I don't like the idea of people getting CBEs or whatever; you might as well add ABC to their names. It's all a bit childish. But

you can stand back and laugh at it, although maybe it's not as easy to do that as I think. If you're a foreigner in England, it's quite different; you escape the class system. In a way, I think, that's why the people affected most are middle-class, because if you're a working-class person from outside London you're an outsider, just like a foreigner. The north of England is a different world from London, a completely different world, and I think it would ruin you if you moved from there down to London to become a middle-class person, because you'd be too susceptible to everything. Bradford is a completely working-class city, and life there is quite different from life in London, or it was when I lived there, certainly. When I say this I'm not saying I'm a class-conscious person; on the whole, artists don't care about class. But I think it does affect English art. There are always rare people who just come along from anywhere and survive no matter what class is about. But I'm sure it's the class system that drives a lot of people abroad. I think Christopher Isherwood admitted that was why he went to live abroad. I remember when he came to England in 1968 he said It's so much better now; and that was because of the liveliness at the time, the opening-up of English society. Christopher recognized that immediately; he said he'd had no idea what it was like. He described to me what it had been like when he was young, and being an aware and sensitive person he'd obviously wanted to escape it; and the only way to do that was to leave the country.

The traps of naturalism

I'd always taken photographs in California, with a polaroid, of things I might want to use in a painting. At the end of 1967 I bought a good camera for the first time and started taking photographs much more seriously, and that's when I began putting them in albums. When I came back to live at Powis Terrace with Peter, I was clearing out and I found boxes of photographs; so I thought, if you've got photographs you might as well stick them in a book. I bought the first of my big albums from Wallace Heaton, and I'm now on volume fifty-five; there's a vast amount of photographs.

Taking photographs quite seriously did have an effect on some paintings. *Early Morning, Sainte-Maxime, L'Arbois, Sainte-Maxime* and *Parking privé* were all based on photographs I had taken and from which I worked. I did a drawing for *L'Arbois, Sainte-Maxime* from the motif, but I also worked from photographs, and that in a way was when the naturalism in the pictures began to get stronger. At the time this wasn't a disturbing thing at all. In America, it was the period when photo-realism was becoming known, and I was slightly interested in it. I wasn't interested in the techniques at all; I never used their technique of projecting a colour slide on to the canvas, so that you're really reproducing a photograph. I just drew the photographs out freehand. It was still similar to using a photograph from *Physique Pictorial*, doing an interpretation of a photograph. In photo-realism the subject matter is not the actual objects represented on the canvas, it's a flat photograph of those objects. 211 213, 212 214

I'm never sure about *L'Arbois, Sainte-Maxime* and *Early Morning, Sainte-Maxime* as paintings. Sometimes I think *Early Morning* is the worst picture I did. I took the composition from my photograph absolutely and didn't alter it at all, which is true of hardly anything else. Even when I use photographs for paintings, as I did for instance in *Mr and Mrs Clark and Percy*, I don't think you could ever actually stand in the room and take a photograph like that, see it like that. *Schloss* is a little like *Early Morning*; it's done from a photograph I took on the Rhine. 252 210

No matter what I think of these paintings as pictures, though, they're relatively unimportant in my work. They're somewhat photo-realist, although they're rather crudely done compared to most photo-realism, I suppose – lots of that's crudely done too, though, I think. But the crudeness was intentional; I wasn't after a photographic effect.

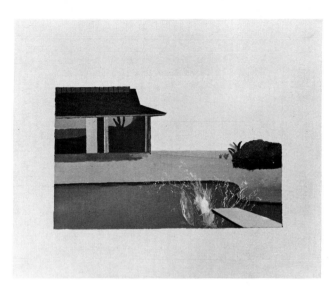

193 *The Little Splash* 1966
194 *The Splash* 1966

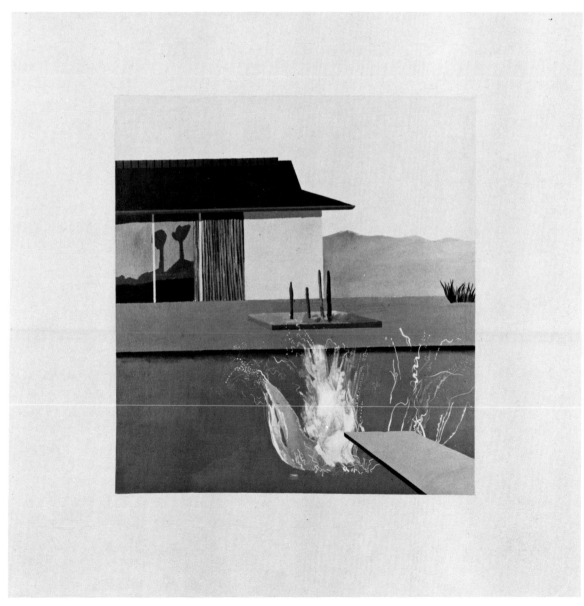

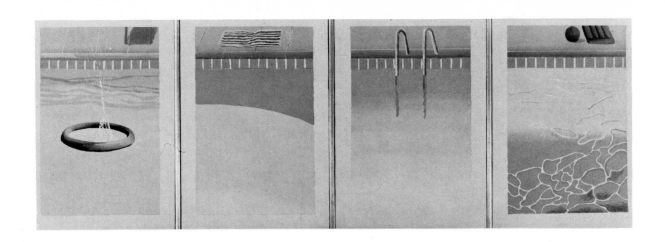

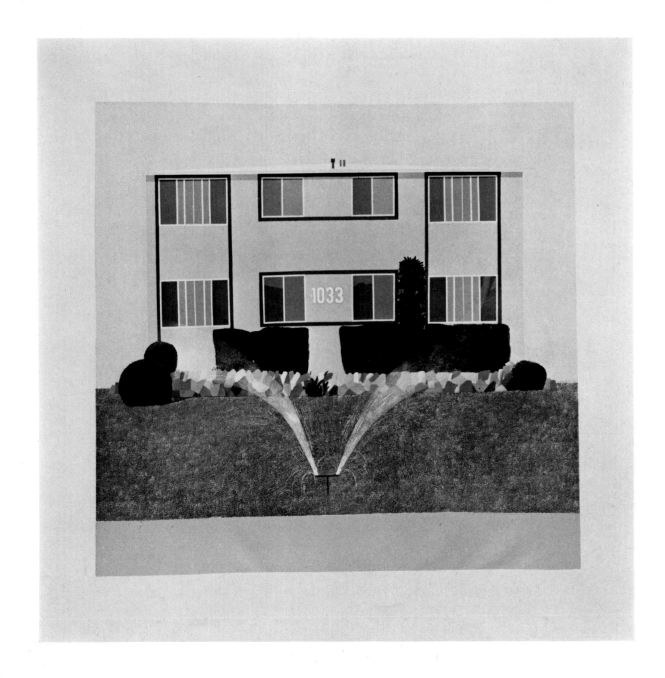

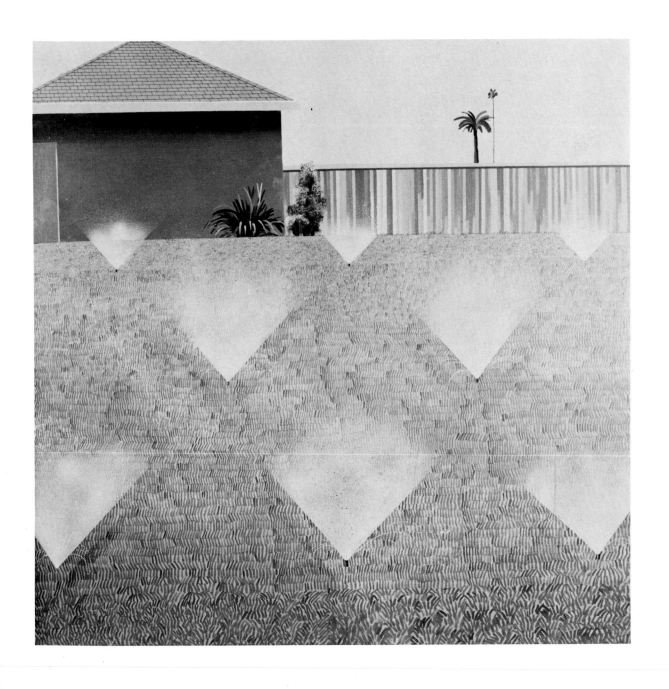

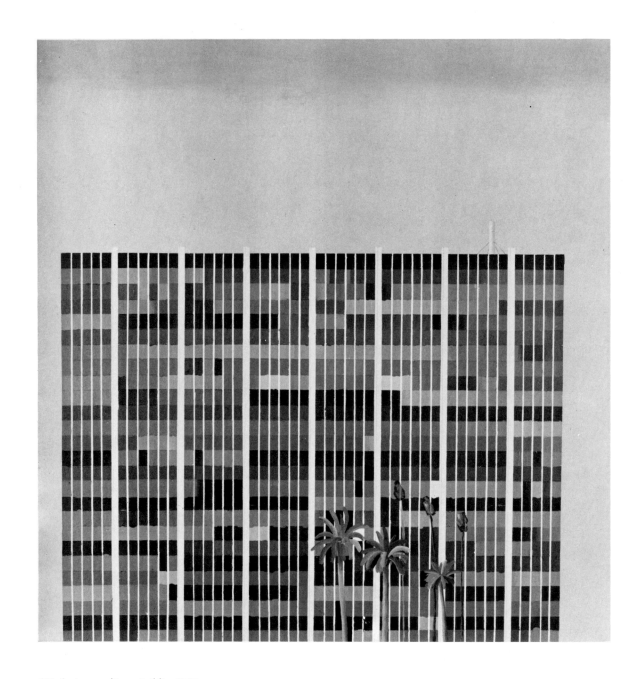

198 *Savings and Loan Building* 1967

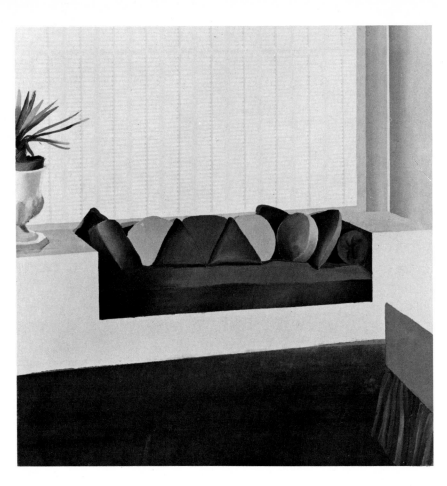

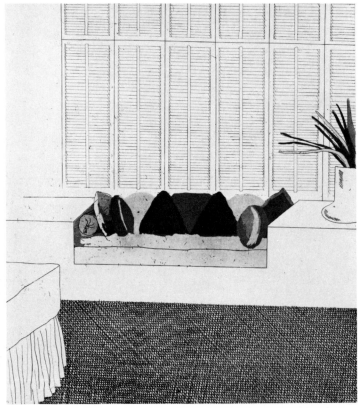

204 *A Table* 1967

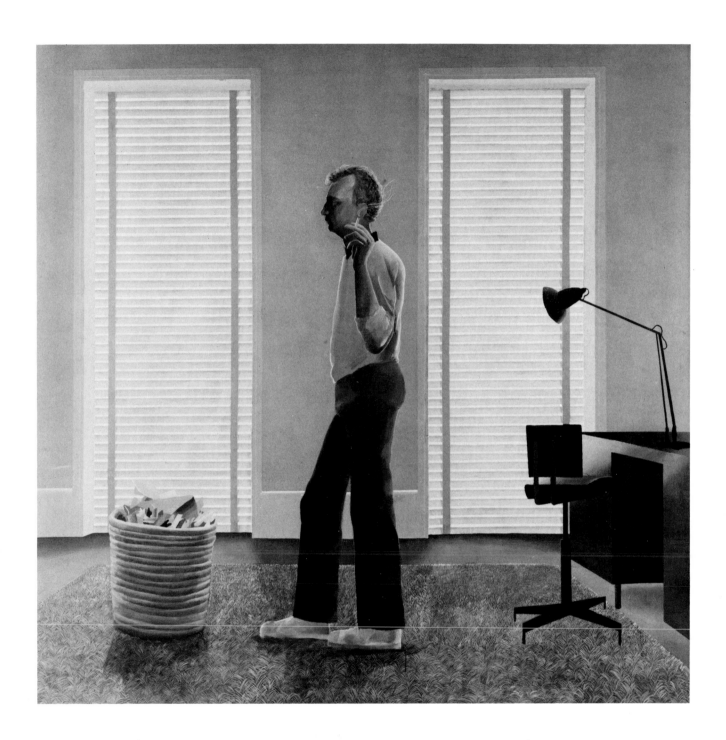

205 *The Room, Manchester Street* 1967

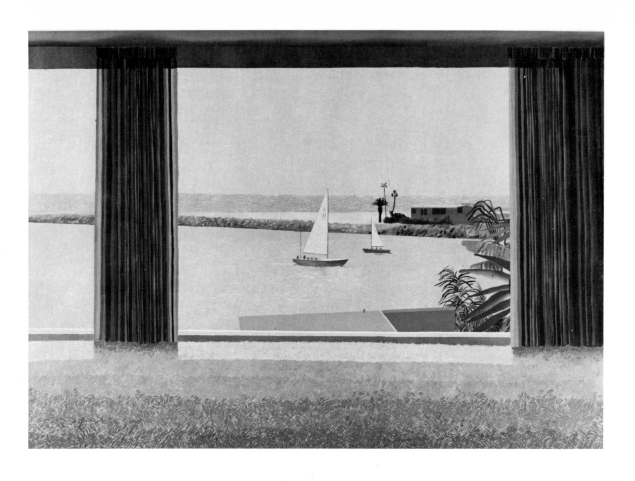

206 *California Seascape* 1968
207 *Tree* 1968

208 *1001 Dental Building,*
 Santa Monica 1968

209 *Bank, Palm Springs* 1968

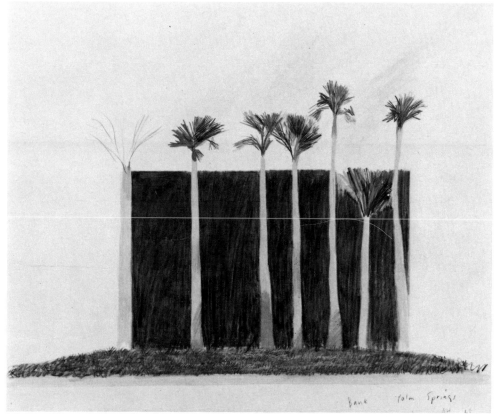

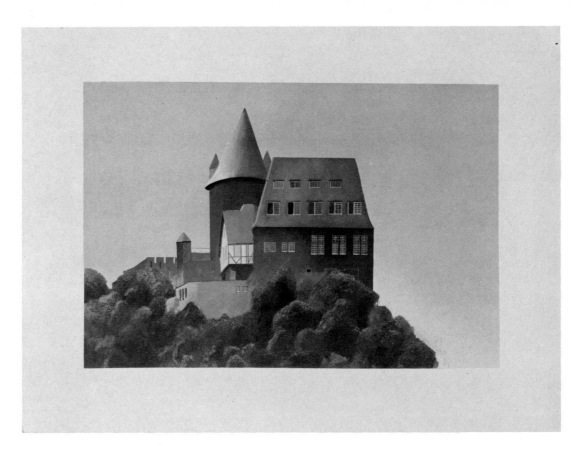

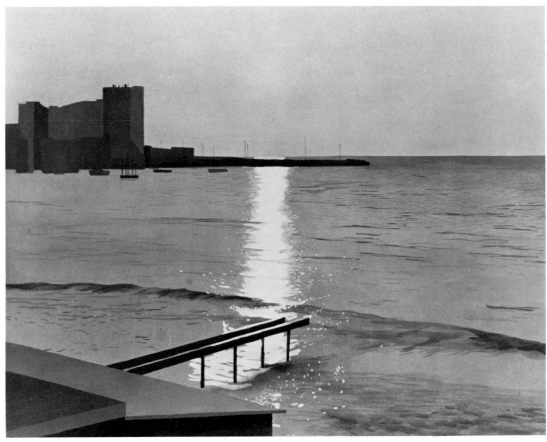

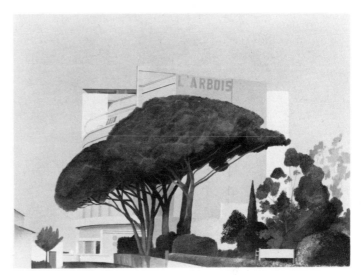

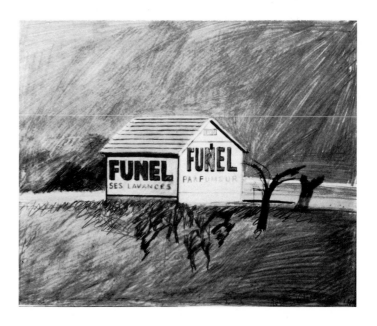

215 *Peter* 1968

216 *Peter* 1969

217 *Peter Reading, Santa Monica* 1968

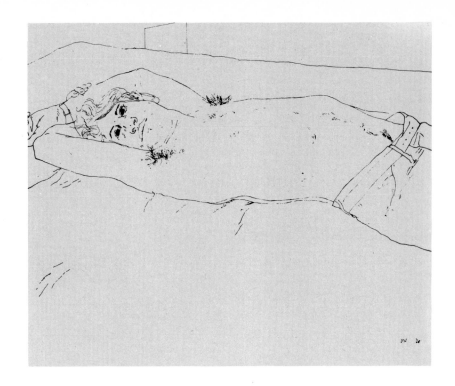

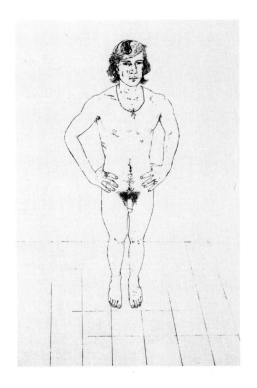

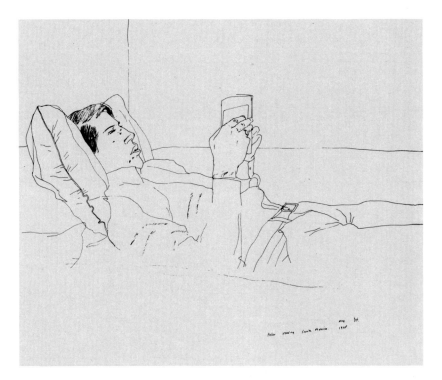

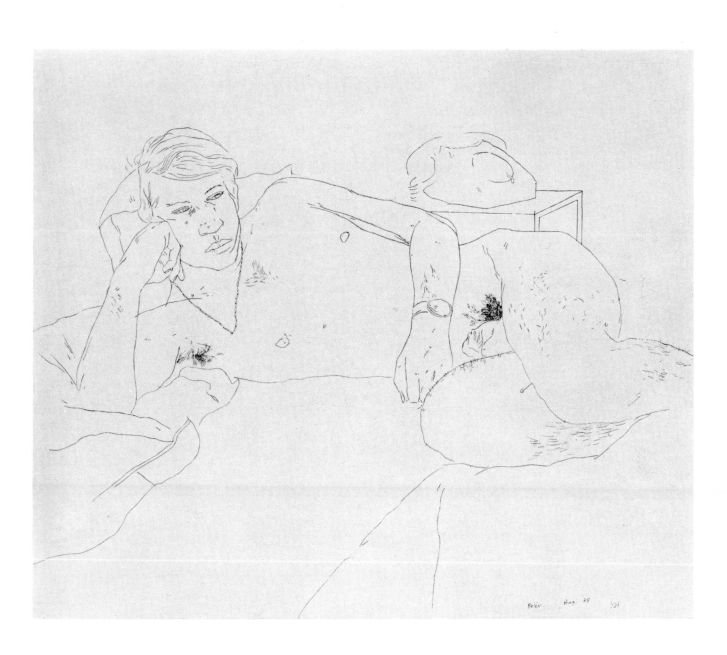

218 *Peter* 1968

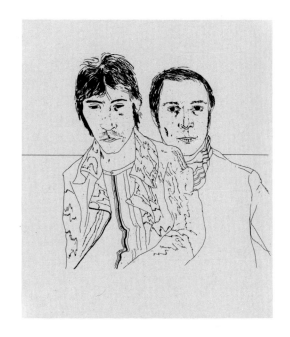

219 *A Portrait of Rolf Nelson*
1965–8
220 *Kasmin Twice* 1968
221 *Ossie and Mo* 1968

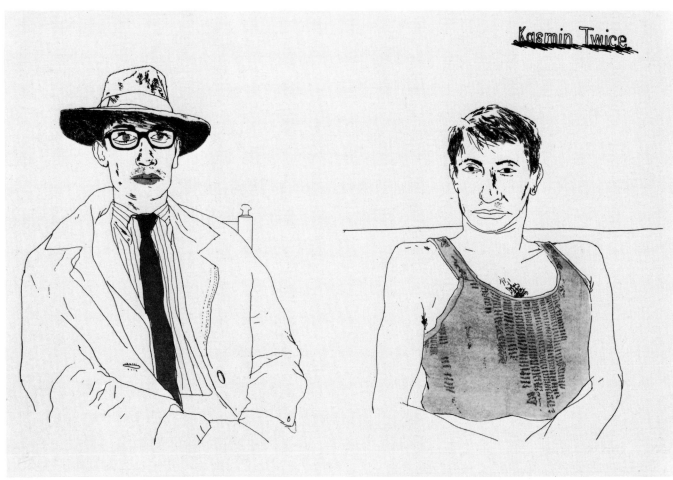

Kasmin Twice

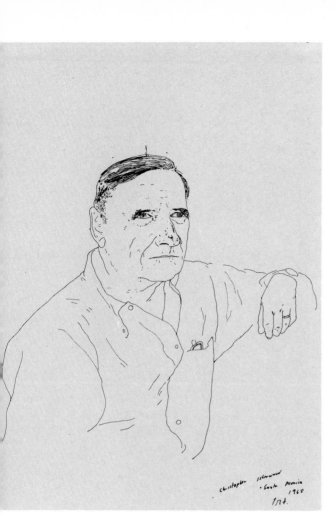

222 *Christopher Isherwood, Santa Monica* 1968
223 *Christopher Isherwood* 1968

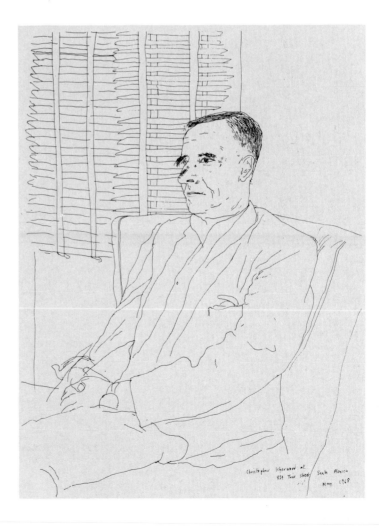

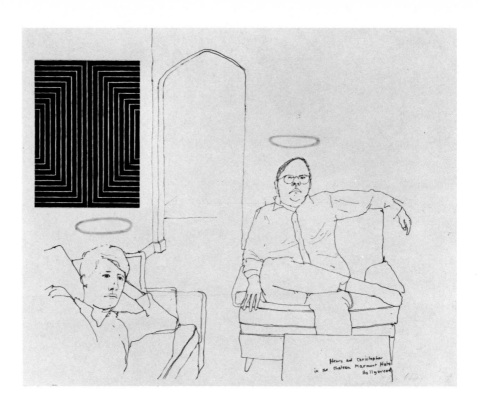

224 *Henry and Christopher* 1967
225 *Henry, Le Nid du Duc* 1969

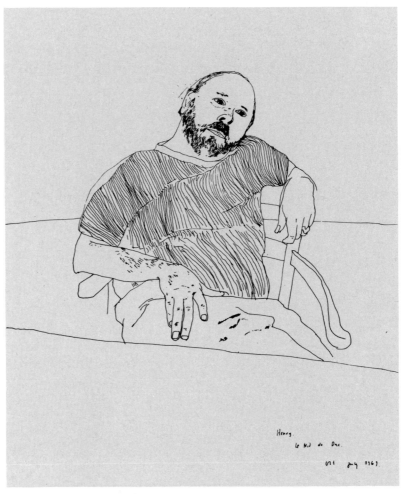

226　*Christopher Scott* 1968
227　*Henry, Hollywood* 1969

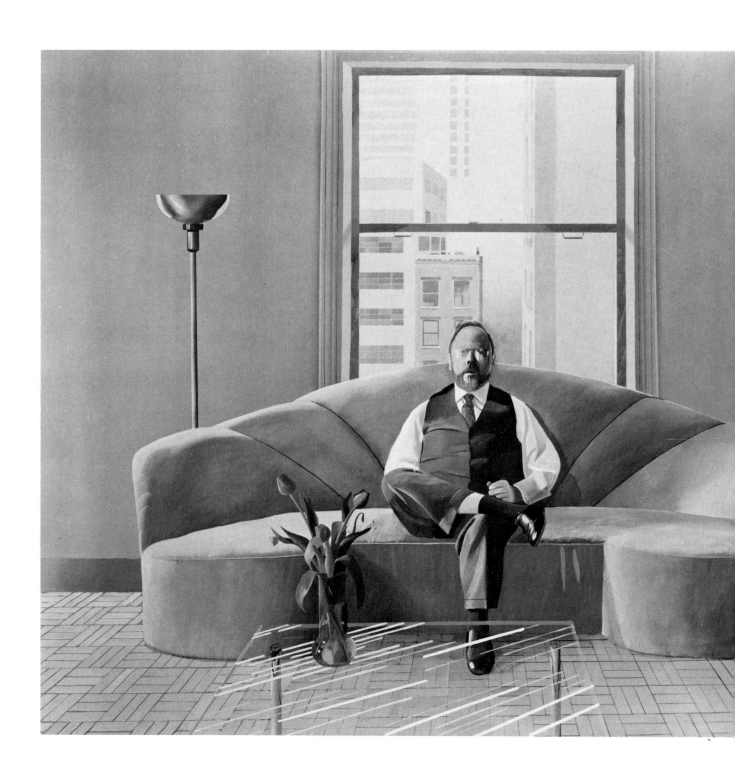

228 *Henry Geldzahler and Christopher Scott* 1969
229 *Henry Geldzahler and Christopher Scott* 1968

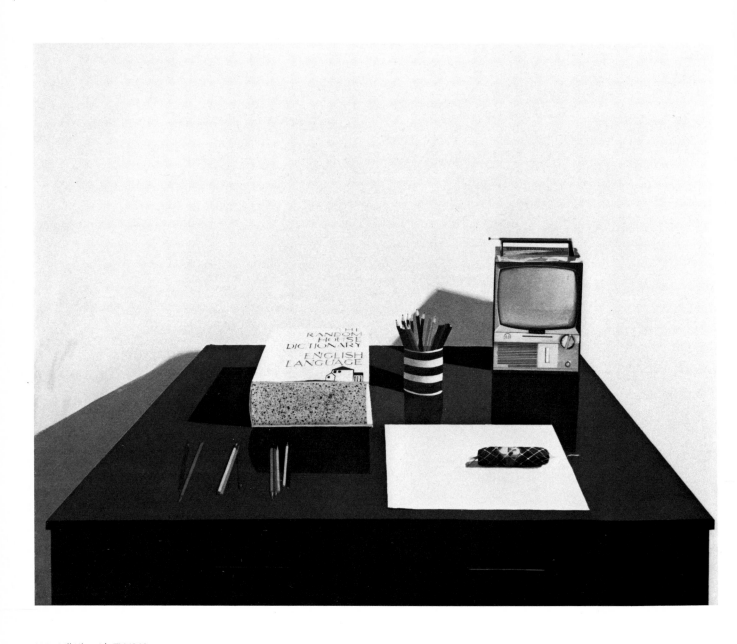

230 *Still Life with TV* 1969

231 *Corbusier Chair and Rug* 1969

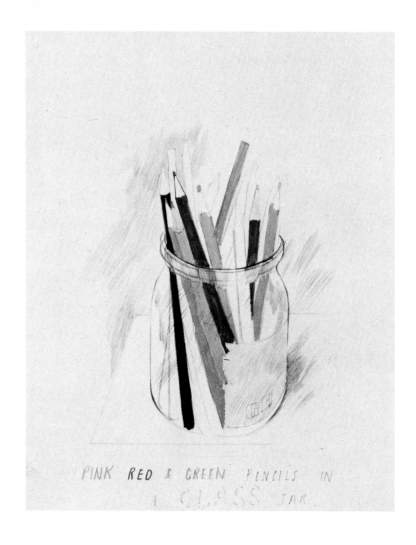

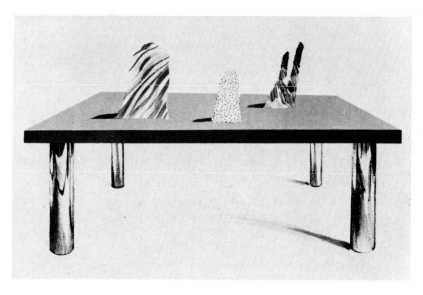

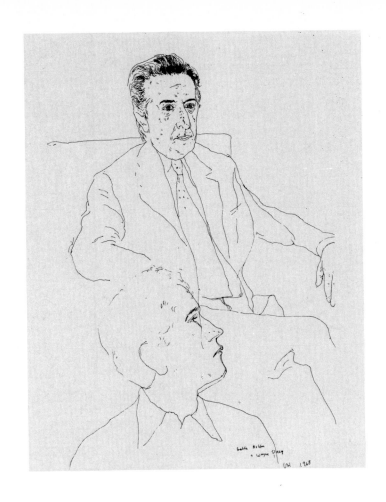

244 *Frederick Ashton and Wayne Sleep* 1969

245 *Wayne Sleep* 1969

246 Peter 1969
247 Mo in Profile 1969

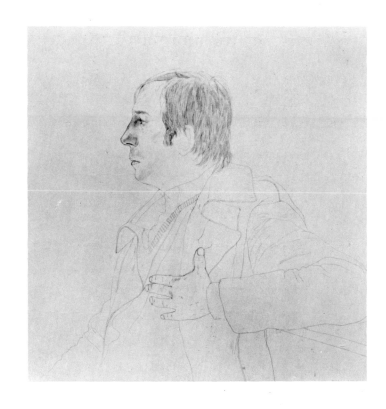

248 *Portrait of Michael Chow* 1969
249 *The Connoisseur* 1969
250 *Portrait of Felix Mann* 1969

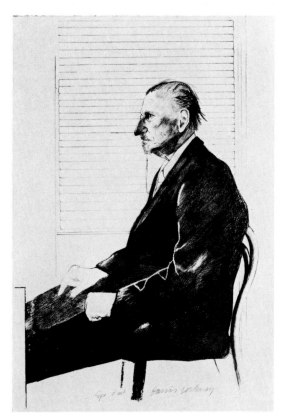

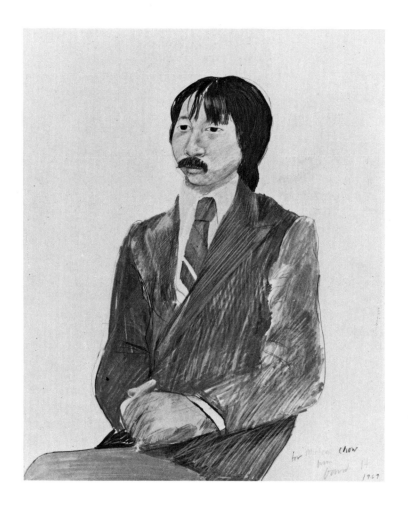

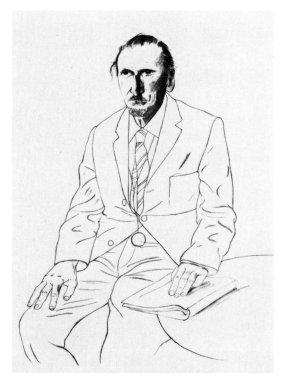

When I decided to do the portrait of Henry Geldzahler and Christopher Scott, I went to New York for just a week to draw; for five days I was in bed with flu. But before I came back to London I made careful drawings of Henry, Christopher and the sofa in Henry's apartment on 7th Avenue, where I planned to set the painting, and I photographed the room, the floor and the views from the window.

Life studies from the nude

The day before I came back, I'd gone to 42nd Street and bought some male nudist magazines. When I got back they were seized by the Customs at London Airport. I arrived at the airport with the magazines just rammed in the top of my bag. In those days they weren't in any sense pornographic; they were just nudes. They were very unsexy, strangely unsexy; they were boys in sylvan glades, a bit artistic, old-fashioned artistic. A very young Customs officer took them off me and said We're seizing these; they're pornographic. And I said Oh, come on, they're not pornographic at all. I was still recovering from flu. I said You've picked the wrong person this morning; I'm not just a little businessman who's not going to say a word. I'm going to fight you, I'll go to court if necessary. So the guy brings a senior Customs man, who finally says No, we're taking them away. I said Well, I'll see you in court; I'll fight it. So I got the receipt for all the magazines written out in this repressed little handwriting, *Golden Boys* and *Naked Youth*. I was very annoyed they'd been taken away. When I got back into London I phoned Norman Reid, at the Tate, and said I'd had these magazines taken away. The point was, I did use magazines like that to draw figures. It wasn't the sole reason I'd bought them, of course. I said I don't see any reason why they should be taken away; there's quite a legitimate reason for my having these magazines; they're just nudes. And Norman Reid said All right, I'll write a letter; which he did, and sent it to the Customs.

I kept phoning the Customs, the head offices in the City, and each man I got said Yes, they're pornographic, we're seizing them; I've passed them on to my superior. Each time I said Well, I don't want to talk to you, I want to talk to your superior, if you've got one. And as we went higher up and higher up, they were still saying Yes, they're pornographic. So finally I got to the top guy, and he said Yes, we're seizing them, they're pornographic. So I said Come on, I'm giving you one last chance. Why are they pornographic? And he said Why, in one of the pictures the boys have painted their genitals with psychedelic colours. I cracked up laughing on the phone and thought, if he doesn't think it's funny, I can't communicate with him at all; no matter what you say the message will never reach him. I remember saying to him Are you an art expert? What are you? He said he was trained as an economist. I said No wonder the place is going to rack and ruin if all you're doing is looking at nudist magazines. And he said No, I've an interest in art, I like art. Anyway, I told him I would see him in court. Afterwards I kept looking for his name in the honours lists. It's sad he was incapable of seeing the beauty of nude boys.

I got hold of Kenneth Clark and said I want you to come to court because we're going to fight this. It was about a year after the United States Supreme Court had decided that the nude *per se* was not pornographic. Why they had to decide it then I don't know, but they had, and I was quite confident that even in the English courts I would win my case. I phoned the National Council for Civil Liberties and they said You're quite right to fight it, but if you lose you'll have to pay the costs. If you win they have to pay them, but if you lose it might cost about five hundred pounds. I said All right, I agree to that; I think I should fight it and I can afford the five hundred pounds if need be. They said If you fight it, of course there'll be publicity. I said Well, whatever you say; you'll have to help me. I didn't have a solicitor. So it was in the newspapers; they issued a statement saying 'Magazines Seized from Artist'. My mother called me up and said Isn't it awful when you need them for your work. It had

become quite amusing. I began to think it'd be nice having my day in court, my first litigation, and I'd begun to get the people lined up. Suddenly the Customs phone up and say We've reversed our decision; you can have them back. The National Council for Civil Liberties had got a solicitor who said to the Customs Now before you destroy them, they must be legally condemned; that's the law. The moment it was arranged that the case would go to court, it must have gone to the Home Secretary. He probably looked at the magazines and said Give them back; it's not worth fighting. He probably also thought I would win. A man with OHMS on his hat delivered them to me in a big envelope with 'On Her Majesty's Service' printed on it – *Golden Boys* and *Naked Youth* and all that.

Meanwhile, I was working on the painting of *Henry Geldzahler and Christopher Scott*. When I got back to London, about December 1968, I started the picture straight away. It took me about two or three months to paint. To draw the floor I laid tapes from the vanishing point, which is about two inches above Henry's head, to the bottom of the canvas. At one point in the work there were twenty or thirty tapes radiating from his head. I photographed the picture then – it looked like an incredible radiant glow from a halo round his head, with an angel in a raincoat visiting him.

I was becoming more aware of and interested in the possibilities of specific light sources and shadows. They can put more space in the picture; they can also make it look more 'academic'. At first this worried me a little, but I became so convinced of the necessity, for me, of using such traditional ideas that I realized the worry was ridiculous; the pursuit and examination of ideas which were new to me were more important than what this particular picture looked like. I had also come to see that a great deal of the work passing itself off as modernist was junk. If you come to a dead end, you simply somersault back and carry on.

While I was working on the *Henry Geldzahler and Christopher Scott* painting, I painted *Still Life with TV* and began the plans for the painting of Ossie and Celia [*Mr and Mrs Clark and Percy*] and for a painting of Vichy, in France, taken from drawings I'd made there in 1969; it later became *Le parc des sources, Vichy*. But for the whole of 1969 there's no other painting, because in about March I started the etchings for *Six Fairy Tales from the Brothers Grimm*. It was something I'd been wanting to do for a few years, and by then I'd got enough material to start. I did quite a few drawings for it; I was drawing a lot at that time, and as I drew more and more the drawings began to get more complex. I drew W. H. Auden, Angus Wilson, Stephen Spender, Peter Langham and many others. Because I'd been painting portraits, I started drawing more direct portraits. I started doing that in 1966, but by 1968 and 1969 I was doing a lot.

The Auden drawings were done because Peter Heyworth, the music critic for the *Observer*, asked me if I'd like to draw Auden and I said certainly I would, just because I wanted to meet him. He was staying with Peter Heyworth, who arranged a time for me to go. Ron Kitaj and Peter Schlesinger came along with me. I thought Auden wouldn't mind Peter, a nice attractive boy. I was imagining he'd be a bit like Christopher Isherwood. Christopher might have objected if you took a few artists, but if there were beautiful boys in the background, he wouldn't complain at all, he'd be delighted. But Auden was a bit grumpy about having three people there, and my impression of him then was that maybe he was playing a role, the grumpy man, because he complained all the time about pornography. He talked all the time. He said every time he went to the railway station in New York to make a journey and he wanted to read detective novels, it was all pornography now, all pornography. He gave me the impression of being rather like the headmaster of an English school. I did three drawings that morning, two of which were OK. In the third one he looked like Oscar Levant; it was a

Grimm Fairy Tales

230

251

260–88

240

239, 237

front view, terrible; I tore it up later. I showed them to him and he commented on them. I don't think he had much visual feeling but I'm always quoting those lines from Auden's *Letter to Lord Byron* – I love them: 'To me art's subject is the human clay/Landscape but a background to a torso; All Cézanne's apples I would give away/For a small Goya or a Daumier.' I think they're marvellous lines, and very sympathetic. They were written about 1937. I know Cézanne's apples are very special, but if you substitute 'all Don Judd's boxes I would give away, or for that matter all Hockney's pools, for a small Goya or a Daumier' it has more meaning. I'm sure that's what he really meant.

Six Fairy Tales from the Brothers Grimm were published by Petersburg Press, Paul Cornwall-Jones. In 1961 and 1962 I'd done some etchings based on Grimm stories, *Rumpelstiltskin*. I'd 36, 37 always enjoyed the fairy tales very much and thought I'd like to illustrate them, make a book rather like the Cavafy book, taking some of the stories; I'd read them all, about three hundred and fifty. By the time I began the etchings I'd decided to cut it down to about twenty stories. I'd done a bit of research into other illustrations of the stories. I'd found a few illustrated copies in Germany and there were the illustrations by Arthur Rackham and Edmund Dulac, which were quite famous in England. I'd got quite a bit of material to use for architectural details from my trip up the Rhine, but not too much; I wanted to dig in it rather spontaneously. In the end I kept cutting out the stories, realizing I couldn't illustrate too many. Some of them were quite long. I first cut it down to twenty; fifteen were translated and eventually I just used six. There were twelve that I really chose and I've still got this other six I might do one day. There are thirty-nine etchings published, although I made about eighty.

They're fascinating, the little stories, told in a very very simple, direct, straightforward language and style; it was this simplicity that attracted me. They cover quite a strange range of experience, from the magical to the moral. My choice of stories was occasionally influenced by how I might illustrate them. For example, *Old Rinkrank* was included because the story begins with the sentence, 'A King built a glass mountain.' I loved the idea of finding how you draw a glass mountain; it was a little graphic problem. I included other stories simply because they were strange. *The Boy Who Left Home to Learn Fear* is such a strange Gothic story; I'd no idea how to illustrate it. I only knew I wanted to do it. I think the best-known stories in England are *Rapunzel* and *Rumpelstilzchen*. *Snow White* is very well-known and would have been interesting to do, but I rejected it in the end partly because it's too well-known, and Disney's film, although I admire it, slightly put me off.

I set up my studio in Powis Terrace with Maurice Payne, my assistant; he did all the technical work on the plates. We cleared the studio of paintings and set up tables covered with plastic to do work on them with acid. The acid bath was put up out on the little balcony, otherwise the fumes would have gone everywhere. As it happened they got to a lot of places and everything metallic in that room went rusty later because of acid fumes. Maurice prepared many, many plates, and to proof them he had to drive down to the Royal College.

I've forgotten exactly how I began. It was clear in my mind that I wanted to make this into a picture book. I wanted it to be a real book, not in the French sense of an artistic book with loose pages. Therefore, on each page there had to be a picture, never a whole page of type. At first I'd no idea how to get round the problem of how to print an etching on the back of an etching. We did it by simply doubling over the paper. George Lawson suggested that; it's an idea which comes from Japanese books. When we solved this problem I was very thrilled, because it meant we could make the book so that each time you turn a page you see the picture on the next page first, before you read the text it's illustrating.

We vaguely decided on the size of the book. As soon as I began illustrating it, Paul Cornwall-Jones started having different types set up. Then I realized that some stories were longer than others, and the longer the story was, the more illustrations were needed because I wanted to have a picture on every page. So I had to keep adding. I'd think a story was finished and then because of the typography and the pages we'd decide we needed more pictures. The pictures are supposed to illustrate the text, but they do it differently from usual fairy-story illustrations, which generally show the most dramatic event in the story, perhaps a confrontation between the characters. If you're only given one illustration for each story, that's what you would choose. I decided that this method was too ordinary; I thought I should begin by just taking details of a story. I began by the *Old Rinkrank* story and did at least six or seven versions of the glass mountain. I remember breaking a sheet of glass and piling it up and then drawing it so it was jagged. In the end I just used the technique of reflection, so you can see a building through the mountain and the glass magnifies what is happening behind. 282–4 282

I did do little drawings, but often I'd work straight on to the etching plate; that's why in the end I finished up with eighty. I wanted a spontaneous effect, so I didn't want to make a detailed drawing and simply copy it on to the etching plate. The drawings are just quickly done, they're real working drawings for prints, working out the style and the references. For example, at times I make references to the period; generally, of course, they were medieval folk tales. I knew that. So for dress and things like that, it's roughly the correct period. I found myself using painters of that period, Carpaccio mostly (especially good for costumes), Uccello, Leonardo da Vinci. I used to get letters from German art historians saying Did you use this for that, and this for that, as though they'd discovered something. I thought it was all perfectly obvious: I was *quoting* Carpaccio or Leonardo.

Sometimes I'd take slight liberties with the stories. For instance, in *Rapunzel*, which is about an old lady, she's called in my translation an enchantress – I've forgotten the German word, but I remember having quite a few discussions with the translator about whether she should be called that or a witch; there's a difference in English between an enchantress and a witch. A witch seems a totally wicked woman; an enchantress is less wicked, really, and after all this woman in the story doesn't keep the child; she's quite kind about it. So I thought the word enchantress was better. In the story she wants the child from a couple who live next door and keep stealing her lettuce. It's a marvellous mad story, if you suddenly put it in modern times: a lady who lives in a little semi-detached house and the couple next door who keep pinching her lettuce; she can cast a little spell and she says You can have the lettuce if you give me your child. It means that the old lady couldn't have a child, that's why she wanted somebody else's. So I assume she must have been an old ugly virgin. I thought, here's an opportunity to point this out visually because there's a very well-known visual subject and convention of the Virgin and Child. So I used the Virgin and Child from Hieronymus Bosch; that's the pose. The face of course is altered to make her ugly. The trees are from Leonardo da Vinci. When you look at it, just visually that picture tells you she's an old virgin, because I've used as a subject the Virgin and Child convention – which is playing with the story a bit and taking slight liberties with it. I did that all the way through. 269–72 270

There are all kinds of references. For example, the room full of straw is a reference to Magritte – those paintings where he's playing with scale. Then there's one which is really abstract: soft lines on the left and hard lines on the right. I called it 'Straw on the left, gold on the right' to show the difference. A line of gold and a line of straw: one is going to be hard and the other is going to be soft. 286

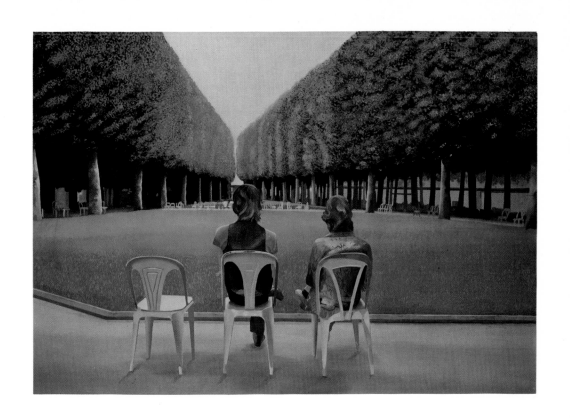

251 *Le parc des sources,*
 Vichy 1970

252 *Mr and Mrs Clark and*
 Percy 1970–1

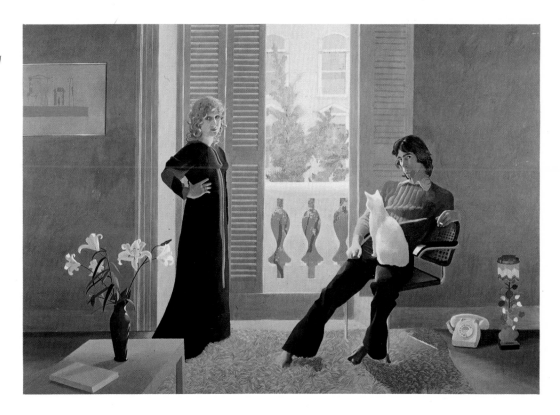

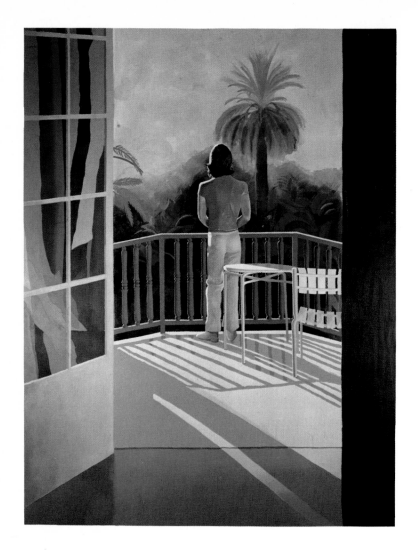

253 *Sur la terrasse* 1971
254 *Peter on Balcony* 1971

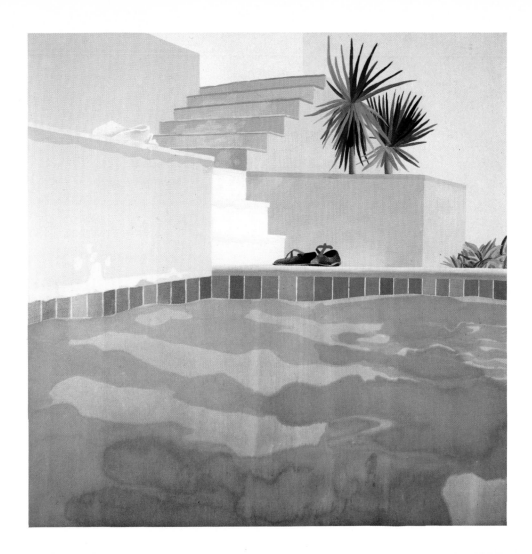

255 *Pool and Steps, Le Nid du Duc*
 1971
256 *Still Life on a Glass Table* 1971–2

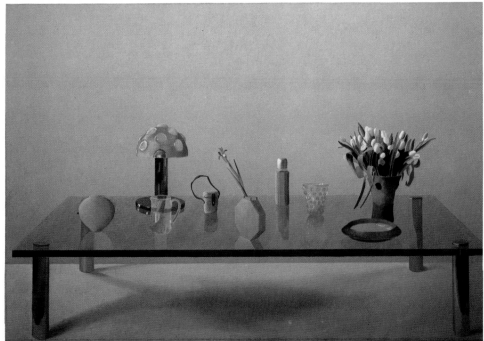

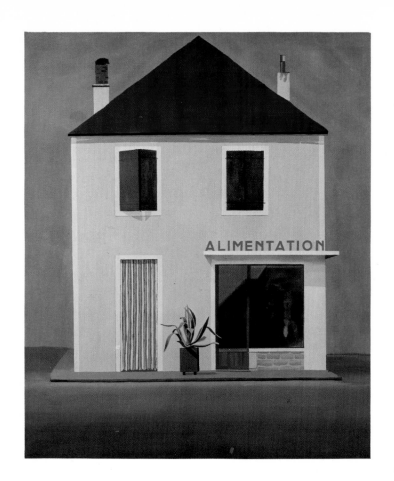

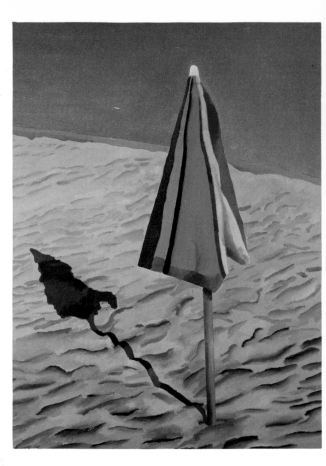

257 *French Shop* 1971

258 *Beach Umbrella* 1971

259 *Rubber Ring Floating in a*
 Swimming Pool 1971

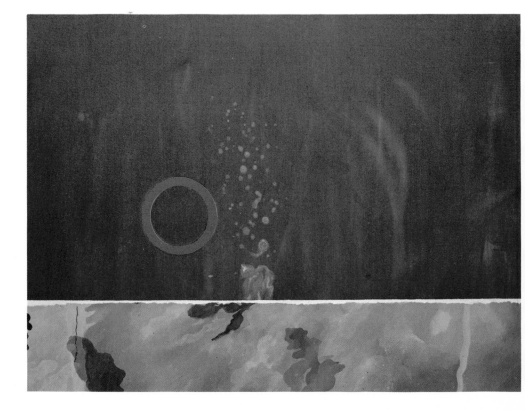

It was very enjoyable working on it. Once I got going I could work quite fast with Maurice Payne, and the more I got going the less I needed to make drawings for the etchings. In the end I only needed to make drawings for technical things, such as the ones in *The Little Sea-Hare* where the figure gets lost in something, 'The boy hidden in an egg' and 'The boy hidden in a fish'. Mo posed for those drawings. And in the same story there is a princess who will only marry the person who can hide from her; and the way he hides is by changing himself into a little sea-hare (which is a mythical thing, anyway) and hiding inside her, under her hair. Again it seems such a strange sexual story – as though she wants a child inside her, without somebody screwing her, really. So in the end, instead of making a little sea-hare and worrying what it looked like, I made the little child, as though the princess is pregnant, and the one place she can't look is inside herself. They are marvellous, strange stories. In *The Boy Who Left Home to Learn Fear* the illustration of the ghost, like those Magritte stone paintings, is just from the phrase: 'The . . . ghost stood still as stone.'

They were marvellous to do, and built up and up. I could have gone on and done the whole twelve stories quite easily, working just another three, four months probably. But by the time I'd done the six stories, we'd already reached thirty-nine illustrations, and the cost of producing the book was going to run quite high, so we had to stop. I finished it about Christmas 1969. Paul Cornwall-Jones did a great deal of work on it. Without him the book would have taken me three times as long; he was the real impresario. Eric Ayers did the typography, and the three of us designed it. Paul had the paper made and it was printed in Amsterdam. At that time each book cost about ninety pounds to make, just the production costs, without any fees, which I thought was a great deal of money. I kept going to Amsterdam when they were printing them. It took about a year to print the whole thing. Oxford University Press had printed the text, real old-fashioned typeface, set by hand and spaced by the eye and not by a monotype machine. A little version of the book was produced photographically to advertise the big book and we were just going to print five thousand of those. Oxford University Press did them; it was Paul's idea. And then Oxford University Press, when they saw it, said could they buy a couple of thousand of them. So Paul said, Yes; print twenty thousand. I thought he was mad. I said What are you going to do with twenty thousand? He said Well, if they want two thousand we can sell the rest. It was a nice idea. They sold for a pound; they've had two reprints since and they're actually on a third reprint; so sixty thousand have been done of this little one, and they've sold forty thousand. I suppose they'll go on selling it.

These etchings turned out to be some of my most well-known works. They're a 'major' work in that they took a long time, nearly a year, to make, just from the artistic point of view; if you'd worked on a painting for a year you'd think of it as a major work. The big book of course is better than the little one; it's a pleasure to look at, I think. If you like etchings, it's very nice. But I love the idea of forty thousand people being able to afford to look at the little book. I found children loved it because of its size; their little hands loved the idea, it's on their scale. The way children's books are the same size as everybody else's is wrong, I think.

They're more complex than my previous etchings. First of all, instead of using aquatints to get tone I decided on a method of cross-hatching, which I used throughout. I just stumbled across it, and thought it was quite a good way to do it. And then I found that you can get very rich black by cross-hatching, then etching, then putting wax on again, and then drawing another cross-hatch on top on another, on another; the ink gets very thick, and that's why the real etchings are more interesting than the prints in the little book. The trouble with the little photographed version of the book is that, though it's very good on line, all the rich

262
264

276

201

blacks are lost. The real ones are much richer in tone. It was a step forward for me in etching techniques. Yet later on, when I worked with Crommelynck in Paris in 1973, I learned more in three months about etching than in all the years I'd been doing it. I discovered many, many techniques that I just hadn't been able to do before. I used a very elaborate technique Crommelynck taught me in the big coloured etchings of the French windows, the *contre-* 385 *jours*. So if one day I do the other six Grimm stories, the technique would be very different. It would be nice to do them.

The painted garden Early in 1970 I began *Le parc des sources, Vichy*, which I'd planned six months or so before and 251 had never been able to start because the studio was completely taken up with etching material for the Grimm tales. About ten months had gone by and I hadn't done any painting at all; it was only the first time in ten years that had happened. *Le parc des sources* is a great big picture, the same size as the double portraits. I began working on it in January and it took much longer than I expected – previous to that, the longest time I'd spent on a painting was about three months, working every day all the time on one picture. There's a strong surrealist element in the painting because of the use of the false perspective, which is really what interested me. The actual trees there form a triangle, not an alley just disappearing into the distance. It's a triangle of trees which diminishes in size, an artificial thing. That's what caught my eye. The idea of the picturesque comes from painting, and gardens and landscapes were planned after Claude or Poussin, although formalized gardens are on the whole a purer art than painting; their sources are in geometry and sculpture.

I'd first visited Vichy in, I think, 1968. I've been back almost every year since then. It's a very pretty town with a park in the middle, a kind of formal garden, and they use this false perspective of trees to make it look longer than it really is. And I thought, it's marvellous, the whole thing is like a sculpture. I could see it as a sculpture then. I'd come into contact with Gilbert and George before this. I was in one of their first sculptures, *The Meal*, in a house in Bromley; they simply cooked a meal and the audience sat and watched us eat it. I was their guest. It was delicious, served by Princess Margaret's butler, very properly, eight courses, all with marvellous wine; it was a very formal dinner, and it was all photographed and documented. They had the menus printed with a stain of each thing; tapioca soup and a tapioca soup stain; sherry and a sherry stain, etc.; a little conceptual art document. So in 1970 I could look at a group of trees and say, because they'd been planted and arranged in some way, It's like sculpture, because of what one or two other people had done in sculpture. Ten years before you wouldn't have thought like that.

In 1969 I made a journey to Vichy specially to draw and photograph it all again. I took with me Peter Schlesinger and Ossie Clark, because I wanted to set the three chairs up for the three of us, me, Peter and Ossie; then I'd get up to paint the scene. That's why the empty chair is there – the artist has had to get up to do the painting. It's like a picture within a picture; I was going to call it 'Painting within Painting', like *Play within a Play*. That gives it the strong surrealist overtones. It's actually a perfectly natural scene, there's no real oddness in it. It's just a mood created by this strong V in the perspective, slightly off-centre.

After I'd started the painting, it began to be a struggle. I think the difficulties stemmed from the acrylic paint and the naturalism, the fight to achieve naturalistic effect, the difficulty of blending colour, things like that. It was ready in April 1970, in time for my big retrospective at the Whitechapel Gallery, but it had taken four months to paint.

I had had a small retrospective at the Whitworth Gallery in Manchester in 1968, but there were only about fifteen or twenty paintings in it. The Whitechapel exhibition, which

was organized by Mark Glazebrook, showed ten years' work, about thirty paintings, a great many drawings and all the prints I'd ever done, including the Grimm Fairy Tales. It took up all the space at the Whitechapel. I never saw the exhibition at all before it opened. I helped Kasmin choose the paintings to go in it, but the actual bother about hanging it, I didn't care. I'd never hung exhibitions of mine, anyway, at Kasmin's; he did it; he always did it better than I did. I'd say Put them there, then Kas would come in and rearrange them, and they always looked better. So I thought, I'm no good at hanging, Mark Glazebrook can do it; it just doesn't matter. I tend to think you can hang figurative pictures anyhow. You can stick them on a wall, like Gertrude Stein did, one above the other. You're supposed to look at each one individually, not like looking at a Rothko, for instance, where you need space round it to feel it.

I was away in France, with Christopher Isherwood, and we came back the day before the exhibition opened and went to the opening like everybody else; so it was a surprise to me. I must admit, just a few days before we came back, I began to think Oh my god, all those early pictures which I haven't seen in ten years are going to look terrible; I'm going to be really embarrassed by them; it's going to be terrible. When I saw them, though, I thought, they do stand up; they're not that bad. I began to see for the first time the way things worked, the way my mind was working. I'd never been able to stand outside it before. I could see the way things progressed, how I'd taken one aspect of a painting and developed it in other pictures so that it changed, quite visibly; it was the consistency of it that surprised me. It's an experience, after all, that not many artists have. A poet can always have his whole work round him and in a day he could probably re-read all his work. That's why poets keep repairing their poems years afterwards. A painter can't do that. If you make your living from painting, the paintings disappear, they're sold, they're gone and you can't do anything about them. Then you think, I wish I'd never let that go; it's terrible. This had never occurred to me before the exhibition. Seeing my work like that, it became something different. Then having the catalogue, where you could flick through ten years of your work on a page – it does have an effect on you. It dawned on me how protean the art is; it's varied, with many aspects, many-sided. I should have known it, and probably did half-know it, but you don't fully realize things like that. I'm not saying I didn't know the weaknesses of the pictures, but seeing the whole body of his work, I think, is quite good for any artist. It's a shock and you see all the faults, but you see the virtues too. Usually all you ever have in your studio is, at the very most, perhaps a year's work.

I had finally started on the portrait of Ossie and Celia [*Mr and Mrs Clark and Percy*], which I'd done little drawings for in 1969, when I was working on the Grimm etchings. I kept taking photographs, making drawings, trying to work out a composition; for these big paintings I worked out the composition before I began, although I didn't draw them out totally. They're often drawn with a brush. I must have begun this painting about April or May 1970 and I didn't finish it until about February 1971; it was in an exhibition at the National Portrait Gallery, together with all the drawings and photographs used for it.

I think now, looking back on it, that apart from the unfinished picture of George Lawson and Wayne Sleep this is the painting that comes closest to naturalism; I use the word naturalism as opposed to realism. The figures are nearly life-size; it's difficult painting figures like that, and it was quite a struggle. They posed for a long time, both Ossie and Celia. Ossie was painted many, many times; I took it out and put it in, out and in. I probably painted the head alone twelve times; drawn and painted and then completely removed, and then put in again, and again. You can see that the paint gets thicker and thicker there.

252

392

203

The one great technical problem in it is that it's *contre-jour*; the source of light is from the middle of the painting, which does create problems. It's easier if the source of light is from the side and you can't see it, because if you *can* see it, it has to be the lightest thing in the painting, and so it creates problems about tone. I think I'm not that good with tone; it's a difficult thing always working it out. To come to terms with tone, you have literally to be in front of something, and really look and see carefully what tonal values really are; you have to look and look. Well, this painting wasn't painted like that. Although the figures were painted from life a great deal they were posed in my studio because the painting is very big. What I wanted to achieve by such a big painting was the presence of two people in this room. All the technical problems were caused because my main aim was to paint the relationship of these two people. Somebody, I think it was Kynaston McShine of The Museum of Modern Art in New York, commented that most of my double portraits are like Annunciations; there's always somebody who looks permanent and somebody who's a kind of visitor. Here, it's odd that Ossie is sitting down; it should really be the lady who's sitting down, but Celia's standing up. That alone causes a slight disturbance, because you know it should be reversed.

A commissioned portrait

In 1970, just before I started the only commissioned portrait I've ever done, *Portrait of Sir David Webster*, I went to California on my own. I knew Peter wouldn't come with me; it was the one place he didn't want to go with me. If I went to the Continent, he always came, but to California he didn't, and I liked going to California. My relationship with Peter was still all right then, except that I'd lived with him for nearly five years and it had probably got a bit boring sexually for both of us. So it was at the back of my mind that I wanted to go to California for some adventure. The day I came back, three weeks later, Peter said he was going to Paris, which I thought was a bit odd. And then I realized he was having an affair with someone else. At first I was a bit hurt, and then I thought, well, there's nothing I can do about it, really. After all, I'd just been to California to release myself, as it were. And I thought, it's probably temporary; can't always expect the magic of something to go on and on.

308

Meanwhile, I started work on the painting of David Webster. When I was asked to do it I refused at first. David Webster asked me himself; he was retiring and Covent Garden said they would like a portrait. I didn't know him but I was an opera fan, so he asked me. I was polite and said I don't do commissioned portraits and I might perhaps do a drawing. But later on a few people said Why don't you do it? First of all, he's quite an interesting man, and if you've never done a commissioned portrait, how can you say you can't do them, or shouldn't do them? At least you should do *one*. And the argument was quite convincing. I thought perhaps I should. Now I've done one, I would never do another, but at the time I thought, well it is an interesting idea to do somebody that asks me, rather than my choosing him. In the past I'd chosen to do people because I knew something about the relationship. So I agreed, and then I found it really difficult. Even before I began the painting, I didn't know how to do it, what setting to do it in. I went to visit David Webster many times; he had a rather attractive house just off Harley Street. But it took me a long time to find the subject. I kept going to see him, trying to find it, while I was painting the Ossie and Celia portraits, and quite a long time – months – went by. Then they began to natter me, When will it be ready, he's retiring on this date, and so on. And in the end I thought, all I can do is paint him in my studio. So that's the setting; the table and chair and flowers are in my studio. I started the painting in 1971. I decided how to do it: I would just sit him in front of me. He came to pose, but it was difficult doing him because he kept falling asleep. He was ill; I didn't know it then, but he was dying. I did a lot of drawings, usually when he was asleep, and when he was awake I took a lot of photographs so that I could paint from them.

307

260 'Catherina Dorothea Viehmann'

Rapunzel

A man and a woman had long wanted a child, and they believed that at last their wish would come true. The house in which they lived had a small window at the back which looked out on a wonderful garden with lovely flowers and herbs. But it was surrounded by a high wall, and nobody dared go in for it belonged to a powerful Enchantress.

One day the woman was standing at the window looking into the garden when she noticed a flower bed. Planted with the most luscious rapunzels, it looked so fresh and green that she couldn't leave the window. 'I must have some', she thought, but since she knew it was forbidden, she grew pale and miserable. Her husband was worried and asked: 'What's wrong with you?' 'Oh, I saw some wonderful rapunzels in the garden behind the house, and if I can't have some I shall die.' The man loved his wife and wanted to help: 'I can't let her die,' he thought, 'I must get her some rapunzels whatever the cost.'

As it grew dark he sneaked into the garden, snatched a handful of the plants and took them to his wife, who quickly made herself a salad. It was so delicious that the next day she longed for more; and to calm her, her husband climbed into the garden once again. He was given a terrible fright when the Enchantress crept up behind him. 'How dare you,' she cried out in a rage, 'how dare you climb into my garden and steal my rapunzels?' 'I know I've done wrong,' he pleaded, 'but pity me. I was forced to do it; my wife saw your rapunzels from the window and she wanted them so much that she certainly would have died if I hadn't

stolen her a few.' The Enchantress was cunning: 'If that's the truth,' she replied, 'I'll let you take all the rapunzels you want. But there is one condition; you must give me your child as soon as it is born. It will have a good life and I'll care for it like a mother.' In his terror the man agreed, and when the child was born the Enchantress took it away and named it Rapunzel.

Rapunzel was the most beautiful girl under the sun. When she was twelve years old the Enchantress led her deep into the forest and locked

her up in a small room high up in a tower, which had neither doors nor steps but only one window at the very top. When the Enchantress wanted to enter she stood under the window and called:

> Rapunzel, Rapunzel
> Let down your hair.

Rapunzel had long blond hair. When she heard the Enchantress calling she would wind it round a window-hook and let it down to the ground, so the old woman could climb up.

A few years later a Prince was riding through the forest and, as he

passed by the tower, he heard a beautiful voice and stopped to listen: Rapunzel was singing. The Prince longed to see her and searched for a door but the tower had none. He couldn't forget her voice and came to listen every day. Then one afternoon he heard the Enchantress calling:

> Rapunzel, Rapunzel
> Let down your hair.

Rapunzel let down her hair and the Enchantress climbed up. 'Oh! If

that's the ladder,' he thought, 'then I can climb up as well.' And when it was dark he went to the tower and called:

> Rapunzel, Rapunzel
> Let down your hair.

Her hair fell down and he climbed up. Rapunzel was very frightened for she had never seen a man; but the Prince was kind and told her how the song had moved him. When Rapunzel saw how young and handsome he

was, she thought: 'He will love me better than the old woman.' She put her hands in his and said: 'I wish I could go with you, but I can't get out. Each time you come bring a roll of silk and I will weave a ladder. When it's finished we'll escape together on your horse.' And to keep out of the old woman's way they agreed he should come only at night.

The Enchantress didn't suspect anything until one day Rapunzel said to her: 'Tell me, why are you so much harder to lift up than the young Prince who comes every night?' 'What's that you're saying? You horrid girl!' the old woman screamed. 'I thought I had hidden you from everyone; but you have cheated me!' She was so angry that she grabbed Rapunzel's hair and cut it off with a pair of scissors; the lovely blond hair fell to the floor. Then the cruel Enchantress carried the girl off to an endless desert and left her to look after herself.

The day she cast out Rapunzel the old woman fastened the long blond hair to the window-hook. When the Prince came and called:

> Rapunzel, Rapunzel
> Let down your hair,

she let it down and he climbed up; but instead of Rapunzel he found the Enchantress. 'The bird has flown,' she sneered, 'the cat has got it and will scratch out your eyes as well. Forget Rapunzel, you will never see her again.' In his sorrow the Prince threw himself from the window. He wasn't killed, but his eyes were pierced by thorns, and blinded, he staggered away. Roaming through the forest, helpless and in great pain, he ate nothing but roots and berries, and wept and mourned the loss of his lovely Rapunzel.

Years later he reached the desert where Rapunzel lived sadly with the twins she had born. When at last she saw him coming she called his name and he knew it was her voice; and as they embraced and wept, two of her tears fell on his eyes and he saw again. So he took her with the children to his kingdom, where they lived happily for many years.

The Boy who left home to learn fear

A farmer had two sons. The elder was clever and knew his way around, but the younger one was stupid and good for nothing. When people saw him they said: 'That boy will give his father trouble.' It was always the elder boy who had to help his father; but if he was sent on an errand late at night and on the way he had to cross the churchyard or some other dismal place, he would plead: 'No father, I'd rather not go, it makes me shudder.'

When the younger brother sat in a corner and heard people telling ghost stories by the fire, he couldn't understand them when they said: 'Oh, that makes me shudder!' 'Why do they always say it makes me shudder, it makes me shudder,' he asked himself, 'I can't shudder—that must be something I have to learn.'

One day his father spoke to him: 'Listen my boy, you're getting older. It's about time you started to work. Look at your brother, he earns his keep; but what do you have to offer?' 'Father, I'd like to learn something,' he answered, 'if I had my choice I'd learn to shudder; I don't know the first thing about it.' His brother grinned and thought: 'Heavens, what a fool he is! He'll never get anywhere.' The father sighed: 'You'll learn soon enough what it is to be afraid; but you won't earn a living that way.'

later he woke him at midnight and told him to go to the church to ring the bell. 'I'll teach him what fear is', he thought, as he took a short cut to the tower. As the boy was about to ring the bell, he turned and saw a white shape on the stairs. 'Who's there?' he called, but the figure was silent. 'Speak up or get out. What do you want here anyway?' Expecting the boy to take him for a ghost, the sexton didn't move. So the boy shouted again: 'What do you want here? Answer me, or I'll throw you down the stairs!' But the sexton didn't take the threat seriously and stood perfectly still. The boy gave him one more chance but when he got no answer he

A few days later the father was telling the sexton his problems: 'The boy's so stupid; he won't work and can't grasp the simplest thing. Just think, when I asked him what he wanted to do, he said he was going to learn to shudder.' 'If that's all he wants,' the sexton grinned, 'I'll teach him. Leave it to me; I'll straighten him out.'

So he took the boy on and gave him the job of bell-ringer. Some days

jumped on the startled ghost and kicked him down the stairs. Then he rang the bell and went home to bed.

The sexton's wife waited patiently for her husband. After a few hours she began to worry, so she woke the boy and asked him: 'Do you know where my husband could be? He left for the church before you.' 'I don't know,' he replied, 'but a figure in white was standing at the top of the stairs, and since he wouldn't answer me or get out of my way, I took him for a rogue and threw him to the bottom. Go and see if it's your husband, I'd be very sorry if it was. That would be bad luck.' The woman rushed to the tower and found the sexton moaning in a corner with a broken leg.

She carried him back to the house and ran screaming to the boy's father: 'Your son has kicked my husband down the stairs and broke his leg! Get him out of our house immediately!' The father was horrified and went to get the boy: 'Damn you!' he cursed. 'What mad tricks have you been up to? Are you completely off your head?' 'Listen to me father,' he answered, 'I've done nothing wrong. It was midnight; a figure was standing there and he looked as if he were up to no good! I didn't know who it was and asked him three times either to speak up or be off.' 'Oh! my God,' his father groaned, 'you bring me nothing but trouble. Get out of my sight.' 'Well father, I don't mind. Just let me stay until morning, then I'll go off and learn to shudder. At least that way I can earn some money.' 'Do whatever you want, I don't care. I'll give you ten pennies, then go away, the further the better. Don't tell anyone where you're from or mention my name. I'm ashamed of you.' 'Whatever you wish, father—if that's all you ask it's easy enough.'

At dawn the boy took his money and walked down to the highway, mumbling to himself: 'If only I could learn to shudder.' He passed a man who heard him talking. They walked together for a while, and when they came to a gallows, the fellow said: 'Look, this is the tree where seven men married the ropemaker's daughter; now they're learning to fly. Just



The boy looked up at them and thought: 'If I'm cold down here by the fire, they must really be freezing up there.' He was sorry for them so he climbed up a ladder, cut them down one by one, and propped them up around the roaring fire so they could warm themselves. They sat very still, and when their clothes caught fire he shouted: 'Be careful, or I'll hang you up again.' But the dead men heard nothing and their rags burned. The boy became angry and shouted louder: 'If you don't care, why should I help you. I don't want to catch fire myself', and one after the other he hung them up again. Then he lay down by the fire and fell asleep.

In the morning the man returned to collect his money. 'Well boy, you must know by now what it's like to shudder.' 'What do you mean, shudder? Those fellows up there wouldn't say a word and were stupid enough to let their dirty rags get burned.' At this the man knew he wasn't going to be richer that morning, so he walked away muttering to himself: 'It beats me, I've never met anybody like him before.'

As the boy went off in the other direction he sighed: 'If only I could learn to shudder!' A shepherd overheard him and asked: 'What's your name?' 'I don't know.' 'Who is your father?' 'I'm not supposed to say.' 'And what are you grumbling about?' 'Well,' answered the boy, 'I wish I could learn to shudder. But no one can show me how it's done.' 'Nonsense,' the shepherd laughed, 'come along with me. I'll find a job for you.' So the boy joined him. In the evening they came to an inn where they decided to spend the night, and as they entered the bar the boy mumbled again: 'If only I could learn to shudder.' The innkeeper heard him and winked: 'If that's what you want, I can help you out.' But his wife overheard him; 'Shut up!' she said. 'For the job you're thinking of, quite a few young men have paid with their lives. It would be a crime if such lovely eyes as his were closed for good.' But the boy interrupted her: 'I don't care how hard it is—I left home to learn to shudder and

stay right here and wait until nightfall, then you'll learn to shudder.' 'That's no problem,' the boy answered, 'if it's as easy as that I'll give you every penny I have. Come back tomorrow morning.'

The boy sat down by the gallows. When night fell he lit a fire, but around midnight he began to feel cold. A strong wind was blowing and the corpses bounced against one another as they swung back and forth.

that's what I'm here for.' And he went on pleading until they told him the story.

'Not far from here is a haunted castle where great treasures are hidden; enough, people say, to make a poor man rich for life; but they are guarded by monsters and evil spirits. The King has promised his daughter to the first man who can spend three whole nights there; and it's worth the risk as the Princess is the most beautiful girl in the world. Many have gone in, but none has come out alive.'

The next morning, the boy went to see the King and asked him if he could spend three nights in the castle. The King liked his looks, so he offered him a choice of any three objects to take with him. The boy chose a fire, a lathe, and a carpenter's bench with its knife; and the King had them taken there before nightfall.

When it was dark the boy went up to the castle and built a huge fire in one of the rooms. He sat down on the lathe and put the carpenter's bench by the fire. 'If only I could learn to shudder,' he thought, 'but surely I'm wasting my time here.' At around midnight he stirred up the fire, and while he was blowing on the coals a wild cry came up from a corner of the room. 'Aaowmeeow! We're freezing!' 'You fools, what are you complaining about? If you're cold, come and sit by me.' Two great black cats leaped out of the darkness, and sitting down on each side of the lathe glowered at him savagely with their fiery eyes. When they had warmed themselves they sneered: 'Now friend, how about a game of cards?' 'Why not!' he murmured, 'but let me see your paws first.' They stretched out their legs and he saw their long sharp claws. Then he caught them by the throat, lifted them on to the carpenter's bench and clamped their paws in the vice. 'I know your game,' he laughed, 'it's no fun playing cards with you!' So he beat them to death and threw them out into the moat.

After silencing those two, he lay down to rest. Suddenly out of every

277 'Corpses on fire'

278 'The haunted castle'

279 (Left) 'The Carpenter's bench, a knife and fire'; (right) 'A black cat leaping'

280 (Left) 'The lathe and fire'; (right) 'Inside the castle'

214

corner there rushed wild cats and dogs on red-hot chains, screeching and stamping on his fire. For a while he let them do as they pleased, but when they began to get on his nerves he cried: 'Get out of here you monsters!' and grabbing his knife he struck at them. A few escaped, but most ended up dead in the moat. The boy lay down again by the fire and fell asleep.

In the morning the King came, and when he saw the boy lying on the floor he thought the ghosts had killed him. 'It's a shame such a fine boy should be dead!' Hearing that, the boy jumped up and laughed, 'It hasn't come to that yet. One night is over, and the others will pass quickly enough.' The King was amazed and so was the innkeeper who couldn't believe his eyes. 'I didn't expect to see you again. Now do you know what it's like to shudder?' 'No, it's just a waste of my time,' the boy complained, 'if only someone could teach me!'

On the second night he walked up to the old castle, sat down beside

the fire and sang the same old song: 'If only I could learn to shudder!' At ten o'clock he heard a long piercing cry. It grew louder and wilder, then stopped abruptly and all was quiet—until suddenly half a man fell

down the chimney. 'Hey, are you real? Where's your other half?' The shrieking started again and moments later the other half dropped at his feet.

'Wait a minute, I'll get a good fire going for you.' When the flames

were high, he turned and saw that the two halves had joined together to make a giant figure sitting on his bench. 'That's not part of the bargain,' the boy shouted, 'that's my bench.' He struggled with the giant and threw him to the ground; but as they wrestled in a corner they fell on nine thigh bones and two skulls, so the boy challenged the monster to a game of

skittles. He took the skulls, put them in the lathe and turned them till they were round. 'Now we'll have some fun', he laughed. They played until the clock struck twelve and then the giant vanished. The boy lay down by the fire and fell asleep.

On the third night he returned to his bench. Towards midnight six giants walked in carrying a coffin. 'This must be my little cousin', he thought, 'who died just a few days ago.' When they put the coffin down, he lifted the lid. There was a dead man inside, his face as cold as ice; so

he lifted the body out and sitting down by the fire, laid him in his lap. He rubbed the corpse to get the blood circulating, but it didn't help, so he put the body into his bed, got a blanket and lay down beside it; after a while the corpse warmed up and began to move. The boy was delighted and whispered to him: 'See what I've done for you, little cousin!' But the dead man put his hands round the boy's neck and tried to strangle him. 'Is that how you thank me?' he shouted, 'away with you'; and

grabbing the body he threw it into the box and slammed down the lid. The six giants lifted the coffin on to their shoulders and carried it away.

Soon after the walls began to shake and split apart, and in the smoke there appeared a magnificent old giant with a long white beard. 'Boy,' he thundered, 'you'll soon know what it's like to shudder. You're going to die!' 'We'll see who's going to die', the boy answered. 'Yes, we'll see,' the giant sneered, 'if you're the stronger I'll let you go.' He led the way through a dark tunnel to a blacksmith's forge, where he took an axe and with two blows drove an anvil deep into the ground. 'That's nothing', grinned the boy walking over with him to another anvil. He split it with a single blow, catching the monster's beard in the crack. 'Now I have you,' he laughed, 'it's your turn to die.' With an iron bar he thrashed the giant until he begged and pleaded with him to stop, promising him a great reward; so the boy set him free. They returned to the castle, where the giant unlocked a cellar door and showed him three chests of gold: 'One is for the poor, the second for the King, and the third is yours.' Just then the clock struck twelve and the giant vanished leaving the boy in total darkness. Next morning the King came and asked what had happened. 'My dead cousin came to see me and an old bearded fellow showed me three treasure chests in the cellar; but no one taught me to shudder.' The King was overjoyed: 'You have saved the castle,' he cried, 'now you may marry my daughter.'

The young Prince loved his wife but he still complained: 'If only I could learn to shudder!' At last the Princess's maid had an idea: she went out to a stream and caught a bucketful of fish. When the Prince was asleep she pulled his blankets back and poured the cold water with the little fish into his bed so that they squirmed and flopped all around him. The Prince sprang up: 'My God,' he cried, 'why do I shudder so?'

281 'Cold water about to hit
the Prince'

282 'The glass mountain'

283 (Left) 'Old Rinkrank
threatens the Princess';
(right) 'Digging up glass'

Old Rinkrank

A King built a glass mountain and announced he would give his daughter
to the first man who could climb it without falling. When a handsome
boy fell in love with the Princess, and went to the palace begging to
marry her, the King said: 'If you can climb the mountain, she will be
yours.' Overhearing this, the Princess thought: 'I will go with him, then
if he slips I'll be able to help him.' So they went off together and began
to climb.

Half-way up, it was the Princess who slipped and fell; and at that
moment the mountain opened and she vanished. The boy made his way
back sadly to the palace where he told her father of the terrible accident.
The King, fearing his daughter was lost for ever, sent his men to break
into the mountain, but no one could find the spot where she had dis-
appeared.

The Princess had fallen deep down into a cave where an old man with
a long grey beard was waiting for her; he caught her by the throat and
threatened her with a long sharp knife until she promised to cook his
dinner, make his bed, and do any other jobs he had for her. Every
morning the old man took a ladder out of his pocket, climbed to the top

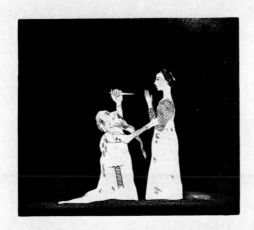

It's me poor Old Rinkrank
On my seventeen-foot legs
On my one great swollen foot
Mother Mansrot do the dishes.

'I've done the dishes', she replied. So Old Rinkrank shouted again:

It's me poor Old Rinkrank
On my seventeen-foot legs
On my one great swollen foot
Mother Mansrot make my bed.

'I've made your bed', she replied. So Old Rinkrank shouted again:

It's me poor Old Rinkrank
On my seventeen-foot legs
On my one great swollen foot
Mother Mansrot open the door.

of the mountain and drew it up after him; and at night, when he came
home, his pockets were full of gold and silver.

After many years she called him Old Rinkrank; and since she too had
grown old, he called her Mother Mansrot. One day when he was out
she made his bed, then she locked all the doors and windows except for
a tiny one through which a little light was shining. When Old Rinkrank
came home at dusk he knocked on the door and shouted: 'Mother
Mansrot, open the door!' 'No, I won't', she replied. He shouted again:

Then he ran round the house to the little window. 'I'll see what she's up
to', he grumbled to himself. He peered in but his beard was so long that
it got in the way, so he stuffed it through the opening and pushed his
head in after. Then Mother Mansrot slammed down the window!

He screamed and howled and begged her to set him free; but now he

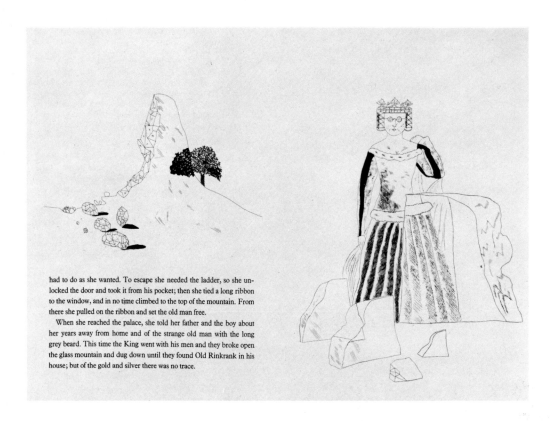

had to do as she wanted. To escape she needed the ladder, so she un-
locked the door and took it from his pocket; then she tied a long ribbon
to the window, and in no time climbed to the top of the mountain. From
there she pulled on the ribbon and set the old man free.

When she reached the palace, she told her father and the boy about
her years away from home and of the strange old man with the long
grey beard. This time the King went with his men and they broke open
the glass mountain and dug down until they found Old Rinkrank in his
house; but of the gold and silver there was no trace.

284 (Left) 'The glass mountain
 shattered'; (right) 'The
 Princess after many years
 in the glass mountain'

Rumpelstilzchen

A poor miller happened to meet the King, and hoping to interest him he boasted: 'I have a beautiful daughter who can spin straw into gold.' The King was impressed: 'That's an art I like; if your daughter is really as clever as you say, bring her to my palace tomorrow and I'll see for myself what she can do.' So when the girl came the next day, the King took her to a small room filled with straw, gave her a spinning wheel and ordered her to get to work. 'You have one night to spin the straw into gold, but if you fail your head will be cut off.' Then he left the room and locked the door behind him.

The miller's daughter had no idea what to do; and after a while she saw there was no escape and burst into tears. But suddenly the door flew open and a strange little man rushed in: 'Good evening my dear, may I ask why you are crying?' 'I have to spin this straw into gold,' the girl sobbed, 'and I don't know how.' 'What will you give me if I do it for you?' asked the little man. 'My necklace', she answered. He took the

necklace, sat down at the wheel and with three turns filled a bobbin with gold; then he took a second bobbin and with three more turns filled that one too. He worked the whole night, and before morning all the straw had been spun into gold.

When the King returned at sunrise he was amazed to see what she had done, so that night he locked her up in a bigger room piled high with straw and set her to work a second time. As the poor girl wept the door flew open and in danced the little man. 'What will you give me if I

help you again?' 'I have only the ring on my finger', she replied. He took the ring and by morning he had spun all the straw into shining gold.

When the King saw the gold he was pleased; but being very greedy he had the biggest hall in the palace filled with straw to the ceiling. As he slammed the door on the girl he made her a promise: 'If you can spin as much as this into gold in one night, I will marry you.' 'She is only a miller's daughter,' he thought, 'but in the whole world I will never find a richer wife.'

As soon as she was alone, the strange little fellow appeared. 'What will you give me if I do your work for you this last time?' 'I have nothing left.' 'Then promise me your first child if you become Queen.' 'A lot can happen between now and then', she thought, and in despair, she agreed. The little man set to work and when all was ready he vanished;

and in the morning when the King found the room filled with gold, he married the miller's daughter and made her his Queen.

A year later she gave birth to a beautiful boy; but by that time she had quite forgotten the strange little man. When he arrived at the palace

one day to claim the child, the Queen was terrified and offered him any part of the kingdom if he would only leave her her son. But he insisted: 'No, I prefer a living creature to all the treasures in the world.' She wept so bitterly that at last he took pity on her: 'If in three days you can guess my name I'll let you keep your son.'

She thought all night of all the names she had ever heard, and even sent out a messenger to comb the country for more. When the little man came back the next morning, she called him Caspar, Melchior, Balthasar, and every other name she knew, but he kept repeating: 'That's not my name.'

The next day she went herself through the neighbourhood questioning the people, and when the little man came she listed the most unusual and curious names she had heard: 'Maybe Ringo, or Zappa, or Kasmin?'

But he always answered: 'That's not my name.' On the third night the messenger returned with a strange tale: 'I couldn't find a single new name, but below a high mountain at the edge of the forest, in the middle of nowhere, I saw a tiny house with a fire in front and a strange little man riding around on a cooking spoon. Every now and then he'd shout:

Today I dance tomorrow I travel
The Queen's child will soon be mine
No one will know from where I came
Or that RUMPELSTILZCHEN is my name.

The Queen was overjoyed to hear this news, for it came only just in time. Soon after the little man arrived and asked her: 'Tell me what is my name?'

'Is your name John?'

'No.'

'Is your name Paul?'

'No.'

'But maybe your name is . . . Rumpelstilzchen?'

The little man was furious and screamed: 'The devil told you that! The devil! The devil!' In his anger he stamped his foot so hard on the ground that his right leg went in up to his thigh. Foaming with rage, he grabbed his left foot with both hands and tore himself in two.

287 (Left) 'Pleading for the child'; (right) 'Riding around on a cooking spoon'

288 'He tore himself in two'

289 *Ossie wearing a Fairisle sweater* 1970
290 *Celia in Red* 1970
291 *Celia in Black* 1970

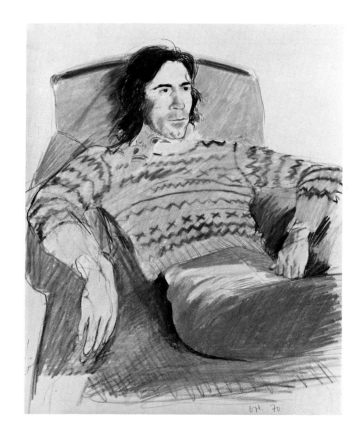

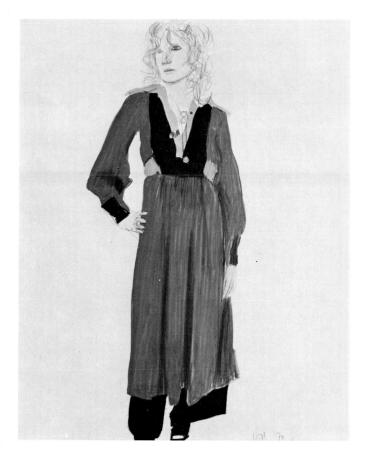

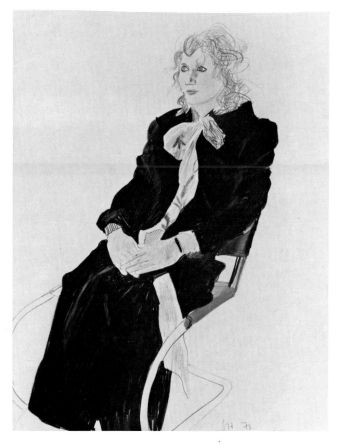

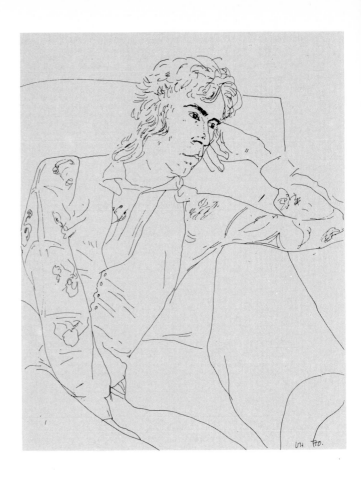

292 *Ossie Clark* 1970
293 *Peter, Hotel Regina, Venice* 1970

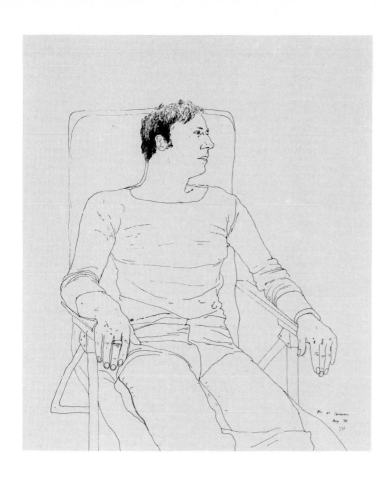

294 *Mo at Carennac* 1970

295 *Mo, Pavillon Sevigné, Vichy* 1970

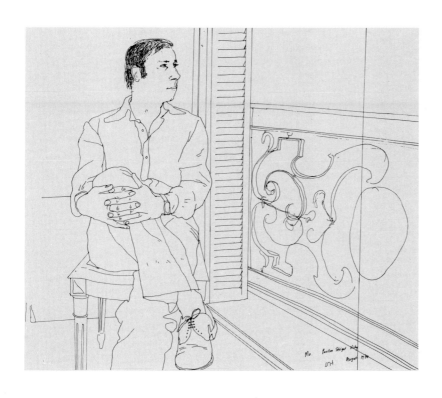

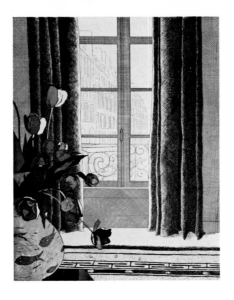

298 Paris, 27 rue de
 Seine 1971
299 Lilies 1971
300 Flowers Made of
 Paper and Black Ink
 1971

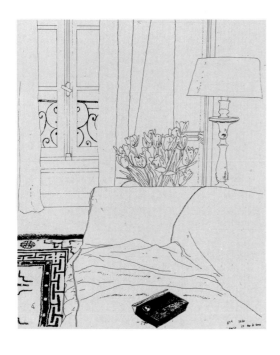

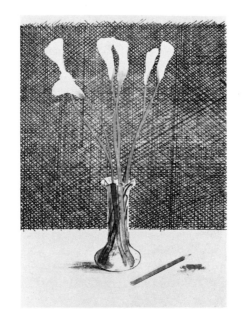

301 Maurice Payne 1971
302 Mo with Five Leaves
 1971
303 Portrait of Richard
 Hamilton 1971
304 Mo Asleep 1971

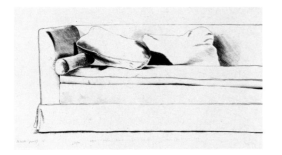

296 Paris, 27 rue de
 Seine 1970
297 Sofa 1971

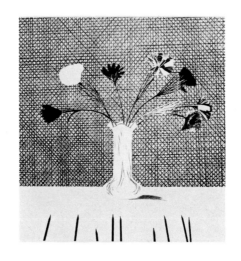

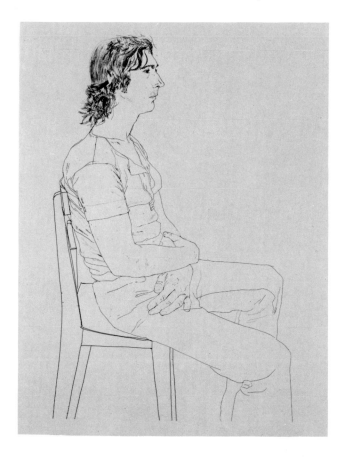

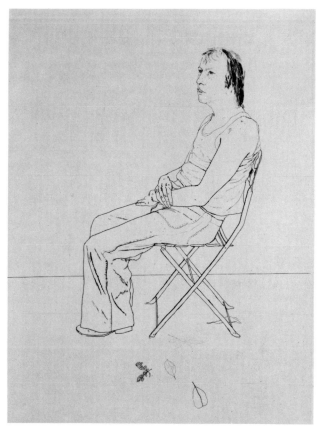

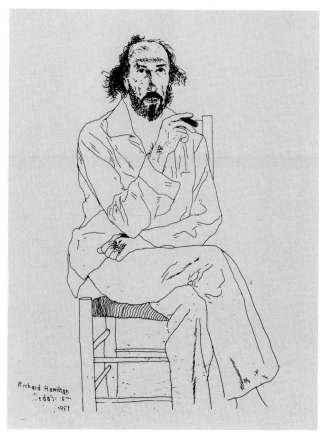

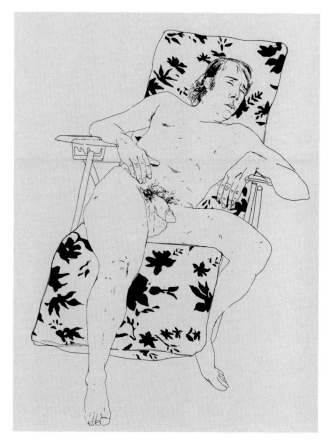

305 *Peter, Mamounia Hotel* 1971
306 *Chairs, Mamounia Hotel, Marrakesh* 1971

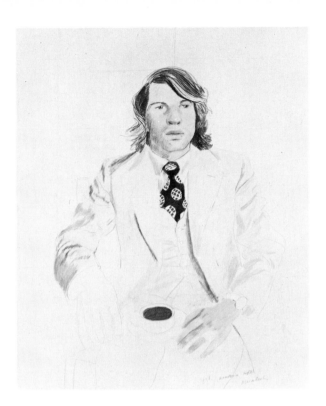

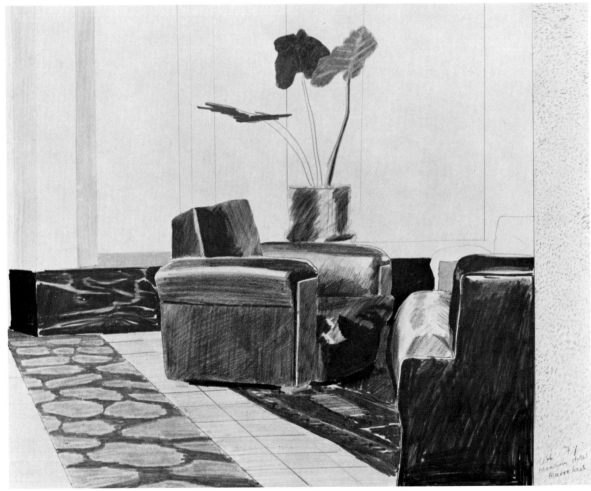

307 *Sir David Webster* 1971
308 *Portrait of Sir David Webster* 1971

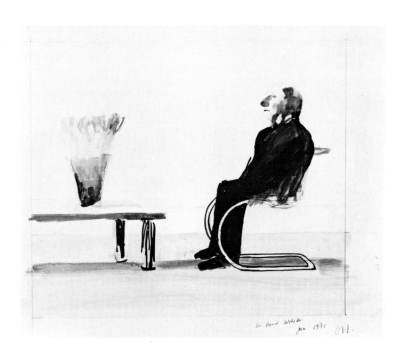

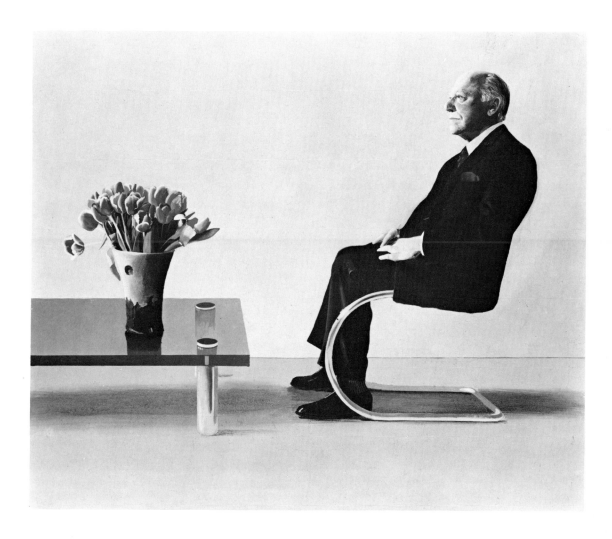

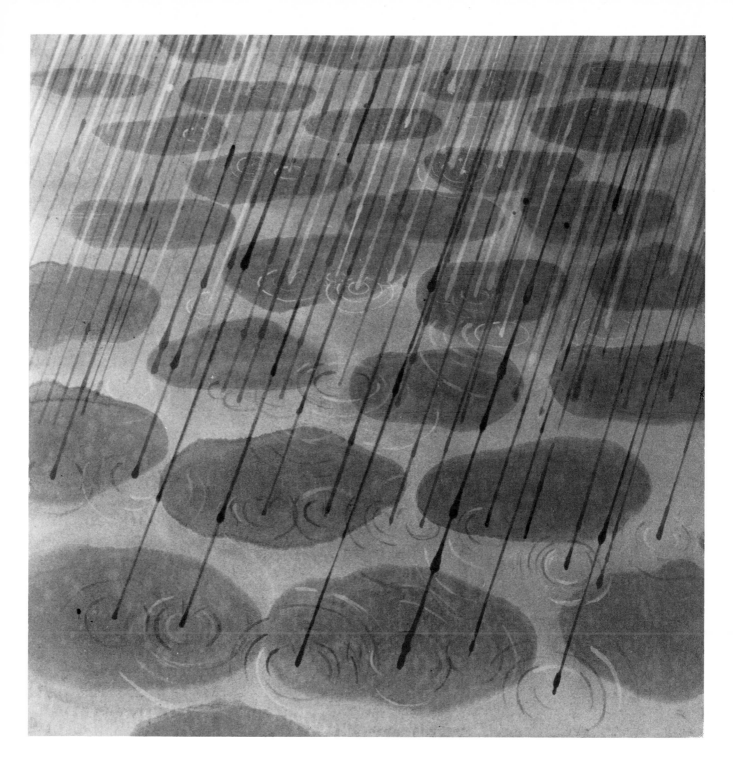

311 *Japanese Rain on Canvas* 1972

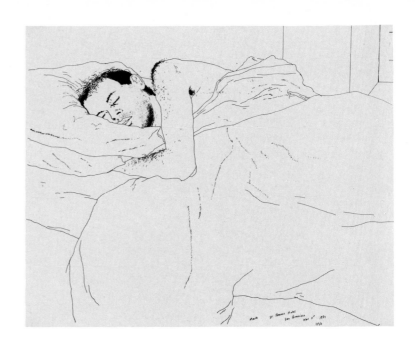

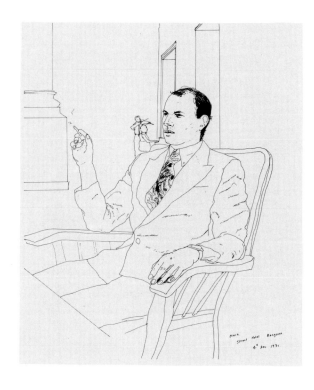

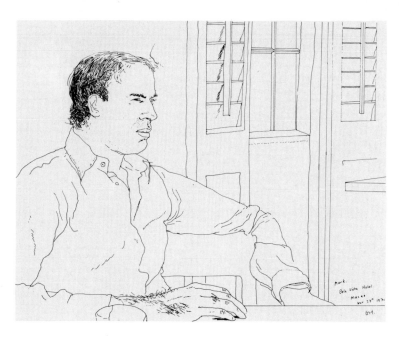

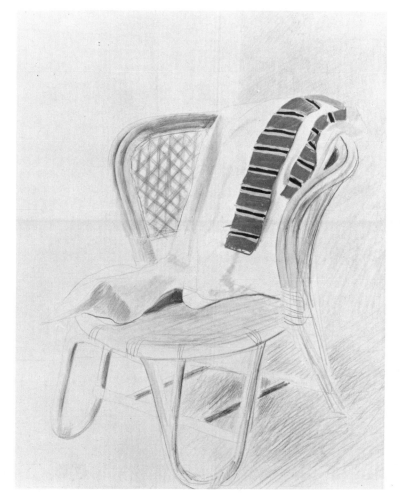

317 *Chair in front of a Horse Drawing by Picasso* 1971
318 *Three Chairs with a Section of a Picasso Mural* 1970

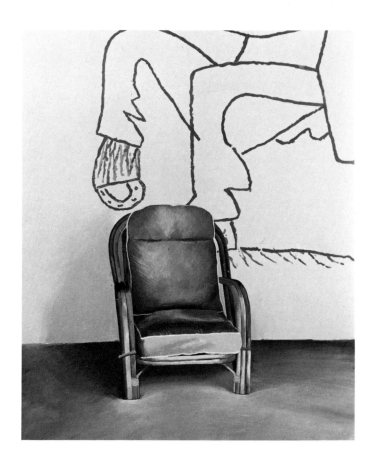

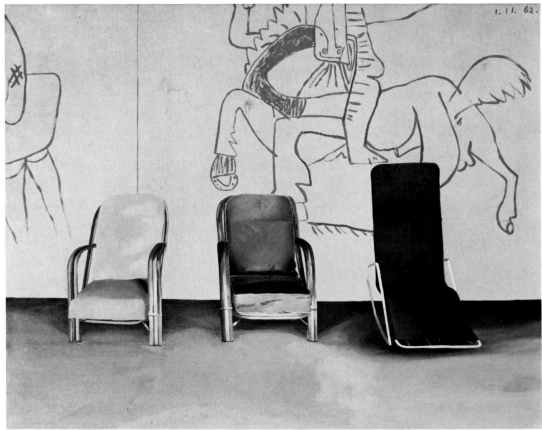

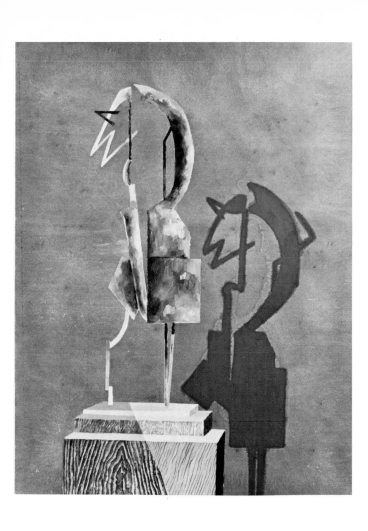

319 *Gonzalez and Shadow* 1971

320 *Cubistic Sculpture with Shadow* 1971

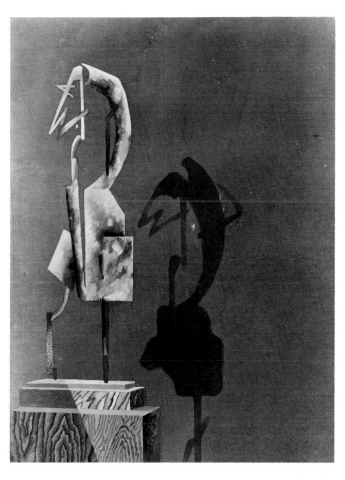

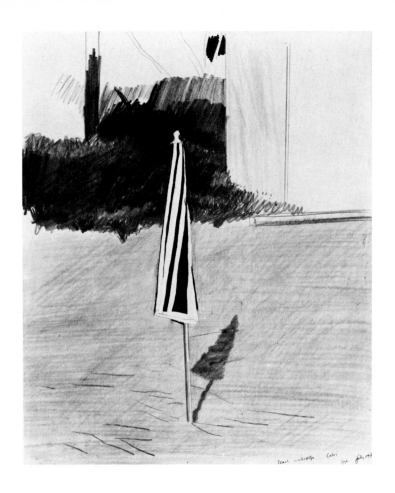

321 *Beach Umbrella, Calvi* 1972
322 *Grand Hotel Terrace, Vittel* 1970

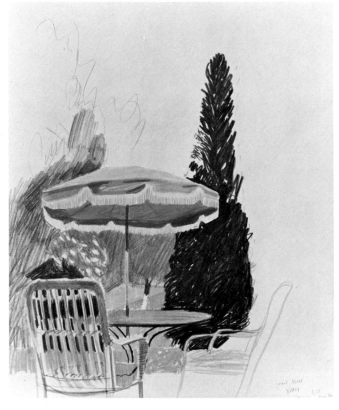

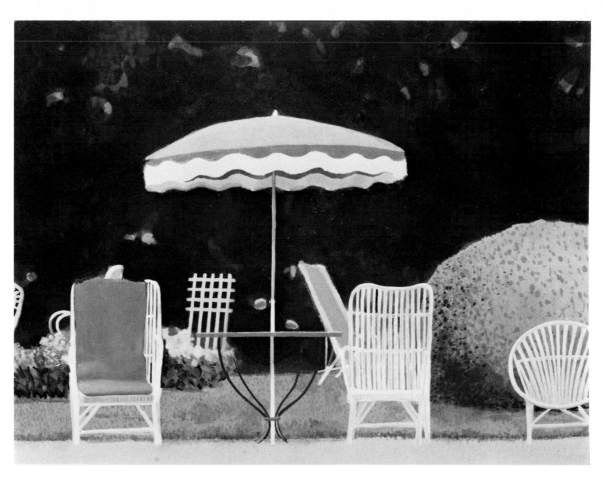

323 *Hotel Garden, Vichy* 1972
324 *Henry, Pavillon Sevigné, Vichy* 1972

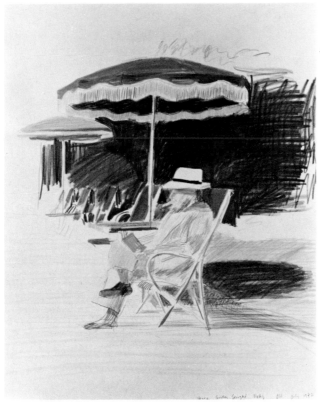

325 *Larger Leeks* 1970
326 *Banana* 1970
327 *Carennac* 1970

328 *Two Red Peppers* 1970

329 *Beans on Paper* 1972

330 *Carrots on Paper* 1972

331 *The Valley* 1970

332 *Portrait of an Artist (Pool with Two Figures)* 1971

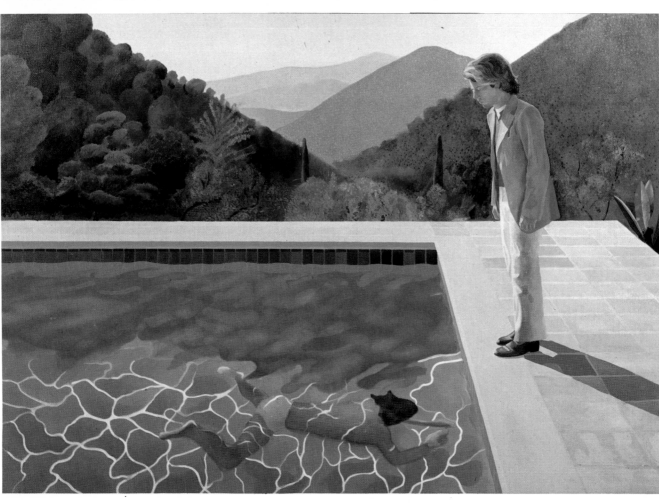

I really did have to struggle with the picture; the whole mood kept going wrong. I can remember at one time there were a few people around at Powis Terrace and I wanted everybody to get out so I could work on it, because I was getting rather frightened. The deadline was coming and I wasn't pleased with the picture at all. I had never worked to a deadline before and I didn't know what to do, and I thought having people around me wasn't helping. Of course, what I didn't quite realize then was that my relationship with Peter was really getting very difficult. Anyway, he went to Paris for three or four days and I locked myself in and finished the painting. I worked eighteen hours a day on it. I can usually work with people around, but when I get nervous over a deadline or something, people just get overpowering.

I was quite relieved when it was finished. Webster liked it a great deal, and his friends loved it. I didn't like it that much, quite honestly, although I had to let it go, but a lot of people did, people whom I respect. Several told me that it was better than the picture of Ossie and Celia, that it had a much stronger mood in it; I rather resented that. The picture of Ossie and Celia *must* be better, I thought, I spent seven months on it. Of course, it doesn't work like that. The Webster portrait took about two months, I think, working every day on it.

That summer Jack Hazan started making his film, *A Bigger Splash*. I was working on *Sur la terrasse*; I'd made drawings and taken photographs for it when I went to Morocco with Celia and Peter for two weeks in February. The scene in life is full of romantic allusions: Peter on a balcony, gazing at a luscious garden and listening to the evening noises of Marrakesh. George Chinnery's painting, *The Balcony, Macao*, was certainly in my mind at the time. The moment we arrived at the hotel in Morocco – we had a bedroom with this beautiful balcony and view – I immediately thought it would make a wonderful picture. So I deliberately set up Peter in poses so that I could take photographs and make drawings. When I came back, while I was still doing the Webster picture, I began the painting. Jack Hazan filmed the work on it; he had said he wanted to make a film and I'd refused him, as usual. And as usual he hadn't believed me. He'd come back, saying Can I just do this little thing? That's how his whole film was made – 'I just need this one last shot.'

After Morocco, we'd gone to Madrid, my first time, to see the Velasquez pictures. I found the Goyas more stunning – all those rooms full of Goyas, they're fabulous; about six rooms in the Prado, beginning with the early works, when he painted pretty pictures of people dancing in sylvan glades, happy pictures, beautifully painted; then the portraits of the royal family, and finally those marvellous pictures he did in his old age, almost like Bacons. It's wonderful to go from the young, free, happy-go-lucky early Goyas, the pretty little scenes, to the late paintings. Marvellous! Great effect, wonderful effect. Much more impressive, to me, than the Velasquez pictures. This was something I didn't expect.

In the summer, when I had finished *Sur la terrasse*, we went to France and Spain: Peter, Ossie and Celia, Mo, George Lawson and Wayne Sleep, Maurice Payne, who came along in another car with etching plates, and Mark Lancaster. First we stayed in Carennac, in France; I drew all the time. Then we went to Spain, to Barcelona, my first visit. In Carennac, Peter and I hadn't been getting on well at all and I was getting very miserable about it. We'd had one very pleasant day when we drove down the Gorge de Tarn and stopped, and then in Barcelona it was quite nice at first. We went to the Museum of Modern Art there, where modern art begins in 1740! The Picasso Museum I thought was fantastic. But Peter was getting a bit bitchy, so I said Let's leave here now, there's too many people; we'll go to Cadaques and stay with Richard Hamilton and Mark Lancaster. But when we were there we kept on having arguments. Mark Lancaster was with a lot of English people, which really put

The end of a relationship

253
254

me off. The next day they were going to have a picnic on a boat. I didn't want to go at all. I was only going to stay in Cadaques two or three days before I went to France and then to England, and Peter was going to Greece to meet his parents. The last thing I wanted to do was to go on a picnic with all these English hoorays. But Peter decided to go with them; we had a terrible row, and I stormed off. I got in my car and drove to Perpignan, where I was going to meet up with George Lawson and Wayne; I stayed the night there in the Grand Hotel, a marvellous place, completely falling down, just a crumbling ruin. [According to George Lawson, an earthquake had struck the hotel the previous day.]

Next day I drove on to Carennac. While I was driving, I was all right. I arrived about two o'clock in the afternoon. Celia had left; she'd gone back to England. Ossie was there, and Mo, and Maurice Payne. The moment I got there and got out of the car I burst into tears, realizing what I'd done; I'd gone, I'd said Fuck off, and left. I thought, I've been really cruel to Peter, what a rotten thing I've done. So I said I must phone up and apologize, and say I didn't mean to be bitchy if I was bitchy. It took us half an hour to get through to Richard Hamilton. I didn't speak to Peter, but Richard said he thought he was all right and he would give him the message. Meanwhile, I was thinking, poor Peter, he'll be in a terrible state, because *I* was, really depressed, in an awful state and a bit nervous. Meanwhile Jack Hazan was at this fucking château wanting to film all the time. And I said Just leave, please, Jack; I'm having a terrible time. And he did; he actually did pack, didn't do any filming, and went back to England. Next day, I said I must go back to Cadaques because I can't just leave on a sour note; it's awful, I must go back, just talk to him and then leave. Ossie said, I'll come with you, it's on the way to the Riviera. Ossie had a big Bentley then. I said, Well, you're in your own car, you can come that way if you want. And Maurice Payne said What am I supposed to do? So Maurice came in the car with me, and Mo went in the car with Ossie, and then Mo and Maurice were going to come back with me.

We set off the next day and drove back in stages to Cadaques. When we arrived, Peter said I don't want you to stay here, get out of this town. But I said I've just driven back, I'm not going to leave now; I'm going to stay a day, I'm going to rest, I've been driving back and forth. Richard Hamilton was quite amused by it all. He said The border police must know you very well, David, and the Grand Hotel at Perpignan.

I stayed two or three days. I thought I'd made it up a little bit with Peter when I went back to France and he went off to Greece. I went back to England, and felt a bit better; that was the end of August. Then Peter came back to London and moved a small bed into his little studio in Notting Hill. And he never moved back into Powis Terrace with me again. It was very traumatic for me, I'd never been through anything like that. I was miserable, very, very unhappy. Occasionally I got on the verge of panic, that I was alone, and I started taking Valium. I'd never taken pills of any kind. The Valium helped a bit. One effect of all this was that during the following year I produced an enormous amount of work. I started painting very intensely that September.

Coping with life: nine new paintings

The truth is, I was so unhappy, there was nothing to do but work. That was when I started staying in. I didn't go out much; I just worked. *Sur la terrasse* was just about finished. *Pool and Steps, Le Nid du Duc* I think was half-finished. *Still Life on a Glass Table* I began in September; the *French Shop* was painted after September, and so were the *Beach Umbrella* and *Rubber Ring Floating in a Swimming Pool*; and I began the *Portrait of an Artist (Pool with Two Figures)*, *The Island* and *Deep and Wet Water* – all from September on. Whereas with Peter I often went out on an evening, from then on I didn't. For about three months I was painting fourteen, fifteen hours a day. There was nothing else I wanted to do. It was a way of coping with life. It was very lonely; I was incredibly lonely.

255
256
257, 258, 25•
332
309

Still Life on a Glass Table is an exercise in the rendering of glass objects which had accumulated over the years. To me, the painting seems quite straightforward, yet friends read a lot into it. It was suggested that, apart from the tulips and the two straw water-containers from Vichy, the objects on the table were not my loves but those of Peter. My emotional state was reflected in the choice of the objects (and even the choice of the subject) and in the gestural electric shadow under the table, representing my real feelings, in contrast to the calm of the still life.

The Island is done from a tinted black and white postcard Kasmin had given me of a small island in the Inland Sea, in Japan. I'd always planned to go to Japan with Peter, but by 1971 the desire to go there was very strong. A clear picture was forming in my mind of what it would be like and I became so convinced that it would be as much a source of visual excitement as California had been that the idea of painting some aspect of it before I went there became appealing. It became a kind of test to see if, like in *Domestic Scene, Los Angeles*, I would be near the mark, even though the painting dealt only with the landscape, a familiar thing to anyone with even a small knowledge of Japanese prints. The postcard attracted me for many other reasons: the problem of depicting the sea because of the inlet, the connections with landscape (or seascape) painting and with Monet, and, not least, that it looked like a piece of cake.

French Shop, Beach Umbrella and *Rubber Ring Floating in a Swimming Pool* were also painted before I went to Japan. *Rubber Ring* was based absolutely on a photograph; it's almost copied from it. I was standing on the edge of the pool, the pool water was blue and there was this red ring, and I just looked down and pressed the shutter. I was so struck by the photograph's looking like Max Ernst abstract painting that I thought, it's marvellous, I could just paint it. At first glance it looks like an abstract painting, but when you read the title the abstraction disappears and it becomes something else. It's a simple little picture, using the technique of stained acrylic paint. The red ring is gessoed with white acrylic first, and then the red paint is put on very carefully, so it sings out. It does look as though it's on the surface and singing out. It was just the idea of this abstraction I liked.

The source for *Beach Umbrella* was a photograph taken one evening in St Maxime – you can tell it's either early morning or evening by the shadow and the umbrella being closed. It's painted using very obviously different textures and paint techniques within the same picture. The actual umbrella is painted with stained acrylic paint, and because it's stained and you see the canvas texture, it makes the umbrella seem real. The actual umbrella would be made of something very similar, so there is a connection with one aspect of its reality. All the rest is gessoed around, with the sand painted in much thicker paint so that the contrast is exaggerated. The sea is loosely painted in an intermediate thickness of texture. But the total effect, although it's a very simple picture, has an uncannily real effect. I realized it's because your eye reads different textures in the painting. It's quite subtle. Most people feel it; it isn't just me. It does work like that.

French Shop is located near the small French spa of Miers, one of those little French towns where, occasionally, when they build a shop, they try and blend it in with the old ones. Its architecture seemed so simple and straightforward that it could almost have been erected by a builder, not an architect. You saw it as you came into the square, and it had something slightly humorous about it. I photographed it and made a drawing of it and painted it when I got back. Most modern architecture I find extremely boring; I long for the Bauhaus influence to fade. Yet this little building had a purity that I found very attractive. The austere façade was enriched by homely little touches: the multi-coloured plastic string curtain and the

casual-looking yet symmetrically-placed plant in between the doors. Everything seemed to be on the correct scale.

Deep and Wet Water is a painting using the acrylic and detergent technique, which I also used in *Pool and Steps, Le Nid du Duc*. The steps come down to the pool and three more steps continue inside the pool, though you can only just see them; they're distorted because of the water. As opposed to the earlier swimming-pool pictures where you get that very stylized jigsaw effect, the water here is done in a more naturalistic way, although it's somewhat stylized. It's ironic that the sandals are Peter's – the little human touch; he'd just jumped into the pool. The painting was done from photographs I took of the steps and the water. I think I might even have begun the painting before the summer and finished it afterwards, so the sandals were not symbolic. I often leave pictures unfinished.

Meanwhile, I was working all the time on *Portrait of an Artist*, Peter looking into a swimming pool with a distorted figure in it. I kept having struggles with it. I must point out that another reason I did a lot of paintings at that time was a vague deadline for a show which had been arranged in New York for May 1972, I think, to which I'd agreed; this was an added stimulus. But mainly I felt there was really nothing else to do. I didn't want to socialize much, so I just worked. I drew a lot closer to Celia at that time, and started making more drawings of her.

Japan, 1971 In November 1971 I went to Japan with Mark Lancaster. I thought it would help me to forget things. We went to America first and spent a few days in California with Christopher Isherwood. Then we stopped in Honolulu for two days. Mark had a shirt exactly like one Peter had been wearing once when I'd drawn him; I didn't know this until one morning I woke up and the shirt was lying on a chair, and I drew it, early in the morning. I made a painting of it *336* later, called *Chair and Shirt*. During the trip I used to get up early and make drawings. Mark *335* complained he was always woken up either by the scratching of my pen writing a long letter to someone, or by the pencil sharpener whizzing because I was drawing. I made a lot of drawings of Mark and various places.

Basically I was disappointed by Japan. I'd expected it to be much more beautiful than it is. At the time I thought most of it extremely ugly. I had expected factories carefully and precisely placed against mountains or lakes and instead I found that any spare, flat bit of land had the most uninteresting factories. We spent just two weeks there; it's not very long, I know. In retrospect it becomes more beautiful. I'm sure it's just a case of remembering what interested me and forgetting what didn't, but it certainly kindled an interest in Japanese art. The temples and gardens of Kyoto are well-known and I wasn't disappointed, but I found something just as exciting because it was unexpected: in the municipal art gallery there was an exhibition called 'Japanese Painters in the Traditional Style'. They were contemporary paintings done from about 1925 to the present, using traditional Japanese techniques (painting in silk and screens), but occasionally treating modern Japan as subject. One picture in particular, called *Osaka in the Rain*, I thought exceedingly beautiful. The misty clouds over the river and street were suggested only by the thin bars of rain, and the little cars and people walking about all had just the slightest suggestion of reflection under them, making the whole thing look extremely wet. I thought perhaps the nearest thing in European art to the painting of the figures and cars was Dufy, an artist I have never been greatly interested in; yet the whole effect was quite magical. I loved the idea of these old men (most of the artists were born about 1900) probably ignoring European painting and yet producing something highly sophisticated and modern.

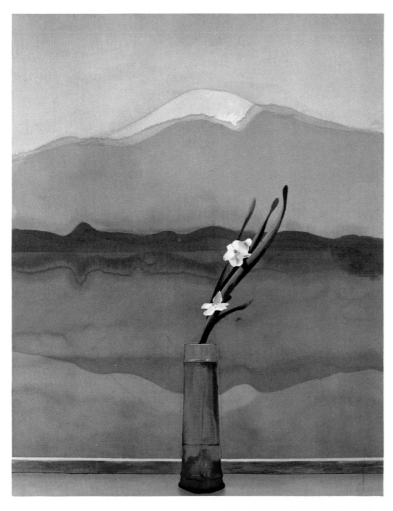

333 *Mount Fuji* 1972
334 *Two Deckchairs, Calvi* 1972

335 *Chair and Shirt* 1972
336 *Suginoi Hotel, Beppu* 1971

337 *Peter, Platzel Hotel,*
 Munich 1972

338 *Gary Farmer at Powis*
 Terrace 1972

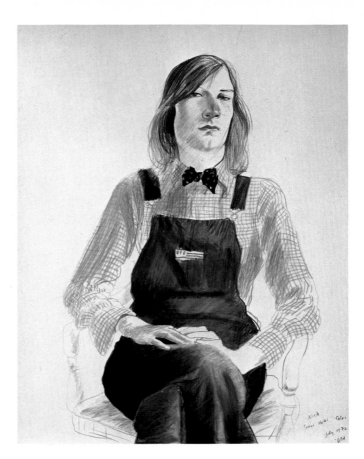

339 *Nick, Grand Hotel, Calvi, July* 1972
340 *Mirror, Lucca* 1973

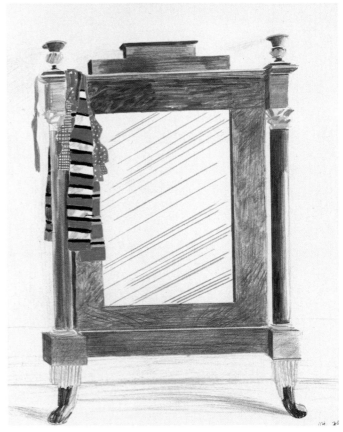

Immediately I got back to London I felt dreadful again, but I started painting and people have commented on how happy the pictures are. I did *Mount Fuji* and later in the year I painted *Japanese Rain on Canvas*. A constantly recurring theme in Japanese art has been the weather, especially rain, and their many ways of representing it are quite fascinating. It made me want to make a picture of rain. The title, *Japanese Rain on Canvas*, is almost literal; the picture is painted in thin washes of colour soaked on to the canvas and, because I was anxious to make the heavily stylized falling rain stand out, I filled a watering-can and let it drip all over the canvas. It didn't seem to have too much effect because the canvas was a little too wet, but that's what suggested the title.

Painting a relationship I was still struggling on with the first version of *Portrait of an Artist*. The subject of the painting had originally been suggested by the accidental juxtaposition of two photographs lying on my studio floor. One was of a figure swimming underwater and therefore quite distorted – it was taken in Hollywood in 1966 – and the other was of a boy gazing at something on the ground; yet because of the way the photographs were lying, it looked as though he was gazing at the distorted figure. The idea of once again painting two figures in different styles appealed so much that I began the painting immediately. In the first version, I painted the underwater figure first, as I wanted it in thin acrylic washes to emphasize the wetness. Then I coated the rest of the canvas with gesso. This meant that I couldn't alter the position of the pool and the figure, and I immediately got into difficulties with the rest of the painting. The figures never related to one another, nor to the background. I changed the setting constantly from distant mountains to a claustrophobic wall and back again to mountains. I even tried a glass wall.

I began the first version in 1971; I kept fiddling with it and leaving it and working on other things, then going back to it. I worked on it for quite a long time. The longer you work on a painting the more you're loath to abandon it, because you think throwing away six months is terrible. So I struggled on and on and fiddled on with it, realizing it didn't work, couldn't work. Eventually, after about four months, it dawned on me what was wrong: it was the angle of the pool which was causing me all the problems. I couldn't alter the water section and it was impossible to adjust it, so I decided to repaint the picture completely, in time to send it to the André Emmerich Gallery for my show in May. There wasn't much time, and Kasmin said I was mad. I said I can repaint it in two weeks because I know exactly what I've done wrong. I know how to do it; I don't need to think about it, which I normally have to do when I begin a painting. What I need now are more references. So I decided to go to the south of France, the nearest place with outdoor swimming pools in April, to photograph the scene again. Peter was away at the time; ironically, I think he was in California filming *A Bigger Splash* with Jack Hazan. So I went down to the south of France with Mo, a boy called John St Clair, who's the boy in the pool, and the pink jacket that I was painting Peter in. To get different kinds of distortion in the water I had John swim underwater in different light conditions (early morning, midday, evening) and with different water surfaces (completely still, gently moving, and as turbulent as possible), and I had Mo gazing at himself with the shadows in differing positions. Another problem with the earlier distorted figure had been that people thought it was a corpse, and that wasn't the effect I wanted at all.

I cut up and destroyed the first version of the picture. I didn't slash it, as Jack Hazan says in his film. It was actually cut up quite carefully because I made a bit of it into another painting and gave it to Ossie and Celia. Some parts were painted quite nicely; there was a whole plant growing from the edge of the swimming pool, with the pool in the background. I thought, I can't throw that away. I could just cut it out and give it to a friend – which is what I did.

When we came back to London Airport after two days in France, we took a taxi to North London with all the film, direct to the processing place. I'd arranged this with the chemist on my corner. We got the film there at four o'clock in the afternoon and they were delivered processed to the chemist next morning at ten o'clock; otherwise, if I'd had to wait four or five days, there wouldn't have been time, and I needed the photographs for reference, especially for the underwater figure. Although I tried making quick drawings, it was better, I thought, to use these photographs. I stuck them all up and down the wall; there was a lot of them and some were very good photographs. Meanwhile Jack Hazan, who was back in London, had seen that I'd cut up the other picture and said What's going on? And I said I've abandoned that and I'm doing this other. So I began to paint the new picture, very frantically, and Jack said Can I film it? And I said Oh my god, no, I'm really going to work eighteen hours a day on this with Mo. Mo's going to do all the spraying, to keep all the paint wet. The last thing I want is somebody interfering. Then Jack said Well, if you want to work at night, I've got all these lights. One problem in my studio was the lighting; at night, all the blues go a different colour, and it became a bit of a technical problem for me. Jack's lights were pure daylight and the blues sing out. He said I'll lend you them. If you have to do it in two weeks, you can have them all here for two weeks. All I want is to come in every two days and film the thing as it progresses. And I agreed, just so that I could have the lights and work night and day. That's how it came to be filmed. Painting it only took about two weeks, but every single day I think we worked eighteen hours on it.

I had difficulty with Peter's figure because my photographs were of Mo, and the drawings I'd made of Peter had been for the other painting. Peter was back by then, so I could take photographs of him in the park, but I had to do it in the same light as in France, same distance, and work it all out at the same time. And I realized that of course the light in London isn't quite the same, it's further north; so I calculated what time of the day it should be, hoped it would be sunny, ignored the shadows; it meant going early. I did it very early one Sunday morning, and Jack Hazan filmed us actually taking the photograph. I'm explaining to him how I'm doing it. At the time, you must remember, I had no idea what his film would be like, and anyway we were always joking about him and his film. He'd become a joke, Jack, really. We thought his film was going to be a twenty-five-minute blurred film with bad sound, that it would be on at the Academy Cinema with a Polish version of Shakespeare. We never expected it to be two and a half hours of weeping music.

I literally finished the painting the night before it had to be sent off to the exhibition. I varnished it – in those days I varnished pictures if I gessoed underneath – and the next morning we got up at six o'clock to begin rolling it. At eight-thirty the men came to collect it to send it off on a plane to New York, and it got there just in time. We went over for the exhibition and so did Jack Hazan. I must admit I loved working on that picture, working with such intensity; it was marvellous doing it, really thrilling.

How paintings sell
 The story of the sale of that painting is sad, considering the effort I put into it. Kasmin had told André Emmerich not to sell any paintings to European dealers; they come over to buy them, take them back to Europe, and resell them for more money to Europeans. There's no point in doing that – try to sell them to people in New York. The Philadelphia Museum were interested in this painting but, like all museums, they took their time deciding. Meanwhile, some man went into André Emmerich before he'd got the picture, and said he knew this picture was coming and could he buy it. André didn't know him, but he assumed the guy knew me in some way. He described the picture so André thought he must have seen it in my studio; he was an American who said he lived in New York and claimed he was quite rich. But

André didn't know him as a client. On the other hand, he didn't know other people who bought my pictures as clients, because my work's different from the other things he sells. So he agreed to sell and I think the picture was about eighteen thousand dollars. It was the most expensive painting in the show. This is in May 1972. By October 1972 the picture is in the hands of a London dealer, and it finishes up at an art fair in Germany. It now belongs to James Astor, who bought it about a year after all this; he paid, I think, nearly fifty thousand dollars. What had happened? The guy had been sent by some dealers in London to buy the picture, tricking both André and myself. Within a year people had made far more on that picture than either Kasmin, André or I had. Considering the effort and trouble and everything that had gone into it, it seemed such a cheap thing to do; an awful thing to do. It's amazing that it could happen. I'm not complaining about the money, but you'd think they would care. They can't be very sensitive people. And the *fragment* of the first version was sold later for seven thousand pounds! So for all the effort I put into those paintings – it was a great deal of work, great physical effort as well – many people made a lot more money out of them than I did; I was paid four thousand pounds at the time and thought it was quite a lot of money.

My pictures were probably a bit underpriced in those days. I thought they were incredibly expensive – eighteen thousand dollars is a hell of a lot of money – but compared to what people were prepared to pay, they were cheap. This was why my pictures became very highly-priced after that. I think they're overpriced; I've always thought they were, actually. People tend to think when they read in the papers that some paintings have been sold for twenty thousand pounds, twenty-five thousand pounds, that the money comes to me. I don't get any of it. The painting's been sold years before for eight hundred dollars. And of course I don't get twenty-five thousand pounds for a new picture. Those high prices are for the old paintings. So a lot of people think I'm much richer than I am. I'm not saying I'm badly paid – I'm not; I'm overpaid, I'm sure. But one thing I'm not going to do is churn out anything for money. If you're an artist, the one thing you can do when you get money is use it to do what you want to do in art. That's the only good thing you can ever do for yourself. As an artist, what do you need to live on? As long as you've got a studio and a place to work in, all you're going to do is paint pictures all day long. What else do you need money for? You don't. But it does mean you've no need to churn out things to earn money. You can take your time, spend a lot of time on it. It's a luxury to be able to spend six months on a picture. In the past, the only reason I didn't was that I couldn't. As an artist who was earning his living by painting, I needed the money. The pictures were cheap. I had to do a few just to make a living, to keep going. There's nothing wrong with deciding that, since the pictures cost so much, you only need to paint ten a year to keep yourself going. If I painted twenty a year I would make a lot of money; but I work it out and think, I don't need paint more than this unless I want to; so I can vary the paintings.

An unfinished painting

After the New York exhibition in 1972, I began the painting of George Lawson and Wayne Sleep. Six months I worked on it, altering it, repainting it many times. It is documented, in its various stages. I kept taking photographs, thinking it was finished myself, and then deciding, it's not right, no, that's not right. I drove Mo mad. He thought it was wonderful at times, and then he'd think, oh my god, he's at it again. I had a real struggle with it. Looking back now, two years later, I can see that the struggle was about naturalism, acrylic paint; it's why I later abandoned acrylic paint and began to move away from naturalism. 392

I spent the rest of 1972 doing that painting, along with *Japanese Rain on Canvas* and *Mount Fuji*. I also painted *Two Deckchairs, Calvi*, from a photograph taken when I went to Calvi, in Corsica, for a summer with Henry Geldzahler. I had photographed washing hung out on lines 334

and mentioned to Henry how sculptural it looked as a result of the work of artists like Robert Morris and Barry Flanagan. Suddenly, seeing the deckchairs closed up for the day and leaning against a wall, I realized they looked even more like poignant sculpture.

During the same period I did the *Cubistic Sculpture with Shadow*. In the Musée d'Art 320 Moderne in Paris there's a room full of cubistic sculpture by Julio Gonzalez. The idea of cubist sculpture was for me much more difficult to grasp than cubist painting. Yet I have loved that room for many years – it's next to the reconstruction of Brancusi's studio. I did think of doing a large painting of the whole room. Then in 1971, as I walked round it, I found myself looking at the walls. There's nothing hanging on them and yet, because the room is artificially lit, there are strong shadows cast by the sculpture. These shadows with their completely flattened forms seemed to contradict the idea of cubist sculpture. They amused me because somehow I'd accepted the intellectual and conceptual idea of cubist sculpture and thought the shadows should obey those ideas as well.

I don't think the painting completely works yet. I tried to create the visual contrast between the object and the shadow by using thick pigment and a stain of almost transparent colour. The painting was made from photographs I took in the room. I have always thought it rather mean and unscholarly that the two main galleries of London (the National and the Tate) don't allow photography in their rooms. As most Continental museums, the British Museum and the Victoria and Albert allow it, I can only conclude that they refuse for the cheap reason that they'll sell more postcards. On the Continent I have always used a small camera to take notes in galleries, and as neither the Tate nor the National Gallery is likely to sell photographs of the shadows of their treasures, perhaps they should allow the art lover to decide what it is about the work that would be useful for him.

All the time I was doing these rather small, simple pictures, I was working on the big picture of George and Wayne for Kasmin's last exhibition before he closed the gallery, at the end of 1972. We both thought the picture would be ready. It looked as though it was finished in October, long before the exhibition, but I struggled on and struggled on, and in the end I wouldn't let him show it. I said No, I can't, because it's not right; I don't want it shown. And so his show was much smaller; just the small pictures and some drawings. It was the first time I'd had two exhibitions in a year: the one in New York and then Kasmin's. By comparison with the one in New York, this looked rather a wishy-washy show, really. I wouldn't normally have shown small pictures like that, without showing a big painting as well.

In January 1973 I went to California again, to work on some big colour lithographs at Gemini, and I did the series of weather prints; I decided that was quite a good subject. The 373–8 first one I did was 'Rain', which was based on the painting *Japanese Rain on Canvas*. After a month it was arranged that Celia would come over with her children, and a girl to look after them. So I rented a house on the beach in Malibu, which was nice for Celia, but for me it meant I had to drive forty miles into Hollywood to work, and then forty miles back, which was a bit of a bore. But I did three or four lithograph portraits of Celia and a picture called *The* 372, 379 *Master Printer of Los Angeles*, which was a portrait of a printer, a very big drawing done on stone. I also did a little portrait of Henry Geldzahler. It was at that time that I read the Flaubert novel I'd never been able to find before, *Bouvard and Pécuchet*, which appears on a print of 383 some flowers.

Then Ossie came out to California because Celia was there and they soon returned to England, a little before I did. I left in April, just before the Watergate scandal got really big. Pity, I thought, what a time to leave America just as it's getting so exciting. I came back to England only to find a heaviness so great I decided I wasn't going to stay.

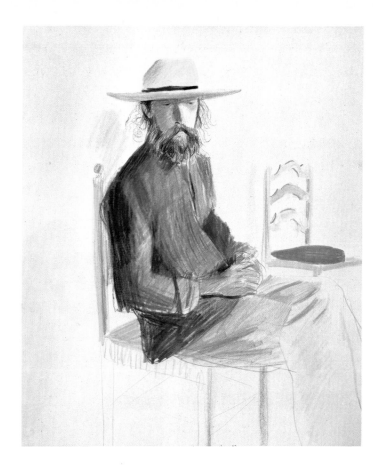

341 *Dr Eugen Lamb, Lucca* 1973
342 *Villa Reale, Marlia* 1973

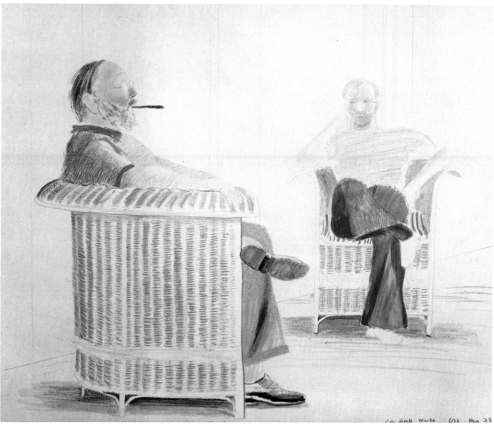

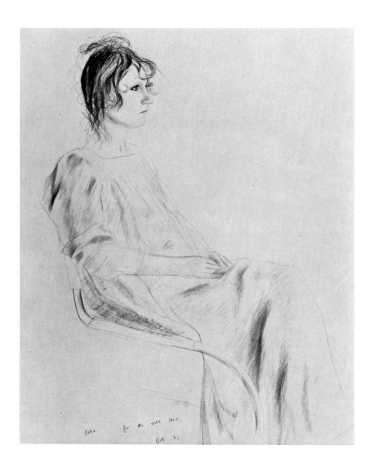

347 *Celia* 1972
348 *Celia* 1972

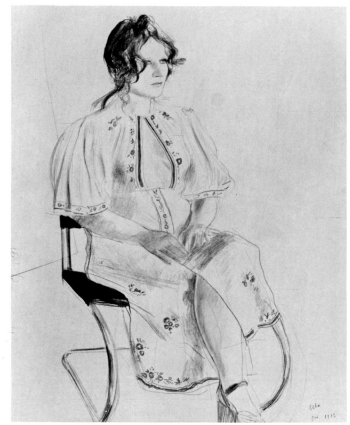

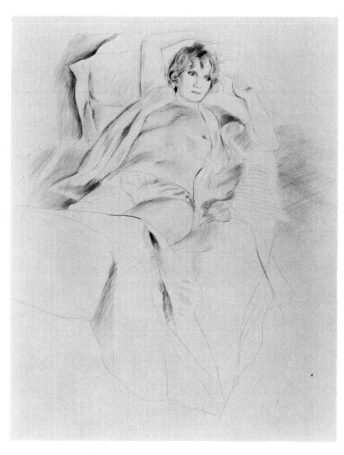

349 *Celia Half-nude* 1975

350 *Celia in Black Slip and
Platform Shoes* 1973

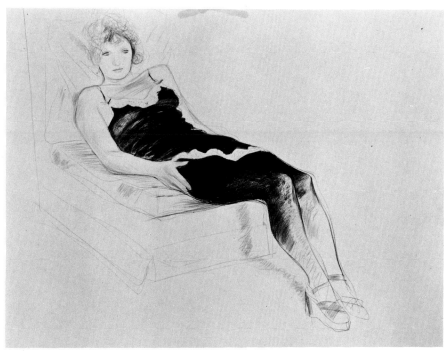

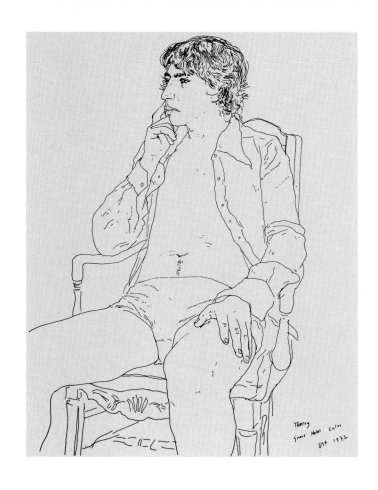

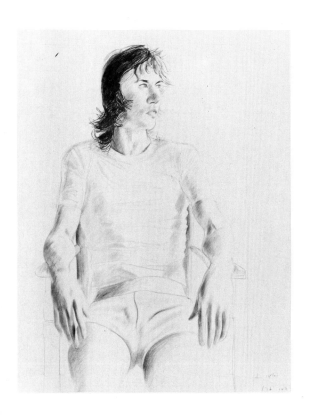

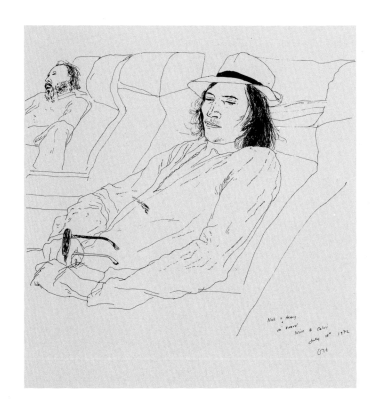

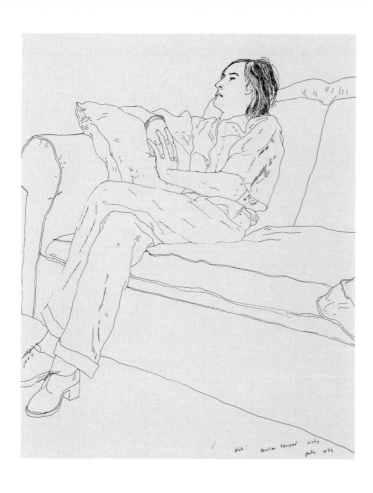

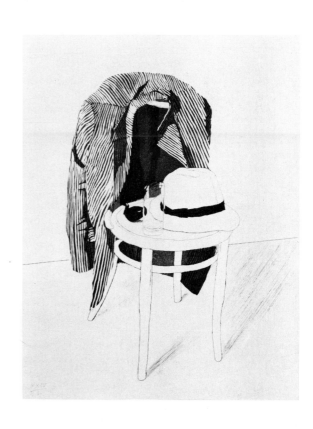

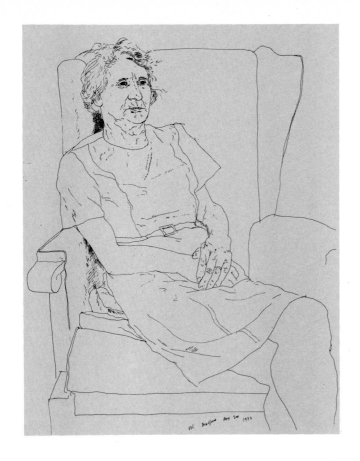

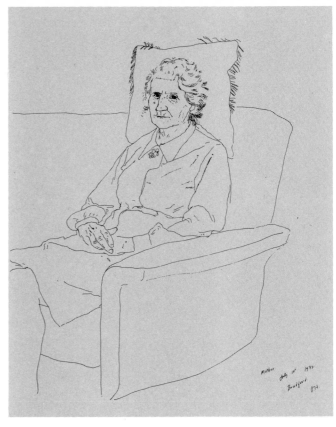

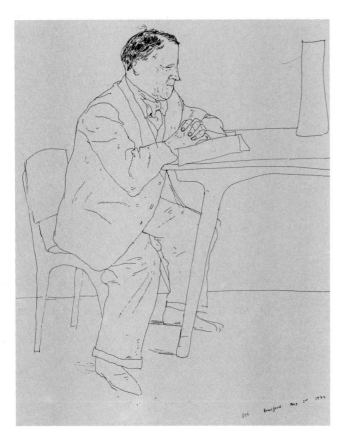

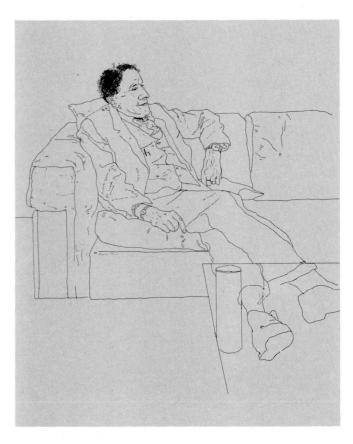

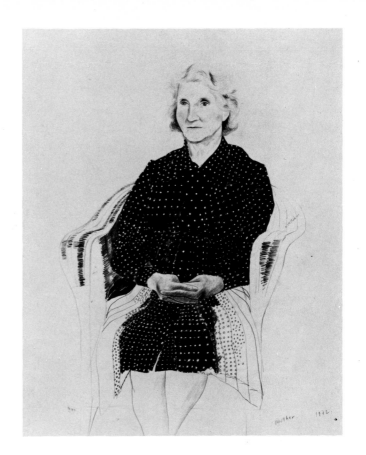

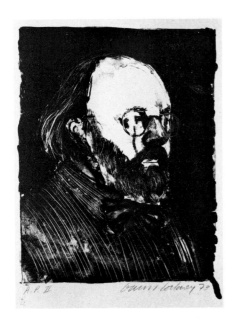

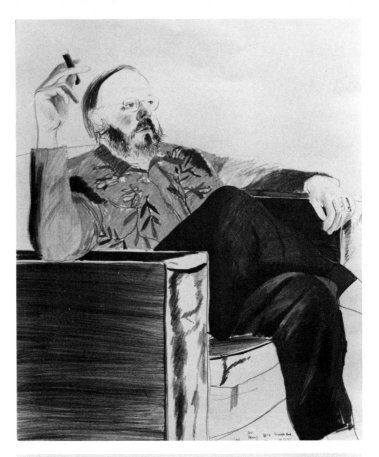

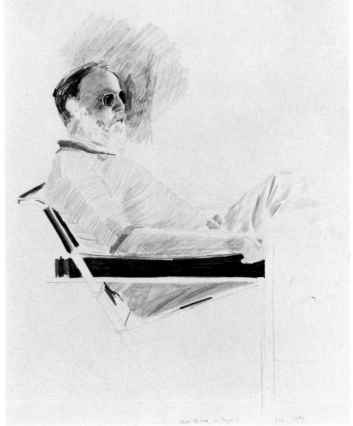

362 *Henry* 1973

363 *Henry, Seventh Avenue* 1972

364 *Sant'Andrea in Caprile (Henry in Deckchair)* 1973

365 *Sant'Andrea in Caprile* 1973

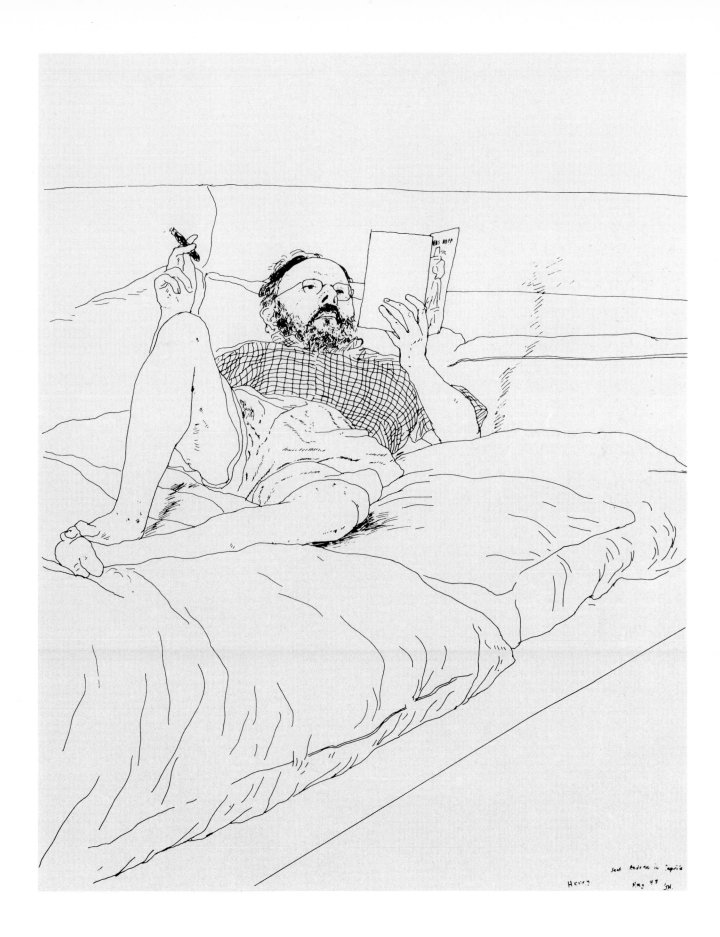

Henry Sant Andrea in Coprie
 Mag 7? '74.

261

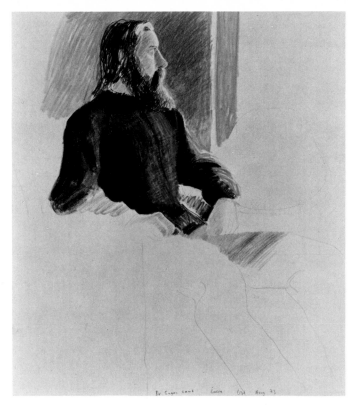

366 *Dr Eugen Lamb* 1973
367 *Chair, Casa Santini* 1973

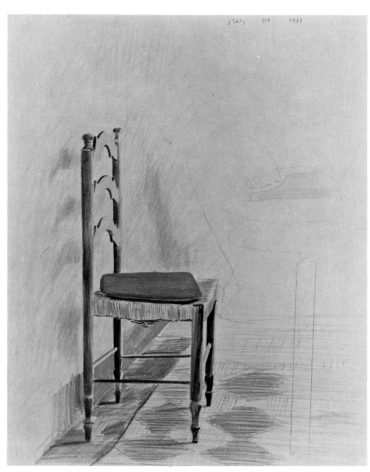

368 *Don Crib, Lucca* 1973
369 *Mo, Lucerne* 1973

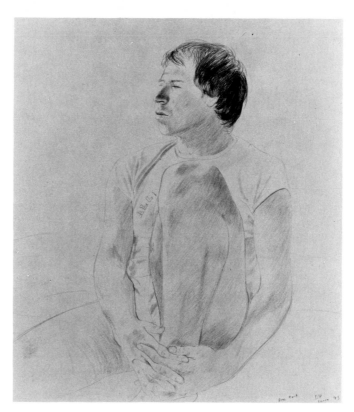

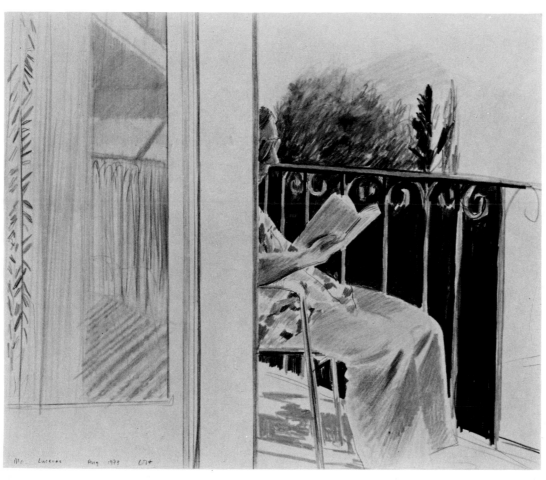

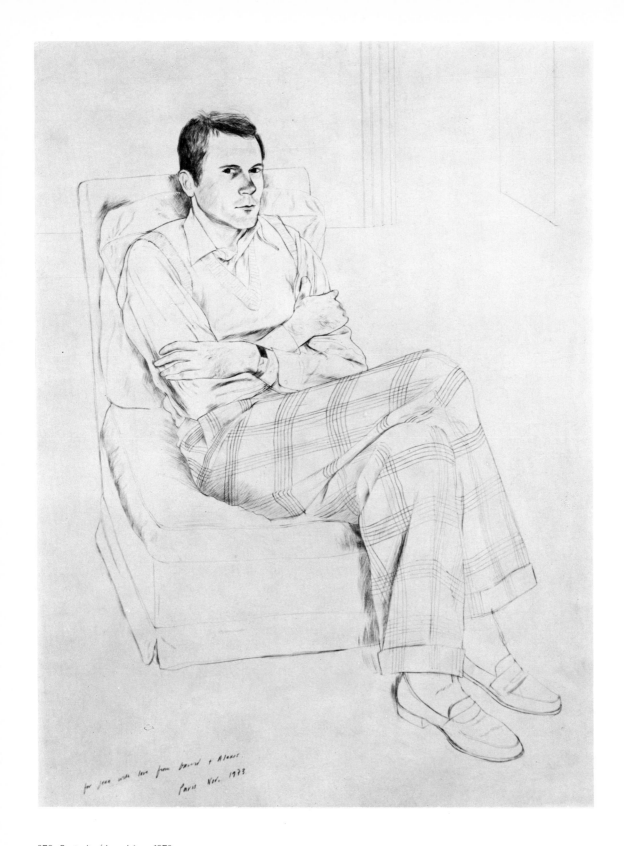

370 *Portrait of Jean Léger* 1973

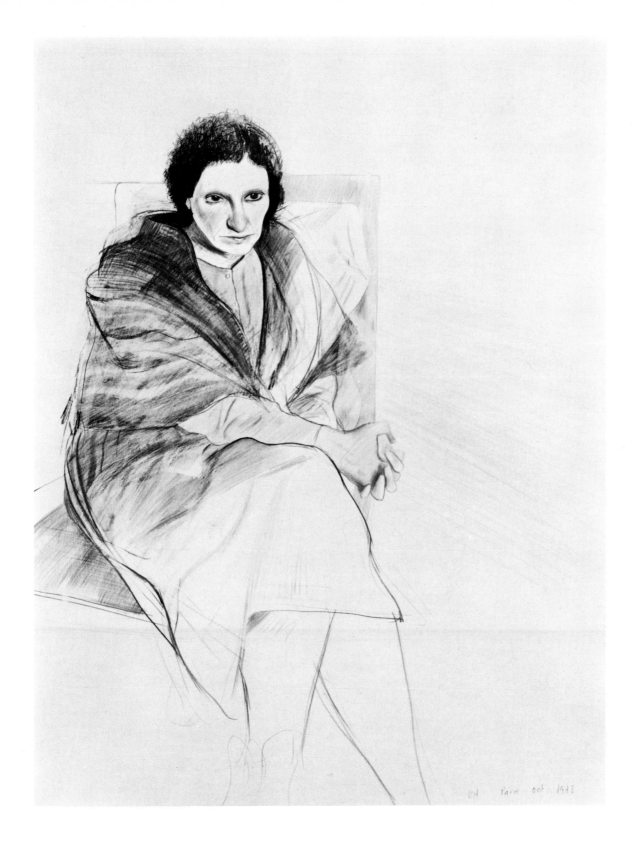

371 *Lila di Nobilis, Paris* 1973

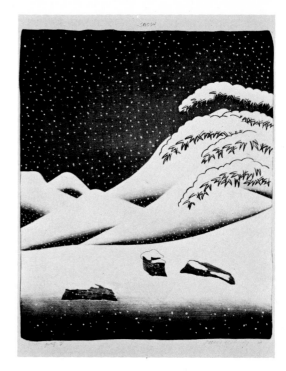

372 Celia, 8365 Melrose Avenue 1973

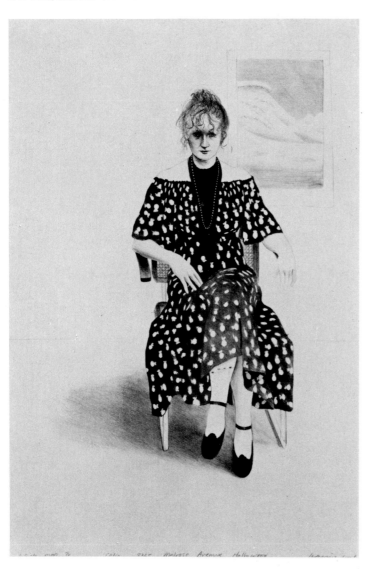

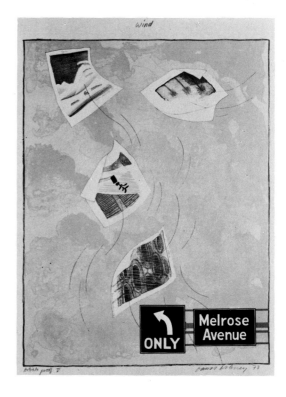

373 'Snow'

374 'Wind'

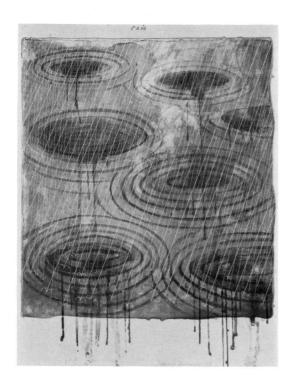

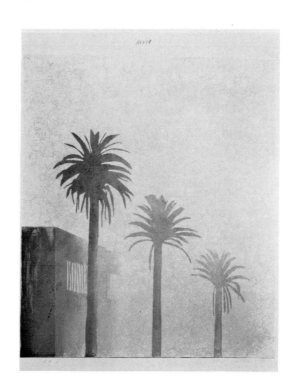

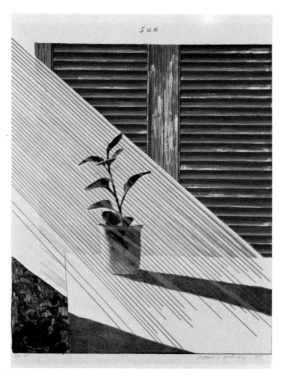

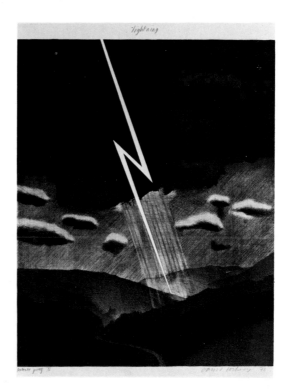

375 'Rain'
376 'Sun'

377 'Mist'·
378 'Lightning'

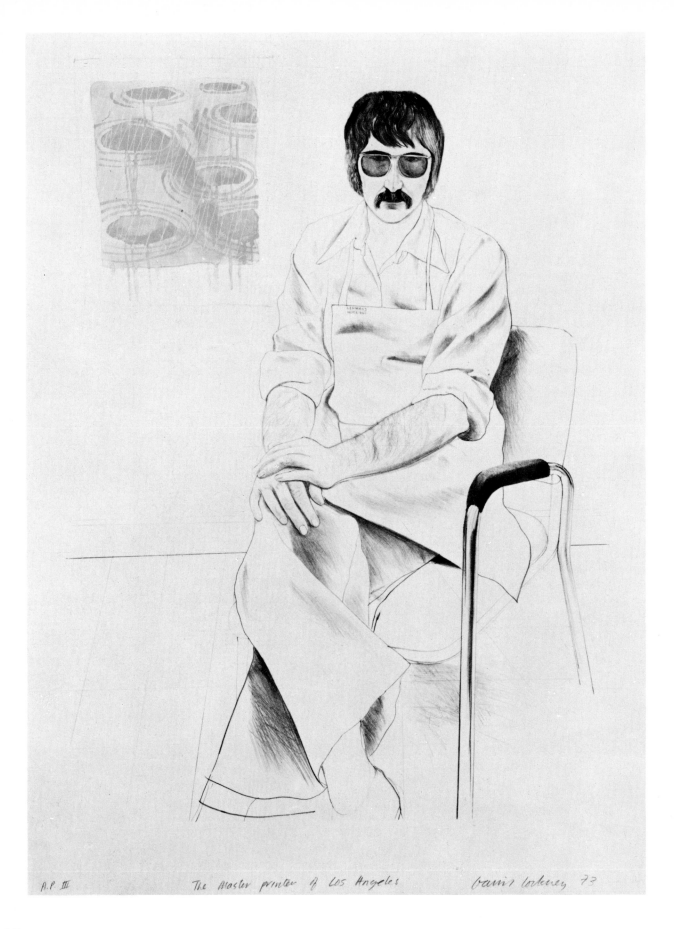

A.P. III The Master printer of Los Angeles David Hockney 73

GUSTAVE FLAUBERT

GEORGE SAND

379 *The Master Printer of Los Angeles* 1973

380 *Gustave Flaubert* 1973

381 *George Sand* 1973

382 *Postcard of Richard Wagner with Glass of Water* 1973

383 *Still Life with Book* 1973

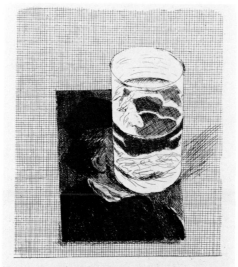

postcard of Richard Wagner with glass of water

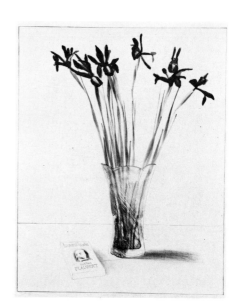

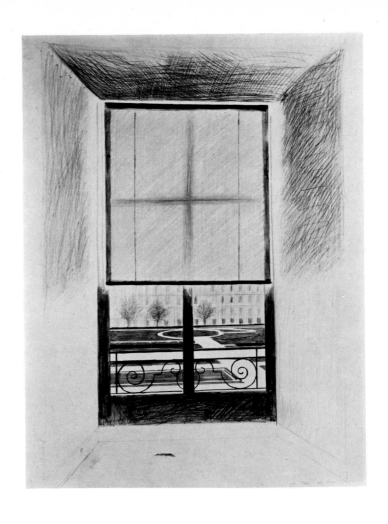

384 *Study for Louvre Window, No. 2* 1974
385 *Contre-jour in the French Style* 1974

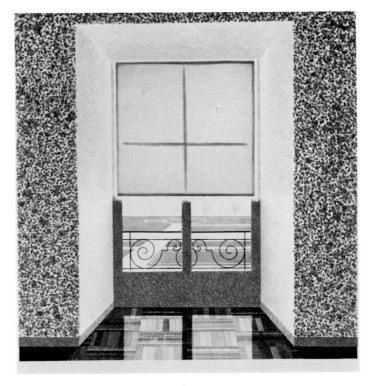

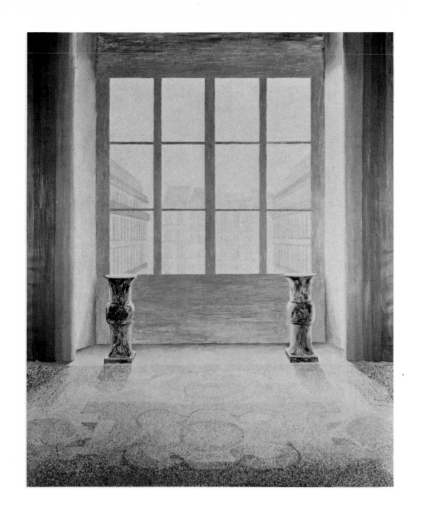

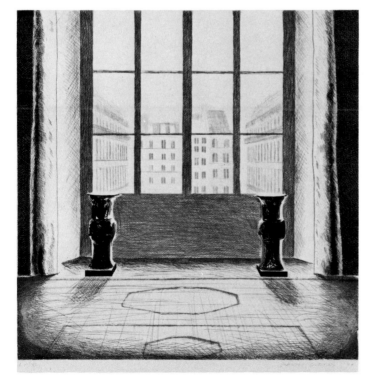

386 *Two Vases in the Louvre* 1974
387 *Two Vases in the Louvre* 1974

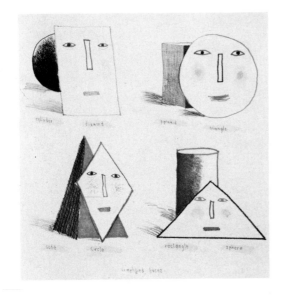

388 *Man Ray* 1973

389 *Simplified Faces (State 2)* 1974

390 *Gregory Masurovsky and Shirley Goldfarb* 1974

391 *Gregory Masurovsky and Shirley Goldfarb* 1974

392 *George Lawson and Wayne Sleep* (unfinished) 1975

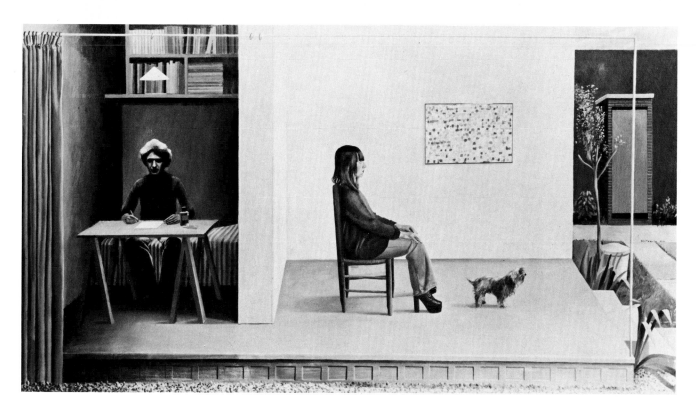

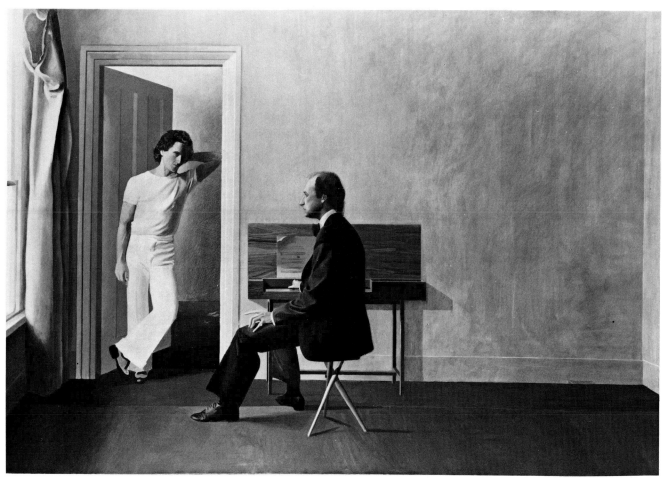

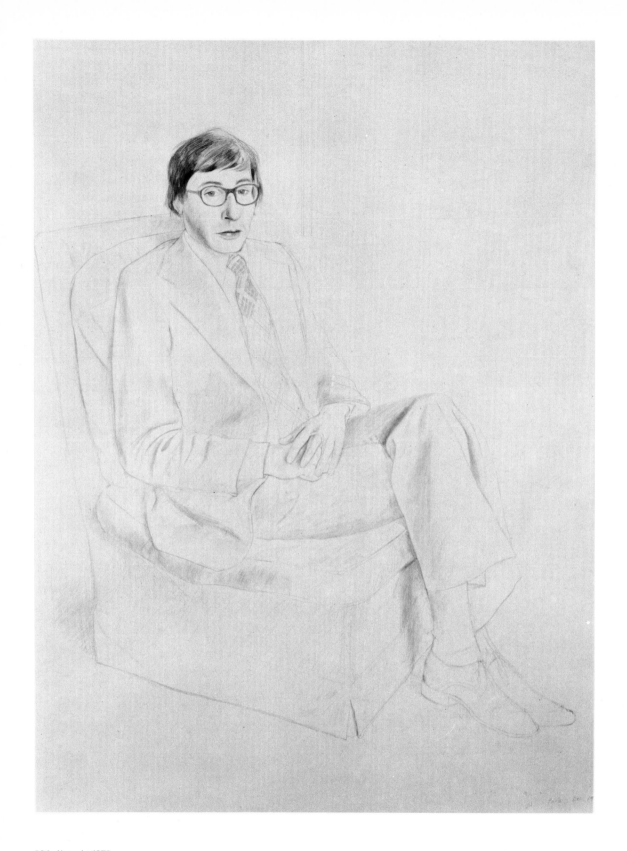

396 *Kasmin* 1973

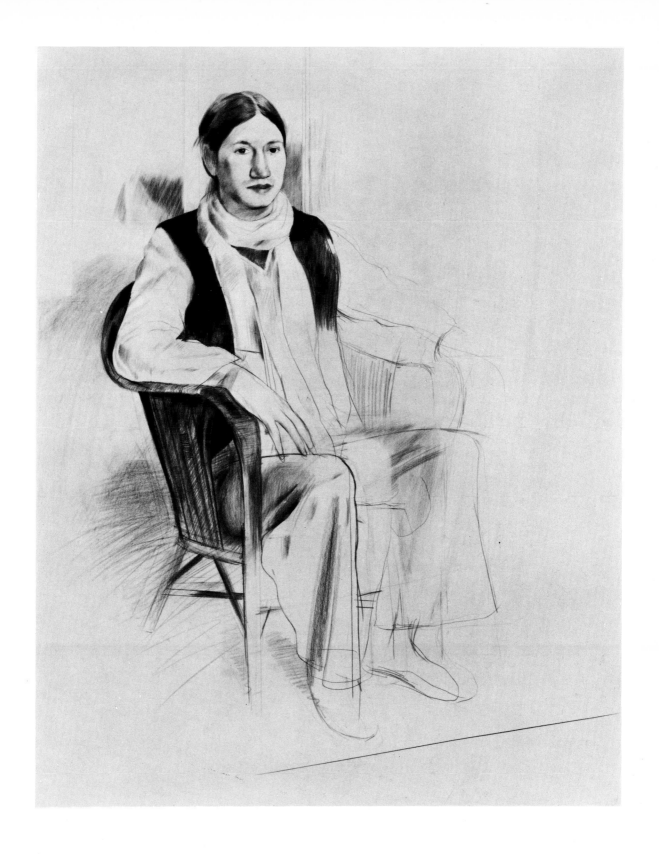

397 *Carlos* 1975

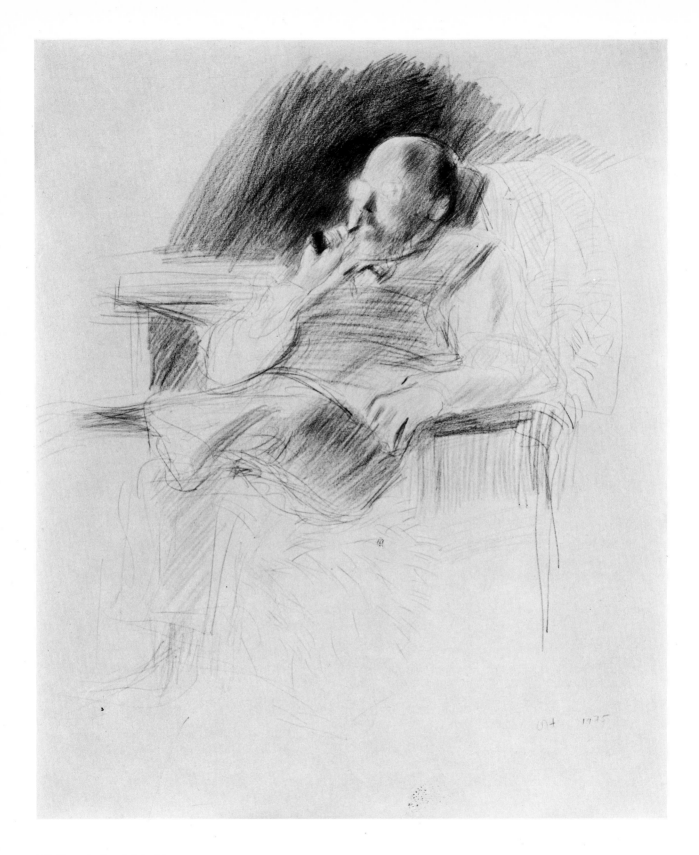

398 *Henry in Candlelight* 1975

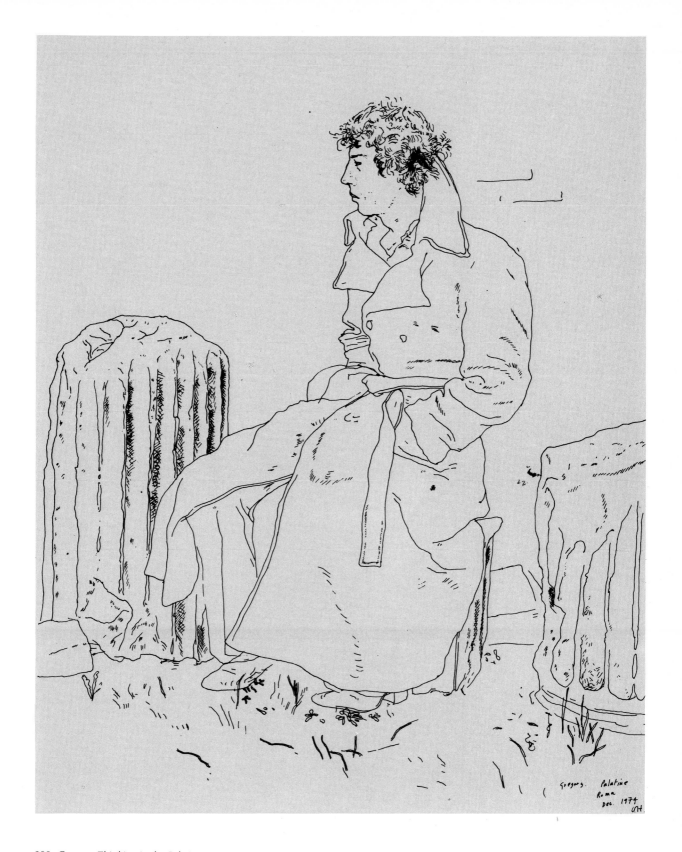

399 *Gregory Thinking in the Palatine Ruins* 1974

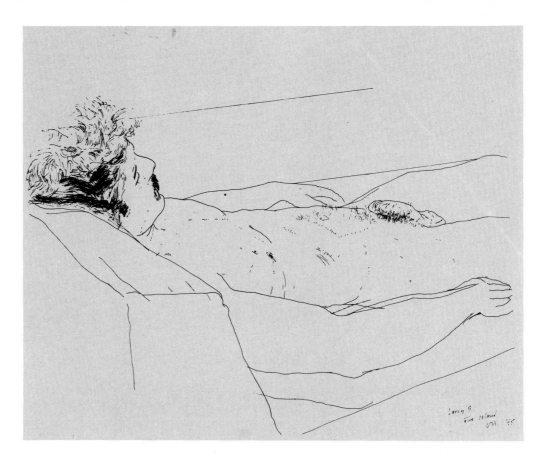

400 *Larry S., Fire Island* 1975
401 *Larry, Fire Island* 1975

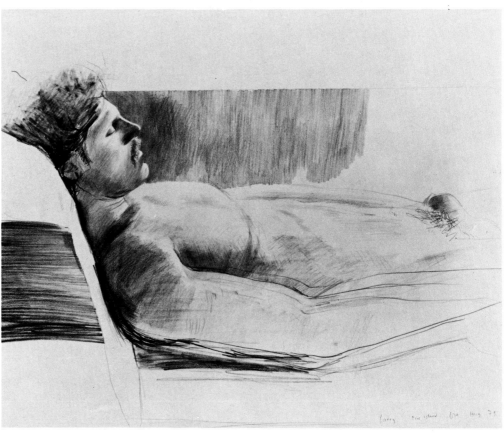

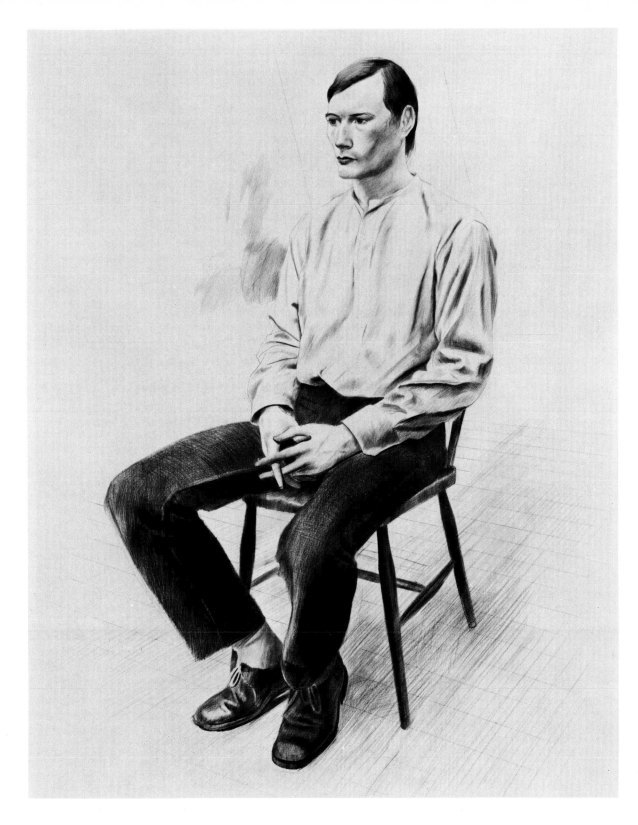

402 *Nicky Rae* 1975

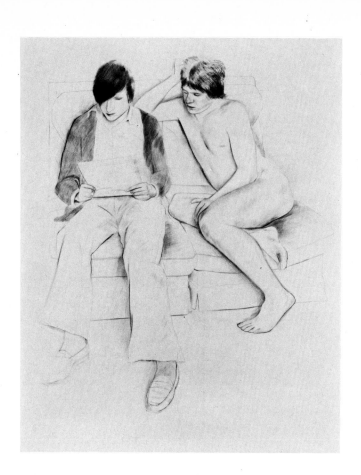

403 *Yves-Marie and Mark in Paris* 1975
404 *Books and Pencils, Fire Island* 1975

405 *Gregory Asleep* 1976

406 *Gregory Asleep* 1976

407 *Gregory in Los Angeles*
 1976

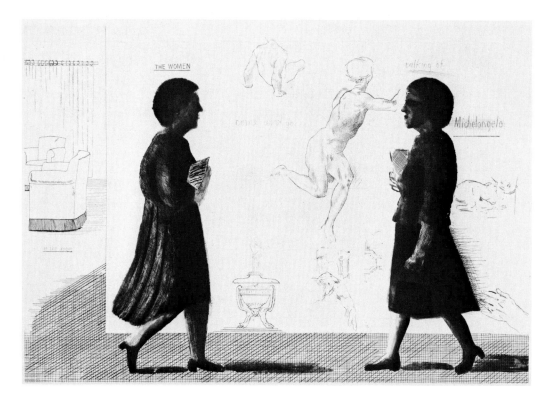

408 Sketch for *The Rake's Progress* 1975

409 *Homage to Michelangelo* 1975

After I left California, I decided to go to Paris; I thought, I'll give up England for a while. California was the place I always used to run to, but I thought, I don't really want to go back there again, I'll go to Paris; I've always liked Paris. I lived in the Hôtel de Nice in the rue des Beaux-Arts at first, and I started doing some etchings in Crommelynck's studio. That summer I went to Lucca with Henry Geldzahler and came back to England for a while. Then I moved over to Paris to paint.

I decided I would paint in oil. I'd temporarily abandoned the picture of George and Wayne. When I looked at it after I came back from California, something put me off working on it again. I thought, I'll leave it, there's no reason to work on it. The first few oil paintings I did in Paris were all abandoned. It was a bit depressing; what happened was that I treated the oil paint just as though it was acrylic, forgetting, because I hadn't used oils for so long. But I began to enjoy Paris, and I started drawing a great deal; that's when I started drawing very big. Celia came over on a few visits, and I started doing big drawings of her. But in a year I only did three paintings: the two pictures of the Louvre, *Contre-jour in the French Style – Against the Day dans le style français* and *Two Vases in the Louvre*; and the portrait of *Gregory Masurovsky and Shirley Goldfarb*.

410

386, 390

By coincidence, just after I moved to Paris the British Council arranged a big show at the Musée des Arts Décoratifs in the Louvre. When the British Council first mentioned it, it was supposed to start in Venice, at the Biennale. I wasn't interested in the Biennale, and I said OK, but I don't care whether you do it or not. Then the Biennale was cancelled, and the organizers said they would like to take the show to some other place, Paris or somewhere else. So I said I think it would be nice in Paris, I'm living there. And then I did take an interest in the show. I'm glad they did it in Paris; it had quite an effect, because my work was completely unknown there – I'd shown very little there before.

The three paintings I did that year were new inventions for me, all of them. *Contre-jour in the French Style – Against the Day dans le style français* – I like the title, I must admit – is simply a window I saw in the Louvre. In the Pavillon de Flore they had an exhibition of French drawings from the Metropolitan Museum, which I thought was a really beautiful show. I went to see it a few times. The first time I went I saw this window with the blind pulled down and the formal garden beyond. And I thought, oh, it's marvellous, marvellous! This is a picture in itself. And then I thought, it's a wonderful subject, and it's very French; here I am in Paris, I've abandoned some other pictures, why don't I do that? So I took some photographs of it, made a drawing, and started painting. I thought, perhaps I'll use a more conscious French style: pointillism. It was a way of getting into oil painting again. The painting went very well right from the start. Usually, if a painting goes well from the beginning, you can keep it going. You can start badly and make it go good, but it's rare to start well and then ruin it; it does happen to me occasionally, but it's very rare, because if you get it going from the beginning, it means you were on the right pitch to start with. The pointillist technique is not very good, but it is pointillist. There's a perversity about using a style like that, especially in France, and in pictures of Paris. After all, painting Hollywood is a modern, post-war thing; painting Paris is something else. People went to Paris to paint it sixty, eighty, a hundred years ago. And also it's been painted by wonderful artists, better than I am. There was a challenge and perversity about it that appealed.

The portrait of Gregory and Shirley was done because I'd known Shirley Goldfarb quite a while, and I thought it would be nice to do another double portrait. It's a small painting. Gregory and Shirley are Americans who've lived in Paris for twenty years. They're both artists, but Shirley doesn't paint much; she wanders around Paris, and spends a lot of time sitting in

the Café de Flore, and every night they go and have dinner and sit in La Coupole. She is quite amusing. I was struck by the small studios they've lived in for twenty years, two tiny little rooms; they're incredibly tiny. I was quite moved by the little studios, and the fact that they'd been in them twenty years, and I thought, there's a subject here as well. Their relationship is a weird subject: he can't go out of the building without her seeing, but she can. They are married, but they are apart. She calls herself Shirley Goldfarb, not Shirley Masurovsky, and they lead kind of separate lives.

Their studios are small, thin rooms – you have to go out of one into the other – and there's a north light, so to look at Shirley and Gregory in the studio I had to remove the wall, as it were. That's why the painting's done as it is. The only way to get the side view of the studio is to take down the wall; the 'platform' is the wall taken down so you can look into the rooms, not a platform at all.

A film without a star

While I was painting their portrait in Paris, I came back to London to see the movie, *A Bigger Splash*. When I saw it I was stunned and shattered, partly because it was like living through the . . . there is something very real about it; despite all one's criticism of the film, there's a lot of truth in it, and I was utterly shattered; I had no idea. I hadn't seen one inch of that film, I didn't expect the sound. The photography stunned me. This wide screen, my god, what are they doing, how could they do this, with one camera? I saw it, I walked out of the cinema; I didn't say a word to Jack about it, not a word, except one thing: I want you to remove 'starring David Hockney'. I'm not a star, not a film star; I don't want to be a film star; please take that off. And I walked away. My impression of the film was that it was boring and long, and I thought, well if I think it's boring and long, everybody else must think so too. Then I thought, the photography was stunning; but I was still worked up about it. I didn't know what to do. The guy's spent four years making it, a lot of his own money, you can't do anything about it. I realized I couldn't say You can't show the film, no matter what I thought. It was a problem.

I went back to Paris and I was thinking about it all the time. What am I going to do? Then I thought, I'll go see it again. So I brought Shirley Goldfarb over to London. She goes and sees every film there is; nothing else to do. She thought it was wonderful and she said she thought it was the best film she'd ever seen about an artist creating pictures. Claes Oldenburg also said that; when he saw it he phoned Jack Hazan up to say so. The first time I saw the film I thought it was formless, but the second time I realized it's not as formless as I'd thought. So then I thought, well I can't do anything about it, so I just left it. I carried on; I'm doing this painting of Shirley. And the next I hear, Jack Hazan phones me up: The film is going to be shown at the Cannes Film Festival, will you come? I said I'm not going anywhere near Cannes if it's showing there. But it was, and the movie critic of *The Times* wrote in his piece that he thought it was really good. Anyway, I thought, I can't do anything to stop the film; I'd signed its release. I did think Jack could have made a much more commercial movie and made a lot of money from it; it would have been possible. But the way he made the film, it's not a commercial movie at all; its a specialized film, I think.

He came to Paris and said They're showing it in Paris because they're showing all the films from the Cannes Film Festival. Come and see it with an audience. He came with David Robinson, who was wanting to do a big piece for *The Times* about how the film was made. I'm painting this picture of Gregory and Shirley, and it's nearly finished. Jack looks at it, quite fascinated, and says You see, David, that's what you do all the time; look at what you're doing to them. And I said I know, I see your point; if Shirley and Gregory say We don't like that picture, I'm not going to destroy it, if I like it.

I did go and see the film with them, sitting in the audience. I've only seen it those three times. And I sat at the back. I told Jack I'm not going to speak about the film. I didn't really make it; it's your film, Jack you can take all the credit and all the blame. It's nothing to do with me – I just appear in it. And as you well know, Jack, I didn't quite know what was going on in that film. That's why you said it's part fiction. I explained all this to David Robinson, who still said It is a marvellous film, David. I left immediately the showing was over. But the French loved it, partly because they didn't understand the dialogue. The story isn't told through its dialogue, which is banal and irrelevant; the film doesn't really need any because the story is told visually. The film became this great success in Paris. Not a commercial success; a success with film buffs in a small art cinema. Film buffs love it. After seeing it, I fled out to La Coupole, and people kept stopping me in the street: Loved your film. *My* film! By sheer coincidence, it opened a few days after the show in Paris at the Louvre. That's one reason why a lot of people said they loved it; they would go to the film, then go to the exhibition and see the real paintings. People say it was a marvellous experience to watch the film and then be able to go and see the real paintings, especially for people who had never come across my work before. I joke about the film. I try and ignore it. I'll talk about it with people, but on the whole I ignore it. In fairness to it, in many ways it's a remarkable film; I don't think it could be repeated, because to repeat it you'd have to find innocent people. If Jack Hazan showed me that film, and then said Now I'd like to make a film about you, can I? I'd say Fuck off. Anybody would, I think. The people in the film were completely innocent, not realizing how it was being done; Jack didn't realize either, although he at least knew what the photography was going to be like. But I think the film will always be shown, because there are good things in it, and you've to take them along with the bad.

New etching techniques I always knew there was an etching technique where you could draw on a plate with acid. The normal way to do aquatints is by laying resin dust on a plate, then blocking out the bits you don't want, which means that you have to draw in a negative way: to protect the plate, you varnish the thing you don't want grey, then you dip the plate in the acid. With an aquatint it doesn't have to be in the acid very long at all – a few minutes, only a minute if the acid is strong. But I knew that Picasso had sometimes used a different technique. Of course, one way round drawing in the negative form is to use what is called 'sugar lift', a process where you mix a saturated sugar solution, and put a bit of poster paint with it; you draw with that where you want your grey aquatint, then you cover the plate with a varnish and put it in water; in the water the sugar melts, lifting off the varnish, and then you can etch it. It's a positive way of drawing. But there's another way: if your plate has got an aquatint resin on it, you can draw with acid direct onto it. You treat the acid as a watercolour and you draw with a brush. The problem is that the brush begins to deteriorate immediately – it only lasts for one minute – because you must use quite strong acid. We tried doing it like that, but you had to work so fast there was no control. Maurice Payne got the idea that if you used a Polycell glue, the kind of cellulose stuff you stick wallpaper on with, you could dip your brush in that first and then in acid; the Polycell protects the brush a little bit and it takes a while for the acid to get through. Also, the Polycell sticks a bit so you get a brush effect on the plate. You still have to draw quite quickly, because the acid's going to get through the glue in the end and the brush will fall apart, but you do get a lot more time. When Maurice thought of it, I thought, Maurice, you're a genius! It's an incredible idea. Because I'd never been able to do sugar-lift etching successfully: I didn't know the secret of melting the sugar. I found it out later in Paris from Crommelynck.

When I was in California with Celia at the beginning of 1973, I had just read the last of the Flaubert novels, *Bouvard and Pécuchet*, and I was still full of thinking I'd love to do 'A Simple Heart' from his *Trois Contes*. The story really affected me and I felt it was a subject I could get into and really use. When Maurice showed me his technique, I had the Nadar photographs of Flaubert and George Sand and I used the technique to draw George Sand. I drew it straight away at one go, and we pulled a print. I said It's incredible, Maurice, it's very good, this technique. So then I tried to do Flaubert and had to do it about five times on five different plates, just throwing them away – once you've done something you can't change it on the plate. I did five or six, using this technique, and I thought, it's marvellous.

Later in 1973 I went to Paris to do an etching in memory of Picasso for a publisher in Berlin. In the end I did two, one for Berlin and one for Petersburg Press. I decided I'd do them at Aldo Crommelynck's. He wanted me to go there; we'd never met and I didn't know he knew my work, so I was very surprised when I first turned up there. At first I was just doing etchings the way I knew how to do them. Crommelynck was Picasso's etching printer for twenty years. Picasso was one of the few painters in France who did his own prints, in the traditional way. He actually worked on the plates himself. In France other people usually worked on the plates, copies and things like that, but Picasso's were never done like that. He worked on them himself – worked on the plate, scratching, cutting, chipping, whatever it was.

Crommelynck showed me how to do the sugar lift properly, and I was so surprised that it always worked. Crommelynck had learned all the techniques from Lecourier; he had gone to work with him when he was nineteen. Lecourier was an old man then. He had taught Picasso how to etch and that's how Aldo came to meet Picasso and do his etchings for twenty-five years, because when Lecourier died, Aldo became Picasso's etching printer. He said to me, after I'd been there a while and we got to know each other, It's a pity you didn't come earlier, you'd have really liked Pablo – he always refers to Picasso as Pablo – and he'd have really liked you. I would have loved to have met Picasso, if only once; it would have been something to remember, a great thrill. Picasso died the day I left California. I was going with Leslie Caron to visit Jean Renoir, and I heard it on the radio in the car, and I told Jean Renoir when we got there. Jean Renoir was an old man, and he said What an un-Picasso thing to do.

The Picasso etchings are drawn from a photograph of Picasso, with a brush; the stripes, everything. Then we put the varnish on, and the sugar lifts it off immediately, the way Aldo does it. I was amazed. Every time I'd tried it in London, I'd had to chip the varnish away, and the sugar didn't come off. Or if it came off, it lifted off lots of other varnish as well. But Aldo doesn't use acid, he uses ferric chloride, which works on the copper plate and eats some of it away, which means you can use the brush because it doesn't rot in the ferric chloride, so you can just keep painting the plate. The more ferric chloride you put on, the darker it gets, so you can have light and dark. These were techniques I'd never used before. In my three months there, I found out so many things.

We were having lunch one day and Aldo asked me Why don't you do any coloured etching? I said I'd thought of it, but it was so difficult to do. To register the colour, you have to use two or three plates; you have to make a drawing to begin with in colour. And I said, It seems to me the whole point about etching is that it can be a spontaneous medium; you can just start a plate and begin drawing anything. You don't need a drawing at the side of you – you can work from life, anything, in black and white. And Aldo said Ah, that's exactly what Picasso said about coloured etchings; he didn't really want to get involved, it was too elaborate, and you lost the spontaneity. And then he said, I thought of a method where you can be spontaneous; you don't need a drawing to begin with, and you can work in colour.

381

380

393, 394

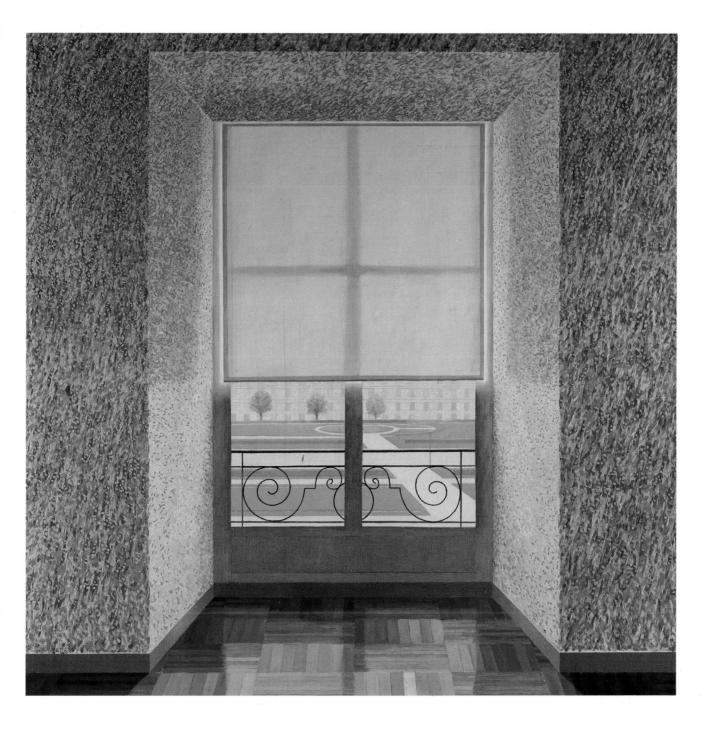

410 *Contre-jour in the French Style – Against the Day dans le style français* 1974

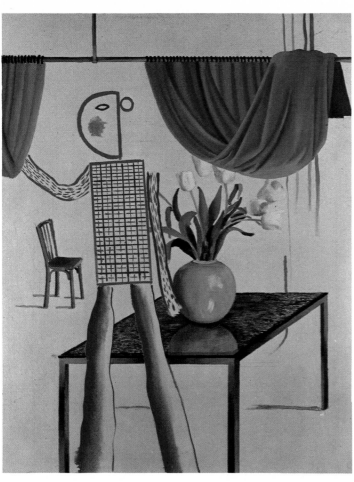

411 *Invented Man Revealing Still Life* 1975

412 Drawing for the design for Roland Petit's
ballet *Septentrion* 1975

413 *Kerby (After Hogarth) Useful Knowledge* 1975

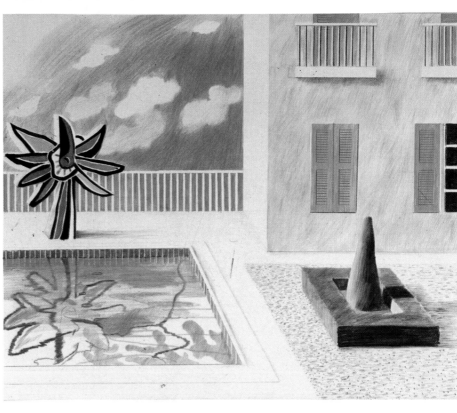

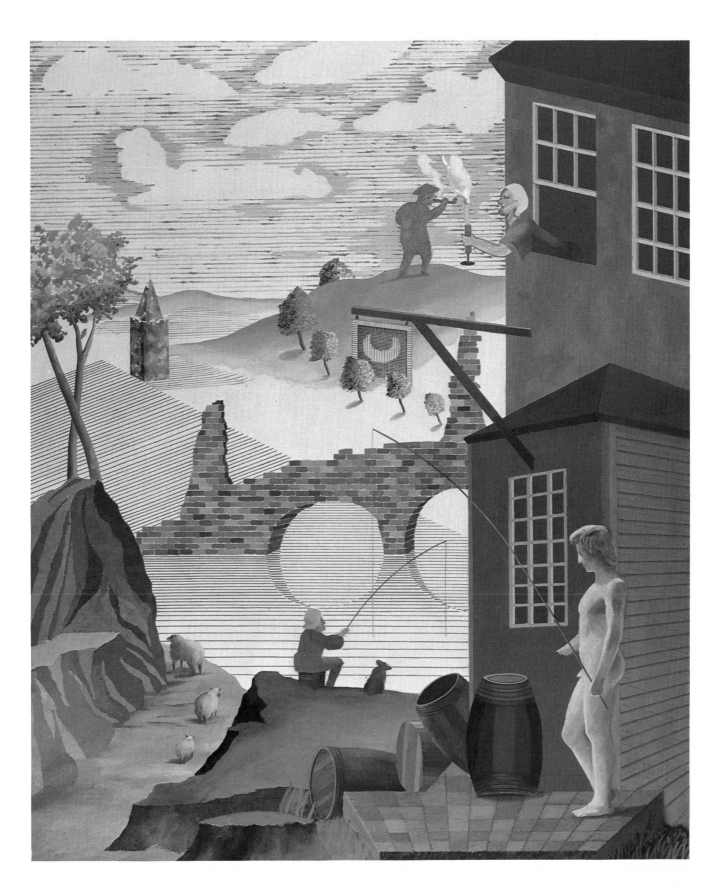

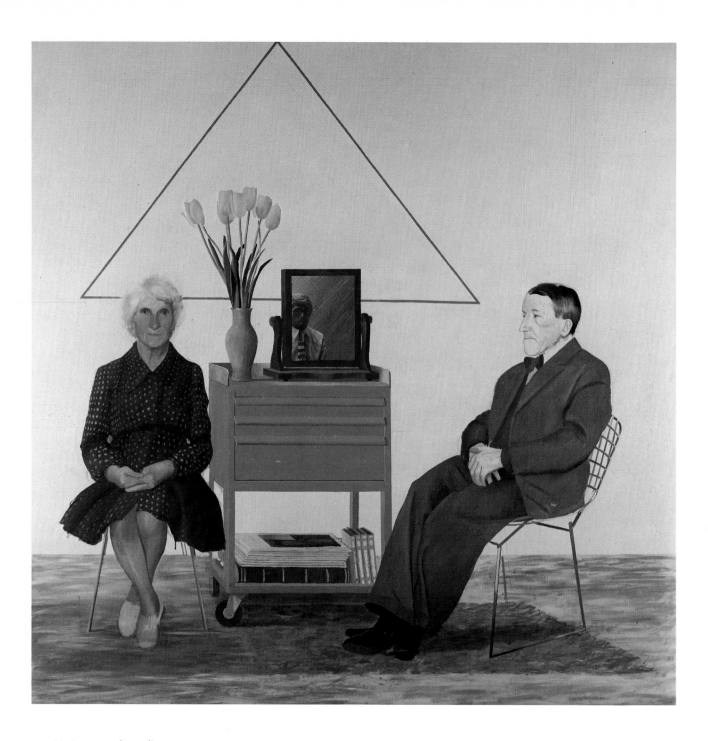

414 *My Parents and Myself* 1975

He explained the method to me, which is basically very, very simple, like all good ideas. I was shocked that nobody had thought of it before, it was so straightforward, using known etching techniques. I was so amazed. I said My god, let's try it this afternoon. I abandoned the Flaubert immediately, just to try the technique. The first print I did with it is called *Simplified* 389 *Faces*. It's no good my explaining the technique; it couldn't be explained without diagrams, but it is very simple, not elaborate at all, just very ingenious. You have to be accurate in making a frame for the plates. Then I realized you could draw from life, in colour. For instance, if you make a black and white lithograph, you draw with black material on a stone and then it's printed, and you know what it looks like. To make a colour lithograph you have to make a coloured drawing first, and then you have to separate the colours, and no matter what colour it is, you draw in black, because the grease is always one colour. Using Aldo's method, you have to draw with coloured pencils. You can etch afterwards, but you must begin with coloured pencils because you have to use soft-ground etching techniques. You can't use hard ground; it won't work. It suited me admirably because I like to draw with coloured pencils, anyway. Picasso never used the technique; Aldo only thought it up just before Picasso died, so I was really the first person to use it, to try it out, and probably I'm still the only person to use it. People are always amazed when they see the prints, and are very surprised they're etchings; they think they're lithographs and all kinds of things. People who look at them say How did you do it? How is it done? I did one of Gregory, in red and blue, drawn straight from life on to the plate. Then I did the Louvre windows, two of them; I've done maybe six or seven. 385, 387

I did the two Picasso prints in this way and some little still lifes, some flowers, the *Marguerites*. They're not terribly interesting as prints; I was just discovering this technique. The flowers are drawn from life, in colour – again, you have to know about prints to realize how difficult they were to do. I'm not saying it's a virtue for a picture to be difficult to paint; a good picture can be easy to paint, I know that. In fact, I've always rather condemned excessive use of technique in prints. Form and content are more interesting, and you can achieve them even with bad technique. It's nice if the technique is good, but good technique on its own will produce nothing at all, whereas if you've got some form and content, the technique can be mediocre and you can surmount it.

I was very excited about learning all these techniques because it widened the scope of etching a bit, and I told Maurice Payne about them over the phone, told him how they were done. He understood immediately how it all worked. He tried an etching with the colour technique, without me demonstrating it to him, drawing himself, and it didn't work. But then I came to England and showed him, and told him he had to use ferric chloride to etch the soft ground because you can watch it working; it doesn't take long, only two minutes, but you have to watch that it doesn't break down. He got the ferric chloride and we tried it, and it worked very well. Aldo knew I was telling Maurice – it's not a trade secret or anything. Maurice was staggered; it was quite a revelation. We did some more elaborate things, and then I said Also, Maurice, I've found out how to perfect the sugar lift. Previously, we'd heated up the sugar and the water to make the syrup, but when it cooled, some of the sugar granulated again, so that when you were drawing the granulated sugar in the solution stopped you getting fine lines. Aldo had said to me You can get perfect thin lines with the brush with sugar lift if you do it right. You don't use hot water at all, you use cold. You have to wait a day until the sugar dissolves; you keep on adding more sugar until you reach a point when no more will dissolve. If it starts granulating, it means you've too much sugar; you have to stop just when you get the complete saturated solution. Maurice made it up and sure enough it worked.

Showing Maurice the Sugar Lift was done just as a test plate. I was showing Maurice first of all how to do the soft-ground technique without the colour, and using the sugar lift. Eventually we made a picture of it; at first I wasn't going to publish it as a print, and then we decided to, because everyone liked it and I thought, it's an interesting thing. Maurice at first was a bit offended by the title because he said People'll think I didn't know about sugar lift. I said Nobody knows what sugar lift is. And I explained Look, Maurice, it sounds like the name of a song: 'Showing Maurice the sugar lift, cha cha cha'. 395

Maurice has printed my etchings for twelve years or so now; he's a very, very good printer – there aren't many about. Printing etchings is quite a difficult job. There aren't that many painters who make etchings now, actually; there used to be more. There are people who only make prints and they're called printmakers, people like Michael Rothenstein, like Stanley Hayter. I'm not a printmaker, I'm a painter who makes a few prints. The point about etching is that you have to know how to draw; it's basically a linear medium.

New drawings, new paintings and an opera design

After the big exhibition at the Louvre, from October to December 1974, I spent a lot of time drawing; they're very complicated, tight, academic drawings. Some of them took a week to make; the first time I'd taken so long over drawings. I began painting again in 1975. There are two or three paintings that are half-done, in fact a bit abandoned. Then I started a big painting of my parents, which I'd been planning for a long time; it's progressing quite well. I'm quite pleased with the way it's going. I did a small strange painting, that at first people didn't understand, thought it was a bit odd. It's an invented figure, like the one in *Showing Maurice the Sugar Lift*, a check man, with a real still life, and the man is moving a curtain which is painted from a Fra Angelico painting, lifted straight from it. It's called *Invented Man Revealing Still Life*. 414 411

Then the one big work I did was Stravinsky's *Rake's Progress* for Glyndebourne. Although I worked a lot from Hogarth drawings, designing that opera took about five months, a lot of work. I did some extensive research on Hogarth, of course, and I found a frontispiece to an eighteenth-century treatise on perspective by a John Kerby; I was quite amused by it because all the perspective is wrong. At first I thought I might use it in the opera; then I thought, no, this kind of visual joke isn't necessary. But I could make a painting of it. I began the painting, *Kerby*, in April or May 1975, at the same time as I started the portrait of my parents. Until my Claude Bernard show of prints and drawings, in Paris in the spring of 1975, I'd been drawing all the time, and working on the opera. I had to stop working on *Kerby* in June because I had to come to England to do work on the opera at Glyndebourne itself; all of June I was at Glyndebourne. And in July I went back to Paris and worked on the pictures. 408 413

I've finished *Kerby* now. It's quite a big picture. It relates to *Invented Man Revealing Still Life*; when people saw *Kerby* they immediately said they saw what *Invented Man* was about. The composition of *Kerby* is the same as the Hogarth frontispiece, which at first glance looks like a normal picture – a river, two men fishing, a bridge, sky, buildings at the side; but when you look more closely you see all sorts of strange things: the wrong perspectives. I never read Kerby's treatise but I think the frontispiece was just Hogarth's joke, making a joke about a perspective book. Perhaps he's trying to show you can do all the perspective wrong and the picture'll still look right. He uses reversed perspective; things are small at the front and bigger at the back. My painting is a transcription of his black and white engraving into paint. Transcribing it was quite interesting: the sky I did the same way, I ruled the lines just as they are in the engraving; but the buildings are solidly painted. I played about with different kinds of paint on the canvas as well. It looks back at earlier work of mine, but it could never have

been painted any other time than now. I couldn't have painted it ten years ago; it wouldn't have been conceived like that.

These three pictures mark, not a new departure exactly, but a kind of release from naturalism. The portrait of my parents is a quite different conception from the other portraits. There's no room, they're just on a canvas. I feel quite free again, and now I've got lots of other pictures I want to do, and I just want to go and invent them. Before, I was trying to get away from something else and it was harder than I thought. It's not that one rejects the move towards naturalism, but it could be a trap. This could also be a trap, what I'm doing now, but when I can detect it, I can do something about it. Naturalism is something which one should be careful about, anyway; any painter can tell you it's a kind of trap. And also, in the history of painting, naturalism has never been that interesting. Realism is interesting, but I don't mean naturalism in that sense.

I won't go back to the Flaubert etchings for quite a while now. I have only done one print 409
for the Michelangelo quatercentenary, Vera Russell walking through a room coming in one side and exiting the other: 'In the room the women come and go, talking of Michelangelo.' And I quote that, and there is this rather hurrying figure going through a room, something blurred – I'm using washes for the blurred figure – and then some references to Michelangelo. I thought it was an interesting way to look at Michelangelo; the Eliot quotation must be the most famous modern literary reference to him. And Vera seems to me to be the sort of woman who would talk of Michelangelo. When I was talking about it to Jasper Johns he told me about a scene in *The Maltese Falcon* where a man says to the detective What does it mean, 'In the room the women come and go, talking of Michelangelo'? And the detective says It probably means he doesn't know much about women. Pretty good. I like that.

List of Illustrations

Measurements are given in inches and centimetres, height before width. Numbers in italics are colour plates.

1 *Adhesiveness*, 1960. Oil on board, 50×40 (127×102). Cecil Beaton.

2 *The Third Love Painting*, 1960. Oil on board, $46\frac{3}{4} \times 46\frac{3}{4}$ (119×119). Mrs George M. Butcher, Oxford.

3 *The Cha-Cha that was Danced in the Early Hours of 24th March*, 1961. Oil on canvas, $68 \times 60\frac{1}{2}$ (173×158). Mr and Mrs Robert Melville.

4 *A Grand Procession of Dignitaries in the Semi-Egyptian Style*, 1961. Oil on canvas, 84×144 (214×367). Robert Lewin, London.

5 *Tea Painting in an Illusionistic Style*, 1961. Oil on canvas, 78×30 (198×76). Bruno Bischofberger, Zurich.

6 *Flight into Italy – Swiss Landscape*, 1962. Oil on canvas, 72×72 (183×183). Marchioness of Dufferin and Ava, London.

7 *The Second Marriage*, 1963. Oil on canvas, $77\frac{3}{4} \times 90$ (198×229). Presented by the C. A. S., London, to the National Gallery of Victoria, Melbourne.

8 *Portrait of My Father*, 1955. Oil on canvas, 20×16 (51×41). Mr and Mrs Bernard Gillinson, Leeds.

9 *Self-portrait*, 1954. Colour lithograph, 16×12 (40×30). Five impressions pulled (no numbered edition).

10 *Fish and Chip Shop*, 1954. Colour lithograph, 18×17 (45×42). Five impressions pulled (no numbered edition).

11 *Woman with Sewing Machine*, 1954. Colour lithograph, 10×16 (25×40). Five impressions pulled (no numbered edition).

12 *Standing Figure*, 1956. Oil on canvas, 48×40 ($121 \cdot 9 \times 101 \cdot 6$). Collection of the artist.

13 *Nude*, 1957. Oil on canvas, 72×48 ($182 \cdot 8 \times 121 \cdot 9$). Collection of the artist.

14 *Drawing of Dog*, 1957. Ink, c. 9×12 ($22 \cdot 8 \times 30 \cdot 5$). Paul Hockney, Bradford.

15 *The First Love Painting*, 1960. Oil on canvas, $50\frac{1}{2} \times 40\frac{1}{4}$ ($128 \cdot 2 \times 102 \cdot 2$). Collection unknown.

16 *Jump*, 1960. Oil on canvas, 30×20 (76×51). James Kirkman, London.

17 *The First Tea Painting*, 1960. Oil on canvas, $29\frac{1}{2} \times 13$ (74×33). Private collection.

18 *Doll Boy*, 1960–1. Oil on canvas, 60×48 ($152 \cdot 4 \times 121 \cdot 9$). Private collection.

19 *Little Head*, 1960. Oil on canvas, $15\frac{1}{2} \times 12\frac{1}{2}$ (39×32). Peter Cochrane, London.

20 *Your Weight and Fortune*, 1961. Oil on canvas, 20×30 (51×76). Paul Jenkins, Paris.

21 *The Fourth Love Painting*, 1961. Oil and Letraset on canvas, $36 \times 28\frac{1}{4}$ (91×72). John Donat, London.

22 *Alka-Seltzer*, 1961. Etching and aquatint on zinc, $11\frac{1}{8} \times 5\frac{1}{8}$ ($28 \cdot 4 \times 13$). Edition of 15, signed in pencil, published by the Petersburg Press and printed by Maurice Payne.

23 *The Most Beautiful Boy in the World*, 1961. Oil on canvas, $70 \times 39\frac{1}{2}$ (178×100). Private collection.

24 *Boy with a Portable Mirror*, 1961. Oil on canvas, 39×55 (99×140). Paul Jenkins, Paris.

25 *Peter C.*, 1961. Oil on canvas, diptych, $23\frac{3}{4} \times 16$ (60×41) and 18×12 (46×30). Private collection.

26 *Sam Who Walked Alone by Night*, 1961. Oil on canvas, c. 36×24 (91×61). Private collection.

27 *We Two Boys Together Clinging*, 1961. Oil on board, 48×60 (122×153). The Arts Council of Great Britain, London.

28 *The Last of England?*, 1961. Oil on canvas, 20×20 (51×51). Mrs Janet Foreman, London.

29 *The Second Tea Painting*, 1961. Oil on canvas, 61×36 (155×91). Private collection, West Germany.

30 *Myself and My Heroes*, 1961. Etching and aquatint on zinc, $10\frac{1}{4} \times 19\frac{3}{4}$ ($26 \times 50 \cdot 1$). Edition of fifty, signed in pencil, printed by Ron Fuller and Peter Matthews.

31 *The Fires of Furious Desire*, 1961. Etching and aquatint on zinc, $5\frac{3}{4} \times 11$ ($14 \cdot 5 \times 27 \cdot 9$). Edition of seventy-five, signed in pencil, published by the Petersburg Press and printed by Maurice Payne.

32 *Gretchen and the Snurl*, 1961. Etching and aquatint on zinc, $4\frac{3}{4} \times 20\frac{3}{4}$ ($11 \cdot 8 \times 53$). Edition of seventy-five, signed in pencil, published by Editions Alecto and printed by Peter Matthews.

33 *Three Kings and a Queen*, 1961. Etching and aquatint on zinc, $9 \times 25\frac{1}{2}$ (23×65). Edition of approximately fifty, signed in pencil, printed by Ron Fuller and Peter Matthews.

34 *Kaisarion with all his Beauty*, 1961. Etching and aquatint on zinc, in two colours, $19\frac{1}{2} \times 11$ ($49 \cdot 3 \times 27 \cdot 7$). Edition of approximately fifty, signed in pencil and printed by Ron Fuller and Peter Matthews.

35 *Mirror, Mirror, on the Wall*, 1961. Etching and aquatint on zinc, two colours, $15\frac{3}{4} \times 19\frac{5}{8}$ (40×50). Edition of approximately fifty, signed in pencil and printed by Ron Fuller and Peter Matthews.

36 *Rumpelstiltskin II*, 1961. Etching and aquatint on zinc, 10×22 (25×56). Edition of fifteen.

37 *Rumpelstiltskin*, 1962. Etching and aquatint on zinc, $11\frac{7}{8} \times 19\frac{5}{8}$ (30.3×50). Edition of approximately ten, signed in pencil, printed by Peter Matthews.

38 *My Bonnie Lies Over the Ocean*, 1962. Etching, aquatint and collage on zinc, in three colours, $17\frac{1}{2} \times 17\frac{1}{2}$ (44.8×44.8). Edition of fifty, signed in pencil, printed by Ron Fuller and Peter Matthews.

39 *The Diploma*, 1962. Etching and aquatint on zinc, in two colours, 16×11 (40.4×28.1). Edition of forty, signed in pencil, printed by Ron Fuller.

40 *Figure in a Flat Style*, 1961. Oil on canvas, c. 36×24 (91×61). Paul Jenkins, Paris.

41 *A Man Stood in Front of his House with Rain Descending*, 1962. Oil on canvas, three pieces, 96×60 (244×153) overall. Private collection.

42 *Life Painting for Myself*, 1962. Oil on canvas, 48×36 (122×91). The Ferens Art Gallery, Yorkshire.

43 *Rimbaud – Vowel Poem*, 1962. Oil on canvas, $47\frac{1}{2} \times 36$ (121×91). Mr and Mrs Curt Burgauer, Küsnacht, Switzerland.

44 *Help*, 1962. Oil, ink and Letraset on canvas, $12\frac{1}{2} \times 9\frac{3}{4}$ (31×25). Private collection.

45 *The Cruel Elephant*, 1962. Oil on canvas, 48×60 (122×153). Lady D'Avigdor Goldsmid, Kent.

46 *The Snake*, 1962. Oil on canvas, 60×48 (153×122). Mrs Betty Barman, Brussels.

47 *Picture Emphasizing Stillness*, 1962. Oil and Letraset on canvas, 72×60 (183×153). Mark Glazebrook, London.

48 *Leaping Leopard*, study for *Picture Emphasizing Stillness*, 1962. Ink, $13\frac{1}{4} \times 19\frac{1}{4}$ (33.7×48.9). Sir Duncan Oppenheim, London.

49 *The First Marriage (Marriage of Styles I)*, 1962. Oil on canvas, 72×60 (183×153). Trustees of the Tate Gallery, London.

50 *The Marriage*, 1962. Etching and aquatint on zinc, $12 \times 15\frac{3}{4}$ (30.4×39.8). Edition of seventy-five, signed in pencil, published by the Petersburg Press and printed by Birgit Skiold.

51 Study for *The Second Marriage*, 1962. Ink drawing, $9\frac{1}{2} \times 12$ (24.1×30.3). Private collection.

52 *Man in a Museum* (or *You're in the Wrong Movie*), 1962. Oil on canvas, 60×60 (153×153). From the collection of Mrs Robert B. Mayer, Chicago.

53 *Study for 'Marriage' Painting – Man*, 1962 Crayon, $12\frac{1}{2} \times 10$ (31×25.4). James Kirkman, London.

54 *Bridegroom*, study for *The Second Marriage*, 1963. Crayon, 18×12 (46×30). George M. Clive, London.

55 *Domestic Scene, Notting Hill*, 1963. Oil on canvas, 72×72 (183×183). Dr Guenther Gercken, Luetjensee, Germany.

56 Figure for *Domestic Scene, Notting Hill*, 1963. Ink, $22\frac{1}{2} \times 17$ (57×44). R. B. Kitaj, London.

57 *Mo*, study for *Domestic Scene, Notting Hill*, 1963. Crayon, $12\frac{1}{2} \times 10$ (31.7×25.4). Private collection, UK.

58 *Domestic Scene, Broadchalke, Wilts.*, 1963. Oil on canvas, 72×72 (183×183). Private collection.

59 *Cubistic Woman*, 1963. Crayon, $12\frac{1}{2} \times 10$ (32×25.5). Mrs E. Corob, London.

A Rake's Progress, 1961–3. Sixteen plates, each one etching and aquatint on zinc, in two colours, 12×16 (30.3×40.4). Edition of fifty, signed in pencil, published by Editions Alecto and printed by C. H. Welch.

60 'The Arrival'

61 'Receiving the Inheritance'

62 'Meeting the Good People (Washington)'

63 'The Gospel Singing (Good People) (Madison Square Garden)'

64 'The Start of the Spending Spree and the Door Opening for a Blonde'

65 'The 7-Stone Weakling'

66 'The Drinking Scene'

67 'Marries an Old Maid'

68 'The Election Campaign (with Dark Message)'

69 'Viewing a Prison Scene'

70 'Death in Harlem'

71 'The Wallet Begins to Empty'

72 'Disintegration'

73 'Cast Aside'

74 'Meeting the Other People'

75 'Bedlam'

76 *Egypt '69*, 1963. Ink, $9\frac{5}{8} \times 8\frac{1}{8}$ (25×22). James Kirkman, London.

77 *The House of a Man who had Made the Journey to Mecca, Luxor*, 1963. Crayon, $12\frac{1}{4} \times 9\frac{3}{4}$ (31×25). A. P. Rushton, London.

78 *Four Heads (Egyptian)*, 1963. Oil on canvas, 48 × 48 (122 × 122). Destroyed in a fire in 1967.

79 *Shell Garage – Egypt*, 1963. Crayon, 11 × 15 (28 × 38). Private collection.

80 *Great Pyramid at Giza with Broken Head from Thebes*, 1963. Oil on canvas, 72 × 72 (183 × 183). Lady John Cholmondeley, London.

81 *Accident Caused by a Flaw in the Canvas*, 1963. Oil on canvas, 24 × 24 (61 × 61). Lady D'Avigdor Goldsmid, Kent.

82 *I Saw in Louisiana a Live-Oak Growing*, 1963. Oil on canvas, 48 × 48 (122 × 122). Private collection.

83 *Two Friends (in a Cul-de-sac)*, 1963. Oil on canvas, 42 × 48 (106·6 × 121·9). Private collection, UK.

84 *Still Life with Figure and Curtain*, 1963. Oil on canvas, 78 × 84 (198 × 214). The Peter Stuyvesant Foundation, London.

85 *Coloured Curtain Study*, 1963. Crayon and pencil, 16 × 12½ (41 × 31). Ronald Alley, London.

86 *The Hypnotist*, 1963. Oil on canvas, 84 × 84 (214 × 214). Jean Dypreau, Brussels.

87 *The Hypnotist*, 1963. Etching and aquatint on zinc in two colours, 19¾ × 19½ (50·2 × 49·9). Edition of fifty, signed in pencil, printed by Peter Matthews.

88 *Seated Woman Drinking Tea, Being Served by a Standing Companion*, 1963. Oil on canvas, 78 × 84 (198 × 214). Harry N. Abrams Family Collection, New York.

89 *Shower Study*, 1963. Coloured chalk and pencil, 19¾ × 12 (50·2 × 30·5). Marquis of Dufferin and Ava.

90 *Two Men in a Shower*, 1963. Oil on canvas, 60 × 60 (153 × 153). Rory McEwan, London.

91 *Two Friends and Two Curtains*, 1963. Oil on canvas, 51 × 41 (129·5 × 104). Pierre Janlet, Brussels.

92 *Portrait of Kasmin*, 1964. Lithograph on stone and silkscreen, in two colours, 19¾ × 25½ (50·4 × 65). Edition of seventy-five, signed in pencil, published by Editions Alecto and printed by Emil Matthieu.

93 *Play within a Play*, 1963. Oil on canvas and plexiglass, 72 × 78 (183 × 198). Mr and Mrs Paul Cornwall-Jones, London.

94 *Closing Scene*, 1963. Oil on canvas, 48 × 48 (122 × 122). Private collection.

95 *Domestic Scene, Los Angeles*, 1963. Oil on canvas, 60 × 60 (153 × 153). Private collection.

96 *California Art Collector*, 1964. Acrylic on canvas, 60 × 72 (153 × 183). Mr and Mrs John C. Denman, Bellevue, Washington DC.

97 *Man Taking Shower in Beverly Hills*, 1964. Acrylic on canvas, 65½ × 65½ (167 × 167). Harry N. Abrams Family Collection, New York.

98 *Jungle Boy*, 1964. Etching and aquatint on zinc, in two colours, 15¾ × 19¼ (40·2 × 49·2). Edition of one hundred, signed in pencil, published by Associated American Artists and printed by Giulio Sorrini.

99 *The Acrobat*, 1964. Etching and aquatint on zinc, 17¾ × 23¾ (45 × 60·4). Edition of fifteen, signed in pencil, published by the Petersburg Press and printed by Maurice Payne.

100 *Edward Lear*, 1964. Etching and aquatint on zinc, 19½ × 15¾ (50 × 40·2). Edition of one hundred, signed in pencil, published by Associated American Artists and printed by Giulio Sorrini.

101 *Ordinary Picture*, 1964. Acrylic on canvas, 72 × 72 (183 × 183). Joseph H. Hirshhorn Collection, New York.

102 *California Bank*, 1964. Acrylic on canvas, 30 × 25 (76 × 64). Private collection.

103 *Plastic Tree Plus City Hall*, 1964. Acrylic on canvas, 60 × 48 (153 × 122). Richard Brown Baker, New York.

104 *Imaginary Landscape with Dog*, 1964. Acrylic on canvas, 48 × 48 (122 × 122). Joseph H. Hirschhorn Collection, New York.

105 *Boy About to Take a Shower*, 1964. Acrylic on canvas, 36 × 36 (91 × 91). Private collection.

106 *Beverly Hills Shower*, 1964. Crayon and pencil, 18½ × 23½ (47 × 59·7). James Grady, Atlanta, Georgia.

107 *Man Taking Shower*, 1965. Acrylic on canvas, 60 × 48 (153 × 122). William Dorr, New York.

108 *Iowa*, 1964. Acrylic on canvas, 60 × 60 (153 × 153). Joseph H. Hirshhorn Collection, New York.

109 *The Actor*, 1964. Acrylic on canvas, 65½ × 65½ (167 × 167). Private collection, London.

110 *Cubist Boy with Colourful Tree*, 1964. Acrylic on canvas, 65½ × 65½ (167 × 167). Joseph H. Hirshhorn Collection, New York.

111 *Arizona*, 1964. Acrylic on canvas, 60 × 60 (153 × 153). American Republic Insurance Company, Des Moines, Iowa.

112 *American Cubist Boy*, 1964. Pencil and crayon, 11 × 14 (27·9 × 35·5). Private collection.

113 *Building, Pershing Square, Los Angeles*, 1964. Acrylic on canvas, 58 × 58 (147 × 147). Private collection.

114 *Pacific Mutual Life*, 1964. Lithograph on stone, 20 × 25 (51 × 63·9). Edition of twenty, signed in

crayon, published by Editions Alecto and printed at Tamarind Studios.

115 *Pershing Square Study I*, 1964. Pencil, 10¾ × 13¾ (27·5 × 35). Anne Gahlin.

116 *Wilshire Boulevard, Los Angeles*, 1964. Acrylic on canvas, 36 × 24 (91 × 61). Dr Wilhelm Dansmann, Hamburg.

117 *Olympic Boulevard, Los Angeles*, 1964. Acrylic on canvas, 36 × 24 (91 × 61). Hans-Edmund Siemers, Hamburg.

118 *Washington Boulevard*, 1964. Crayon, 13½ × 10½ (34·3 × 26·7). C. D. Hamilton.

119 *Picture of a Hollywood Swimming Pool*, 1964. Acrylic on canvas, 36 × 48 (91 × 122). Sir Robert Adeane, London.

120 *Swimming Pool*, 1965. Pencil and crayon, 14 × 17 (35·5 × 43). Collection unknown.

121 *Hollywood Pool and Palm Tree*, 1965. Crayon, 9¾ × 12½ (25 × 32). Private collection.

122 *California*, 1965. Acrylic on canvas, 60 × 78 (168 × 198). Dr Guenther Gercken, Luetjensee, Germany.

123 *Two Boys in a Pool, Hollywood*, 1965. Acrylic on canvas, 60 × 60 (153 × 153). Joint property of Lord and Lady Beaumont of Whitley, London.

124 *Water Entering Swimming Pool, Santa Monica*, 1964. Crayon, 11 × 14 (27·5 × 35·5). Bernard Cohen.

125 *Water Pouring into Swimming Pool, Santa Monica*, 1964. Lithograph on stone, in four colours, 20 × 26 (51 × 66). Edition of seventy-five signed in pencil, published by Editions Alecto and printed by Emil Matthieu.

126 *Striped Water*, 1965. Crayon, 13¾ × 16½ (35 × 42). Mrs Gudrun Boston, London.

127 *Different Kinds of Water Pouring into a Swimming Pool, Santa Monica*, 1965. Acrylic on canvas, 72 × 60 (183 × 153). Mrs Jane Kasmin, London.

128 *Rocky Mountains and Tired Indians*, 1965. Acrylic on canvas, 67 × 99½ (170 × 253). The Peter Stuyvesant Foundation, London.

129 *English Garden*, 1965. Acrylic on canvas, 48 × 48 (122 × 122). Private collection.

130 *Monochrome Landscape with Lettering*, 1965. Acrylic and Letraset on canvas, 48 × 48 (122 × 122). Private collection.

131 *Atlantic Crossing*, 1965. Acrylic on canvas, 72 × 72 (183 × 183). Private collection.

132 *A Painted Landscape* (or *Red and Blue Landscape*), 1965. Acrylic on canvas, 60 × 60 (153 × 153). Private collection.

133 *Picture of a Still Life*, 1965. Acrylic on canvas, 24 × 24 (61 × 61). Private collection.

134 *Blue Interior and Two Still Lifes*, 1965. Acrylic on canvas, 59¾ × 59¾ (157 × 157). Mr Lapidus, Geneva.

135 *A Realistic Still Life*, 1965. Acrylic on canvas, 48 × 48 (122 × 122). Private collection.

136 *A Less Realistic Still Life*, 1965. Acrylic on canvas, 48 × 48 (122 × 122). Kasmin Ltd, London.

137 *Portrait Surrounded by Artistic Devices*, 1965. Acrylic on canvas, 60 × 72 (153 × 183). Arts Council of Great Britain, London.

138 *A More Realistic Still Life*, 1965. Acrylic on canvas, 60 × 58¾ (153 × 149). The Hon. James Dugdale, Yorkshire.

A Hollywood Collection, 1965. Six colour lithographs, each 30 × 22·(77 × 56).

139 'Picture of a Still Life that has an Elaborate Silver Frame'

140 'Picture of a Landscape in an Elaborate Gold Frame'

141 'Picture of a Portrait in a Silver Frame'

142 'Picture of Melrose Avenue in an Ornate Gold Frame'

143 'Picture of a Simple Framed Traditional Nude Drawing'

144 'Picture of a Pointless Abstraction Framed under Glass'

145 *Peter Getting Out of Nick's Pool*, 1966. Acrylic on canvas, 84 × 84 (214 × 214). Walker Art Gallery, Liverpool.

146 *Sunbather*, 1966. Acrylic on canvas, 72 × 72 (183 × 183). Hans Neuendorf, Hamburg.

147 *Portrait of Nick Wilder*, 1966. Acrylic on canvas, 72 × 72 (183 × 183). Harry N. Abrams Family Collection, New York.

148 *Nick Wilder Watching My TV*, 1966. Pencil, 14 × 17 (35·5 × 43). Ron Davis.

149 *Nick Wilder's Apartment with John McCracken Sculpture*, 1966. Ink, 14 × 17 (35·5 × 43). Collection unknown.

150 *Portrait of Kas and Jane*, 1965. Crayon, 14 × 17 (35·5 × 43). Private collection, London.

151 *Bob, 'France'*, 1965. Pencil and crayon, 19 × 22¾ (49 × 58). Mrs Loehnis.

152 *Swimming Pool and Garden, Beverly Hills*, 1965. Pencil and crayon, 19 × 24 (48·3 × 61). David Brown.

153 *Hollywood Garden*, 1965. Crayon and water-colour, 19 × 23½ (49 × 60). Mr and Mrs Alan Bowness, London.

154 *Nehemiah Checking the Walls of Jerusalem*, 1966. Ink, 20 × 12½ (51 × 31). Collection John Torson, New York.

155 *Beirut*, 1966. Ink, 12½ × 10 (32 × 25). Gene Baro, London.

156 *Mountain Landscape, Lebanon*, 1966. Crayon, 15¾ × 19½ (40 × 50). Private collection.

Illustrations for Fourteen Poems from C. P. Cavafy, 1966. Fourteen poems with thirteen original etching illustrations, 14 × 9 (36 × 23).

157 'Portrait of Cavafy II'. Etching and aquatint.

158 'Portrait of Cavafy I'. Etching and aquatint.

159 'According to the Prescriptions of Ancient Magicians'. Etching.

160 'In the Dull Village'. Etching.

161 'In an Old Book'. Etching.

162 'In Despair'. Etching.

163 'Two Boys Aged 23 and 24'. Etching and aquatint.

164 'One Night'. Etching and aquatint.

165 'Beautiful and White Flowers'. Etching and aquatint.

Preliminary drawings for Ubu Roi, 1966. 14½ × 19½ (37 × 50).

166 'The Beginning'. Etching and aquatint.

167 'He Enquired After the Quality'. Etching and aquatint.

168 'The Shop Window of a Tobacco Store'. Etching and aquatint.

169 'To Remain'. Etching and aquatint.

170 'Père and Mère Ubu'. Pencil and crayon. Gene Baro.

171 'Battle Machine'. Pencil, crayon and ink. Robin Campbell, London.

172 'Bordue in His Cell'. Crayon. Marquis of Dufferin and Ava, London.

173 'Ubu's House'. Crayon. Stephen Spender.

174 'Ubu's Banquet with Conveyor Belt Table'. Crayon. Mrs Corob.

175 'Ubu Thinking'. Crayon. Carter Burden.

176 'Polish Army'. Crayon. The Museum of Modern Art, New York.

177 *Peter in Santa Cruz*, 1966. Ink, 9 × 12 (22·9 × 30·5). Private collection, USA.

178 *Peter, La Plaza Hotel, Santa Cruz*, 1966. Pencil, 17 × 14 (43 × 36). Collection of the artist.

179 *Peter in Bed*, 1966. Ink, 17 × 14 (43 × 36). Prince Amyn Aga Khan.

180 *Peter, Swimming Pool, Encino, California*, 1966. Crayon, 14 × 17 (35·5 × 43). John Torson, New York. This was Hockney's first drawing of Peter.

181 *Peter (Albergo da Flora II)*, 1967. Ink, 14 × 17 (35·5 × 43). Dr Boscoff.

182 *Peter*, 1967. Pencil, chalk and crayon, 17 × 14 (43 × 35·5). Whitworth Art Gallery, Manchester University.

183 *Mo on a Grey Bed*, 1966. Pencil and crayon, 15¾ × 19¼ (40 × 48·9). Robin Symes.

184 *Mo*, 1967. Crayon, 17 × 14 (43 × 35·5). Private collection, UK.

185 *Kasmin in Bed in his Château in Carennac*, 1967. Ink, 17 × 14 (43 × 35·5). Private collection, London.

186 *Jane in a Straw Hat, Carennac*, 1967. Water-colour, c. 9 × 12 (22·9 × 39·5). David Pearce.

187 *Beverly Hills Housewife*, 1966. Acrylic on canvas (diptych), 72 × 144 (183 × 366). Private collection.

188 *The Room, Tarzana*, 1967. Acrylic on canvas, 96 × 96 (244 × 244). Rory McEwen, London.

189 *A Bigger Splash*, 1967. Acrylic on canvas, 96 × 96 (244 × 244). Marchioness of Dufferin and Ava, London.

190 *A Lawn Sprinkler*, 1967. Acrylic on canvas, 48 × 48 (122 × 122). Mr and Mrs J. G. Studholme, London.

191 *American Collectors (Fred and Marcia Weisman)*, 1968. Acrylic on canvas, 84 × 120 (214 × 305). Mr and Mrs Frederick R. Weisman, Beverly Hills.

192 *Christopher Isherwood and Don Bachardy*, 1968. Acrylic on canvas, 83½ × 119½ (212 × 304). Private collection.

193 *The Little Splash*, 1966. Acrylic on canvas, 16 × 20 (41 × 51). Anthony Allen, La Medusa Gallery, 124 Via del Babuino, Rome.

194 *The Splash*, 1966. Acrylic on canvas, 72 × 72 (183 × 183). Private collection, UK.

195 *Four Different Kinds of Water*, 1967. Acrylic on canvas, 12 × 48 (31 × 122). Private collection, London.

196 *A Neat Lawn*, 1967. Acrylic on canvas, 96 × 96 (244 × 244). Herbert Meyer-Ellinger, Frankfurt A.M.

197 *A Lawn Being Sprinkled*, 1967. Acrylic on canvas, 60 × 60 (153 × 153). Claus Borgeest, Neuenhain, Germany.

198 *Savings and Loan Building*, 1967. Acrylic on canvas, 48 × 48 (122 × 122). Mr and Mrs Ehepaar Lueg, Dortmund.

199 *Los Angeles*, 1967. Crayon, 14 × 17 (35·5 × 43). Private collection, London.

200 *House near Olympic Boulevard*, 1967. Crayon, 14½ × 16¾ (37 × 42·5). Mrs B. Organ, Wolverton.

201 *Some Neat Cushions*, 1967. Acrylic on canvas, 62 × 62 (158 × 158). Carter Burden, New York.

202 *Cushions*, 1968. Etching and aquatint on copper plate, 15 × 13¾ (38 × 35). Edition of seventy-five signed in pencil, printed by Maurice Payne.

203 *Two Stains on a Room on a Canvas*, 1967. Acrylic on canvas, 72 × 60 (183 × 153). Private collection.

204 *A Table*, 1967. Acrylic on canvas, 60 × 60 (153 × 153). Collection of the artist.

205 *The Room, Manchester Street*, 1967. Acrylic on canvas, 96 × 96 (244 × 244). Private collection.

206 *California Seascape*, 1968. Acrylic on canvas, 84 × 120 (214 × 305). The Hon. James Dugdale, Yorkshire.

207 *Tree*, 1968. Lithograph on zinc, six colours, 25½ × 19½ (65 × 49·8). Edition of ninety-five, signed in pencil, published by the Petersburg Press.

208 *1001 Dental Building, Santa Monica*, 1968. Crayon, 14 × 17 (35·5 × 43). Robin Symes.

209 *Bank, Palm Springs*, 1968. Crayon, 14 × 17 (35·5 × 43). Galleria Milano.

210 *Schloss*, 1968. Acrylic on canvas, 36 × 48 (91 × 122). Louise Ferrari, Houston.

211 *Early Morning, Sainte-Maxime*, 1968–9. Acrylic on canvas, 48 × 60 (122 × 153). Private collection.

212 *Parking privé*, 1968. Acrylic on canvas, 36 × 48 (91 × 122). Galerie Springer, Berlin.

213 *L'Arbois, Sainte-Maxime*, 1968–9. Acrylic on canvas, 44 × 60 (113 × 153). Carter Burden, New York.

214 Study for *L'Arbois, Sainte-Maxime*, 1968. Mixed media, 14 × 17 (35·5 × 43). Fauvel.

215 *Peter*, 1968. Ink, 14 × 17 (35·5 × 43). Private collection, Paris.

216 *Peter*, 1969. Etching, 28 × 22 (69 × 54). Edition of seventy-five.

217 *Peter Reading, Santa Monica*, 1968. Ink, 14 × 17 (35·5 × 43). Dr R. Mathys.

218 *Peter*, 1968. Ink, 14 × 17 (35·5 × 43). Peter Coni.

219 *A Portrait of Rolf Nelson*, 1965–8. Lithograph and watercolour, three colours, 41¼ × 29½ (105 × 75). Edition of twelve, signed in pencil, printed by Kenneth Tyler.

220 *Kasmin Twice*, 1968. Etching and aquatint on copper plate, 13¼ × 21½ (34 × 55). Edition of ten signed in pencil, printed by Maurice Payne.

221 *Ossie and Mo*, 1968. Etching on copper plate, 12½ × 13¾ (32 × 35). Edition of seventy-five, signed in pencil, published by Petersburg Press and printed by Maurice Payne.

222 *Christopher Isherwood, Santa Monica*, 1968. Ink, 17 × 14 (43 × 35·5). Private collection, Switzerland.

223 *Christopher Isherwood*, 1968. Ink, 17 × 14 (43 × 35·5). Private collection, Los Angeles.

224 *Henry and Christopher*, 1967. Colour lithograph with collage and crayon, 22 × 30 (57 × 76). Edition of fifteen.

225 *Henry, Le Nid du Duc*, 1969. Ink, 17 × 14 (43 × 35.5). Kasmin Ltd, London.

226 *Christopher Scott*, 1968. Pencil, 14 × 17 (35·5 × 43). Walter Reichenfeldt.

227 *Henry, Hollywood*, 1969. Ink, 14 × 17 (35·5 × 43). Private collection, Los Angeles.

228 *Henry Geldzahler and Christopher Scott*, 1969. Acrylic on canvas, 84 × 120 (214 × 305). Harry N. Abrams Family Collection, New York.

229 *Henry Geldzahler and Christopher Scott*, 1968. Ink. 11 × 14 (27·9 × 35·5). Private collection, Germany.

230 *Still Life with TV*, 1969. Acrylic on canvas, 48 × 60 (122 × 153). Private collection.

231 *Corbusier Chair and Rug*, 1969. Mixed media, 17 × 14 (43 × 35·5). Collection of the artist.

232 *Pink, Red and Green Pencils in a Glass Jar*, 1968. Pencil and crayon, 17 × 14 (43 × 35·5). James Kirkman.

233 *Still Life*, 1969. Etching and aquatint, 22 × 28 (54 × 69). Edition of seventy-five.

234 *Flowers and Vase*, 1969. Etching and aquatint, 28 × 22 (70 × 55). Edition of seventy-five.

235 *Pretty Tulips*, 1969. Colour lithograph, 30 × 22 (73 × 57). Edition of two hundred, published by the Petersburg Press, printed by Ernest Donagh.

236 *Glass Table with Objects*, 1969. Colour lithograph, 18 × 22 (45 × 56). Edition of seventy-five.

237 *Peter Langham*, 1969. Ink, 14 × 17 (35·5 × 43). Private collection, London.

238 *James Kirkman*, 1969. Ink, 16¾ × 13¾ (42 × 36). James Kirkman, London.

239 *Stephen Spender*, 1969. Ink, 28 × 20 (71 × 50·8). Stephen Spender, London.

240 *W. H. Auden,* 1968. Ink, 17 × 14 (43 × 35·5). Private collection, London.

241 *Celia (Paris, March 1969).* Ink, 17 × 14 (43 × 35). Private collection, London.

242 *Celia,* 1969. Etching and aquatint, 28 × 22 (69 × 54). Edition of seventy-five.

243 *Patrick Procktor Painting,* 1969. Ink drawing, 17 × 14 (43 × 35·5). Collection unknown.

244 *Frederick Ashton and Wayne Sleep,* 1968. Ink, 17 × 14 (43 × 35·5). Collection John Torson, New York.

245 *Wayne Sleep,* 1969. Etching on copper, 10 × 10 (25 × 25). Edition of thirty, printed by Maurice Payne.

246 *Peter,* 1969. Ink, 17 × 14 (43 × 35·5). Collection unknown.

247 *Mo in Profile,* 1969. Pencil, 14 × 17 (35·5 × 43). Collection unknown.

248 *Portrait of Michael Chow,* 1969. Crayon, 17 × 14 (43 × 36). Michael Chow, London.

249 *The Connoisseur,* 1969. Lithograph, 30 × 22 (76 × 57). Edition of thirty.

250 *Portrait of Felix Mann,* 1969. Lithograph on zinc, 26 × 21 (67 × 53·2). Edition of a hundred, signed in pencil, published by Ketterer and printed by Stanley Jones.

251 *Le Parc des sources, Vichy,* 1970. Acrylic on canvas, 84 × 120 (214 × 305). Private collection.

252 *Mr and Mrs Clark and Percy,* 1970–1. Acrylic on canvas, 84 × 120 (214 × 305). Collection Tate Gallery.

253 *Sur la terrasse,* 1971. Acrylic on canvas, 180 × 84 (457 × 214). Private collection, Switzerland.

254 *Peter on Balcony,* 1971. Crayon, 13¾ × 10½ (35 × 27). Mrs Littman.

255 *Pool and Steps, Le Nid du Duc,* 1971. Acrylic on canvas, 72 × 72 (183 × 183). Private collection, London.

256 *Still Life on a Glass Table,* 1971–2. Acrylic on canvas, 72 × 108 (183 × 274·4). Private collection.

257 *French Shop,* 1971. Acrylic on canvas, 72 × 60 (183 × 153). Acquavella Gallery, New York.

258 *Beach Umbrella,* 1971. Acrylic on canvas, 48 × 35¾ (122 × 91). Mr and Mrs Miles Q. Fiterman, New York.

259 *Rubber Ring Floating in a Swimming Pool,* 1971. Acrylic on canvas, 35¾ × 48 (91 × 122). Private collection, Japan.

Six Fairy Tales from the Brothers Grimm, 1969. Six stories with thirty-nine etching illustrations and text translated by Heiner Bastian.

260 'Catherina Dorothea Viehmann'. Etching and aquatint on copper, 11 × 9 (28 × 24).

261 'The Princess in her tower'. Etching and aquatint on copper, 18 × 13 (45 × 33).

262 *(Left)* 'The boy hidden in an egg'. Etching, aquatint and drypoint, 8 × 7 (21 × 18). *(Right)* 'The boy hidden in a fish'. Etching and aquatint on copper, 9 × 11 (24 × 28).

263 'The Princess searching'. Etching and aquatint on copper, 11 × 7 (28 × 18).

264 *Mo,* study for illustrations to 'The Little Sea Hare', 1969. Ink, 17 × 14 (43 × 35·5). Beneson.

265 'A wooded landscape'. Etching and aquatint on copper, 13 × 11 (34 × 28).

266 *(Left)* 'The cook'. Etching and aquatint on copper, 7 × 11 (19 × 29). *(Right)* 'The pot boiling'. Etching and aquatint on copper, 7 × 8 (19 × 21).

267 *(Left)* 'The rose and the rose stalk'. Etching, 11 × 5 (29 × 13). *(Right)* 'The church tower and the clock'. Etching and aquatint, 11 × 5 (29 × 13).

268 'The lake'. Etching and aquatint on copper, 18 × 13 (46 × 33).

269 'Rapunzel growing in the garden'. Etching and aquatint, 18 × 13 (46 × 33).

270 *(Left)* 'The Enchantress in her garden'. Etching and aquatint on copper, 9 × 5 (24 × 14). *(Right)* 'The Enchantress with the baby Rapunzel'. Etching and aquatint, 11 × 9 (28 × 24).

271 *(Left)* 'The older Rapunzel'. Etching and aquatint on copper, 9 × 10 (24 × 27). *(Right)* 'The tower had one window'. Etching and aquatint on copper, 14 × 6 (35·5 × 15).

272 'Rapunzel, Rapunzel, let down your hair'. Etching and aquatint on copper, 10 × 9 (27 × 24).

273 'Home'. Etching on copper, 18 × 13 (46 × 33).

274 *Armchair,* 1969. Ink, 14 × 17 (35·5 × 43). Collection unknown.

275 *(Left)* 'The bell tower'. Etching and aquatint, 11 × 7 (28 × 17). *(Right)* 'The sexton disguised as a ghost'. Etching and aquatint, 9 × 11 (24 × 28).

276 'The sexton disguised as a ghost stood still as stone'. Etching and aquatint, 18 × 13 (46 × 33).

277 'Corpses on fire'. Etching, aquatint and drypoint on copper, 11 × 10 (28 × 25).

278 'The haunted castle'. Etching and aquatint on copper, 14 × 8 (35·5 × 21).

279 *(Left)* 'The Carpenter's bench, a knife and fire'. Etching, aquatint and drypoint on copper, 6 × 7 (16 × 18). *(Right)* 'A black cat leaping'. Etching and aquatint on copper, 9 × 11 (24 × 28).

280 *(Left)* 'The lathe and fire'. Etching, aquatint and drypoint, 6 × 7 (16 × 18). *(Right)* 'Inside the castle'. Etching and aquatint on copper, 10 × 7 (25 × 18).

281 'Cold water about to hit the Prince'. Etching and aquatint on copper, 16 × 11 (40 × 28).

282 'The glass mountain'. Etching on copper, 18 × 13 (46 × 33).

283 *(Left)* 'Old Rinkrank threatens the Princess'. Etching on copper, 9 × 11 (24 × 28). *(Right)* 'Digging up glass'. Etching and aquatint on copper, 5 × 4 (14 × 12).

284 *(Left)* 'The glass mountain shattered'. Etching, 9 × 11 (24 × 28). *(Right)* 'The Princess after many years in the glass mountain'. Etching and aquatint on copper, 18 × 13 (46 × 33).

285 'Gold'. Etching on copper, 14 × 10 (35 × 25).

286 *(Left)* 'A room full of straw'. Etching and aquatint, 9 × 10 (23 × 25). *(Right)* 'Straw on the left, gold on the right'. Etching on copper, 6 × 10 (15 × 25).

287 *(Left)* 'Pleading for the child'. Etching on copper, 11 × 10 (28 × 25). *(Right)* 'Riding around on a cooking spoon'. Etching, aquatint and drypoint, 7 × 10 (17 × 25).

288 'He tore himself in two'. Etching and aquatint, 18 × 13 (46 × 33).

289 *Ossie wearing a Fairisle sweater*, 1970. Crayon, 23½ × 20 (60 × 51). Marquis of Dufferin and Ava, London.

290 *Celia in Red*, 1970. Crayon, 17 × 14 (43 × 35·5). Collection Mrs R. Newman, New York.

291 *Celia in Black*, 1970. Crayon, 17 × 14 (43 × 35·5). James Astor, London.

292 *Ossie Clark*, 1970. Ink, 17 × 14 (43 × 35·5). Kasmin Ltd, London.

293 *Peter, Hotel Regina, Venice*, 1970. Ink, 17 × 14 (43 × 35·5). Gerhard Schark.

294 *Mo at Carennac*, 1970. Ink, 17 × 14 (43 × 35·5). Collection John Torson, New York.

295 *Mo, Pavillon Sevigné, Vichy*, 1970. Ink, 14 × 17 (43 × 35·5). Private collection.

296 *Paris, 27 rue de Seine*, 1970. Ink, 17 × 14 (43 × 35·5). Kasmin Ltd, London.

297 *Sofa*, 1971. Lithograph, 22 × 30 (57 × 76). Edition of thirty.

298 *Paris, 27 rue de Seine*, 1971. Etching, 27 × 21 (68 × 54). Edition of a hundred and fifty.

299 *Lilies*, 1971. Colour lithograph, 30 × 22 (76 × 57). Edition of a hundred.

300 *Flowers Made of Paper and Black Ink*, 1971. Lithograph, 40 × 38 (99 × 95). Edition of fifty.

301 *Maurice Payne*, 1971. Etching, 35 × 28 (89 × 72). Edition of seventy-five.

302 *Mo with Five Leaves*, 1971. Etching, 35 × 28 (89 × 72). Edition of seventy-five.

303 *Portrait of Richard Hamilton*, 1971. Etching and aquatint, 22 × 17 (55 × 43). Edition of thirty.

304 *Mo Asleep*, 1971. Etching and aquatint, 35 × 28 (89 × 72). Edition of seventy-five.

305 *Peter, Mamounia Hotel*, 1971. Crayon, 17 × 14 (43 × 35·5). Private collection, London.

306 *Chairs, Mamounia Hotel, Marrakesh*, 1971. Crayon, 14 × 17 (35·5 × 43). Whitworth Art Gallery, University of Manchester.

307 *Sir David Webster*, 1971. Mixed media, John Torson.

308 *Portrait of Sir David Webster*, 1971. Acrylic on canvas, 57 × 72 (145 × 183). Royal Opera House, Covent Garden, London.

309 *The Island*, 1971. Acrylic on canvas, 48 × 60 (121·9 × 152·4). John C. Stoller, Minneapolis.

310 *Inland Sea (Japan)*, 1971. Crayon, 14 × 17 (35·5 × 43). Kasmin Ltd, London.

311 *Japanese Rain on Canvas*, 1972. Acrylic on canvas, 48 × 48 (122 × 122). Private collection.

312 *Mark, St Francis Hotel, San Francisco*, 1971. Ink, 14 × 17 (35·5 × 43). Mrs Kingsmill.

313 *Strand Hotel, Rangoon*, 1971. Crayon, 17 × 14 (43 × 35·5). Private collection, USA.

314 *Mark, Strand Hotel, Rangoon*, 1971. Ink, 14 × 17 (35·5 × 43). John Torson.

315 *Mark, Bella Vista Hotel, Macao*, 1971. Ink, 14 × 17 (35·5 × 43). Collection unknown.

316 *My Suit and Tie*, 1971. Crayon, 17 × 14 (43 × 35·5). Private collection, New York.

317 *Chair in front of a Horse Drawing by Picasso*, 1971. Acrylic on canvas, 34 × 28 (86·4 × 71·1). Private collection, Germany.

318 *Three Chairs with a Section of a Picasso Mural*, 1970. Acrylic on canvas, 48 × 60 (122 × 152·4). Private collection, New York.

319 *Gonzalez and Shadow*, 1971. Acrylic on canvas, 48 × 36 (122 × 91·4). Collection of the artist.

320 *Cubistic Sculpture with Shadow*, 1971. Acrylic on canvas, 48 × 36 (122 × 91·4). Collection of the artist.

321 *Beach Umbrella, Calvi*, 1972. Crayon, 17 × 14 (43 × 35·5). British Museum, London.

322 *Grand Hotel Terrace, Vittel*, 1970. Crayon, 17 × 14 (43 × 35·5). Private collection.

323 *Hotel Garden, Vichy*, 1972. Acrylic on canvas, 36 × 48 (91·4 × 122). Private collection, USA.

324 *Henry, Pavillon Sevigné, Vichy*, 1972. Crayon, 14 × 17 (35·5 × 43). Henry Geldzahler.

325 *Larger Leeks*, 1970. Crayon, 14 × 17 (35·5 × 43). Marquis of Dufferin and Ava, London.

326 *Banana*, 1970. Crayon, 17 × 14 (43 × 35·5). Marquis of Dufferin and Ava, London.

327 *Carennac*, 1970. Ink, 14 × 17 (35·5 × 43). Private collection, London.

328 *Two Red Peppers*, 1970. Crayon, 17 × 14 (43 × 35·5). Private collection, Belgium.

329 *Beans on Paper*, 1972. Crayon, 17 × 14 (43 × 35·5). John Curtis, London.

330 *Carrots on Paper*, 1972. Crayon, 17 × 14 (43 × 35·5). Private collection, UK.

331 *The Valley*, 1970. Acrylic on canvas, 36 × 48 (91·4 × 122). Ian Dunlop.

332 *Portrait of an Artist (Pool with Two Figures)*, 1971. Acrylic on canvas, 84 × 120 (214 × 275). Private collection, UK.

333 *Mount Fuji*, 1972. Acrylic on canvas, 60 × 48 (153 × 122). The Metropolitan Museum of Art, New York, Mrs Arthur Hays Sulzberger Gift Fund.

334 *Two Deckchairs, Calvi*, 1972. Acrylic on canvas, 60 × 48 (153 × 122). Museum Boymans-van Beuningen, Rotterdam.

335 *Suginoi Hotel, Beppu*, 1971. Crayon, 14 × 17 (35·5 × 43). Collection unknown.

336 *Chair and Shirt*, 1972. Acrylic on canvas, 72 × 72 (183 × 183). Private collection, UK.

337 *Peter, Platzel Hotel, Munich*, 1972. Crayon, 17 × 14 (43 × 35·5). William Evans, Missouri.

338 *Gary Farmer at Powis Terrace*, 1972. Crayon, 17 × 14 (43 × 35·5). Kasmin Ltd, London.

339 *Nick, Grand Hotel, Calvi*, July 1972. Crayon, 17 × 14 (43 × 35·5). Mr and Mrs T. H. Gibson, London.

340 *Mirror, Lucca*, 1973. Crayon, 17 × 14 (43 × 35·5). Private collection, New York.

341 *Dr Eugen Lamb, Lucca*, 1973. Crayon, 23 × 20 (60 × 51). Marchioness of Dufferin and Ava, London.

342 *Villa Reale, Marlia*, 1973. Crayon, 14 × 17 (35·5 × 43). Kasmin, London.

343 *Celia in a Black Dress with Coloured Border*, 1973. Crayon, 25½ × 19¾ (65 × 50). Collection of the artist.

344 *Celia Wearing Checked Sleeves*, 1973. Crayon, 25½ × 19¾ (65 × 50). Collection of the artist.

345 *Celia*, 1973. Lithograph, 42 × 28 (108 × 71). Edition of fifty-two.

346 *Celia Smoking*, 1973. Lithograph, 38 × 28 (98 × 71). Edition of seventy.

347 *Celia*, 1972. Crayon, 17 × 14 (43 × 35·5). William Evans, Missouri.

348 *Celia*, 1972. Crayon, 17 × 14 (43 × 35·5). Private collection, USA.

349 *Celia Half-nude*, 1975. Crayon, 25½ × 19¾ (65 × 50). Collection of the artist.

350 *Celia in Black Slip and Platform Shoes*, 1973. Crayon, 19¾ × 25½ (50 × 65). Collection of the artist.

351 *Thierry: Grand Hotel, Calvi*, 1972. Ink, 17 × 14 (43 × 35·5). Private collection, UK.

352 *John St Clair*, 1972. Crayon, 17 × 14 (43 × 35·5). Collection Mrs R. Newman, New York.

353 *Nick and Henry on Board, Nice to Calvi*, 1972. Ink, 17 × 14 (43 × 35·5). British Museum.

354 *Nick, Pavillon Sevigné, Vichy*, 1972. Ink, 17 × 14 (43 × 35·5). Kasmin Ltd, London.

355 *Panama Hat*, 1972. Etching, 17 × 14 (43 × 35·5). Edition of 125.

356 *The Artist's Mother*, 1972. Ink, 17 × 14 (43 × 35·5). Collection of the artist.

357 *Mother (1 July, Bradford)*, 1972. Ink, 17 × 14 (43 × 35·5). Collection of the artist.

358 *The Artist's Father, Bradford*, 1972. Ink, 17 × 14 (43 × 35·5). Collection of the artist.

359 *The Artist's Father*, 1972. Ink, 17 × 14 (43 × 35·5). Collection of the artist.

360 *Mother*, 1972. Crayon, 17 × 14 (43 × 35·5). Collection of the artist.

361 *My Mother with a Parrot*, 1974. Etching with aquatint, 28 × 20 (71 × 51). Edition of a hundred.

362 *Henry*, 1973. Lithograph, 16 × 12 (40 × 30). Edition of fifty.

363 *Henry, Seventh Avenue*, 1972. Crayon, 17 × 14 (43 × 35·5). Henry Geldzahler.

364 *Sant'Andrea in Caprile (Henry in Deckchair)*, 1973. Crayon, 17 × 14 (43 × 35·5). Kasmin Ltd, London.

365 *Sant'Andrea in Caprile*, 1973. Ink, 14 × 17 (35·5 × 43). Private collection, UK.

366 *Dr Eugen Lamb*, 1973. Crayon, 14 × 17 (35·5 × 43). Private collection, UK.

367 *Chair, Casa Santini*, 1973. Crayon, 14 × 17 (35·5 × 43). Kasmin Ltd, London.

368 *Don Crib, Lucca*, 1973. Crayon, 17 × 14 (43 × 35·5). Society of Contemporary Arts, London.

369 *Mo, Lucerne*, 1973. Crayon, 14×17 (35·5×43). Private collection, USA.

370 *Portrait of Jean Léger,* 1973. Pencil, 25½×19¾ (65×50). Jean Léger, Paris.

371 *Lila di Nobilis,* Paris, 1973. Crayon, 25½×19¾ (65×50). Private collection, USA.

372 *Celia, 8365 Melrose Avenue,* 1973. Lithograph, 47×31 (121×80). Edition of forty-six.

Weather Series, 1973. Six colour lithographs. Edition of ninety-eight.

373 'Snow'. 37×31 (94×77).

374 'Wind'. 40×31 (102×79).

375 'Rain'. 39×32 (99×81).

376 'Sun'. 37×31 (94×77).

377 'Mist'. 37×32 (94×81).

378 'Lightning'. 39×32 (99×81).

379 *The Master Printer of Los Angeles,* 1973. Colour lithograph, 48×32 (122×81). Edition of twenty-seven.

380 *Gustave Flaubert,* 1973. Colour etching, 31×22 (79×57). Edition of twenty-five.

381 *George Sand,* 1973. Colour etching, 31×22 (79×57). Edition of twenty-five.

382 *Postcard of Richard Wagner with Glass of Water,* 1973. Colour etching, 8×6 (21×15). Edition of a hundred.

383 *Still Life with Book,* 1973. Colour lithograph, 32×25 (81×64). Edition of seventy-eight.

384 *Study for Louvre Window, No. 2,* 1974. Crayon, 41½×29½ (105·4×74·9). Kasmin Ltd, London.

385 *Contre-jour in the French Style,* 1974. Etching and aquatint, 39×35½ (99×90). Edition of seventy-five.

386 *Two Vases in the Louvre,* 1974. Oil on canvas, 72×60 (184×152·5). Kasmin Ltd, London.

387 *Two Vases in the Louvre,* 1974. Etching and aquatint, 39×35½ (99×90). Edition of seventy-five.

388 *Man Ray,* 1973. Crayon, 17×14 (43×35·5). Private collection, France.

389 *Simplified Faces (State 2),* 1974. Etching, 22×20 (56×51). Edition of thirty.

390 *Gregory Masurovsky and Shirley Goldfarb,* 1974. Oil on canvas, 48×84 (122×214). Kasmin Ltd, London.

391 *Gregory Masurovsky and Shirley Goldfarb,* 1974. Crayon, 29½×41½ (74·9×105·4). Private collection, Hamburg.

392 *George Lawson and Wayne Sleep* (unfinished), 1975. Acrylic on canvas, 84×120 (213·4×304·8). Collection of the artist.

393 *The Student: Homage to Picasso,* 1973. Etching, 30×22 (76×57). Edition of twenty.

394 *Artist and Model,* 1974. Etching, 32×24 (81×61). Edition of one hundred.

395 *Showing Maurice the Sugar Lift,* 1974. Etching, 36×28 (92×72). Edition of seventy-five.

396 *Kasmin,* 1973. Pencil, 25½×19¾ (65×50). Private collection, London.

397 *Carlos,* 1975. Crayon, 25½×19¾ (65×50). Collection of the artist.

398 *Henry in Candlelight,* 1975. Crayon, 17×14 (43×35·5). Private collection, France.

399 *Gregory Thinking in the Palatine Ruins,* 1974. Ink, 25½×19¾ (65×50). Private collection, Paris.

400 *Larry S., Fire Island,* 1975. Ink, 14×17 (35·5×43). Kasmin Ltd, London.

401 *Larry, Fire Island,* 1975. Crayon, 14×17 (35·5×43). Private collection, Germany.

402 *Nicky Rae,* 1975. Crayon, 25½×19¾ (65×50). Collection of the artist.

403 *Yves-Marie and Mark in Paris,* 1975. Crayon, 25½×19¾ (65×50). Collection of the artist.

404 *Books and Pencils, Fire Island,* 1975. Crayon, 17×14 (43×35·5).

405 *Gregory Asleep, Sunday Inn, Houston,* 1976. Ink, 14×17 (35·5×43). Collection of the artist.

406 *Gregory in Bed, Hollywood,* 1976. Ink, 17×14 (43×35·5). Collection of the artist.

407 *Gregory, Arizona, Biltmore,* 1976. Ink, 17×14 (43×35·5). Collection of the artist.

408 Sketch for *The Rake's Progress,* 1975. Coloured inks and watercolour, 14×17 (35·5×43). Collection of the artist.

409 *Homage to Michelangelo,* 1975. Colour etching and aquatint, 18×26½ (46·2×67·5). Edition of two hundred with thirty artist's proofs, printed by Aldo Crommelynck.

410 *Contre-jour in the French Style – Against the Day dans le style français,* 1974. Oil on canvas, 72×72 (183×183). Kasmin Ltd, London.

411 *Invented Man Revealing Still Life,* 1975. Oil on canvas, 36×28½ (91·4×72·4). Private collection, USA.

412 Drawing for the design for Roland Petit's ballet *Septentrion,* 1975. Crayon, 14×17 (35·5×43). Private collection, USA.

413 *Kerby (After Hogarth) Useful Knowledge,* 1975. Oil on canvas, 72×60 (183×152·4). The Museum of Modern Art, New York.

414 *My Parents and Myself,* 1975. Oil on canvas, 72×72 (183×183). Collection of the artist.

Index

All references are to page numbers; those in italic indicate illustrations